OFF LIMITS

OFF LIMITS 40 ARTANGEL PROJECTS

Artangel | **MERRELL**

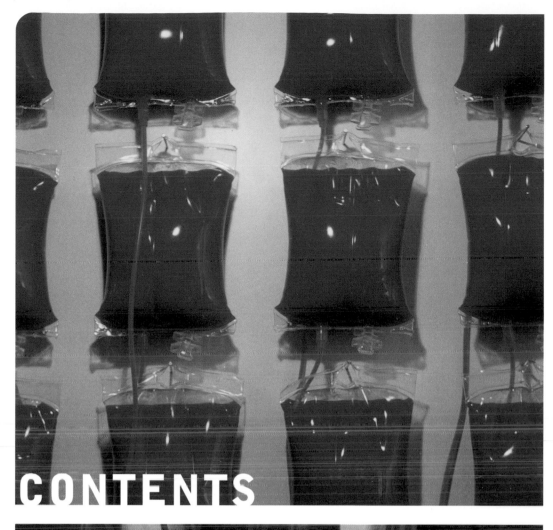

CONTENTS

Off Limits, 40 Artangel Projects has been made
possible by London Arts and The Company of Angels
with the support of the Fine Family Foundation.

Edited by Gerrie van Noord

FOREWORD

Marina Warner

An ace of spades arriving in the post; a blue-white phantom of solid concrete looming in the night from an urban waste ground; daisies in an infinity loop; a solitary figure bobbing on a buoy in midstream on the Thames; a colossal fist drubbing at the Georgian window of a Soho square; the boom of John Berger's voice in the deep tunnels of the Underground, summoning a prehistoric bear, as we, the audience, lay on the platform under his spell; a police charge, on horseback, down a country road with a bright ice-cream van incongruously standing in the way: Artangel have given me extraordinary experiences that have stayed with me and changed the way I think.

And these instances are only a few from many intense and memorable encounters with art they have brought to London and, sometimes, farther afield, as in the case of Jeremy Deller's *The Battle of Orgreave*. Over the last ten years, it seems to me that Artangel has brilliantly managed to square a circle that has proved impossible for every other commissioning body: it has stood behind originality and experiment, encouraged little-known artists and unfamiliar art works, expanded the spaces and processes of art, and yet never lost touch with audiences but continued, consistently, to generate excitement with not a few initiates, but with many varied and different publics. I know that I've been extremely fortunate to be there, during this decade, and attended so many of Artangel's events; it has been a historic epoch. Indeed, the death of both Helen Chadwick and Juan Muñoz remind us how little time there can be to make such works. Without the structures Artangel puts in place, and the trust they offer, some artists would never be able to move the ideas they have in mind out of the cave of shadows into the world of act and form.

Michael Morris and James Lingwood, Artangel's Co-Directors since 1991, have shown remarkable imagination and judgement, curiosity and knowledge; they have proven and unrivalled midwifery skills in bringing to completion projects that truly seemed wild and impossible dreams. The artists with whom they have worked have redrawn the map, reinvigorated London's multiple geographies, and brought to life different zones and strata. There's no word for what James and Michael are: vocabulary stumbles at clunky neologisms, such as enabler, or facilitator. Producer has changed its meaning – though they do indeed produce Artangel's projects. Impresario is the one I like a little more – an older word, it summons up figures like Diaghilev, who gave inspired artists in all kinds of media a way to make art and remain exuberantly innovatory and even outrageous.

But there's a difference, an altogether unprecedented quality to Artangel. Impresarios / producers / patrons of the past stamped their seal on the works appearing under their auspices in the same way as old Hollywood studios had a look, a house style, a typical moral to the story they told, and exercised ownership of their stars. Artangel has a signature, but it has managed to deterritorialise it, to unhook it from personal property: they give artists the freedom to make art the way they would if nobody owned them or directed them or wanted to tell them the story in a certain way, to meet sponsors' ambitions or the state's civic purposes.

What Artangel does brought to my mind those famous lines of Theseus from *A Midsummer Night's Dream*, when he talks about fantasy, and says that "the lunatic, the lover and the poet, give dreams a local habitation and a name" – Artangel gives a local habitation and a name to artists in a landscape that otherwise offers them slender opportunity to follow their own fantasy.

In the 1960s Gilbert and George used to send out a series of postcards every now and then, with a different picture of themselves doing something; the postcard was rubber stamped with the slogan, To Be With Art Is All We Ask. But this was more of a question than a statement, an ironical, modish question, begging more than it let on. For of course they were also asking "what is art?", and they were claiming by stealth that they were the answer. Artangel has dared to reconfigure the issue from the ground up – or from even deeper down, as in John Berger and Simon McBurney's piece *The Vertical Line*, when they descended into the depths of the Underground.

Off Limits, this record in book form of a remarkable body of work over the last ten years, tracks art that of its very nature no longer exists: the auratic intensity of Artangel's characteristic projects glow through these afterimages, and communicates the uniqueness of the events as they happened at the time. The section headings of the book, Motion, Past, Navigation, Pulse and Time, convey the difference in the work Artangel has brought into being from the traditions of fine art, including Modernism, and the essays and artists' statements vividly illuminate the aesthetic possibilities that they have explored and the development of the changes in which they have participated. *Off Limits* captures the excitement of the works when they were made; but it also shows how crucial so many of them were to reconfiguring the pattern of art, its expression, its objects, its audiences, its meanings. This is a chronicle of changes that are still happening; the works represented here may be completed, but the story of the difference they have made is by no means concluded.

June 2002

A conversation between Michael Craig-Martin, Lisa Jardine, James Lingwood and Michael Morris

LJ Let's start by talking about the early Artangel.

MCM One of the things that interests me is what you thought it was you were taking over in late 1991. Obviously you knew Artangel's history.

MM James and I come from different backgrounds, although we worked together at the ICA in London – James as a curator and I was running the performing arts programme. It was a time when the performance agenda was changing and in my last days at the ICA I was particularly interested in extending the programme there into unusual spaces.

LJ Was that specifically beyond galleries?

MM In the mid-1980s, the black box of the ICA theatre began to feel like a constraint, so we imagined how the programme might extend beyond the Mall. It was a time when the lure of an untouched Docklands provided performance spaces both large and small. A time when the Royal Victoria Docks hadn't yet made way for a City Airport and Butler's Wharf had not yet been colonised by Conran. The attraction of Artangel was the opportunity to continue developing an interest in the animation of unexpected places, even though Artangel then was primarily involved in particular areas of the visual arts. James and I felt that we could expand that to include the performing arts whilst not trying to over-categorise or compartmentalise what we would do.

JL It's easy to assume that the conditions we work in now mirror the conditions of ten or fifteen years ago. But the cultural landscape has shifted a lot. The topography of opportunity and expectation and audience had begun to change and we were interested in being part of that change. It was happening in a number of ways. On the one hand, when the Saatchi Gallery opened in the late 1980s it was almost shocking in its scale and confidence. On the other hand, the idea of urban regeneration through culture had enjoyed its first high-profile success through Glasgow's rebranding of itself as City of Culture in 1990. We felt intuitively that there was a space which we could open up alongside the mainstream institutions and that Artangel could offer an alternative means of production and presentation, another way of working closely with artists. But we didn't want alternative implicitly to mean marginal or secondary, to be in any kind of hierarchical relationship to these institutions. We wanted to put ourselves alongside them and to give artists a depth of focus and a breadth of possibility which perhaps was not easy to find elsewhere.

MM When we started at Artangel, a lot of the big institutions seemed to have become distracted by internal reorganisation and had perhaps lost sight of the fact that the main purpose of an arts institution is to engage with artists for the benefit of audiences. We thought Artangel could actually be a place that was really driven by artists.

LJ There are two key issues you've identified here: the first is a commitment to artists and the second is to renegotiate their relationship with the institutions that present and promote art. What you have done over the years is redefine

the relationship between art and the space in which it finds itself and the way it comments on that space. Was that your particular aim when you moved from the ICA?

JL We were at a point where certain orthodoxies of Modernism had been convincingly dismantled. The idea of the *tabula rasa*, of starting with a blank canvas, was pretty hard to sustain. It wasn't necessary to eliminate a sense of environment, history, the layering of culture, the experience of the street from the work. The Arte Povera artists, for example, had opened up a very different kind of aesthetic space. We were interested in the idea that there could be a seepage of the work into the world and vice versa, to break down where the edge of the 'made' work might be, and where the edge of the 'found' world might be. In many of the projects with which we've been involved there is this kind of seepage of the one into the other. The choice of location is never secondary and is often something that contributes actively to the meaning of the work. It's not just a container.

MM That place or location, whether a natural or architectural environment, has always emerged at a different point in the protracted development we encourage. There are times when it's been there as a starting point and times when it remains abstract until very late. In every case, the choice of environment irreducibly shapes the final work, making uprooting or relocating often impossible.

MCM When you take an artwork or art experience in whatever form it takes, outside an institution that's specifically devoted to contemporary art like the ICA or the Whitechapel, you change the relationship with the audience. This in turn creates the sense of a highly specific experience and an immersion in that experience. You can go to a museum and a detachment between you and the work can still exist, whereas if you go somewhere very particular to see something that has been created *in situ*, that is in itself already very special.

MM The journey to and the discovery of the spaces we have animated becomes in itself an event or an experience. Whereas visiting a cultural institution – whether a theatre, a gallery, a museum or a concert hall, however well managed – is completely different, because you know broadly what to expect from the experience. An encounter with an Artangel project knows no such bounds and we have often played with that element of surprise in the way we announce our commissions. One of the reasons some of Artangel's projects have become memorable is because discovering them proved such an unusual occurrence: *H.G.* in the Clink Street vaults or *Break Down* in a former C&A store on Oxford Street, for example.

JL I'd like to use the analogy of a film camera. When you're looking at a work in a frame, your eye zooms in, it settles within the frame. You have a space to concentrate on. The frame cuts off any relationship to anything outside. Alternatively there's the idea of a pan across space which provides a range of different visual information, a changing set of relations. It's an interesting question to me as to how you experience something in relation to other things –

but without necessarily losing any intensity of looking or experience. Perhaps the best example of that would be how you could look at Rachel Whiteread's *House* from different vantage points, so that if you looked at the work from the North to the South, you would see it in relation to Canary Wharf. If you were looking at it from the park at the back, you would see various attempts to organise housing by metropolitan authorities from the Victorians to the 1960s, from terraces to high-rise blocks. From one particular angle you could see three different churches in the background, encouraging a reading of how social stability was transferred from organised religion to an idea of home in the nineteenth century. There's always this sense of moving the eye from what the artist might have placed in front of you or around you, to what else is there and wanting to stimulate meanings through that relationship.

LJ For so many people *House*, for better or for worse, is equated with Artangel precisely because it includes that relationship with the rest of the world. For many people this was crucial to it: the encounter and the act of self-definition against the work.

MCM There's one other factor that I think is very central to all the works that you've commissioned and produced and that is that they're temporary, even something like *House* Many people were unhappy with *House* being temporary. I've always felt it's one of the best things about it. The worst would have been it still being there, falling apart.

LJ Interestingly, the lobby – which included local and national politicians – trying to save *House* from demolition wasn't over aesthetics, it was about the community's right to make up its mind for itself.

MCM There's an absolutely critical moment when elements from the performing arts combine with aspects of the visual arts. There is the performative moment, which lasts for a certain length of time and then it's calm. It's recorded but it's gone. It seems to me that's a very critical aspect.

JL It's certainly always been a starting point of discussions. We never start a discussion looking for any kind of permanence. I think it's also about the fact that permanence has tended to be very constricting. If you want to do something in a public space for a longer period, then there are all sorts of forces which will conspire against the full realisaion of an artist's idea. That's why so much public art is almost invisible, because it's almost a condition of being allowed to be there for ever and ever.

LJ I wonder whether in the transition from the first few years of Artangel to the decade you have been responsible for, the political element, which was a recurring element in many of the projects that were realised before you became Co-Directors, was renegotiated, even if it wasn't explicit.

JL I think that's exactly right. In the early years of Artangel, as it was set up in 1985 by Roger Took, the projects were sometimes initiated through themes that Roger or John Carson would suggest, issues surrounding AIDS for instance,

Rachel Whiteread, *House*, 1993–94

or homelessness. Or they started with the idea to deconstruct or subvert certain forms of communication such as advertising. We always started with the artist and his or her ideas and let things emerge.

LJ It's a really important issue, not just in relation to Artangel but in relation to this way of encountering art. Have you consciously renegotiated the relationship between the encounter of art and politics?

JL The similarities between what Roger and John achieved in the first generation of Artangel projects and what we have been trying to do are more striking than the differences. Perhaps some of the earlier Artangel projects were more explicitly interventionist. We were probably interested in exploring projects in which the politics might be more embedded and less immediate. That's not to say avoiding the political, but negotiating it in a less frontal way.

LJ Do you think that's a 1990s versus a 1980s thinking? The message across the billboard, as it was used by people like Barbara Kruger, Les Levine and Rasheed Araeen, seems to me to belong to a certain generation.

MM Don't forget that these artists felt the need to respond to particular public issues in fairly polemical terms. This was an Artangel navigating its way through the Thatcher years. We have always encouraged the artists with whom we have worked to embrace and understand a range of different contexts – historical, social, environmental, architectural – but to let these inform the work in more implicit ways.

MCM I've watched decades come and go and there are certain things that get resolved in the decades. There's a way in which they get played out and then something else comes along, which isn't necessarily a nice, clean direction. Something happened at the end of the 1980s – much larger than just what the Britart generation did – and Artangel seems to me to be part of that shift.

JL I do think there's a relationship between what we've been trying to do and what happened at the emergence of what's now called Britart at the end of the 1980s. It reminds me of what the architect Alison Smithson said about the Independent Group in the 1950s, which was basically "We are fed up waiting in line". Because they knew it would be a long wait, queuing up after Henry Moore and St Ives and all the other work the Establishment was supporting. One of the things that characterised the 'Freeze' generation was a kind of entrepreneurial spirit – to do it and do it now. They weren't happy to wait in line or wait to do things in the normal way. If there's a vision by an artist to realise a project out there, which has to be done in a way that's not been done before, we have to find a way of doing that. We didn't want to wait in line either.

LJ One of the things that intrigues me about Artangel is that it's kind of anti-entrepreneurial. What's so delightful about Artangel projects is that they run so counter to anything that anyone has financed or at least put their name to.

MCM Whenever I hear about a project that's organised by Artangel, I expect it to be very special. You do things at a big scale and there's the feeling that

Alain Platel / The Shout, *Because I Sing*, 2001

no corners have been cut. That if it needed a lot of expenditure, it got a lot of expenditure. If it needed an extraordinary place, the place was extraordinary The artist actually gets to do what they in their wildest dreams most want to do. And if it wasn't for Artangel these projects wouldn't happen because nobody else would create the support system.

MM It's extremely important to us to be working with an artist for whom that opportunity is vital. *The Battle of Orgreave*, *Because I Sing*, just to mention two recent projects from 2001, couldn't have been done in any other way. They needed patience, time and a refusal to accept second-best. We've always given each project the time it actually needs and have never flinched from deferring projects that don't feel ready to hatch. We don't run an institution with the restrictions of slots that need filling and monthly brochure deadlines that have to be met. So for us, the luxury of time can often be our most valuable resource.

LJ That's was what I meant by anti-entrepreneurial.

JL The one thing I think we would always want to feel, having completed a project, is that whatever ideas were there initially have been explored to the fullest potential. That whatever the artist or artists wanted to do has been as uncircumscribed as possible. We've often talked about this in relation to the question of limits. When an artist is engaged in a conversation about an exhibition or a commission, the limits of what that project might become are often put in place at the beginning of the conversation. There might be limits of time or money or scale or location. What we're interested in doing is discovering what those limits are at the end of the process rather than putting them in place at the beginning. If you don't impose limits, you also keep the artist at the centre of the conversation.

LJ That element of involving the artist is very specific. Could we talk a little bit about your relationship with the audience?

MM Our relationship as producers is to maintain an equilibrium between a commitment to the public and a commitment to an artist. It's impossible to generalise about the way each artist works and it's difficult to generalise about our audience, as it mutates and expands from project to project. There are a number of publics that overlap. A small circle of people follow everything that Artangel does. But there is a much bigger audience generated by the projects themselves, often determined by where they take place. It is hard to estimate the size and nature of audiences for the very public projects (Tony Oursler, Rachel Whiteread and Michael Landy, for example) but we have equally produced work for deliberately small audiences (commissions by Neil Bartlett, Janet Cardiff or *The Vertical Line*). One of the great advantages of not working within the culture of an institution is that you get the kind of peripatetic members of the audience, who stumble across one of our projects and then may learn more about it. So each project builds its own audience and enriches our database for next time.

LJ You've given us the ambitions that you have for artists and have reflected on institutions. Do you have any kinds of ambitions for audiences?

JL It's hard not to use certain buzz-words of the moment. We do have an
ambition that the projects should have the potential to be genuinely inclusive.
It's important that they can engage people who come intentionally – and often with
a considerable amount of previous knowledge – and those who arrive accidentally.

MM They should have the capacity to involve the knowledgeable as well as the
curious, the dedicated visitor and the passer-by. People always say, too, that our
commissions provide memorable experiences for those with families. We also have
to bear in mind the publicity that attracts audiences in the first place: the way we
communicate with our public, with the media as a useful bridge. We've always
been extremely careful in using language that is clear, that is free of jargon and
that tantalises an audience by not giving them too much information and there-
fore pre-empting specific expectations. We didn't describe exactly what that piece
of celluloid was doing in Atom Egoyan's installation *Steenbeckett* in the Museum
of Mankind. We didn't have a picture of a bouncy castle in the *Tight Roaring
Circle* leaflet. It's important that people discover things for themselves and that
then generates infectious word of mouth, not by over-hyping something before
anyone's ever seen it, but by allowing an audience to feel they are discovering
something for themselves.

MCM Over the last 15 years, the whole nature of the audience for art and the
relation of artwork and artist to audience has changed beyond recognition, certainly
in Britain. One of the things that always struck me about the younger generation
is that because they started so young, they got attention and they have always
assumed that there is an audience. Whereas people of my generation assumed
there was no audience. If you went to an exhibition by a major artist, there'd
be eight people at the opening in the 1970s. Artangel has played an important
role in this change and it's something that's not just to do with the audience
becoming interested but with the artist wishing to have a bigger audience. The
artist seeking an audience.

MM That goes hand in hand with the media and the press, which in Britain
is so much more open and sophisticated than it was in the 1980s. The arts
really have become news now.

LJ All these words are coming up – audience, performance, theatricality –
before visual art crossed that boundary, theatre had already gone there. I'm think-
ing of promenade theatre and theatre that came out from the proscenium, and
the theatre that required its audiences to be participants as well as spectators,
that's something that has now become much more common in the visual art world.

MM Those kinds of developments happened in parallel, although there have
been very few bridges between the visual arts and the performing arts. What
we've done within Artangel, hopefully, is to have created a hybrid that has a foot
in both camps. All of our projects blur the boundaries. Although James and I
lead on separate projects, it's never a given that I'm going to run projects with
composers, choreographers and theatre people and James with sculptors and

Atom Egoyan, *Steenbeckett*, 2002

Michael Clark, *Mmm...*, 1992

visual artists. I think we are both compelled by the ideas of artists but have no real preconceptions as to the form of their expression.

JL These hybrids have not displaced the abiding traditions of proscenium theatre or the frontal experience of painting or photography. These traditions persist and despite what is sometimes said, they are still being re-thought and renewed. I think we can add to them and challenge them, as the best of those ways of working also offers a challenge back. I think that many forms of culture have become more performative. Sculpture has become more performative, museums and exhibitions have become more performative. We've been talking quite a bit about the late 1980s and early 1990s, which may be when this shift can be located. Of course Artangel didn't create that paradigm shift any more than the 'Freeze' generation did or, indeed, the hundreds of thousands of people who were going to raves through the 1980s. What characterises all of this is firstly a sense of expectation and secondly an idea of a movement away from the centre, whether it's bound to the Docklands or to Michael Clark in a warehouse behind King's Cross or a rave beyond the M25. The people who take part in any of these different events bring those experiences and subsequent expectations back into the centre. That's probably why, when you go to a gallery or museum now, you're a lot less sure about what you might discover there compared with 10 years ago, but there is also a different kind of expectation of how that exhibition or display might perform. A lot of these spaces have co-opted ideas and forms of experience which might, in the first place, have been conceived of elsewhere or experienced elsewhere.

LJ Artangel is a catalyst for this I was asking Michael [CM] if that's how it feels from the artist's point of view.

MCM In the late 1960s and early 1970s so many things were happening in art, which started with a kind of breaking down of boundaries, starting with painting. Suddenly you had people making sculptures, which were not really considered sculptures by sculptors because they'd be made by painters and so forth. What happened in that period was that the visual arts welcomed, in a way that no other art form did, any activity at all, absolutely anything. Dancers were more conservative than artists, so artists would do performances. It was the visual arts world that was the fermenting place for advances in all the different art forms. That attitude of openness has been appropriated by the more traditional art forms, so now people in all the different fields are working in a more open way

MM So you end up with installation artists designing operas and artists making feature films.

MCM This is a very different world than it was in the 1970s, where these things had no place at all.

JL They were denounced. And being called theatrical was a term of critical abuse, somehow corrupt and impure.

LJ We've detected a shift from the previous generation of Artangel, a paradigm shift that was an interesting change in itself. Then we've got that fusion or hybridis-

ation which was allowed to happen, which has fed back into the separate spaces from which it came, enriching those other spaces. What more could you hope for?

JL That is a very difficult question to answer because we have never set off with a set destination. The destinations are created by artists. We initiate and try to facilitate the conversations but without a signposted direction.

MM We never had a ten-year plan, nor do we now.

LJ It isn't about having a ten-year plan or a corporate mission statement. Do you have ambitions of some new kind of hybridization or one-off ideas?

JL Perhaps we've reached a sort of crescendo with the huge success of many of the major public institutions here. Things might move outwards again, disperse. One of the things I'd be interested in, is to look at certain projects which would enable a quiet, contemplative experience with an artwork again. It has become pretty noisy. Helping artists make a quiet place for their work would be interesting.

MCM It's very telling that Charles Saatchi has closed Boundary Road. And everyone is having to adjust to the existence of Tate Modern as a powerful force, culturally, and I'm sure it must have an effect on you too. It may be very difficult to know exactly, for some time and maybe years to come, how things can shift from here.

MM It would be great to do things that are more light on their feet and maybe don't take three or four years to realise.

MCM Do people ever apply? Surely there must be people who send you ideas?

MM I think it is recognised that we have a clear agenda and that we almost always identify artists pro-actively.

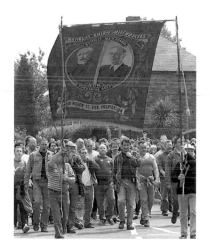

Jeremy Deller, *The Battle of Orgreave*, 2001

JL Which is sometimes regrettable. We did this open call with *The Times*, just called 'Open'. We had nearly 700 proposals out of which two of the most extraordinary projects emerged. One of them was Michael Landy's *Break Down*. The other was Jeremy Deller's *The Battle of Orgreave*, which came in as a memorable, one-paragraph proposal. Although there is a considerable number of artists we're interested in working with, we should from time to time open the door specifically to allow other ideas to come to us, which we couldn't possibly find ourselves. Artists get to a certain point in their career when a huge number of opportunities come to them. We need to create a situation where ideas can come in, that people can let us know that they might have ideas in an informal way, without the conversation being too loaded on either side.

LJ We shouldn't lose sight of what was mentioned before: the fact that there now is an audience. And it may be moving further. I chair the governors of an inner city comprehensive school, over 50 percent black. They take their girl-friends to Tate Modern. Once you've got 16 year-olds doing that then obviously opportunities have changed.

JL There is an openness to the unknown, people aren't intimidated to the same extent as they were in the past.

LJ There's one positive element we haven't discussed in relation to the younger generations. From toddlerhood they have encountered screens and one of the magic things for them about these kinds of encounters is the physicality of it.

JL And the physicality of the environment.

MM That's why the old model of spectatorship, of look-but-don't-touch is disappearing.

MCM In the beginning of the 1990s, in discussions about the future of the Tate, there was a concern that the experience of actual objects, of actual things, might diminish. In fact it might be the opposite, the more information people get about things through an intermediary medium, the more they have a desire to see the actual thing, the real experience.

LJ Just as the real book is right back in style. We probably inhabit a magic moment with a generation that actually is hungry for things that we thought were going to go out of fashion.

MM People believed television drama would be the death of live theatre and quite the reverse has been the case, even though it has been the death of naturalism – now the province of film and television. We've got to put that behind us, without mourning it, and focus on making experiences that can't be captured on screen, that can't be shrunk.

MCM But almost every new development has always been referred to initially as the death of whatever was before and it's never actually killed off anything. Every change has been an addition.

LJ What we have identified is the lack of fear. One thing that has changed, and you can certainly feel it in classrooms, is a fearlessness about the unknown and a fearlessness about encountering the unexpected in ways that absolutely play to Artangel's strengths. I can see that you wouldn't know what the future had to offer you, but I think it's a pretty fortunate moment from the auguries to offer a receptive space for that kind of curiosity.

JL We are enthusiastic about what can be done by giving certain artists opportunities with cinematic or moving-image work – because there is a big gap between what used to be possible within independent cinema and what is becoming possible within our world. When we present cinematic work we want it to be as physical as possible. The way Douglas Gordon's *Feature Film* was presented was a case in point. Or Steve McQueen's *Western Deep*. Or the way Matthew Barney talks about his cinematic work as essentially sculptural. We are particularly conscious of the experiential dimension of the work. The idea of the actual experience in a particular time and a particular place isn't new, but it's still important.

MCM You need to stick to the original idea that's driven Artangel, which was providing the opportunities for things that wouldn't have happened otherwise. Now other people are doing things you might have done. It seems to me that

you need to be watching for those other zones, for the things that deserve to be made but don't get made. That may be more difficult to locate and identify now but I think it's never been more important.

MM There are certainly uncharted areas on the map. We don't know where they are and the conduit to those areas is the imagination and the vision of the artist. We arrive there because of them, not because we've set out to get there …. It's about being prepared to work in the dark.

LJ I'm curious about what the implications of that are for things like raising money for projects.

MM Each project has its own potential, and each project is a kind of patchwork of fundraising from the public sector and the private sector; there's no formula or rule of thumb as to how resources gather.

LJ Is there as big a constituency out there of people who are going to put money into these projects as there is of consumers?

JL I think patterns of patronage have shifted more slowly than patterns of consumption and we still have to recognise the fact that Britain is stuck between two different models in terms of making things happen. One is the American model of private patronage funded by tax breaks and a particular tradition of philanthropy, and the other is the continental-European model, which is one of centralised state patronage. Britain is situated between the two. It's why this entrepreneurial culture emerged in the first place, because there wasn't an obvious model of one kind, of the market or the state, to appeal to.

MM It's not a bad thing because it actually allows us, on these parallel tracks, to maximise our revenue. Our support from the public sector has grown slowly but surely over the past ten years whilst still representing about the same proportion of our turnover.

JL We can't chastise the public sector for being unresponsive. They have been the foundation on which Artangel has continued to build. Artangel was set up by Roger Took as a privately-funded charitable trust. It did some extraordinary projects in the first years but perhaps its difficulty was to find an effective transition from the uncertainties of private funding to the stronger foundation of public support. When we took over, effecting that transition was our first major task.

MM We have put more emphasis on developing individual patronage than we have on corporate patronage, partly because it takes a special kind of corporate partner to hold hands with us in the dark, and to feel as comfortable as we do with never quite knowing when or where a commission will occur until quite late in the day.

MCM Going back to my sense about the 1960s and 1970s, when the importance of public funding in all fields was so much greater: it tended to centralise everything, there was far too little possibility for a variety of ways of operating. Even without meaning to, it limited the forms that things took. The expansion into

the combination of public and private money has allowed for quite unique formats. Things that are in contradiction with each other can run side by side now.

JL It is an advantage to have a multiplicity of patronage rather than a single source of funding.

LJ Ironically, the nature of your projects pretty well protects you from those kinds of backers because what have they got to collect (to put in a gallery or a museum) at the end of the day? It's gone.

JL Not entirely. There's sometimes something left – either the work, or a residue of it. But that's not what drives the process. If the form can be more nomadic and can be remade or seen again in another time and place, that's fine so long as the logic of the remaking comes from the work itself and not the economics of its making.

MCM I was very self-conscious when I was asked to participate in this conversation, believing that I hadn't seen enough of Artangel's projects and I was happy to realise that I'd seen many more of them than I realised.

LJ That's exactly how I felt. That's very telling. All these things happened and I thought, oh yes, I remember seeing that but I didn't realise it was Artangel. That's very interesting. You really have become part of the landscape.

25 April 2002

"AS IF I WAS LOST AND SOMEONE SUDDENLY CAME TO GIVE ME NEWS ABOUT MYSELF"

Claire Bishop

1

The idea of the viewer's first-hand experience has become an increasingly important concern in site-specific installation art. But what does 'experience' mean in this context? In the light of recent discussions about an 'experience economy' and both culture and entertainment as 'experience', the word has become particularly loaded. Looking at the history of installation art, two arguments have repeatedly been mobilised as a way of distancing installation art from mass media entertainment: the first is the concept of activated spectatorship, and the second is the idea of decentring the viewer. However, I'd like to argue that these ideas in fact undermine installation art's claims to political and philosophical significance – but without aligning myself with those reborn Modernists who have recently denigrated installation as one more manifestation of Post-modern sensation. Against this, I'd like to propose a model of viewing experience that the most successful site-specific installation art does structure for its visitors – one that cuts against the 'schizophrenic' reading of Post-modernism (defined by Fredric Jameson as a time of heightened but disconnected visual encounters). This model, I would like to argue, does not exist outside of historical memory, but draws connections between the individual and the cultural, the past and the present.

2

One of my starting points is the fact that I feel deeply uncomfortable writing about Artangel projects that I have not seen first-hand. This insistence on first-hand experience is something that has been implicit in installation art since its inception: its history is littered with examples of work that seeks to provide an immersive, exploratory experience for the viewer. Back in the late 1950s and 60s, environments and happenings – the immediate precursors of installation art – were conceived with precisely this type of intense viewing experience in mind. Adhering to the avant-garde mantra of blurring 'art' and 'life', Allan Kaprow and Claes Oldenburg (to name but two artists) sought to make the encounter with art less preciously auratic: works were staged in non-gallery locations (loft spaces, a car park, a swimming pool) and used non-traditional materials (found rubbish, chicken wire, sound). For Kaprow in particular, environments were touchy-feely, interactive spaces, in which the viewer was both a formal component of the work (the colours of your clothes adding to the overall effect of the assemblage) and an activator of the space as a whole.

For Kaprow, immersing the viewer in a site-specific work carried a quasi-moral agenda: the heightened immediacy of social and psychological interaction structured by the 'environment' meant (in his eyes) that visitors would be better able to negotiate assaults of the unexpected in everyday life. In other words, if you could cope with the displacing uncertainty of an installation, you'd be well placed to behave more flexibly elsewhere in the world at large. Jeff Kelley has convincingly argued, in his introduction to Kaprow's collected writings, *Essays on the Blurring of Art and Life*, that the artist's ideas were influenced by the philosopher John Dewey, whose

book *Art as Experience*, 1934, Kaprow had annotated extensively as a student. Dewey maintained that human development could only occur as a result of active inquiry into and interaction with our environment. Being thrust into new circumstances would mean having to reorganise one's repertoire of responses accordingly, and this in turn would enlarge one's capacity for 'experience', defined by Dewey as "heightened vitality ... the complete interpenetration of self and the world of objects and events".[1] The work of art could not be understood as separate from human existence, argued Dewey, and it was society's duty to restore continuity between everyday events and the "refined and intensified forms of experience that are works of art".[2] Kaprow seized this idea and took it literally, plunging visitors into an immersive art environment in order to prompt an experience of heightened consciousness.

This thinking also explained Kaprow's preference for siting his environments in non-gallery venues: the transformative potential of experience was simply not possible in a place where viewing was inhibited by ingrained responses. The pristine gallery was synonymous with the eternal and the canonical – in other words, the predictable. Hence Kaprow's insistence on flux, change and development: the space should be "dirty" and "rough", filling the viewer with "tense excitement" and a sense of "risk and fear".[3] Such feelings of unease and tension were considered essential for increasing the viewer's ability to assimilate new events elsewhere in life. The assemblaged materials used in this 'new art' were therefore intended not merely to break with medium-specific conventions but to provide visceral irruptions into everyday consciousness for the sake of its growth and expansion. Kaprow argued that art work that was politely contained – in a frame or a gallery – "stood for experience rather than acting directly upon it".[4] And yet his 'blurring' between literal and imaginative space, between the work of art and the 'world' beyond it, was far from uncomplicated. Although Kaprow's environments sought to defetishise the art object, the viewer's experience of being immersed in a unique, temporary environment paradoxically reintroduced the auratic: what was fetishised now was not the work of art but the viewer's highly charged, liminal encounter with it.

3

I digress into Kaprow because he introduces a whole range of issues that became increasingly and explicitly politicised throughout the 1960s. No longer called 'environments' but 'installations', this type of work also sought to offer a heightened, immediate experience for the viewer – but this was now conceived as a gesture of opposition to the numbing mediation of passively-consumed spectacle (tabloid newspapers, television, Hollywood cinema and so on). The word 'installation', with its neutral overtones of the exhibition hang, gained currency throughout the latter half of the 1960s, particularly in art magazines where 'installation shots' increasingly accompanied exhibition reviews.[5] These documentary photographs implied that the sum of the works *in situ* was more important than any single image

of one object in the show; they recorded the negative space between individual works and the interplay between them, together with a host of contingent factors like the colour of the walls and floor, the height of the ceiling, and the quality of light.

By contrast, the early 1970s installation shots of work by Bruce Nauman, Vito Acconci and Dan Graham often include one or more figures, a direct reflection of the way in which these installations explicitly solicited the physical participation of the audience. This inclusion went beyond the Minimalist interest in phenomenological perception, however, and acquired a political momentum: in the wake of May 1968 and Vietnam, an analogy between physically activating the viewer in the work of art and the idea of political agency in the real world was increasingly implicit. This connection was not a new one: Constructivism's emphasis on movement in the 1920s was founded on a similar metaphor of activism and activated spectatorship, as evidenced in El Lissitzky's dynamic designs for exhibition rooms, or Tatlin's *Monument to the Third International,* 1919. Dan Graham's installations of the 1970s – influenced by Constructivism's engagement with architecture and design – also position the viewer as an active, inquiring subject: you have to work out for yourself where to stand and how to interact – not just with the piece, but with the other visitors to the work too.[6] Even today, installation art continues to trade on an implicit analogy between activated spectatorship and an active (questioning, critical) relationship towards culture and politics. This connection is clearly seen in the work of Susan Hiller, whose installations harness marginal or 'irrational' phenomena (such as the Punch and Judy Show in *An Entertainment,* 1990, or UFO sightings in *Witness,* 2000) to present a multiplicity of viewing positions; her aim is to make people aware that "what they're seeing is because of who they are; so they are conscious of the fact they are part of a mechanism for producing pleasure and pain, that we're not just walking through life as though it were someone else's film".[7]

But something else is at stake here too. The late 1960s moment of activated spectatorship coincided with French theory's proclamation of the decentred subject.[8] This analogy lent weight to the idea that the experience of viewing installations was significantly different to the experience of viewing painting and sculpture, because it did not place you in a hierarchical relationship to the work of art. Instead you were 'decentred' – that is, left with no ideal position from which to survey the object. Models of subjectivity and vision have run hand in hand throughout the history of art, and Panofsky's equation of Renaissance perspective with the Cartesian subject in *Perspective as Symbolic Form,* 1924, is perhaps the most significant of these links in this context. Since the late 1960s, the relationship that conventional perspective structures between the work of art and the viewer has come increasingly to attract a critical rhetoric of 'possession', 'visual mastery' and 'centring'. The multi-perspectivalism of installation art has come to be seen as an alternative to this tradition. This appeal to the discourse of decentring is particularly marked in critics influenced by feminist and post-colonial theory, for example in

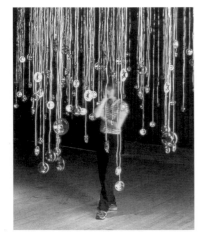

Susan Hiller, *Witness,* 2000

Jean Fisher's description of Gabriel Orozco's oval billiard table in *Empty Club*, 1996:
"the people who are watching or playing [are] unable to map themselves within
an entirely familiar field, lose a sense of certainty – and become 'decentred'....
Orozco's decentring operation produces a compelling analogy with current cultural
debates on centre-periphery relations. In a deterritorialised world that no longer
possesses a centre (a *telos* – an organising principle such as God, the Imperium,
or even the gentleman's club), there can be only a multiplicity of inflections or
contingent points of view [Orozco] provides no privileged position from which
to survey the field, but an indefinite number of equally tangential points of view".[9]

This contingent point of view means in turn that (for the viewer) a more active
relationship to the work is required – in order to locate yourself in relation to the
space, its idea and the actions of other visitors.

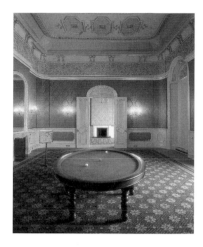

Gabriel Orozco, *Empty Club*, 1996

4

So this insistence on first-hand experience brings together two important strands
in installation art's self-positioning as a philosophically and politically significant
riposte to 'traditional' art: activated spectatorship, and the idea of decentring the
viewer. In the case of some of Artangel's projects, these emphases can be seen in
numerous ways, beyond the 'work itself' to the whole process of encountering it.
Because the projects are not sited in one familiar location but are conceived and
made for a particular place, the whole experience of visiting each work acquires a
purposive character comparable to that of a pilgrimage.[10] You need your London
A-Z and your wits about you. As a result, the pre-experience of each project
acquires a heightened, quasi-cinematic charge of a kind that never occurs en route
to the Tate or trekking around East End galleries. On my way to Robert Wilson and
Hans-Peter Kuhn's *H.G.*, 1995, the damp, Dickensian gloom of old Southwark
infected my imagination long before I arrived at their eerily cinematic tableaux
in The Clink. Even today, my memory of Susan Hiller's *Witness* is inseparable
from my late summer trek through West London to find it: the post-Portobello
Market streets in the fading sun, unfolding with litter and listless adolescents.

The loaded character of this journey does not diminish upon finding the site:
entering the Neo-classical portal of Orozco's *Empty Club*, visitors were handed
a map of the building. It was unclear whether the work began at this moment or
later, when you encountered one of Orozco's startling interventions face to face.
Padding stealthily around the pristine interiors of 50 St James's Street was tensely
exciting, like being an intruder. Finally encountering the oval-shaped billiard table,
and watching someone silently cue the red ball high off the table was like entering
a parallel and exquisitely wrought new world. In a similar way, my experience of
Douglas Gordon's *Feature Film*, 1998, cannot be condensed to one image of the
projection spectacularly suspended in the vast Atlantis warehouse; instead, the
work bleeds into my long, green-tinged ascent of the winding industrial staircase
and the soundtrack of fraught strings spiralling down to meet me.

Robert Wilson / Hans-Peter Kuhn, *H.G.,* 1995

But how do we define this kind of 'experience'? Is it the same as Kaprow's understanding of the term – Dewey's sense of a "complete interpenetration of self and the world of objects and events"? It depends how this 'interpenetration' is understood – as physical, psychological, perceptual, or all of these. Listening to the soundtrack of Janet Cardiff's *The Missing Voice (case study b),* 1999, the streets of Whitechapel became a film set into which I was thrust, all moods and movements directed by the artist's breathy voice. In Orozco's *Empty Club* and Robert Wilson's *H.G.,* by contrast, you had a sense of having to improvise your movements and your lines, unsure of the script or what might be coming next. Other installations offered a mode of encounter that could be termed 'phenomenological', involving a heightened immediacy of one's perceptual faculties. As with *Feature Film,* it was the sound in *H.G.* that lured me on, into dark rooms where bodily sensation (for example, of uneven earth underfoot) was the dominant mode of encounter. A similar eclipse of the visual, albeit only temporary, occurred upon entry to Tatsuo Miyajima's *Running Time,* 1995. Stepping onto the balustrade overlooking the ballroom of the Queen's House, Greenwich, you were robbed of vision: plunged into an engulfing, consuming pitch blackness, you had to grope blindly ahead. Finding the rail of a balcony, a moment of stability, you could then lean forward to see dozens of red LED numbers circulating on the floor down below.

These Artangel installations remain faithful to Kaprow's requisite of "risk and fear" in that their identity bleeds out from the work itself to the unforeseeable conditions under which we come to experience it. This unpredictability is an important aspect of the various types of heightened 'experience' that they offer: an encounter with these works refuses to be neatly filed away in our mnemonic archive of white cube museum moments. And yet there is always a safety catch: although the space-time of the installation coincides with that of our own, we are never really in doubt as to whether or not we are inside a preconceived work of art. The experience is always in parentheses, as it were. You limit your actions because you know that you're in a work of art. And as Acconci noted in the 1970s, the "interpenetration of self and world" in installation art can only go so far: activated spectatorship is inevitably circumscribed by both the artist and by the place of exhibition, as the gallery situation will always compromise what kind of gestures (if any) can be taken by the viewer.[11] Moving art away from the gallery does not fundamentally affect this conditioning. It could therefore be argued that what site-specific installations offer us is something far more carefully staged and premeditated than Kaprow's utopian desire for a blurring of art and life. Instead of an art experience as a bolt of 'existential' lightning,[12] we have an experience better described, perhaps, as the 'experience of experience'.

5

This may sound like a sceptical position – particularly in the light of current discussions about experience-oriented commerce, and culture as an 'experience

economy'.[13] Left-wing theorists like Fredric Jameson would certainly argue that installation art is part of this trend, affecting contemporary art and culture as a whole: in his well-known account of Post-modernism, Jameson describes cultural production as 'schizophrenic' (in the Lacanian sense), because it fragments experience into a series of 'perpetual presents' that are "powerfully, overwhelmingly vivid and 'material'" – and by implication, consumable. The upshot of this situation, for Jameson, is that each individual moment of experience does not appear as a heightened perception but is felt to be a loss of reality: we live in a "perpetual present" with a consequent "disappearance of the sense of history", tradition and identity.[14] This situation, he argues, is particularly characteristic of the temporal arts – music, poetry, narrative texts. I would include installation here too, as Jameson's words are what Rosalind Krauss has in mind when she condemns it for complicity with "a globalisation of the image in the service of capital":[15] in other words, the endless stream of installation art in biennials and triennials world-wide that are (for her) yet more 'schizophrenic' ephemera, forgettable entertainment, the collapse of aesthetics into leisure. Jameson's examples are more dated: he cites the experience of listening to the music of John Cage, which he found to be one of "frustration and desperation" at its disconnected sounds.[16] It should be pointed out that the avant-garde has a tradition of deliberately seeking out the complex and frustrating as a direct counter to the easy seductions and flimsy gratifications of pop culture, and that installation art's aim to 'decentre' the viewer is an essential continuation of this oppositional strategy.

But this is not just a question of 'demanding' art for the sake of it. Jameson's text also implicitly appeals to a romantic notion of 'authentic' experience – one which he considers Post-modern art production to be incapable of providing. But what if the authentic experience of today *is* one of fragmentation and decentring? (Lacan, whom he invokes, would certainly argue that this is so.) And what if the unique circumstances of each installation both reflect and compensate for this situation? The best examples of Post-modern, post-medium-specific art are not just forgettable moments ('perpetual presents') on the infinite horizon of consumption, but intensified encounters that cathect the individual and cultural on a far more profound level. Installation art's preference for outmoded spaces is integral to this process of retrieval, as is its use of found objects.[17] In this light, rather than offering us 'the experience of experience' (one more moment to be consumed in the 'perpetual present'), site-specific installation art might offer us a more complex 'experience of decentring'. Rather than actually fragmenting the viewer (which would result in trauma and / or psychosis), these works provide a fantasy of dispersed and decentred subjectivity. (It is important to stress here that fantasy is not understood in the sense of daydreaming, but as a perceptual lens through which all experience is mediated.) Although it is imaginary, this 'fantasy' experience of decentring may nonetheless prompt not only memory but a questioning and re-evaluation of our environment.

6

So where does this leave us? It's true that this argument about the 'experience of decentring' is probably only of relevance for those interested in the political and philosophical implications of installation art. But I am concerned that it might also provide further ammunition for the reborn formalists like Krauss, whose anxiety is that installation art – unlike traditional media, painting, sculpture, film, and so on – has no inherent criteria against which we can evaluate its success: without a sense of what the medium of installation art is, the work cannot attain its holy grail of self-reflexive criticality.

It should not be forgotten that one of the motivations behind the break with medium specificity in the late 1960s was precisely the desire to establish a different discursive arena for art, one in which content (narrative) would be regarded as highly as a self-critical relationship to its material support (Clement Greenberg's understanding of the 'medium'). Instead of the art object participating in a dialogue with the historical development of painting, sculpture and so on, mixed-media initiated a switch of focus to an engagement with social and political issues; Greenberg, let us not forget, thought that painting should "avoid content like the plague". Think of that archetypal site-specific installation, *Womanhouse*, 1972, by Miriam Schapiro, Judy Chicago and their students: for all its heavy-handed imagery, the feminist content is perfectly matched to its location (an abandoned mansion house in LA) and is unthinkable as a formalist abstraction. Likewise the meditative installations of Paul Thek from the early 1970s, which created a passage for the viewer akin to a ritualistic procession: visitors to his *Ark, Pyramid*, 1972, followed paths in wood and sand through scenes that were softly lit with candles, and which contained a variety of opportunities to sit and rest in contemplation with other visitors. Such work offered a more poignant mode of encounter than the agenda of Kaprow, in which the immediacy of experience is configured simply as a wake-up call to the everyday – the 'life' to which 'art' will logically be subsumed. It differs also from historical avant-garde strategies of 'shock', since the decentring rhetoric of installation does not concern a fast fix of the new, but a carefully wrought dialogue between viewer and context through the intervention of the artist.

I would like to posit, however, that one particular moment in the historical avant-garde can offer a suitable analogy for installation art's insistence on viewer experience: the Surrealist idea of the chance encounter. This is evidenced in installation art's recuperation of found objects, from the installation itself to the site in which it is located. The relation between literal and psychic space in the Surrealist *rencontre* was fundamental: the nineteenth-century Passage de l'Opéra, the waxworks museum, the Saint-Ouen flea market – these were places redolent of a previous age, and rife with potential for 'catalysing' encounters with outmoded and second-hand objects.[18] Elsewhere in the city, chance encounters could arise during nocturnal strolls, in random cinema attendance or in wandering through the soon-to-be-demolished arcades. As Hal Foster (following Walter Benjamin)

has argued, such spaces were relics of a supplanted order, and their use queried the dominant system of commodity exchange and rampant industrialisation.[19] It is this mode of encounter with the outmoded or marginalised spaces of the city that is revisited in Artangel's most memorable projects: a disused chapel, an empty gentleman's club, a defunct department store. These sites are haunted by events that did and will occur in them, and provide a vital riposte to Jameson's accusation that Post-modernism is a time without memory.

The Surrealist encounter could liberate the subject from a certain 'paralysing' state in relation to his or her desire, but this was not just a matter of individual, subjective release: it was a significant and liberating catalyst for society and culture at large. Today's most successful site-specific installations harness something of this transformative and re-evaluatory potential. As my title – taken from André Breton's *L'Amour Fou* – suggests, it is as if an object, space or city had come to give us news about ourselves.

1 John Dewey, *Art as Experience*, London: George Allen and Unwin, 1934, p. 19

2 John Dewey, Ibid., p. 3

3 Allan Kaprow, 'Happenings in the New York Scene', in Jeff Kelley (ed.), *Essays on the Blurring of Art and Life*, Berkeley and Los Angeles: University of California Press, 1993, p. 22

4 Kaprow, *Assemblage, Environments and Happenings*, New York: Abrams, 1968, p. 156

5 A preference for the term 'installation' also arose as a consequence of minimalist artists wishing to distance themselves from the work then referred to as 'environmental': work by Kaprow, Oldenburg, Kienholz, Segal and others. These artists adopted precisely those aspects of the Abstract Expressionist legacy that Minimalism sought to eliminate: the emotive, the organic, the implicitly narrative. Anything associated with the psychodramatic tendencies of the Happenings could not (in the eyes of minimalist artists) be further removed from their sparse and literal 'what you see is what you see' aesthetic

6 Dan Graham, describing his 1976 installation *Public Space / Two Audiences*, articulates this position in characteristically pithy fashion: "The observer is made to become psychologically self-conscious, conscious of himself as a body which is a perceiving subject; just as, socially, he is made to become aware of himself in relation to his group. This is the reversal of the usual loss of 'self' when a spectator looks at the conventional artwork In this traditional, contemplative mode the observing subject not only loses awareness of his 'self', but also consciousness of being part of a present, palpable, and specific social group, located in a specific time and social reality and occurring only within the architectural frame where the work is presented." Dan Graham, *Two-Way Mirror Power*, Cambridge, Mass: MIT Press, 1999, p. 158

7 Susan Hiller, *Susan Hiller*, Tate Gallery Liverpool, 1996, p. 44

8 For example, in Lacan's positioning of the subject as split (ex-centric to the Freudian ego), in Roland Barthes's 'death of the author', in Foucault's subject as an effect of discourse, and in Derrida's re-inscription of the subject as one of différance, destinerrance and alterity

9 Jean Fisher, 'The Play of the World', *Gabriel Orozco Empty Club*, London: Artangel, 1998, pp. 19–20

10 The religious overtones of this are perhaps appropriate given Artangel's name and indeed the organisation's whole ethos – striving to fulfil the 'vision' of the artist in places where others 'fear to tread', as their promotional leaflets often state!

11 See Acconci, interview with Robin White, *View*, vol. II, no. 5 / 6, Oct–Nov 1979, p. 17. Steven Melville raises similar points in 'How Should Acconci Count for Us?', *October*, no. 18, Fall 1981, p. 86: the gallery space "is always articulated by a prior, implicit or explicit, contract which assures that a law will be either obeyed or not, but will not in any case be put into play"

12 Kaprow, *Essays on the Blurring of Art and Life*, p. 23

13 See Jeremy Rifkin, *The Age of Access: how the shift from ownership to access is transforming modern life*, London: Penguin, 2000

14 Fredric Jameson, 'Postmodernism and Consumer Society', in Hal Foster (ed.), *Postmodern Culture*, London: Pluto Press, 1985, pp. 111–125

15 Rosalind Krauss, 'A Voyage on the North Sea', *Art in the Age of the Post-medium Condition*, London: Thames and Hudson, 2000, p. 56

16 Jameson, 'Postmodernism and Consumer Society', p. 121

17 I am drawing an important distinction here between the found object – the Surrealist *objet trouvé* – and the ready-made: the former bears the indexical traces of previous use and ownership, the latter is mere pristine commodity

18 André Breton, *L'Amour Fou*, London, 1987, p. 45. Think of Breton's 'slipper-spoon' and Giacometti's ethnic half-mask, found at the Saint-Ouen flea market

19 Hal Foster, 'Outmoded Spaces', *Compulsive Beauty*, Cambridge, Mass.: MIT Press, 1993; Walter Benjamin, 'Surrealism: Last Snapshot of the European Intelligentsia', *One-Way Street*, London: Verso, 1979, pp. 225–239

MOTION

(DIS)CONTINUOUS PERFORMANCE

Jonathan Romney

Generations of cinema-goers grew up on the formula of 'continuous performance'. Magic words that always carried a faint promise of 'perpetual revolution'. In practice, this simply meant that film programmes worked on rotation, so that you could either take your place promptly for the start of the show or drift in at any point during a loop of trailers, ads, newsreel, short and full-length double bills. The commercial realities of film exhibition have relegated this format to the distant past, and with it the healthy disdain for narrative linearity that was once part of the movie-going experience: the awareness that you could walk in late and catch the start of the story two hours after the ending. Little wonder that cinema has largely forgotten the malleable possibilities of alternative narrative styles: the wilful entanglements and fracturings of Godard, Roeg, Resnais.

It is still possible to walk into an art gallery when you please – or into a gallery masquerading as a cinema, or vice versa. We like to think we know exactly where we stand in our cultural pursuits: beginning, middle or end; art gallery or movie show. Art is for broad daylight, walking, and talking while you walk. Cinema is for the dark, to be consumed in silence and sitting down, to the mechanic crunch of popcorn. We might make a special exception for that arcane, perhaps archaic form 'art cinema' – a phrase used by funders and culture Ministers to denote a recklessly unsound investment (to be distinguished in turn from the 'art movies' marketed by Hollywood as a 'niche' luxury: lavishly aesthetic confections offering Judi Dench and views of Provence).

The categories become more confused when art strays into the cinema, or when cinema airs itself – 'improperly', you might say – in galleries and other exhibition spaces. Take two seemingly similar Artangel projects, one early, one recent. Melanie Counsell's 1993 installation in the Mile End Road used the Coronet Cinema, a disused picture palace – a long-established home for mainstream movie entertainment and, even before that, a music hall that had hosted Charlie Chaplin and Fred Karno. On the screen, Counsell projects a black and white film, but it is only visible from the top of the circle, where viewers have to climb in order to peer over the top of a frosted glass barrier. What they see is black and white footage of a glass of dark liquid, slowly evaporating before the viewer's transfixed, bewildered, possibly outraged glare.

Atom Egoyan's 2002 *Steenbeckett* is an installation in the former Museum of Mankind, the now-disused ethnographic treasure house and palace of classification behind the Royal Academy. More specifically, the site is the Museum's projection room, once the venue for such celluloid attractions as *Wooden Flowers of Nova Scotia*. Viewers feel their way up stairs and along corridors cluttered with detritus of the past – cupboards, file cards, strips of withered film – to come face to face with Egoyan's adaptation of Samuel Beckett's *Krapp's Last Tape*. John Hurt's virtuoso one-man performance scrolls by on DVD in a narrow corridor, while visitors watch seated on a bench, pressed far closer to the screen than they ever would be in a cinema, or even when watching TV at home. In the next room, the

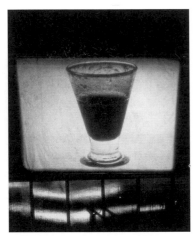

Melanie Counsell, *Coronet Cinema*, 1993

film itself, in its original concrete form, snakes around the room in a labyrinthine loop – 2000 feet of celluloid cantilevered through pulleys, up and down across walls and ceilings, finally passing through a Steenbeck machine, the now-obsolete editing desk through which all celluloid imagery once took shape. Here proximity is replaced by distance – we can see the celluloid, but not the images etched into it, and even the miniature screen on the Steenbeck, across the room, shows only a blur of an image (an image increasingly devoured by scratches and daily degeneration of the vulnerable celluloid medium). As in Counsell's piece, the fact of placing yourself eyes open in front of a screen ceases to be automatic or without obstacles.

Atom Egoyan, *Steenbeckett*, 2002

Counsell's and Egoyan's installations are ostensibly alike, variations on the same premise – conjurations of audio-visual spectres, seances in deserted mausoleums. Both use venues with complex histories, sites haunted by their own past and apparently condemned to disuse – already deconsecrated cultural temples. Both works thrive on their venues' incongruity – the viewer doesn't stumble in by chance to find the wrong programme playing, but arrives expressly to watch material that no-one would normally expect to see there. (What has Beckett to do with institutional ethnography? Who would ever visit an East End dreamhouse to watch non-narrative footage, let alone imagery that makes a Marguerite Duras feature look racy?)

In terms of their production and their authors, however, the two projects seem diametrically opposite. Melanie Counsell is an artist specialising in the temporary transformation of unoccupied buildings. She may not deal specifically in narrative, but her work creates spaces where a viewer comes face to face with an event – a phenomenon that becomes a narrative as soon as we enter and begin to react and interpret. Egoyan, conversely, is used to working in a field that denies or suspends the direct involvement of a specific viewer in a specific place. As a high profile film maker who financially at least – has moved increasingly closer to mainstream practice, he is obliged to deal in story, that deal-breaker element without which financiers won't play ball. His films can only enjoy an indirect, deferred relation to their audience. They can be shown to any number of viewers, or no viewers at all, anywhere or at any time – on your home DVD, at a festival, at 4 am on a digital movie channel. *Steenbeckett*, then, departs from Egoyan's normal practice, allowing him to say, like Counsell: here and now, and *only* here and now is the show. Walk right in.

Film and its metaphors have fed art for the last century, but we are currently going through a critical period in terms of what film stands to gain from art, and specifically from art's forays into the moving image field, however importunate or opportunistic they may sometimes seem. At the end of its first century, film's future as a developing form can no longer be taken for granted. The funding and exhibition mechanisms have all but dried up that once made it possible for film-makers to explore abstract, theoretical or non-narrative concerns, as art practitioners routinely have the freedom to do. And the economic squeeze on specialist

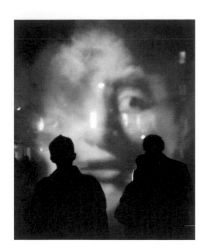

Tony Oursler, *The Influence Machine*, 2000

distribution means that only industry professionals on the festival circuit have access to the current cinema's entire spectrum of innovation. That circuit still harbours practitioners concerned to refine new chemistries of the moving image (among others, Tsai Miang-Liang, Sandrine Veysset, Claire Denis, Guy Maddin), but they are condemned to more or less marginal status.

Meanwhile, through the 1990s, the distinction between the cinema and the gallery as 'proper' places to project moving images grew increasingly indistinct, to the point where you often needed to go to galleries to keep up with innovative film-making, and just as often wished that certain cinema films could find a gallery space to breathe in. But how much does it finally matter whether a producer of moving images is classified as an artist or a cineaste? The crucial distinction seems to lie in the type of experience and the measure of attention that different viewing conditions call for. For cinema-goers, space and time are at a premium. To watch Jean-Luc Godard's latest feature requires us to remain stationary and alert in the dark for 98 minutes; to watch the mesmeric *Satantango*, by Hungarian director Bela Tarr, demands a commitment of some eight hours.

Given these inescapable economies, it's easy to think of installations and galleries providing a walk-in-walk-out quick fix. Yet the recent traffic between film and art venues has made it ever harder to walk into a particular space without wondering to some degree just why we choose one rather than the other, and why we become fixated on the habits that different types of venue impose on us. Why do we prefer to behave the way we do – with studious respect, seated hand on chin in the art-house stalls, or with the disdain shown by the sceptical gallery stroller, timing visits to a brisk 20 minutes maximum?

Artangel's moving-image projects have insistently raised questions of context and venue. These questions address a medium's survival as much as they respond to challenges of curatorial entrepreneurism. Where, indeed, to make and show motion pictures if cinemas proper have become a corporate no-go zone, a tax opportunity for soft drink multinationals? If it came to the crunch, cinema might have to go outside, take to the trees, as in the whispering disembodied faces and voices of Tony Oursler's *The Influence Machine*, floating in the smoke-filled tree-tops of Soho Square at night. Or it might retreat into the viewer's own head and body, as with Janet Cardiff's mystery-thriller walk, experienced by a peripatetic listener-viewer armed with a Discman. Such projects share a flavour of secrecy and conspiracy, together with a memory of cinema's sideshow origins, and perhaps intimations of a subterranean samizdat future.

With Richard Billingham's *Fishtank*, the venue is a slice of not-quite-prime-time TV scheduling, a slot in BBC2's now-defunct risk-taking 'Tx' strand. Mainstream terrestrial television has been used as a site for one-off art projects in the past – in Europe more commonly than in Britain – but the nature of Billingham's material, his own family, together with the circumstances of transmission, makes *Fishtank* an inquiry both into watching habits and into the myths of British domesticity.

The television in the parlour becomes the fishtank that Billingham's own family, at home in the Midlands, is most likely watching at the very same time as we watch them. Billingham's intimate, even excessively intimate, home movie evokes the old pre-satellite myth of television, the utopia of a nation united by the box, a consensual social aquarium in which all British families resemble each other, but only for as long as it takes to watch *Morecambe and Wise* or the Queen's speech.

Commissioned and originated outside established film distribution circuits, projects such as Matthew Barney's *Cremaster* cycle can be shown in cinemas, but function as a rebuke to mainstream movie spectacle – for Barney goes one better than Hollywood's claim to be a dream factory. His outlandish confections pursue their hermetic obsessions to a bewildering, even frightening extreme, yet manifestly deliver many of the classic virtues of big screen entertainment. *Cremaster 4* has it all – chase-movie action, tense cross-cutting, elaborate production values and prosthetic make-up effects, sex (albeit of a perversely encoded ritual variety), a strong degree of narrative resolution, and a virtuoso tap routine from Barney's Astaire-like satyr. (Later *Cremaster* episodes go even further, adding *bona fide* stars Ursula Andress and Norman Mailer). Barney's work is an extreme, delirious example of how working outside the cinema proper makes it possible once again to explore the old contested criterion of beauty: the *Cremaster* cycle exemplifies a dandyish aesthete's sensibility, a degree of attention to grain, colour and texture that in mainstream cinema would be regarded as a strictly supplementary luxury. (Where story comes first, stylistics are written off as mere style.)

Following the death of 'continuous performance', mainstream film is obliged to operate in conventional finite slices of time, in lengths that easily slot into a programmer's grid. With artists' moving images, however, the possibilities expand again: moving imagery can either be circular, as good as infinite (*Steenbeckett* asks: how long is a piece of celluloid?), or can work on smaller scales, isolating and focusing on moments. Steve McQueen's *Caribs' Leap / Western Deep* takes the passages of a body falling in mid-air and extends them, at once freezing and stretching time, in commemoration of a moment of Caribbean history. McQueen's intention: "to prolong a historical moment by pressing a pause button in order to see and reflect". In the mainstream, the pause button has long been abandoned: we've learned to watch as if on perpetual fast-forward (the new non-linear modes of the DVD player have barely begun to impose their own metaphors on our watching habits).

Cinema at its fullest potential has always militated against a conception of time as fugitive, merely consumable. The leaflet for Melanie Counsell's 1993 show quoted Andrei Tarkovsky's dictum that going to the cinema is a matter of "time lost or spent or not yet had". When cinema's possibilities, after a hundred years, seem already exhausted, fixed and codified, hybrid projects like Artangel's remind us of unexplored avenues and as-yet-unlived durations; they re-invent the art of (dis)continuous performance.

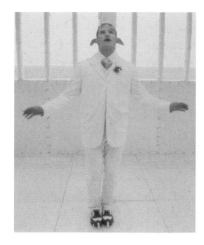

Matthew Barney, *Cremaster 4*, 1995

My first encounter with Artangel was with James Lingwood, in a café, over a beer, on a wet, windy day, under a cloud, in Glasgow. That was in 1993.

Six years later, in London, we realised a project that had evolved over further drinks, in many bars, in other cities and with other people.

When we began discussions, we talked around and about the many possible and even more improbable ideas that I had hidden away in the back of my head – imagining that they would never exist outside of my late-night, half-asleep, mostly-forgotten, hallucinations.

These included an idea to try and communicate with Barnett Newman's ghost via a seance from his favourite bar in New York. Seriously.

When I introduced this idea to James, over a coffee, he didn't blink an eye, never cast a doubt, but asked me, seriously, if I was prepared enough to enter a discussion that might involve terms unfamiliar to my own practice – colour, scale, aesthetics, faith, restraint, and so on.

Needless to say, I dropped the idea after some initial research, and that seemed to suit both of us.

As the years passed, and we grew older, it sometimes seemed as if we might never focus on any idea worth pursuing. I grew anxious but the Artangel team held firm and remained calm.

Eventually, about five years after our courtship began, we engaged quietly, and began planning my 'feature film'.

The making of the work was an incredible challenge for everyone involved – we managed to convince a conductor, his entire orchestra, a radio studio, a film crew, and many others, to join us on a venture with no real idea as to what might transpire.

I managed to masquerade as a film director for a while – ducking questions from the musicians about "what was your last film, Mr Gordon?" and nodding wisely when the film crew talked in those technical terms that only 'insiders' would understand.

However, the making and doing of the work were a clear indication that our project would end soon. This was depressing. I knew why.

As I look back and try to remember the 'why' question, I realise that the most important part of the process was the gestation period we allowed for a project to evolve. It was a unique situation – then and now.

These days, and as a result of this experience, I do tend to imagine and attempt to pursue ideas, small and 'obese' – as one critic noted – without any curb or collar.

Anything can happen. DOUGLAS GORDON 3 May 2002

Feature Film had a long genesis: we first talked back in 1993 in Glasgow and the project wasn't realised until 1999.

There were several ideas which we didn't follow through. Once we looked at *The Exorcist* and *The Song of Bernadette* overlaid together on tape. Although the idea was interesting and the final realisation, at the 'Münster Sculpture Project', was very powerful, I guess we didn't do that together because when Douglas proposed the idea the work was already in many ways done. It didn't really need Artangel

I remember spending a weekend with Douglas in Berlin. He had prepared various CDs of film music which we listened to intently, *The Greatest Story Ever Told*, *Ben Hur*, *Psycho* etc. Douglas was building me up to listen to *Vertigo*. We listened to the music for the film in its entirety, and then watched the film. There was almost no need for Douglas to explain – which he did very convincingly – why the work he needed to make needed to be based on Bernard Herrmann's score for Hitchcock's film, with its themes of doubling and duplicity.

Douglas then cast the conductor. There was discussion at one stage about whether the conductor might be a woman with blonde hair, and we found someone who was very good. However, eventually Douglas cast James Conlon, Director of the Paris Opera, not only because he is a great conductor but also because he looked right – not really like a classical maestro and more like an actor, and because he rarely used a baton. I realised later that there were certain similarities between Conlon and Gordon

The filming in Paris was set up almost as an equivalent of a live broadcast, because once the musicians had begun to play, there was an imperative to create a full new recording of the entire score within an extremely tight time scale (the overtime payments for the 100 strong orchestra were frightening ...).

There was a magical moment at the beginning of the first day in Paris. The musicians turned up at the concert hall, Douglas introduced himself and Conlon talked about the score briefly, each of them looked at their part – which they had not seen until that moment, Conlon raised his hand and they started to play. It wasn't approximately what we'd been hoping to hear, it was exactly what we had hoped to hear

Douglas was directing three cameramen and watching all the material as it was simultaneously relayed to him in a director's box in the concert hall. I was hugely impressed that, at a point of maximum tension for us all, he was composed and concentrated and made absolutely the best of the time and the people that had been brought together – just as James Conlon and the sound team made absolutely the best of the musicians who had been brought together

JAMES LINGWOOD May 2002

It is a long walk up to the top floor of the old Truman Brewery on London's Brick Lane, where you can see Turner Prize-winner Douglas Gordon's latest work, *Feature Film*. This is based on Hitchcock's *Vertigo*, and the climb may make you think of James Stewart's scary ascent, following Kim Novak to the belfry from which she fell. She did fall, didn't she?

The double-sided screen, hanging at a midpoint in a vast darkened space, feels a long way away. The screen is dark. The echoing space is silent. Suddenly the space is filled with sound – a fragmented orchestral score as brooding, anxious, precipitous and dark as the space it inhabits. But what is up on the screen? Not Jimmy Stewart with his vertigo of confusions and desires, not Kim Novak in her double, duplicitous role in this most desolate of Hitchcock's films, but a close-up of James Conlon, *chef d'orchestre* of the Paris Opera and the Cologne Philharmonic, conducting an invisible 100-piece orchestra. [...]

Feature Film, an Artangel commission, is simply the most complex and accomplished work that Gordon has made to date. His seamless, dramatic edit of the camerawork (Conlon was scrutinised by several cameras at once), ending with a close-up of the conductor's fierce and glistening eye, is to my mind, heart-stopping. This is a blind man's movie, a dancer's movie, a Hitchcockian installational McGuffin, a piece of art to dissect and be swept away by. [...]

Adrian Searle, 'Hitchcock's finest hour', *The Guardian*, 3 April 1999

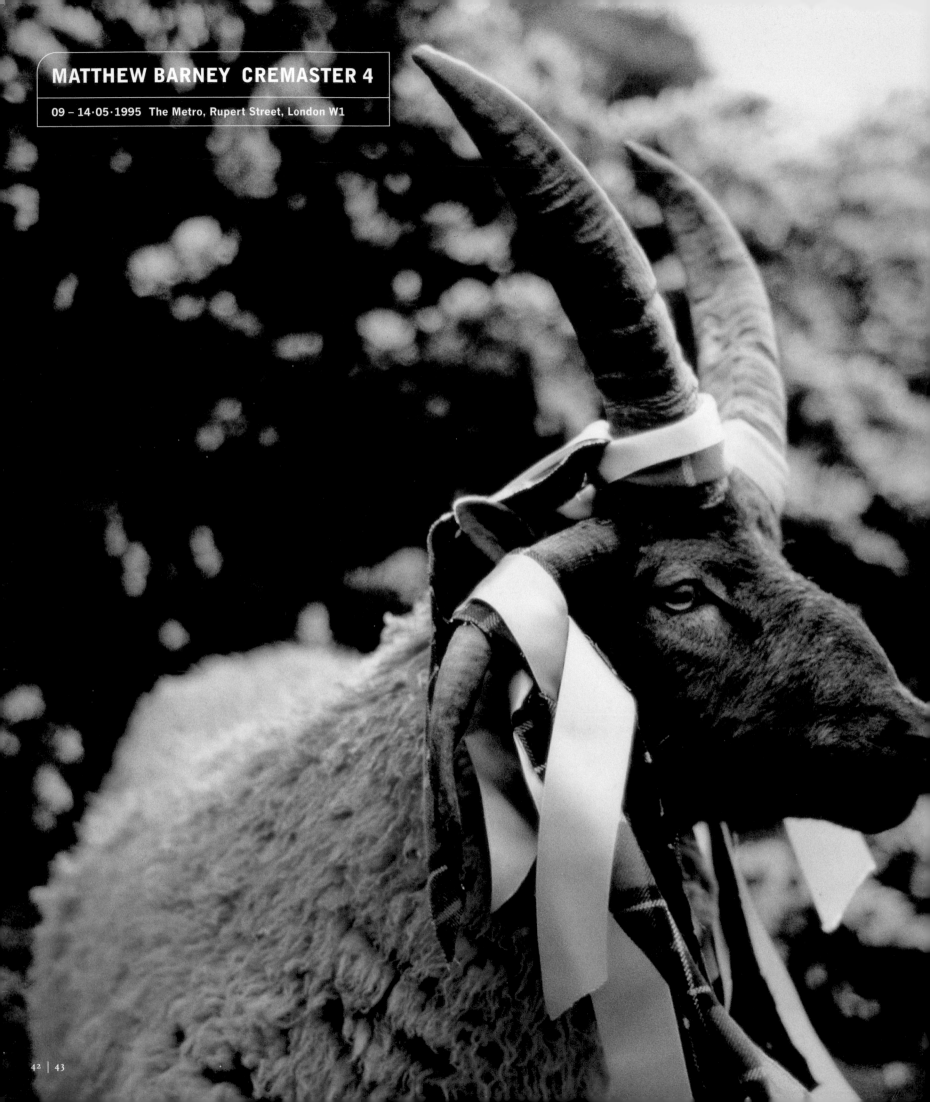

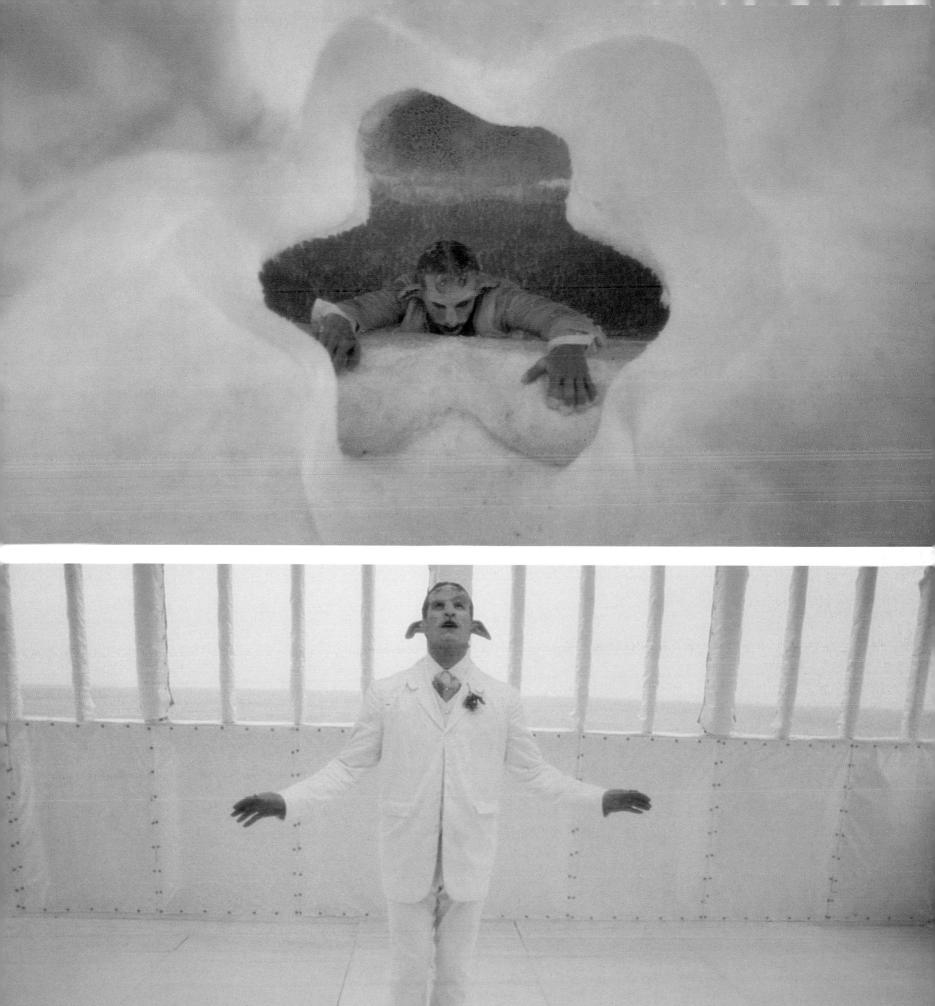

cabbage field (ascent)

another option "LUNCHEON"

45

46

42

8

10

JAMES LINGWOOD The Isle of Man is of singular importance to your new film, *Cremaster 4*. How did you come to conceive of the island as the site for the film?

MATTHEW BARNEY I was interested in working in either Ireland or Scotland, somewhere Celtic. And when I was in Scotland, I kept on seeing this island on the map, like a kind of autonomous form in the middle of the Irish Sea. For obvious reasons, I was attracted to the name. Then I found out about the TT (Tourist Trophy) motorbike races that take place there. The fact that the race course circumnavigates the island, like a kind of circulation system, was very interesting to me. The scale was small enough that the island seemed sculptural. And when I finally made it over there, it felt sculptural.

LINGWOOD What do you mean by feeling sculptural?

BARNEY Wherever I stood on the island, I could feel the edges and have a visceral understanding of it as a form. I was looking for something like that for the film – a piece of architecture that had some kind of organic structure to it, and that could be understood as an organism regardless of where you stood on it Some of the films that I'm drawn to are the ones in which the main character is the site. A film such as *The Shining* – which is relevant to *Cremaster 4* – is a piece of biological horror that is essentially architectural. The lodge is the main character in *The Shining*, like the pier house and the island in *Cremaster 4*. Each of the films I'm envisaging for the *Cremaster* project is based on a particular landscape or architecture. [...]

LINGWOOD Does the visceral understanding of the island extend to it being a metaphor for a body?

BARNEY That's the way I approach any site that I work with, although I don't end up literalising it as a body. I'm interested in a scale that fluctuates constantly between the microcosmic and macrocosmic. Even though it's a flexible term, somehow naming the site as a body could close down some of the potential to keep that scale in flux.

LINGWOOD In *Cremaster 4*, the shifts in scale are paralleled by a movement from the interior space of the pier house to the external landscape of the Isle of Man itself and back again. You haven't had that relationship in your previous work.

BARNEY When we got back the rushes of the movie, I realised the extent to which I was literally dealing with the landscape. Just dealing with green alone was a big change for me.

LINGWOOD Did you need Manx mythology as well as the landscape to give your film its structure?

BARNEY Even though they were new to me, the specificities of the Isle of Man made so much sense in terms of the whole *Cremaster* project that I wanted to integrate the local mythologies, the fact of the TT races as well as the pattern of the Manx tartan. I'd used yellow and blue before as a way of organising a narrative conflict, so the Manx tartan broke up into a colour scheme that made a lot of sense to me. The green in the tartan created the third leg in the conflict of equilibrium which the piece ended up being. In the film, the three aspects of the narrative are analogous to the three legs of the Manx symbol, and the narrative revolves around the central axis of the three spinning legs. [...]

LINGWOOD Can you say that the conflicts which create the film – physiological, psychological, sexual – are enacted within one body?

BARNEY Within one organism. The different characters in the film don't have any development as individuals; you can't really identify with them as characters.

LINGWOOD In early medieval literature there's a genre of story-telling called the *Prüfungsroman*. The hero's physical and moral integrity is tested by a sequence of trials and ordeals. You've submitted yourself to some very dangerous and testing experiences in your films. We've just mentioned one of them – the satyr has to negotiate various obstacles on his journey in to the island. How important is this physical ordeal?

BARNEY I carry all the baggage of 'truth to materials' and the body has been a primary material for me. It's a medium which I tested through my experience as an athlete, knowing what my body could do. When you're training as an athlete, you devise internal narratives to perpetuate the body project, ways of developing yourself towards a heightened performance state. You develop an almost heretical view of what's going on inside, which enables you to isolate parts of your body to work on. What's liberating about story-telling is that it forces me to get away from that value system.

Matthew Barney interview with James Lingwood, 'Keeping track of Matthew Barney', *tate*, summer 1995

[...] A drum roll introduces a view of an impossibly long, Victorian pier jutting from a rocky, green landscape. To the drone of a bagpipe, the familiar *Cremaster* logo is seen at speed, before Barney himself appears in a white performance space, his face more animal than human, the bright red hair offsetting the whiteness of the room, his suit and the white mistletoe in his buttonhole. As he combs his hair over them, we cannot help but notice the two strange holes in his head where his horns once were. The room is a pavilion at the very end of a mile-long pier, leading to a beach and a road. For the setting is the Isle of Man, a place where it comes as no surprise to encounter mutations. For man, on Man, may have become as much as a hybrid as the elaborately horned goats to be seen there or the rambling route of the Tourist Trophy motorcycle races. In this white room in the white pavilion, near the end of the long pier, three naked, muscled, red-haired, epicene figures pander to their master's every need. By the insertion of a large pin, they give his hooves new resonance, for example. And as he starts to tap-dance in front of a mirror, they cluster in anticipation. Meanwhile, on the island, two teams of two men in blue or yellow leather start up their motorcycles and sidecars. Side by side and facing in opposite directions, they wait for the flag to drop. Just before it does, the camera rises above them to show that their conjunction forms the outline of the *Cremaster* logo, with its vertical capsule intersected midway by a narrow horizontal. And, in an unexpected piece of animation, the logo is surmounted by the three legged symbol representing the Isle of Man. As we watch, the symbol revolves to indicate the start of the race. [...]

Stuart Morgan, 'Of Goats and Men', *frieze*, issue 20, pp. 35–38

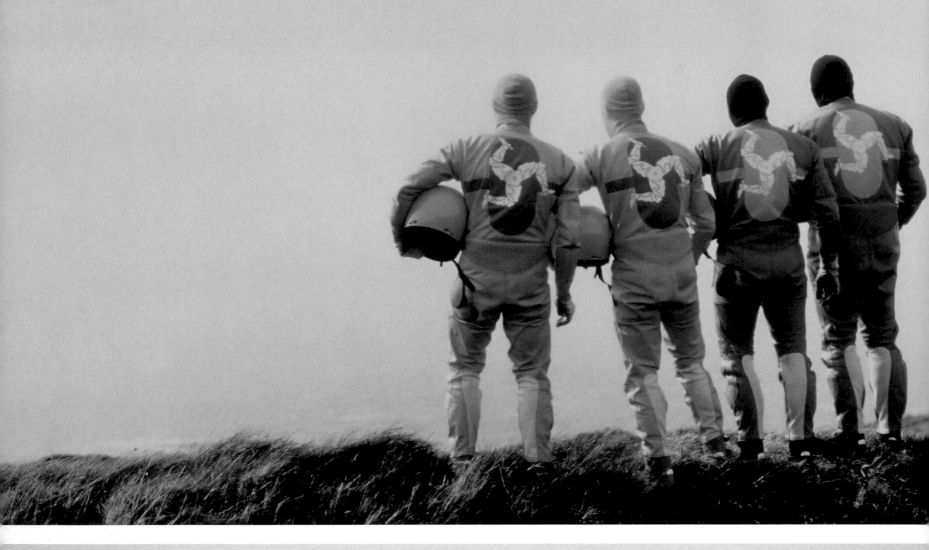

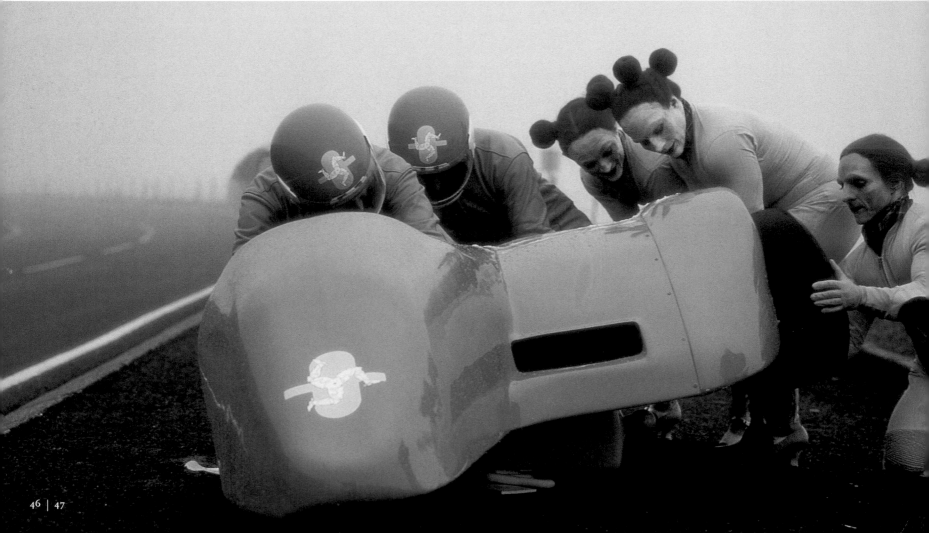

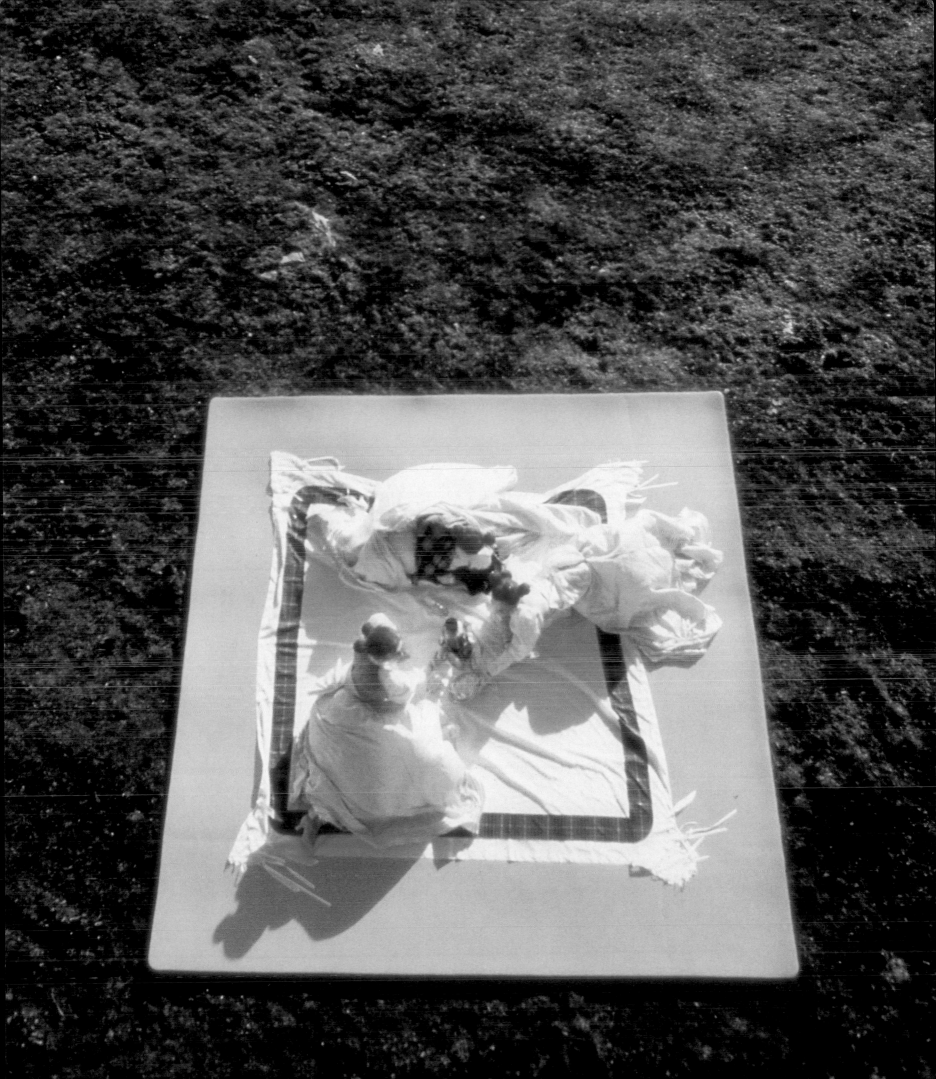

I first got a camcorder in 1996. The main reason was that I wanted to make some short films for gallery spaces. Also, I wanted to take photographs from the TV screen, of the video footage I'd recorded played back. The third reason was that I'd been trying to write a screenplay for some time, but what I was finding difficult was the dialogue. So I figured the camcorder would help by recording people's voices and gestures, which I could later study.

I didn't originally intend to make a film for TV. If I had, I would have got some better quality equipment. But when I began putting particular short pieces of footage together, I realised they would make one long coherent film if I could put them in the right sequence.

The best footage was when I'd been just looking and not really thinking (trance-like) so that the camcorder was more an extension of the eye. Also, I did choose to hold on things – a head, a mouth, the sky ... – for long periods, in order to build up emotional tension.

The relationships that came out in the film, between my father, mother, brother or me are inherent to looking through my eye in those ways.

RICHARD BILLINGHAM April 2002

Fishtank was Artangel's first commission for television. It was developed with television as a particular physical and psychological space within people's houses in mind. Even though it has been seen as a film and has been screened at film festivals, the scale, the subject matter and pacing of it – even the kind of quasi-documentary / anthropological forms it played with – related to different kinds of television film, to natural history programmes and domestic dramas. Screens keep appearing throughout the film – the idea of being absorbed into a screen as a form of escapism is quite strong, whether that screen is a Playstation or a television.

Richard had been making this video material of his family over the course of time. There was a huge amount of material to work from, and there was a lot of extremely interesting footage which stayed on the cutting-room floor.

It was a big challenge for Richard to work out how that material could be edited into a form which might both inhabit but also somehow break out of the documentary mode of TV.

Early on, I showed some of Richard's material to Adam Curtis. It was important to have someone involved who had made exceptionally distinctive television films but who didn't come from an arts TV viewpoint. We didn't particularly want *Fishtank* to be seen simply as an artist's film. JAMES LINGWOOD May 2002

Billingham's TV debut pushes you so close to his fighting, drinking, low-income family that it hurts. His photographs have always wrong-footed any neat interpretation, and now *Fishtank* uses a camcorder to up the emotional ante with an often excruciating, sometimes exquisite fusion of intimacy and objectivity. It's a strange sensation to scrutinize mother Liz as she puts on her makeup, or to be made to linger on the ravaged face and sagging throat of father Ray. But Billingham doesn't ask for your sympathy or empathy – his work is neither soap opera nor social documentary. In this film, flies on the wall tend to get swatted.

Louisa Buck, 'Richard Billingham: Fishtank', *Artforum*, December 1998, pp. 113–114

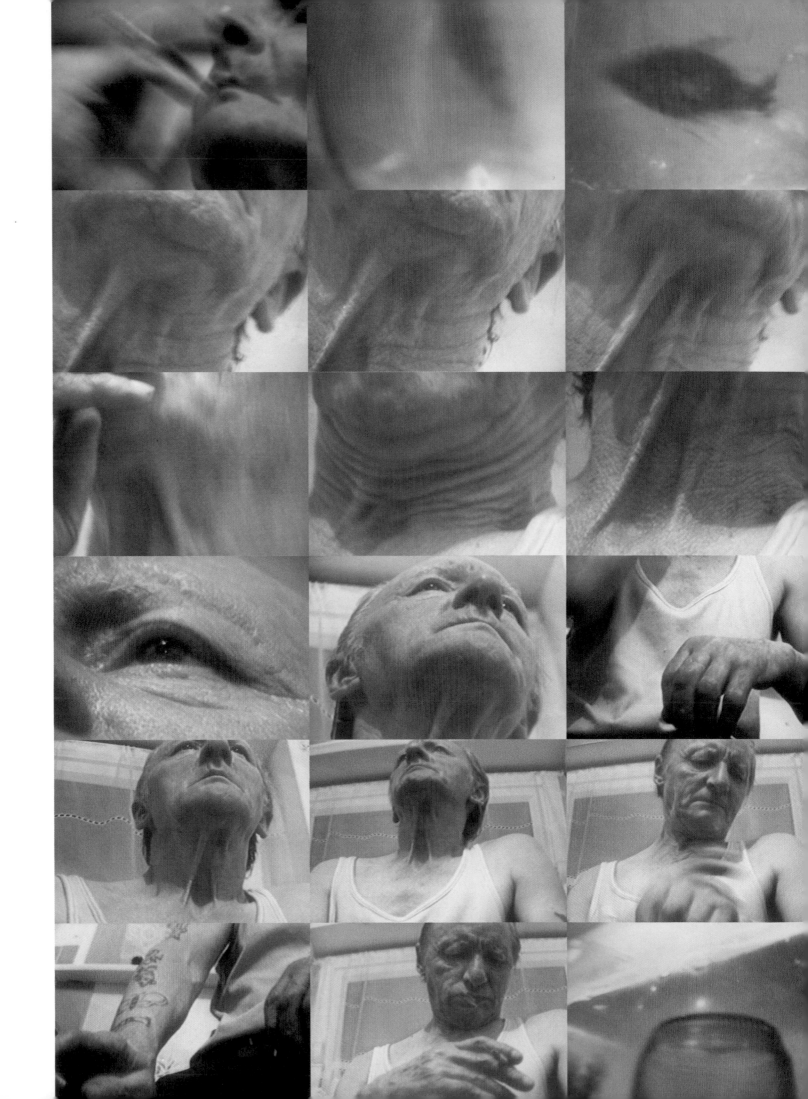

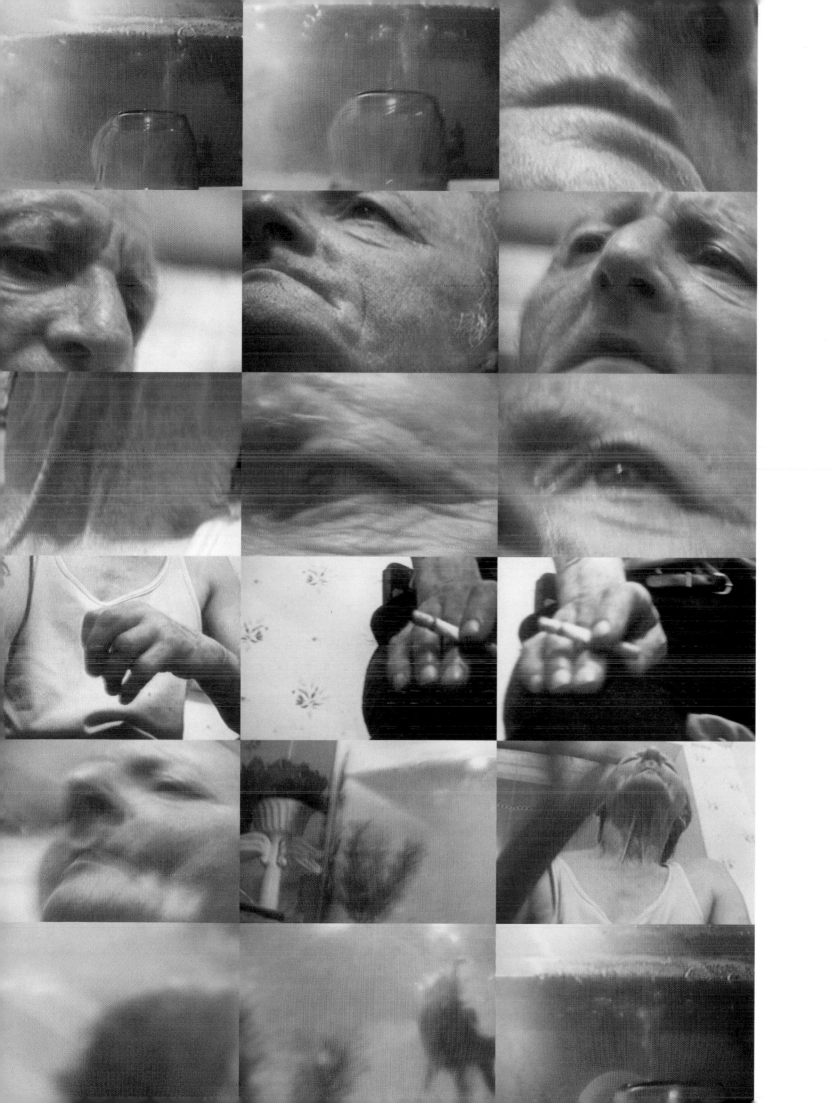

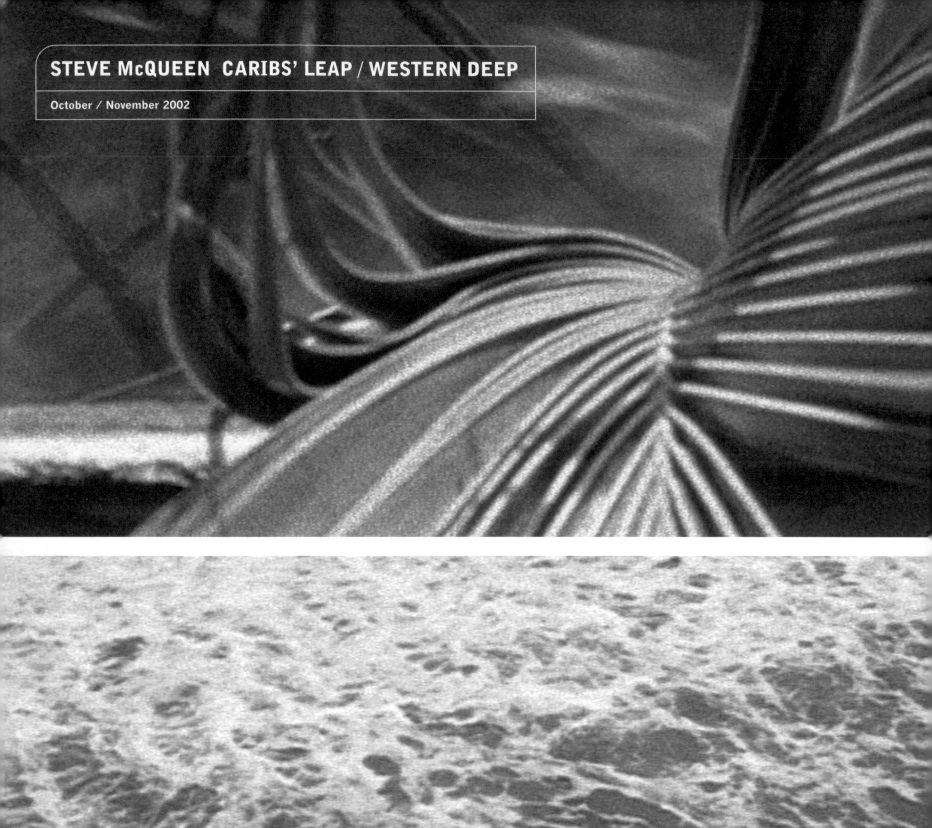

STEVE McQUEEN CARIBS' LEAP / WESTERN DEEP

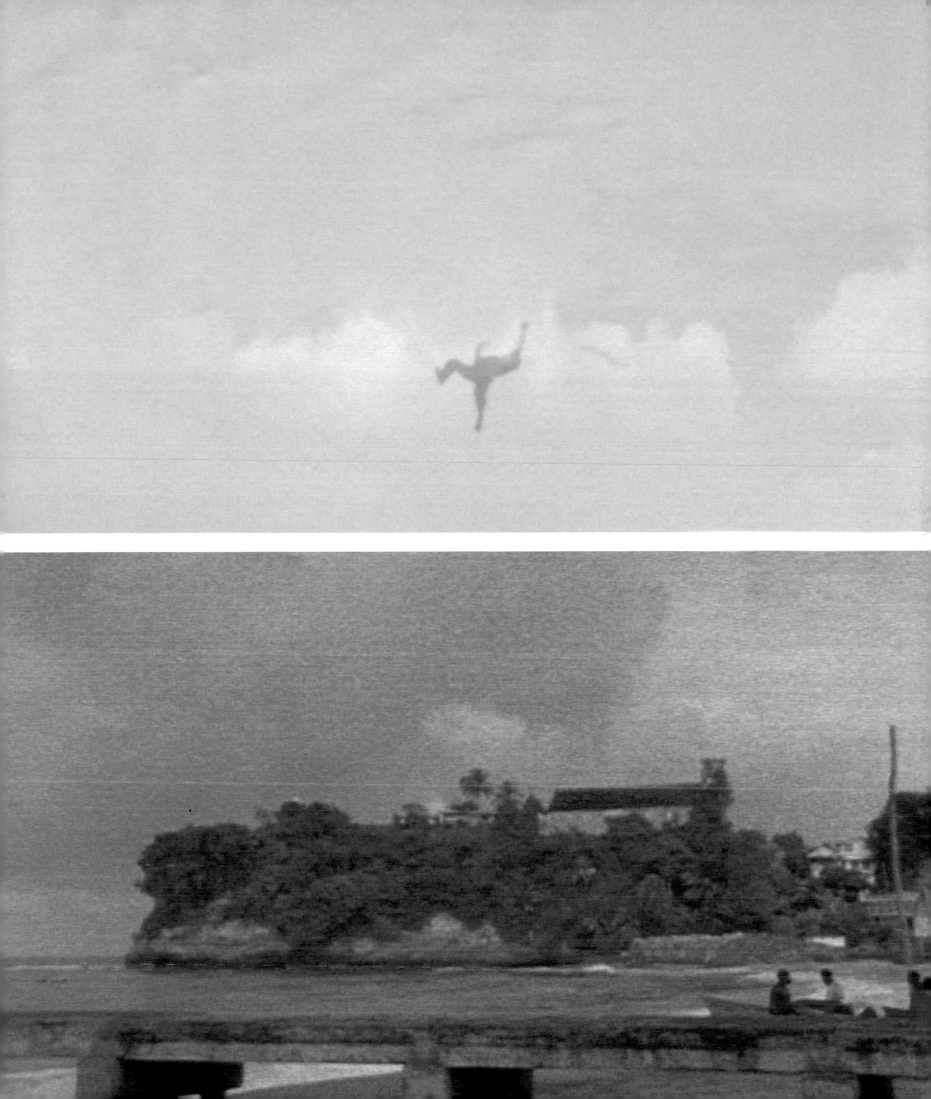

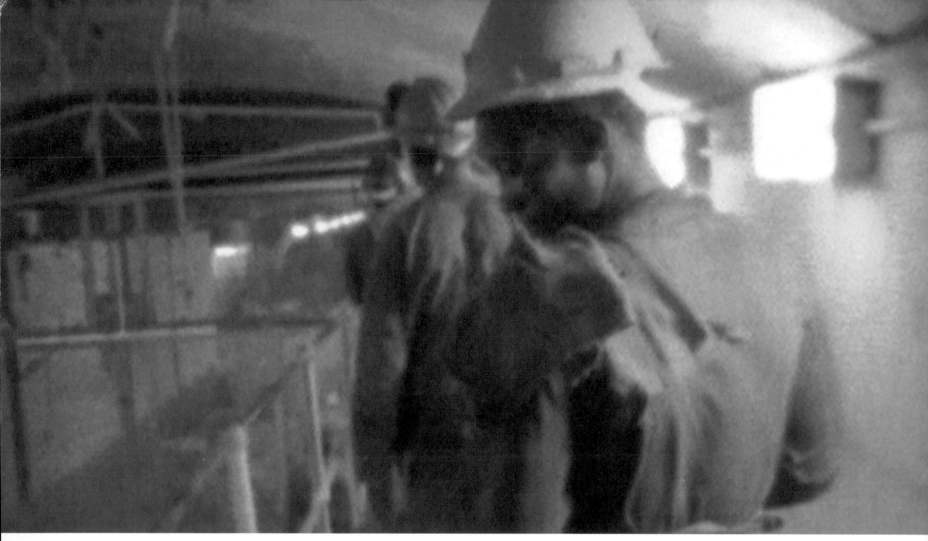
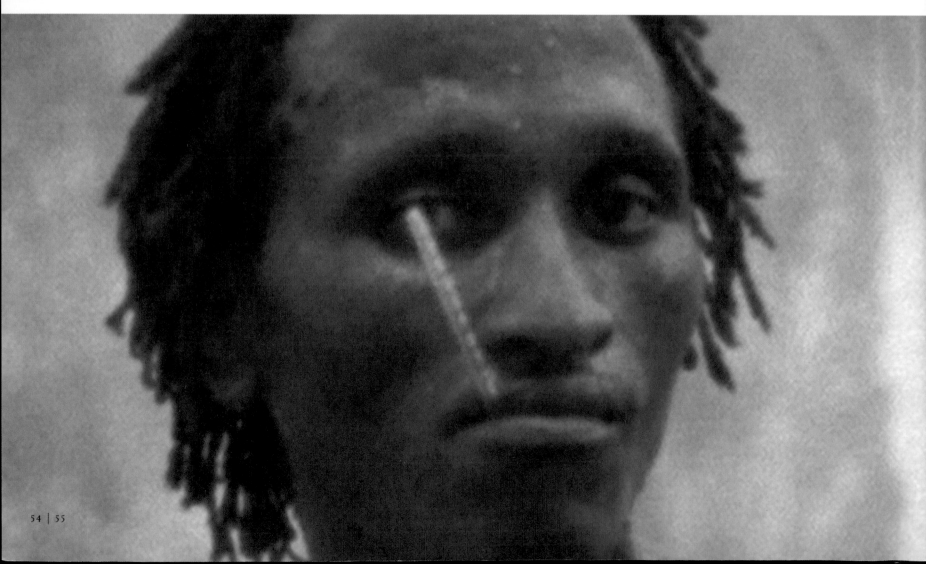

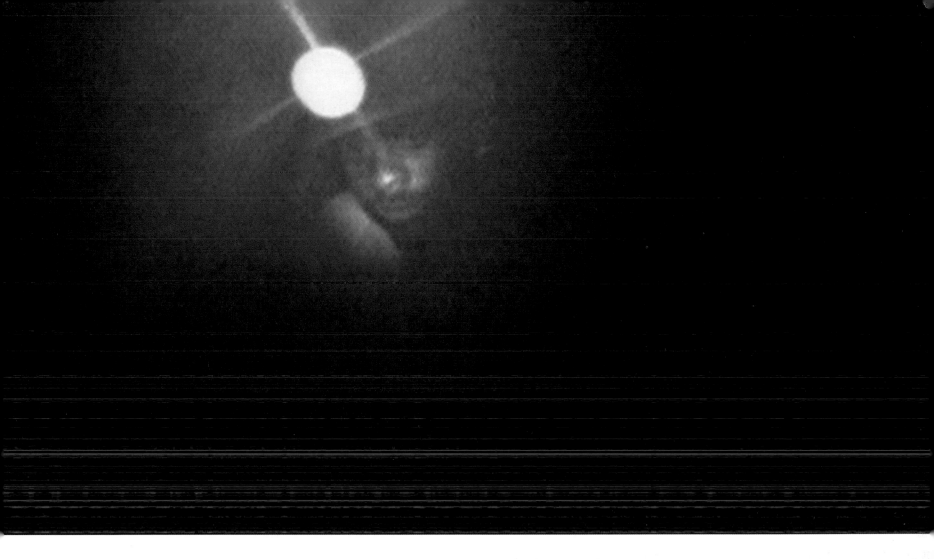

I had been thinking of making a film based on the story of *Caribs' Leap* since I returned to Grenada for my grandmother's funeral a few years ago. She was buried in the cliff-top graveyard of the church in Sauteurs.

In 1650 Governor Du Parquet of Martinique bought Grenada from the Caribs for a few hatchets and some brandy. A year later, the French sent soldiers to drive the natives off the island. The Caribs were forced to the northern tip of Grenada. Rather than surrender, they jumped from the cliff, now called Caribs' Leap, to their deaths.

Whilst I was trying to work out how to make the film in Grenada, I decided to make a film about a very different kind of descent in a very different kind of space.

Western Deep, near Johannesburg, is one of the world's largest goldmines. One of the shafts goes two and a half miles down into the body of the earth.

Shot on Super-8, *Western Deep* begins at the surface as the miners prepare for the descent. The camera follows them down in the compressed spaces of the lifts and shafts. The only light is that of the miners' lamps, creating sharp contrasts on bodies, faces and rock surfaces.

A year later, I was able to go back to Grenada. I wanted to film everyday things happening on the island, which carries its history within it – local people on the beach and in the water.

The only thing that to my mind is exotic in this film is death. Not the image of death, but the idea. Familiar, but unrecognisable.

The two film locations juxtapose the extra-ordinary with the ordinary. One in a claustrophobic environment, the other in a seemingly vast openness.

STEVE McQUEEN May 2002

With *Caribs' Leap*, one of the challenges was to keep a space for improvisation open for Steve. Everything, from negotiating on locations, to choosing the right kind of equipment, to briefing your crew – all this has to be planned in advance with film. The issue was how he could keep some freedom of action and openness of form. In Grenada, Steve needed to be as unencumbered as possible – to let the film be formed by this place.

The first day's filming after I had arrived to join the crew in Grenada was in the funeral parlour in St George's. The crew spent an hour with Steve quietly filming the people laid out in coffins and people casually coming in to have a look. Keith Griffiths and Pinky Ghundale of Illuminations with whom we had worked since the start of the project sat outside, reflecting on how extraordinary it was that for years we had been talking with Steve about how to make a cinematic equivalent for one kind of death, over three hundred years ago, and now he was filming with real bodies in a real place.

Many other things happened in Grenada – shoots that were planned but didn't happen, and situations which Steve filmed that hadn't been planned. Five years of talking came down to ten days of filming.

JAMES LINGWOOD May 2002

The Logic of the Birds is a non-literal re-adaptation of the mystical text by the Persian philosopher and poet, Attar. Our narrative, which is a combination of film, music and performance, traces a mass of people, without clear identities (birds), who follow a mythical leader through a difficult, transformative journey, only to discover in the end that they contain within themselves the qualities they searched for in the leader. In this work we have attempted to extract what we consider the essence of the philosophical text and its message of self-revelation, presented in an exercise of visual, lyrical, musical, and performative symbiosis. The Logic explores the dynamic / attraction between the mass and a female protagonist (Hoopa) whose nature is uniquely both human and divine as well as compassionate and devilish, focusing on the development and transformation of this relationship. Conceptually and visually, The Logic of the Birds explores the concepts of illusion and reality and individual and collective which are fundamental aspects of Persian and Islamic mysticism.

One of the themes that infuses our work is the perception of Iran's cultural shift from a Persian identity to an Islamic one. In an article in The New York Times, Shoja described is as follows: "Persian culture is 5,000 years old, and the Islamic invasion only happened 1,500 years ago. The history of Iran is resistance to domination through a mystical approach to Islam. Basically, what we are doing is trying to make sense of this confused identity, to go back to our roots and translate them into a universal language." SHIRIN NESHAT May 2002

I sat with Shirin Neshat and Roselee Goldberg in Kensington Gardens during the summer of 2000, having just seen Shirin's film installations at the Serpentine. We imagined what it might be to experience works such as this with the added dimension of a live presence, thinking particularly of Sussan Deyhim, Shirin's longstanding collaborator, who I remembered for her blistering performances whilst she lived in London in the 1980s. We also imagined what it would be like for Shirin's signature veiled crowds to have a presence on stage as well as on screen.

The Logic of the Birds came out of a shared desire to realise this vision. The first space we imagined making it for was a trio of massive disused oil drums under Tate Modern. Nick Serota had taken James Lingwood and I down there with a group of other producers in the late 1990s. As far as we knew, no refurbishment had taken place since and it felt like somewhere to return to with Shirin and Sussan in mind. Health and safety issues defeated us, however – a rare example. Instead, we turned to the neo-Gothic Union Chapel in Islington, established by a congregation of non-conformists in the early nineteenth century who even now are responsible for identifying and employing their minister. This history of self-determination and non-conformity made Union Chapel feel doubly appropriate for a contemporary work inspired by similar themes in Attar's masterpiece of classical Persian literature.

MICHAEL MORRIS June 2002

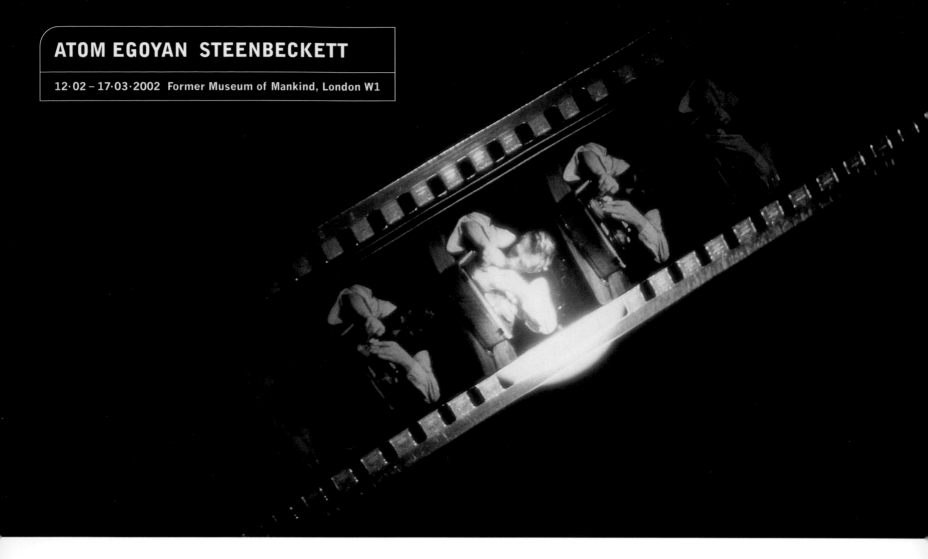

ATOM EGOYAN STEENBECKETT

12.02 – 17.03.2002 Former Museum of Mankind, London W1

Working with Artangel was an exceptional experience. Every step of the development of *Steenbeckett* has been a true collaboration, with ideas and concepts being clarified, challenged, nurtured and finally realized. I always felt that every possible path we might have walked down was carefully researched and fully explored.

Steenbeckett involved a complicated negotiation of rights, both in terms of the literary property, and the securing and preparation of the location. The staff of Artangel were exceptionally dedicated and well-experienced in securing permissions, and organizing all the things to make this experience rich and satisfying.

Steenbeckett was produced at an extremely busy time in my life. I was simultaneously directing an opera and in the midst of finishing a feature film. Artangel was able to accommodate my schedule, and was completely understanding of my needs. This has been an extremely gratifying and memorable journey, and I am indebted to the vision of Artangel in making this possible. In fact, Artangel can make *anything* possible!

ATOM EGOYAN 27 March 2002

Samuel Beckett's *Krapp's Last Tape* is without a doubt the most influential dramatic monologue of the 20th century. In the play, an old man celebrates his 69th birthday by sorting through boxes full of ancient tape recordings, trying to reconcile his memories of events with actual notes that he has scribbled in an old ledger. He settles on a recording made 30 years earlier. On this tape, he hears his 39-year-old self commenting on a tape he has just finished listening to, recorded some 10 years before – a task he refers to as "gruesome", but helpful before he "embarks on a new retrospect". By the end of the play, after an evening of listening to unbearably beautiful memories of a moment of romantic bliss, he is ready to start his final recording. He is tortured, yet exhilarated; intolerant, yet forgiving. By the end of his recording, Krapp is almost paralysed with melancholy over the memory that he has listened to earlier in the evening.

Some of the most emotional moments in *Krapp's Last Tape* show the physical effort the old man puts into taking the tapes out of the box, putting the spools on the machine and then, so tenderly, placing the magnetic tape into the slot of the playback machine. With this simple gesture, both man and technology expressed something vulnerable.

Compare that with our current state of affairs. We record images on digital cameras, download them on to computers, transmit them effortlessly around the world, and erase them with a few strokes on a keyboard.

ATOM EGOYAN, excerpt *The Guardian*, 7 February 2002

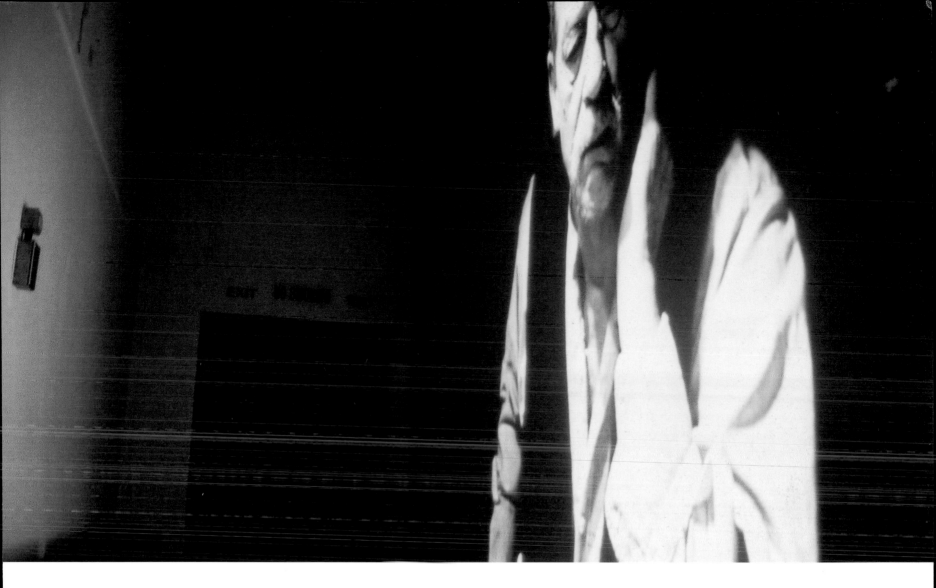

Atom Egoyan visited the Kabakovs' *Palace of Projects* when he was in London to work with Gavin Bryars. He seemed intrigued by what we did. Much later I visited Atom's studio in Toronto. He was cutting a Beckett film on an old Steenbeck table and showed me the final reel: an unedited twenty-minute take of John Hurt as Krapp, preparing his spools to listen to the last tape. Krapp's analogue world seemed linked to that of the Steenbeck and Atom and I were both struck by the sense of having embarked on something.

The former Museum of Mankind was a location we had looked at many times with different artists. One of its more prosaic spaces was an old viewing theatre and adjoining rooms, piled high with dusty canisters: the Ethnographic Film Library. Atom imagined how all 2,000 feet of celluloid – the single take we had watched in Toronto – might be pulled around the auditorium through a forest of bobbins and sprockets, powered by the motor of a lone Steenbeck, without any idea how long the image nor the sound of Krapp's voice would survive this incessant looping.

Visitors were shown up a darkened staircase into the projection booth, from which you could just about make out the Steenbeck in the room below. Further exploration uncovered an assortment of cluttered back rooms until you were confronted by Krapp again, this time as a voluminous DVD projection – pristine, digitised and immortal. MICHAEL MORRIS June 2002

There is a fashion in art at the moment for re-creating actual spaces. In this case we seem to be in a subterranean editing suite that has seen better, predigital days. Hurt's hurt looms up above you on a big screen only after you have blundered along an assortment of dark corridors, past cans of unwanted film, past various mysterious props that turn out later to be mementos to Krapp's sad story.

Finally, having sat through the single take lasting 20 or so minutes of Hurt's magnificently grumpy playing of Krapp, you enter an extraordinary climactic room, in which the entire monologue you have just watched, preserved on 2,000 ft of film, crisscrosses the blackness like laser beams in a high security vault and surrounds you with plangeant whirling and evocative rustles. [...] Egoyan's piece is surely a lament upon the passing of film's unparalleled ability to burrow into your imagination in the dark and stay there, haunting you, just like a memory.
Waldemar Januszczak, 'The best Canadian art stays with you forever ...', *The Sunday Times*, 12 March 2002

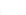
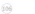

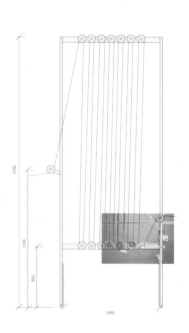

Detail 1

Detail 2

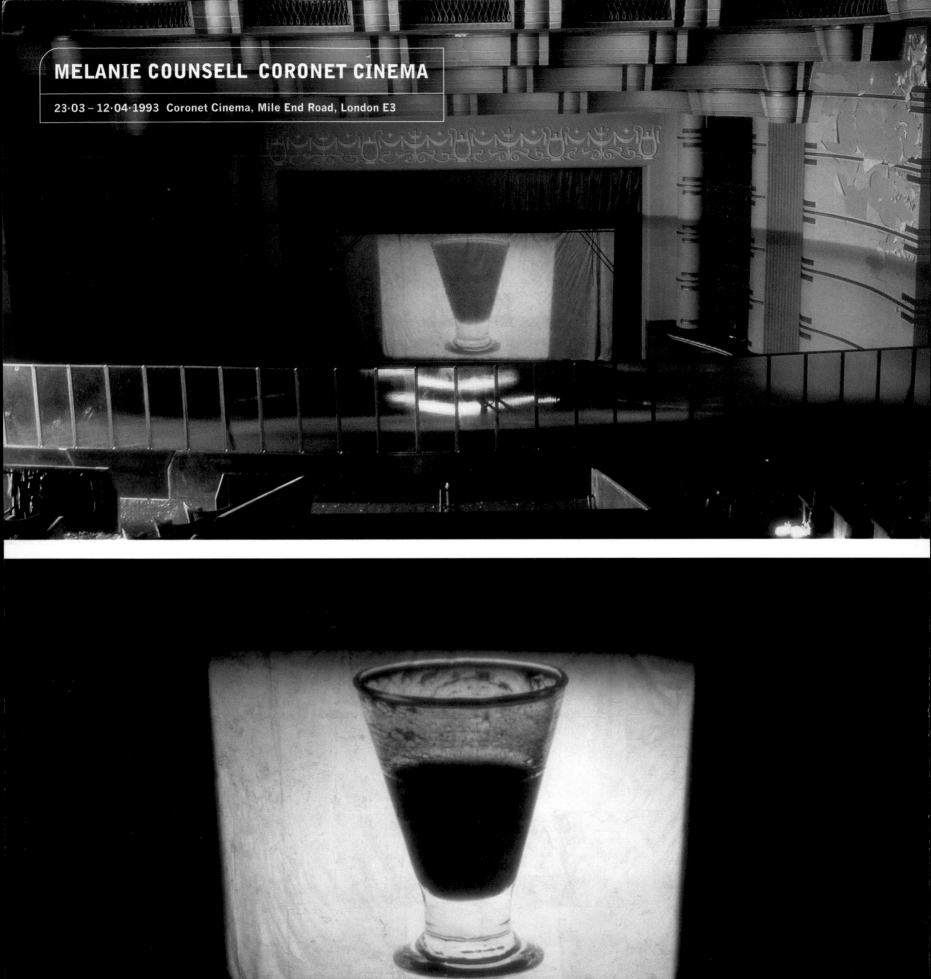

MELANIE COUNSELL CORONET CINEMA

23·03 – 12·04·1993 Coronet Cinema, Mile End Road, London E3

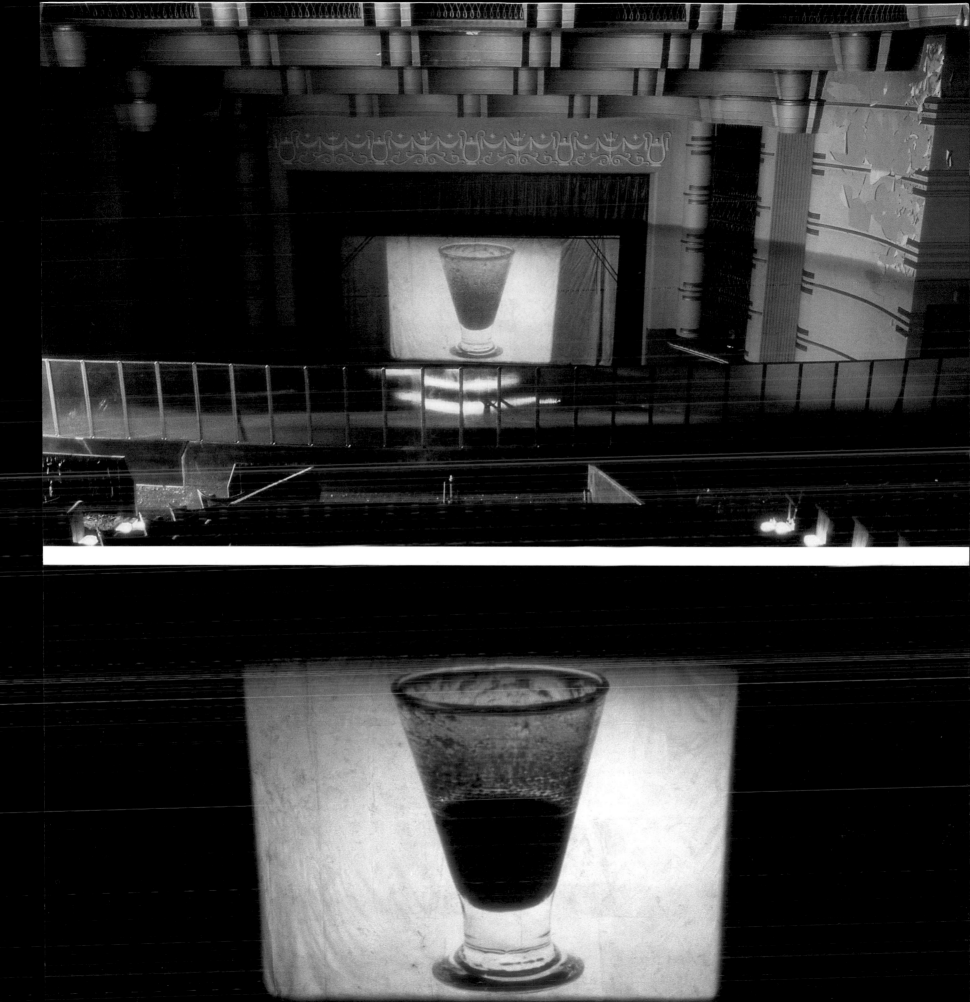

The result of Melanie Counsell's collaboration with Artangel was a half-hour film screened in the now derelict Coronet cinema in Mile End Road. Once capable of drawing an audience and constituting within itself a community whose members participated in its dreams, the building now stands empty, unable to sustain its earlier success, but not yet supplanted by anything more viable. On entering the cinema, members of the audience were directed upstairs, through a graffitied lobby and into the circle, yet on coming up the gangway and out into the auditorium it proved impossible to look directly at the screen. A barrier of fluted glass reaching just above head height stretched from one side of the space to the other, following the curve of the seating. Flickering light, visible through the glass and the noise of the projector in the stalls below, aroused a gentle curiosity and pushed one up the floor-lit aisle in an effort to get an unhinged view of the screen. The film, when it at last became visible, proved to be extremely simple. Shot entirely from a single fixed camera position it showed a small glass of dark-coloured liquid standing on a white cloth. At the beginning of the film the glass is brim-full, at the end, without any visible extraction of the liquid, it is empty save for a black residue coating the glass. What had been happening, one presumed, was that the liquid had been evaporating, leaving behind whatever particles had been in suspension. [...] There was no soundtrack, so the sounds one heard were the whirr of the projector, noises filtering

in from outside, and the shufflings and whisperings of one's fellow spectators. One smelled, too, the damp disuse of the cinema and remembered that an atmosphere charged with maleficent vapour, the moistness of decay, had been an element common to many of Counsell's works.

Since the building had been disused for so long, a special screen had been erected for the occasion. It, too, looked to be a white cloth, similar to that in the film on which the glass rested. Stretched slightly askew, the screen went into a fan of creases at the corners. These creases did not distract. They were, rather, a sign that the cinema's current occupation was not a rehabilitation or a restoration of the full glamour of its former function, but a borrowing from, and tapping into, the building's history. Physically manipulated by the very nature of the place, the obscuring screen, the lighted gangways, and the evidence, visual and aural, that something is going on, the audience is led towards the very point from which a cinema film would normally be projected. What holds us is the acknowledgement that what we are witnessing is a rudimentary narrative structure that shadows the cinema's current status – an emptied-out vessel with leavings – and which is reanimated and enlivened by renewed imaginative engagement. In some ways, what one is looking at is not very much at all. But, should one care to accept it, what is on offer is much more.

MICHAEL ARCHER, 'O Camera O Mores'. *Art Monthly*, May 1993, pp. 14–16

Melanie had decided that she wanted to make a new work in an old cinema. The scale of the cinema was important – it needed to be somewhere with a sense of grandeur. The Coronet gave a very strong sense of a cinematic experience before the age of television, when cinema-going was a kind of communal, collective activity.

It felt as if the work was moving the viewer through the space (rather than the artist directing the viewer). The movement was always upwards, up the stairs from the foyer into the auditorium. On entering the auditorium, the immediate view of the image was disrupted by a ribbed glass screen, which was too high to see over. So you were compelled to move upwards again, to see over the glass screen. Only when you had ascended right to the top of the upper circle could you see the full projected image.

Not for the last time, the work came together at the last moment, when the time-lapse 16mm reel arrived. It wasn't until Melanie showed me the rushes of this very slow evaporation that I understood how the whole project would work Sometimes it's important not to ask too many questions whilst an artist is working through their ideas.

Perhaps it's worth repeating the Andrei Tarkovsky quote that Melanie had put in the leaflet. "Why do people go to the cinema? What takes them to a darkened room where for hours, they watch the play of shadows on a sheet? I think what a person normally goes to the cinema for is time: for time lost or spent or not yet had."

Working on the book project *Annette* with Melanie and Robin Klassnik from Matt's Gallery was slow in an enjoyable way. Very long deliberations about paper and sequencing. The flood of images, all taken from her Super 8 films, overlaps and repeats, like a fragmented film JAMES LINGWOOD May 2002

Annette was an important project for us because it was the first time we had worked with an artist to try and find an equivalent – in the form of a book – for the experience of an installation. This collaboration persuaded us to make publishing an integral part of Artangel's activities, and we've continued to work with artists to make particular books and videos where possible. The fact that the book often appears some time after the initial project has disappeared creates an interesting space for a different kind of collaboration.

PAST

WHEN TIME BECOMES SPACE

Lynn MacRitchie

We are the past. It is inside us and it surrounds us. We live each new moment as the summation of all the seconds that went before it. And as we decide our future actions, based on our assessment of previous events, the past shapes our bodies and forms our minds. Time becomes space, the place where we live.

As surely as we know this – and we feel it, literally, in our bones – we also lose our consciousness of how we come to know it. For the delicate strands of memory that link us to those deeper, denser layers of impacted time become tangled with the mundane ties of everyday routine until we forget that they exist. One of the things that some of the artists who have worked with Artangel have done most effectively over the years is help us to find those strands again, and follow them back into our own pasts.

Physicality plays an important part in this. For these sort of memory traces are buried deep, part of the fabric of our bodies. They are laid down from the very beginning, the second that we enter the world, vainly trying to keep hold of our remembrance of the comfort of the womb. Then, everything is nothing but sensation, intense sensation – brightness, darkness, warmth, cold, pleasure, pain. These feelings never stop – but over time, we teach ourselves to forget them, so that we can get on with just living. But sometimes, something we see, or hear, or smell, or touch or taste can bring those sensations back again. For one, at least of a little crowd of onlookers shivering in a chilly wind on an open stretch of ground in the East End of London on a sunny October morning in 1993, all the sad sweetness of this progress to forgetfulness seemed to be embodied in the object of our gaze – a blank, grey mass of concrete, looming solitarily at the corner of Grove Road and Roman Road.

London's East End is a special place. It is a place of history, of suffering and fortitude. It got bombed flat but it kept on living. Rachel Whiteread's *House* – for that is what the concrete block was, a cast she had made of the interior of a complete terraced house – revealed the architecture of that living in a way that it had never been made visible before. Standing alone, cast from the sole survivor of a terrace of similar houses demolished to make way for an urban green space, *House* let us see the true dimensions of those interiors in which individuals became families, cherished children, faced old age and death, all within a huddled series of rectangles piled one on top of another. How crude they seemed, how stark and brutal, those haphazard spaces where passing time had been shared in the closest intimacy. The work evoked a powerful response because of this element of revelation, of suddenly being able to see the shabby underpinnings of the basic stuff of life, the site of our most essential relationships revealed as no more than an arbitrary structure with an uncertain future.

Not so very far from Grove Road is Whitechapel, where the Royal London Hospital has been caring for the sick since 1740. One summer evening in 1997 Neil Bartlett gave a performance in the hospital's lecture theatre. He talked about some paintings; seven paintings made by the French artist Nicolas Poussin

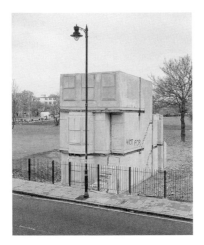

Rachel Whiteread, *House*, 1993–94

400 years ago, depicting the sacraments of the Christian church. They now hang in the National Gallery of Scotland in Edinburgh. Bartlett saw them there and they stayed in his mind, as important things do. He described them to the audience, attempting as he did so to give an account of the various ceremonies they depicted – baptism, confirmation, marriage, penance, ordination, the Eucharist, extreme unction. Some of these sounded very familiar, some very strange. For these days, while we recognise our need of such rituals to help us through the crises of our lives, it gets harder all the time to remember just exactly how we're supposed to conduct them.

Bartlett made this point by interspersing his descriptions of the paintings with anecdotes about attending contemporary versions of some of the ceremonies. For while Poussin's paintings have stayed frozen in time, with the static majesty of certainty, around them life has rollicked on. Bartlett acknowledged this. His monologue was full of personal anecdotes and sharp, political observations, at once touching and very funny. To bring the work to a close, he left the lecture theatre and went to another room nearby, where the audience was invited, one by one, to join him as he sat in silence watching over an empty bed. Looking at him watching, listening to his silence, the perfect poise of Poussin's classicism became reanimated through the performer's body, the ancient past reconnected with the living experience of the present.

Death is not always a private affair, attended with the sublime ceremony of Poussin's *Extreme Unction*. Some deaths are public, willed by the state. War memorials commemorate those who died because they were told to. They are listed on the memorial together. For these dead are named not as particular individuals, mourned by their families, but as representatives of the group – the regiment, ship's crew, RAF squadron or the like – as one of which they made their ultimate sacrifice. Their commemoration is part of a public ritual of remembrance. War memorials have a certain formal vocabulary – they may incorporate a classical shape, such as an obelisk, or include carved groups of figures. If the memorial is inside a church, the regimental colours may be hung close by, torn and battle stained.

In his sculpture *Untitled (Monument)*, erected in the Jubilee Gardens along the Thames in 1992, Juan Muñoz used some but not all of these devices. On a rectangular monolith of artificial stone, about ten feet high, were mounted three flags made of bronze. No names were carved anywhere, and the flags were without pattern, except for the dull sheen of the metal. This memorial commemorated no individuals, not even that unknown soldier who sometimes serves as a token representative of the unnamed dead of war. Looking at its blank and impassive surface was a shock: for this anonymous object seemed to function not as a reminder of lives lived but rather of death itself, the inevitable end of us all. Set by the glinting flow of the Thames, the river of London's life which is also sometimes a means for its desperate to put too burdensome an existence to an end, it seemed to say that life and death exist together, as one.

Neil Bartlett, *The Seven Sacraments of Nicolas Poussin*, 1997

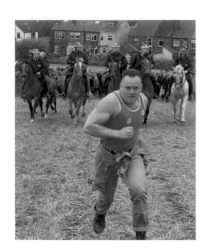

Jeremy Deller, *The Battle of Orgreave*, 2001

That unknown soldier, or sailor, or airman was unlikely to have been an officer. For while Muñoz' blank obelisk may have made death in war anonymous, the actual experience of fighting was regulated by social position. The upper classes, as officers, gave the orders, the lower classes, in the other ranks, obeyed them. The history of Britain is a history of class, and of class struggle, and sometimes that struggle could get physical. One June-day in 2001, in a field in South Yorkshire, some 1,000 spectators watched in an odd, tense and almost complete silence as on the grass in front of them massed ranks of hundreds of men, in casual jackets, jeans and T-shirts, surged and heaved against row upon row of uniformed policemen, some of them helmeted and carrying shields, like Roman legionaries who had returned to the bleak fields of their empire's most northern outpost. They were witnessing a re-staging of the Battle of Orgreave, the most notorious incident of the 1984 miners' strike, recreated on the initiative of artist Jeremy Deller, performed by members of historical re-enactment societies, joined for the day by many of the local people who took part in the original event, and filmed for Channel 4 by Mike Figgis.

Deller is fascinated by juxtaposing contemporary and traditional examples of British culture, such as having brass bands play acid house tunes, or filming the ancient fertility rites which survive in traditions such as hobby horses or fire festivals and showing them as part of art exhibitions. The re-creation of the Battle of Orgreave, however, was on a totally different scale. On 18 June 1984, a violent confrontation took place between a mass picket of thousands of striking miners from all over the country and a large contingent of police, including officers from the Metropolitan force in London, outside the Orgreave coking plant in South Yorkshire. It was an event which changed the nature of industrial disputes, leading to the banning of secondary picketing, and it was an event that changed individual lives, lives still being lived in the community asked to host its re-staging. This re-enactment, then, could not be undertaken lightly. Deller spent many months in careful negotiation with potential participants. It was the first time that a contemporary incident would be the subject of a re-creation by historical re-enactment societies, which are themselves a curious manifestation of the British fascination with the past. Members, all dedicated amateurs, spend their weekends immaculately kitted out in perfect reproductions of medieval armour, or masquerading as Cavaliers or Roundheads or the like, complete with elaborate and historically accurate costumes, made at their own expense, staging perfect re-creations of the battles of long ago. These, while no longer mortal combats, are certainly engaged in with deadly seriousness, and the re-enactors bring impressive discipline and thoroughness to their self-imposed task. Deller, however, had also invited miners and policemen involved in the original incident to take part. The situation could not have been more delicate. For, in order to enable the re-creation to be staged with the scrupulous accuracy required, participants in the original event had to describe their actions on the day,

in the greatest of detail, so that they could be choreographed for others to perform. The process resembled a kind of psychological enquiry, enabling a traumatic event from the past literally to be looked at again by those who had taken part in it in the first place.

Thus, as they stood watching the grunting, heaving lines of men grappling together in the middle of that field, listening to the cries of "The miners, united, will never be defeated", the men and women who had been there on that first June day, seventeen years before, were witnessing part of their own lives, lives that it had changed forever. For this, this awkward, ugly skirmish in a field had been part of a real battle, for jobs and livelihoods, for the existence of whole communities. "And we lost", as one of the men who had been there put it, simply, devastatingly. For their children, it was a chance to see for themselves, to understand, maybe for the first time, what their parents had gone through – smelling the horses, hearing the horrible sound of police truncheons beating on their shields, seeing the white, frightened faces, of policemen and pickets, pursuers and pursued. For those neither miner nor policeman, re-enactor or resident, it was a chance to witness the death-throes of a social model of class conflict that, pushed to its brutal conclusion in a village street turned into a battle ground, with mounted police charging down fleeing miners, could sustain itself no longer. Deller, with his interest in all the eccentric manifestations of British life, from brass bands and hobby horses to acid house raves, this time revealed its darkest and most painful undercurrent, the brutal struggle of state against working class – 'the enemy within' – which, hopefully, can never take quite this form again.

Back in London, the river flows on and life flows on with it. The great city is many places, home to individuals and families, setting for births and deaths, affairs of state and affairs of the heart. Those who live there live there knowing, however unconsciously, that their everyday world meshes with a greater, more extensive realm of politics and power that contains and shapes their private, ordinary one. Artists working with Artangel have taken their audiences to East End streets and West End clubs, into hospital wards and out along the banks of the Thames. They have taken them from the city and demonstrated how the power structures mapped out in its streets hundreds of years ago impose themselves on communities far, far away from East and West End. Art can do those things. After the re-enactment at Orgreave, the people of the village and their neighbours in South Yorkshire sat down in the social club with their visitors from the South and beyond and shared their memories and their hopes for the future. An artist's idea, made real, had moved all of them, both physically and mentally, into a shared space, present and past, North and South connecting in a common experience, a life briefly shared.

In 1992, two sculptures by Stephan Balkenhol were set up, like the monument by Juan Muñoz, as Artangel's contribution to the Hayward Gallery's 'Double Take' exhibition. One, set on the empty pillars beside Blackfriars' Bridge, was an enor-

Stephan Balkenhol, *Figure on a Buoy*, 1992

mous wooden head of a man, his hair and face painted in naturalistic tones, his expression bland. Down below, in the river itself, a full-length wooden figure of a man, about half life-size, stood on a floating buoy. Unlike his giant counterpart, who gazed ahead without seeing him, this little figure seemed frighteningly exposed, in imminent danger. So real was his air of vulnerability that several calls were made to alert the river police of an accident in the making and a story began to circulate that a woman had indeed dived into the water to save him, fortunately surviving her selfless impulse. How must she have felt, standing on the bank before she dived in? Overcome, impelled to act, the combination of artwork and setting, suggestion and reality, triggering an ancient response she could not control. What a tribute to the power of some carved and painted wood, carefully sited, what a testament to the necessity of life to preserve itself in the face of death.

Life. Life begins for us without our willing it and continues as long as we can sustain it. We shelter it at home, and celebrate it in ceremonies and sacraments. We commemorate it in memorials, and enjoy it in gambling and games, in making money and wielding power. Or we may struggle through it with difficulty, for the means to enjoy it are not given to us equally. One minute we are giants surveying a city, the next frightened pygmies in danger of being swept away. It's been like that forever, as we struggle to understand and give some dignity to our physicality and some humanity to our social interactions. Often we fail and fall into conflict, making ourselves ugly. We repeat all this over and over, again and again and again. One of the things that art can do, by making things which last that we can continue to look at or by offering experiences we can share with strangers, is remind us of this, comfort us that someone else was grappling with it too, 400 years ago, or 100 years ago or less than twenty years ago or just last week. For that continuing dynamic, that flow and counter flow of remembrance and forgetfulness, understanding and questioning, peace and chaos, is life; life as art, by letting us access the very depths of ourselves, not just once but over and over again, can surely help us to know it.

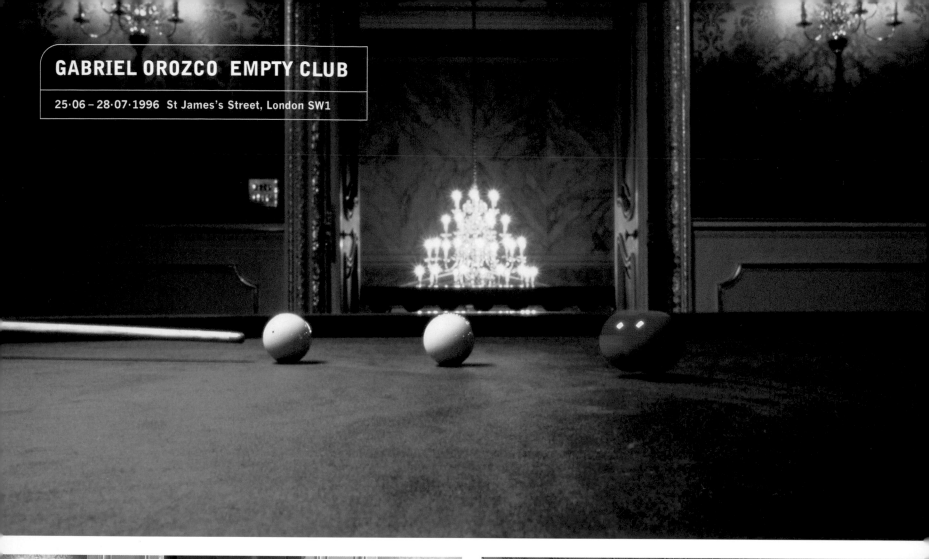

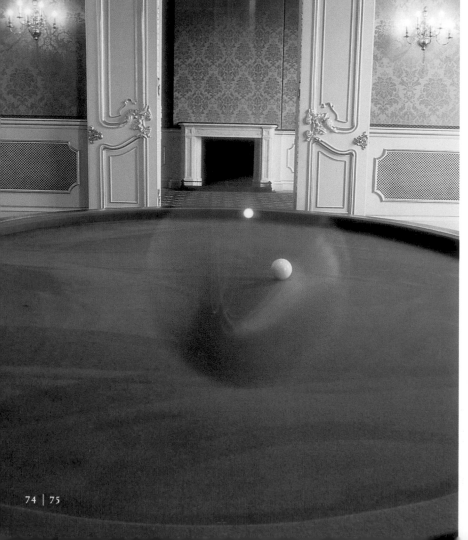

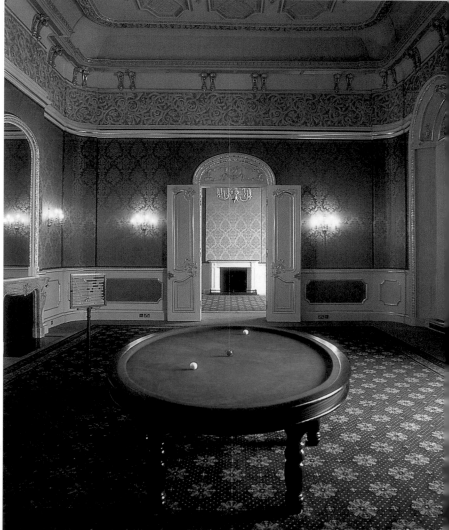

I wanted to open up the building for people to explore the actual conditions of their self-mythical past and experience this within the architectural present of the interior of this club – a corporate space available to rent.

I wanted to penetrate the private mythology of the building with my own private mythology. The spaces were opened up, but at the same time they were permeated with impenetrable secrets. I was not interested in a description or analysis of the life and myth of the club. I was interested in the confrontation of scale and time between two 'private' spaces, that of the building and of my work.

I was interested in the space working for me, and not in me working for the space. I was quite conscious that my work was going to travel afterwards, that it would be moving, and that the building would remain there, static, for a long time. The centre of that building is the building, the centre of my work is something else.

The Atomists, the Billiard Table and *the Moon Trees* travelled quite well afterwards, they are not mine any more and they have developed their own history by now. There were also some less successful moments in my project, the ones that didn't survive the double imposition of the building and myself. That's how art works or it doesn't. It doesn't work when locality, romanticism and our own private mythologies become an imposition for the others, the same as countries and artists.

GABRIEL OROZCO May 2002

Gabriel Orozco's *Empty Club* came slowly into focus as he lived in London for a period of time in 1996. The fact that he had given himself a lot of time in the city was critical. He had time to absorb a range of material – spaces, signs, different stimuli. Initially we discussed quite a fugitive and improvisational project, but somehow the idea of a club as a kind of indoor park came to Gabriel, and he worked it out from there. The different floors of *Empty Club* rotated around the form of the ellipse and the circle, tying in with Orozco's interest in the work of The Atomists, a school of Greek philosophy that first posited the idea of constant mobility, and consequently the void.

We talked a lot about the connections between sporting rituals and rules and etiquettes and their relationship to geopolitical realities and England being the epicentre of Empire in the nineteenth century, when many games with complex rules were developed. We visited sporting environments, we visited gentleman's clubs, but the idea of working within one seemed pretty remote. To find a building which had ceased to be a club but had not become anything else was not easy – though the economy was not very buoyant at the time which was to our advantage. We looked at several grand buildings, some of which had been clubs, and we were fortunate enough to persuade the estate agents who were representing the building at 50 St James's to give us a temporary lease. The fact that we actually became legal tenants of this huge building in the heart of London for two months continues to amaze me even now JAMES LINGWOOD May 2002

[...] the club's spaces have been filled with a playfulness that comments on the sportiveness of the English character. [...] There are no rules for Orozco's billiards, but the British genius for inventing games is celebrated on the floors above, with large photo-panels featuring adapted images of cricket, rugby, football and rowing, an indoor bowling green, and on the topmost floor, a model of Lord's cricket ground, where players and spectators have trees sprouting from their shoulders.

Orozco's playfulness is light fingered. Emptiness is his theme, and you need to sink deep into one of the club's armchairs to meditate on this strange moment in the building's history, moving between past and future on the pendulum of time. Then you can play his game.

Robert Hewison, 'Games of enchantment', *The Sunday Times*, 30 June 1996

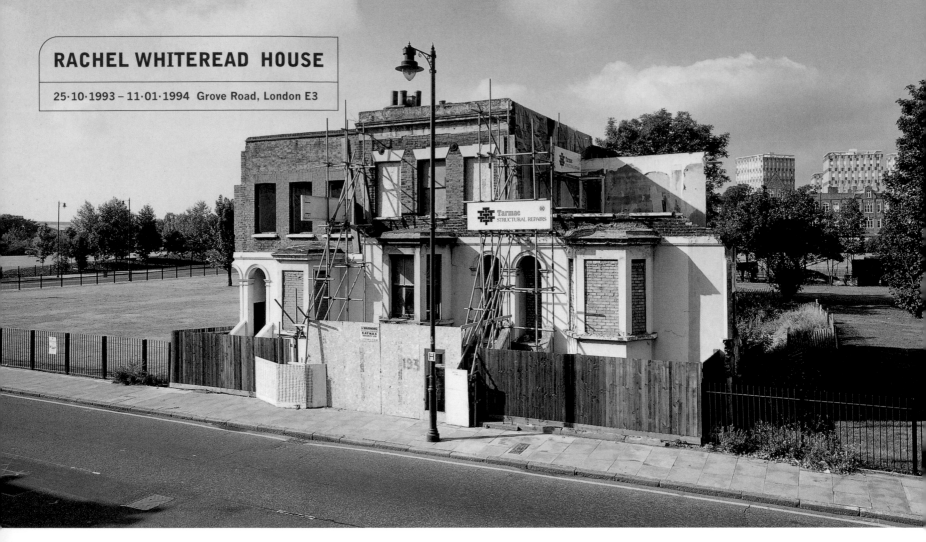

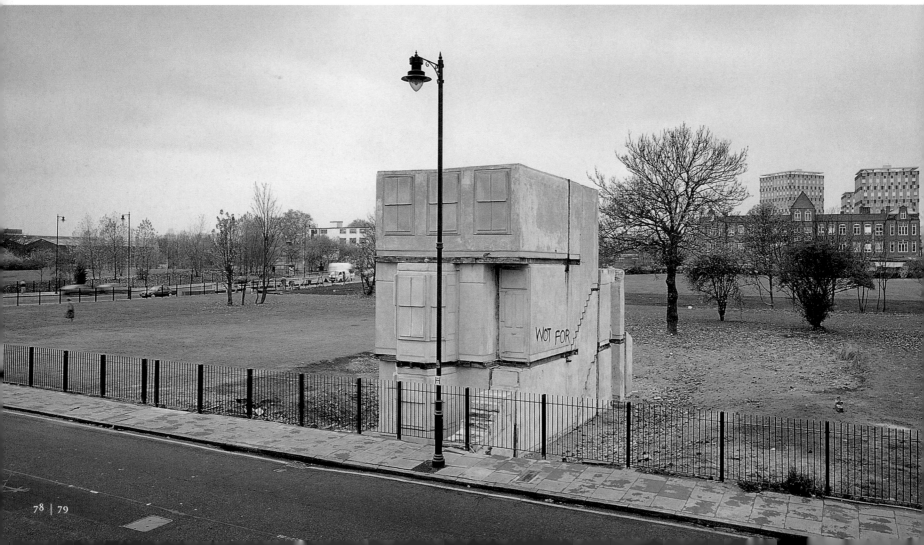

In the summer of 1991, James Lingwood came to visit me in my studio at Carpenter's Road, London E15. I remember we chatted for a while about what we had been up to and what plans we had. James tentatively enquired if I had any ideas for making larger works. Innocently, I replied I'd like to make a house in concrete, in an urban setting. Initially, it was as simple as that.

We started to think about how that might be possible and various people helped in the search for the house. I had certain criteria: that it could be seen from various corners, maybe the end of a terrace, preferably on its own and around the area I was totally familiar with – i.e. Hackney / Tower Hamlets. I was also sure that the house should be uninhabitable as I didn't want to take away a potential home.

Eventually we found it, 193 Grove Road, the long-term residence of the Gale family – who had refused to be moved into high-rise council housing and were having their own private war with the council. They had finally won their battle, and were being rehoused in a Victorian terrace house just around the corner.

Various negotiations were made with Sydney Gale and he said he would be honoured to have his ex-family home turned into a concrete memorial.

Eventually the money was raised and the concrete house was built with the input of the engineers at Atelier One and many other helpful souls.

It took three years in the planning and making and stood with varying degrees of dignity for three months. In January 1994 it took three hours to be demolished.

We struggled to make it and it was finally a mute concrete memorial called *House*. It stirred the artworld, the politicians and people who didn't even think they cared about art or politics.

I'm very proud to have made it.

RACHEL WHITEREAD 5 May 2002

When I first visited her studio in London, Rachel ventured the idea that she would like to make the cast of a house. She was very clear about it. So in the first instance Artangel had simply asked the right question to the right person at the right time – and in the right place. It had to be in London, because it wouldn't have been right to make *House* in an urban environment which she didn't know very well already.

The idea was clear, but nothing else was. Finding the right situation for the sculpture was a particular challenge. There were a number of false starts before we were able to secure temporary use of the house on Grove Road – just around the corner from the Chisenhale Gallery in East London where Rachel had shown her cast of a room, *Ghost*, a couple of years earlier. From the beginning the relations with Bow Neighbourhood Council, a localised branch of Tower Hamlets Council, were extremely complicated, because the leader of the council, Eric Flounders, had a visceral dislike of the project. But we found more sympathetic voices within the Planning Department and amongst other, less vociferous, members of the Council.

After we'd found the right place, we needed to find the right means to make the sculpture. Through one of our trustees at the time, Will Alsop, we were introduced to Neil Thomas, a structural engineer from Atelier One who suggested that the work could be made with concrete sprayed onto the interior walls of the house. By this time, we were working under considerable time pressure, because the period between gaining access to the house, and having to return the site to the Council was very tight.

At this point, all the energy was directed towards the physical difficulties of making the work – Rachel and a team of builders were working in the dark, damp interior in extremely inhospitable conditions. We wanted to keep the project quiet until it was finished, to avoid any distraction from the challenges of actually making it.

After weeks of working on the inside, and a further anxious period waiting for the concrete to cure, the work of releasing the mould from the cast – under a wrap of netting – began.

There was a very small private opening before its short life as a very public sculpture began. The debate raged from the streets around it to the press and media and on to the House of Commons. Despite attempts to dust down old battle plans from previous cultural controversies – most particularly Carl Andre's bricks – one of the most interesting aspects of *House* was how it eluded these formations. Neither the opposition nor the support for *House* could be neatly packaged into local against international, art world against 'real' world, as they had hoped. The contours of the controversy about *House* were then, and remain now, more complex and less predictable than that. JAMES LINGWOOD May 2002

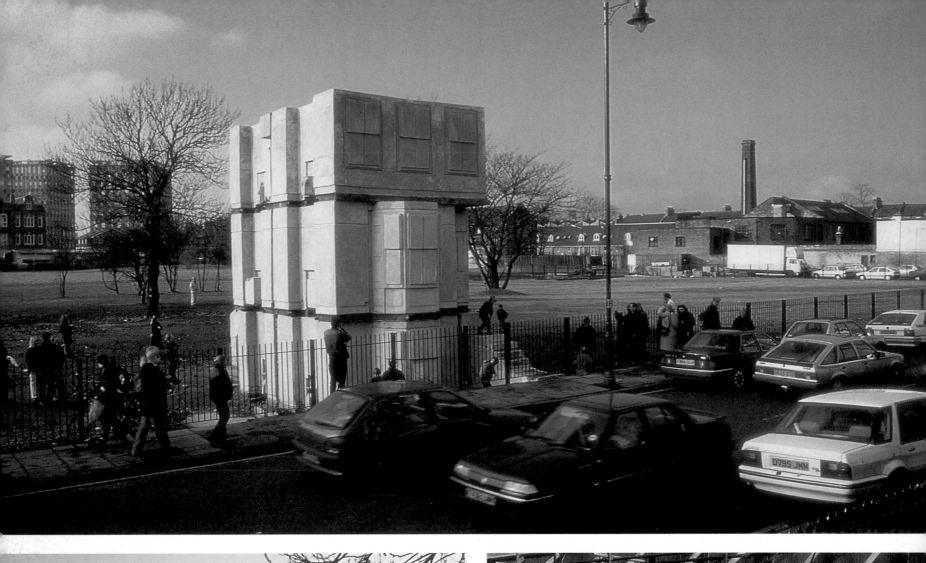

Value of a house set in concrete

From Mr John Stathatos

Sir: Your leading article "A concrete idea well worth preserving" (3 November) urging the preservation of Rachel Whitehead's *House* was perceptive, for it has taken very few days for a consensus of informed opinion to emerge that *House* is perhaps the most impressive work of public art to appear in this country for many years.

I spent two hours or so on the site last Tuesday, and can testify to a steady stream of fascinated viewers, including a couple from Birmingham and a man who had travelled specially from Lyme Regis. Nor is support coming only from specialist visitors; about half the locals I spoke to were in favour of the work.

Bow council is to be commended for its imaginative support of Artangel; now that it finds itself with what is rapidly becoming a nationally famous monument on its hands, it should consider maintaining it in perpetuity. We tend to think of any public art not made of bronze or marble as essentially ephemeral, but the demolition of *House* after a mere four weeks would be a tragedy.

Perhaps not surprisingly, even those I spoke to who disliked the piece finished by commenting on the waste of money implicit in its destruction.

Yours faithfully,
JOHN STATHATOS
London, N4
3 November

From Cllr Eric Flounders

Sir: Those poor, unsophisticated readers who share my view that *House* is utter rubbish can rest assured that, despite the pleas of the *Independent*, the monstrosity will not remain in place beyond the end of November.

The Bow Neighbourhood Committee decided on a date for removal even before work began, in order that we can continue laying out a new park. This half-constructed park is, naturally, littered with bricks, bulldozers and half-demolished roads as work goes on. Your dismissal of it as merely "scruffy" leads me to wonder what sort of standards you have in municipal parks as well as in art.

Yours faithfully,
ERIC FLOUNDERS
Chair, Parks Board
Bow Neighbourhood Council
London, E3
4 November

A concrete idea well worth preserving

THERE it stands on a scruffy patch of parkland in Bow, east London, the concrete ghost of a Victorian terrace house, opposite the Kingdom Hall of Jehovah's Witnesses in Grove Road. But those who bear witness, Bible in hand, will knock on the concrete door of No 193 in vain. This is a house inhabited only by solidified particles of sand and concrete.

Rachel Whiteread, who created this remarkable artefact, is one of the four artists shortlisted for the much-criticised Turner Prize. Three years ago she gave the world *Ghost*, a plaster cast of a bedsitting room in an abandoned house in the Archway Road, London. It was bought by Charles Saatchi, and one of its offspring, *Untitled Room*, is among the works by the shortlisted artists on view from today at the Tate Gallery on Millbank, London. *House*, as the creation in Grove Road is called, is a logical development of those smaller works.

Whiteread's inspired idea was to use the derelict house that stood on the same spot as a mould, a traditional method of making bronze sculptures. Room by room, floor by floor, the house was filled with concrete. Then the brick walls and windows that formed the mould were delicately removed. The result is unexpectedly moving. Sightless, solid windows indented by vanished transoms and mullions gaze out unseeing. A departed staircase zigzags up a wall. The hole that was once a fireplace protrudes like some primitive adornment. For a sculpture, the bulk is impressive, yet the overall effect is strangely spectral.

Whiteread's was in many ways a wacky as well as a brilliantly original idea: just the sort of thing that people who dislike much contemporary art, and especially abstract art, tend to hate. Yet the artist has, in the most traditional way possible, taken an everyday object — albeit a very large one — and transformed it into a work of art. Being literally a concrete image of a dwelling, *House* could not be further removed from the abstract.

Bow Neighbourhood Council, which generously lent the site to the sponsoring organisation, Artangel, had requested that *House* be demolished at the end of this month. It would be performing a service to art if it were to extend its presence there not just for a month or two more, but until it has lost its pulling power. That is likely to be a long time hence.

Sculpture brings good luck to Bow

From Mr Tim Neilson

Sir: It is to be hoped that Bow Neighbourhood Council is beginning to realise, from the enormous amount of interest that has been generated by Rachel Whiteread's sculpture "House", what an extraordinary piece of good luck has befallen it.

Without commission, without cost and without a team of town planners, one of the most significant public sculptures of recent years has simply emerged in the council's brand new park. It is a once-in-a-lifetime gift that a thousand towns and cities across Europe would seize readily.

Yet, with undisguised relish, the chair of the Parks Board (Letters, 5 November) has indicated that the decision to demolish "House" will go ahead.

It hardly needs to be repeated that this is a major work — probably a masterpiece — by a young British artist (and Turner Prize nominee) with an impressive body of work behind her and a brilliant future ahead.

Bow Parks Board, with its excellent rejuvenation of Victoria Park, has already shown what it can do. Now, if it is bold, it has the chance to give the East End a landmark which would undoubtedly become a "must see" in every guidebook to London.

Yours sincerely,
TIM NEILSON
London, E9
12 November

JOHN MANNING

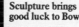

Rachel Whiteread's "House" lures viewers in Bow, east London

Our house is a very nice house

The Turner prizewinner's work needs saving, **James Lingwood** says

Rachel Whiteread's *House* stands in Grove Road in London's East End, as a memorial to housing and to history, to community and to memory. Like most works of art, and all monuments, it is mute. Although it is eloquent in many ways, perhaps it is the silence of *House* amid the cacophony of partisan support and unrestrained prejudice which is so impressive. It absorbs all that is given to it, thought of it, and thrown at it with dignity.

But if *House* is silent, it is not anonymous. And it seems that in this particular local contest (I am not prepared to generalise about the attitudes of local authorities), contemporary public art must aspire to anonymity if it is to be allowed to exist at all. In short, it is only OK if it is meaningless.

This culture of the lowest common denominator is exemplified by the decision of three councillors of Bow neighbourhood to insist on the immediate demolition of *House* on the same night that Rachel Whiteread was awarded the Turner Prize. (There were three councillors who supported an extension, but the casting vote of the chair, Eric Flounders, ensured its fate.) When *House* is pulled down, the wooden sculptures in the adjacent park will stay. They have already acquired that prized invisibility which is ultimately the fate of almost all monuments and which Whiteread's masterpiece self-evidently does not yet have.

Perhaps it is worth recalling what the artist and Artangel, the organisation which commissioned *House*, had hoped to get from that meeting in Bow. Permanence has never been our ambition, though it might have been our dream. Our contract with the neighbourhood states that the site should be restored as parkland by the end of November. We applaud their generosity in giving us permission in the first place. The agreement had been negotiated in March, signed in May. We had hoped to take possession of the condemned house at the end of the month. In fact, for reasons outside our or the council's control, we did not gain access to the vacant property until the beginning of August. All we have been asking for is a compensatory extension of a couple of months. Hugo Young in *The Guardian* lamented this limited attempt at compromise as a sad reflection of our cultural aspirations. We are compelled to fly with wings clipped by prejudice.

It seems inconceivable that this moderate extension was refused. Inconceivable until one remembers how easy it can be to mistake private opinion for public interest. An opportunity for quiet compromise has been turned into noisy confrontation. Perhaps it is still not too late for an amicable understanding.

It is the view of the chair of Bow neighbourhood that *House* is an "excrescence". It is also his contention that *House* is a conspiracy of the chattering classes. He cannot acknowledge the unusual constellation of informed opinion that *House* is indeed a rare achievement, even a masterpiece. More alarmingly, he cannot allow himself to see the thousands of people who visit *House* each week as anything but outsiders from other, more comfortable places.

It would be disingenuous to claim that *House* excites universal acclaim — locally or nationally. Clearly it attracts hostility and indifference as well as support. But it is more disingenuous to claim that there is no local interest. Local builders have called the sculpture "amazing", people living across the road have said it is "impressive" and "wonderful", a local resident said on Thursday that "it should stay for future generations to remember what it was like here". Rachel Whiteread was approached by two locals who had lived in the now demolished terrace for 40 years and thanked for "making their memories real".

The success of this sculpture has been to fracture the normal stereotypes of opposition and support. It is simply not a case of "them" against "us", local against national. The hunger to erase *House* so quickly masks an insecurity about the potential for art to communicate in ways which are unheralded and unpredictable.

On Remembrance Sunday, a public silence falls before perhaps the most successful public monument in Britain, the Cenotaph in Whitehall. *House* is a domestic cenotaph, a memorial to the spaces people live in, the places society creates for them, a monument to both the fragility and the resilience of life. Like the Cenotaph, it commemorates and honours the act of memory itself. But it does not seek to mediate memory into some acceptable political form.

What can be done? Perhaps our only encouragement is that the Cenotaph itself was originally conceived as a temporary structure. But through a rare congruence of public interest and political imagination, it was decided to make it permanent. In fact we do not seek an indefinite life for *House*, only a longer one. There seems a startling absence of reason as to why this should not be.

The author is co-director of Artangel

> House is a domestic cenotaph, a memorial to the spaces people live in

Sculptor could scoop award for her concrete capers

There's a stoney house!

BY ULLA KLOSTER

THE arts world flocked to the East End this week when a top sculptor unveiled a cast of a Victorian house.

The three-storey lump of concrete could win Hackney-based artist Rachel Whiteread a top national prize.

Bow Neighbourhood, which had bulldozed a string of houses to add to Mile End Park, gave a deal with the 30-year-old artist earlier this year.

Rachel would tear down the house - 193 Grove Road - after she had filled it with concrete and turned it into a memorial to a bottle.

The piece, only feet from where the first V2 rocket landed, is named 'house' and made with a £50,000 sponsorship.

BEFORE and... ...AFTER!

22, said: 'You must be joking! I thought it was an old building waiting to be knocked down.'

Retired bus driver Jim Chalupinski, 82, of Roman Road, Bow, said: 'I've got my memories of growing up in Whitechapel during the War already without this. I think it's a waste of money.'

He said: 'That money would be better spent on buying a new house.'

WEE WEE

'They've taken the wee wee out of me.'

The white sculpture, finished on Tuesday, will be razed to the ground by the end of November. Er for it has got mixed reactions from East Enders.

But Palmer's Road based designer, Dick Stringer, 40, said: 'I think it is brilliant. I like the inside and quality. It's a nice way of looking at traditional things.'

Rachel hailed the rising star in the English art establishment, has just shortlisted for the Turner Prize. Some of her work can be seen at the Tate Gallery.

■ OFF THE CUFF P24

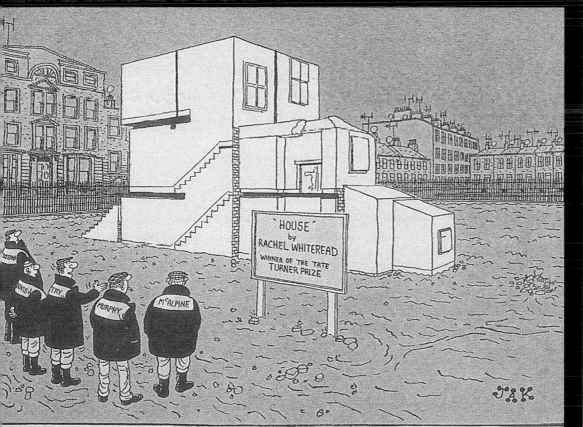

'HOUSE' by RACHEL WHITEREAD WINNER OF THE TATE TURNER PRIZE

"Note the subtle exploitation of the relative value, combined with the juxtaposition of pure form in relation to...!"

JAK

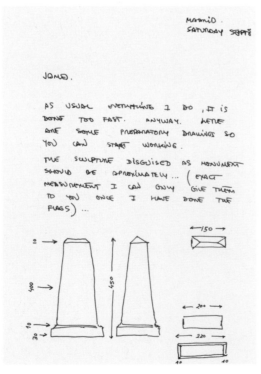

MADRID.
SATURDAY SEPT 5

JAMES.

AS USUAL EVERYTHING I DO, IT IS DONE TOO FAST. ANYWAY. HERE ARE SOME PREPARATORY DRAWINGS SO YOU CAN START WORKING.
THE SCULPTURE DISGUISED AS MONUMENT SHOULD BE APROXIMATELY... (EXACT MEASUREMENT I CAN ONLY GIVE THEM TO YOU ONCE I HAVE DONE THE FLAGS)...

PROBABLY IT CAN BE DONE IN BLOCKS OF SQUARE PIECES OF GRANITE OR THE SAME MATERIAL AS IN THE BANISTRADE BY THE RIVER.
THE BIGGER THE PIECES, THE BEST, SO THERE IS NOT A LOT OF CHECKERS OR SQUARES DRAWING THE SURFACE.

THE DRAWINGS ARE NOT ALL THAT REALISTIC CONCERNING PROPORTIONS BUT I HOPE THEY ARE OF SOME USE TO YOU.

KEEP ME IN TOUCH.

MUÑOZ

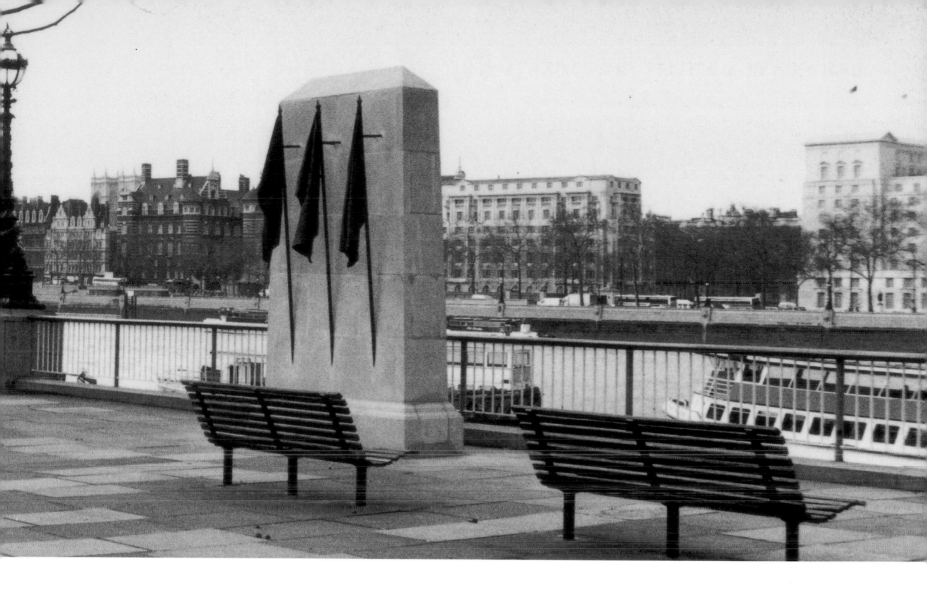

The sculptures by Juan Muñoz and Stephan Balkenhol
which we commissioned with the Hayward Gallery were
the first projects Michael and I realised with Artangel.

Juan wanted to make an anonymous sculpture, one
which people would pass by as if it had always been there.
We both liked the comment by Robert Musil about
monuments and the city – that attention slips away
from them like water slips off a duck's back.

He chose a place by the River Thames, and specified
a certain shape which a friend, Peter Fleissig, drew up so
that a company could then produce the individual blocks
of artificial 'stone'. He cast the bronze flags in a foundry
in Spain and sent them over. Then one wintry week, the
monument suddenly appeared, unannounced and unex-
plained. It disappeared again in the same quiet way.

We have had a huge amount of moral support from
artists over the past ten years. Juan was always there for us
at Artangel, always engaged, and sometimes evangelical
on our behalf. Without this friendship and belief, the
whole Artangel project would not have been possible.

JAMES LINGWOOD May 2002

Nicolas Poussin's great series of paintings known as *The Seven Sacraments* hangs in a small, dark, marble-floored room in the National Gallery of Scotland in Edinburgh. In the summer of 1994 I noted in my diary that I had visited this room every year for the past fifteen years of my life, and had cried each time. I realised as I wrote that these paintings were going to be the material of my next piece of work. A year later, looking for a possible site for the piece, Michael Morris took me to the Edinburgh City Morgue – he pretended that we were reconnoitring a location for a film. In the Chapel of Rest, I noticed that the pane of glass through which relatives are invited to view the corpse was of exactly the same dimensions as one of Poussin's canvasses. Around this one detail the text for the performance began to cohere. Michael first heard it, in private, in a hesitant voice, in a room over a church hall in Brighton. It was first given in public in 1997 in a lecture theatre hidden in the bowels of the Royal London Hospital, Whitechapel. There, I remember the sight and sound of people in the audience crying quietly. I remember my father coming to see the piece, and not speaking to me, just touching me gently on the shoulder. I remember a passage where I spoke in character as Mary Magdalen, naked except for underpants beneath a backless surgical gown, feeling freer and fiercer and more queer than I ever have (on stage) in my life. In late May 1998 I performed the piece for the last time, this time in Southwark Cathedral, accompanied by an orchestra and a choir and sixty schoolchildren and an audience that filled the nave and both transepts. I wore my best suit and carried a prayerbook. As I spoke the last words (stolen from John Donne), I lifted my face up into the great golden vault of the crossing, and then down to look at the three nine-year-old boys who were sitting at my feet, and I felt astonished at what we had done, and done in those particular spaces. There were several moments over those three years of work which were genuinely extraordinary, of real worth; I would like to thank Artangel for their part in bringing together the extraordinary teams of artists, technicians and producers who made them happen. And for never asking me why I was doing what I was doing.

NEIL BARTLETT 19 March 2002

Bartlett achieves several things in this unique show. He illuminates Poussin's work in a way that makes one want to rush off to Edinburgh to examine the original paintings. He also dwells on mortality. The final image, as we file into another room, is of Bartlett silently grieving over an empty hospital bed. But best of all, he reminds us that anything is possible in theatre: not only that you can endlessly reinvent the form but that it is one of the places where a group of strangers can foregather and be reminded, while being instructed and entertained, of their common humanity. **Michael Billington**, 'Life, death and theatre as a form of holy communion', *The Guardian*, 3 July 1997

In the last painting, the seventh, there are again twelve figures gathered around a thirteenth. They are all there. The Quiet Girl from *Confirmation* is there, she's still fifteen. The Boy with the candle is there, he's kneeling with it now, because there's hardly space for everyone round the bed. The grandmother is there, and she's crying. The best friend, the man who threw up his arms when he saw the sun coming out over Jordan all those years ago is there, but he's not a year older, he throws up his arms again, he so longs to take the figure in the bed in his arms, but he knows he can't ever be sure if they are in pain or not, can you? Someone's brought the baby – the nurses must have said that it would be alright to do that. Someone asks the doctor questions, as if that could help; and the doctor says the right things – because someone has to. One woman covers her face, she really doesn't want to upset anybody – and you can never be really sure if they can hear you or not can you? Another woman sits at the foot of the bed and weeps. She has no shame, and her shoulder is bare. The Nurse is really exhausted. It's been a long shift. It could be any time between three a.m. and six-thirty, she really has no idea. She is looking at the window and she is wondering if that is really the dawn that she can see.

The twelfth figure, right on the edge of the bed, the man in the yellow robe, is me. He is reaching out with his right hand, gently, and is going to touch the back of the hand of the person on the bed. The first time that you see this painting you may think that there is so little air between his fingers and the dying hand that they are touching already.

But in fact he is waiting for an exact moment,
The moment when the nurse says
Yes I think this is it now
The moment when you lean forward and say
Go now
It's alright, go.
Go.
The moment when the breathing actually, finally, stops;
When the last breath isn't followed by a next one.

And at that moment, I promise you, no one will ask you what you are feeling.

Of course it may not actually happen like that,
It may be sudden, not everyone may be able to get there on time,
But that is the great virtue of this, the seventh painting, the last one, that whether you need to use it to remember,
Or to use it to help you imagine
What you just can't imagine,
You do know that this has happened
Or will happen to everyone who has ever seen this picture.

You do know that whenever you need it,
It will always be there

Behind a curtain.

Will you please all follow me now.

Fragment from NEIL BARTLETT,
The Seven Sacraments of Nicolas Poussin, pp. 48–49

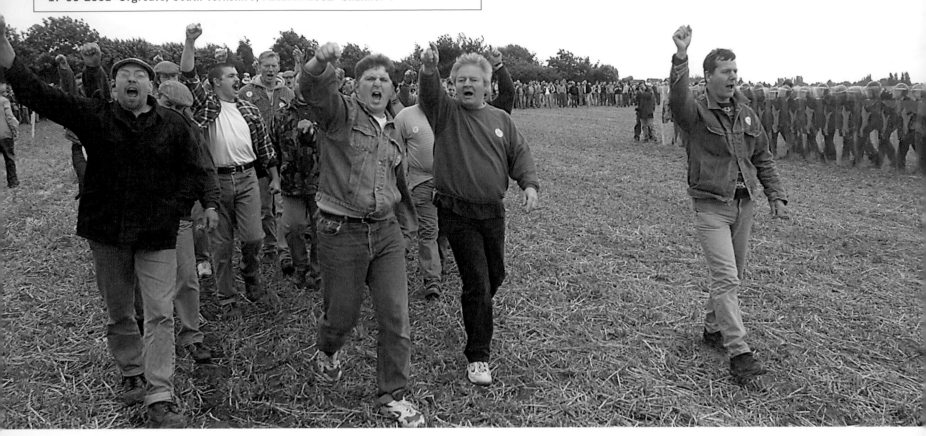

On 18 June 1984 I was watching the evening news and saw footage of a picket at the Orgreave coking plant in South Yorkshire in which thousands of men were chased up a field by mounted police. It seemed a civil war between the North and the South of the country was taking place in all but name. The image of this pursuit up the hill stuck in my mind, and for years I have wanted to find out what exactly happened on that day with a view to re-enacting or commemorating it in some way.

When I started to do proper research, the consequences of that day took on a much larger historic perspective. After over a year of archive reading, listening and interviewing many of those involved – the re-enactment finally did take place on, or as close to as possible, the original site, with over 800 participants. Many of these participants were former miners (and a few former policemen) who were reliving events from 1984 that they themselves took part in. The rest were members of Battle re-enactment societies from all over the country.

I wanted to involve members of these societies for mainly two reasons: first of all, they are well trained in recreating combat and in obeying orders. More importantly, I wanted the re-enactment of The Battle of Orgreave to become part of the lineage of decisive battles in English history.

I was also interested in the term 'living history' that is frequently used in relation to re-enactments, and I thought it would be interesting for re-enactors to work alongside veterans of a battle from recent history, who are a personification of the term.

Also, as an artist I was interested in how far an idea could be taken, especially an idea that is on the face of it a contradiction in terms "a recreation of something that was essentially chaos".

Of course I would never have undertaken the project if people locally felt it was unnecessary or in poor taste. As it was, we encountered a lot of support from the outset because there seemed to be an instinctive understanding of what the re-enactment was about.

JEREMY DELLER spring 2002

Jeremy Deller proposed his project to Artangel via the Open competition that we launched with *The Times* and the A4E National Lottery scheme. For the first time Artangel opened its doors to proposals from artists, rather than identifying projects through invitation and discussion. Some 700 ideas came in and Rachel Whiteread, Brian Eno and Richard Cork joined James Lingwood and myself to select a pair of projects to commission and produce.

Jeremy Deller's *The Battle of Orgreave* – a dangerously ambitious form of community play proposed via a short fax – was an immediate provocation. The project demanded to be realised even though it appeared impossible. It was probably this that drew us to it.

With Deller's idea, it was clear that the decoy of a film would be necessary. This would not only provide a source of finance (there was no getting away from the fact that this would be a lengthy and expensive undertaking) but it would also lend the project a certain degree of credibility. Throughout the last ten years at Artangel, we've always found that people (especially the owners of extraordinary locations) often become much more interested and much more co-operative if film or television is involved.

Jan Younghusband at Channel 4 came on board with unwavering enthusiasm and Mike Figgis, equally gripped by the scale and ambition of Deller's vision, agreed to direct the film which fast became much more than simply a means to an end.

We gave ourselves a year in which to build bridges of trust with the community of former miners in South Yorkshire and resolved to abandon the project at the first sign of hostility. They would become the cornerstone of the re-construction. It would be their memories and histories that would be re-staged.

Persuading Britain's weekend Vikings to participate was less of a problem, having enlisted expert re-enactment tactician Howard Giles onto our team.

The day itself unfolded with military precision but came across (particularly in the police cavalry charge down Highfield Lane) as though it was happening for real. Which in many ways it was – a piece of social history re-lived, not re-enacted.

MICHAEL MORRIS June 2002

[...] History is no more than a series of scraps, punctuated by fairs and feasts. But the 1984 miners' strike presents a history that's by no means settled. [...] Its political, economical and personal consequences are still keenly felt. [...]

The re-enactment follows standard practice. There's commentary throughout. The MC stresses much that this is a show, not a real battle, "that these people are all friends", that ex-miners are here playing police, and even vice versa. The mass shake of hands follows. Then there's an introductory parade-past of forces, the pickets in Eighties casuals, the policemen with their various kinds of riot gear. The film crew buzz about among them. But for all of these alienating effects, a sense of reality still keeps breaking into the evident theatre of it.

And so the confrontation begins Authentic taunts and chants from the pickets. "The Miners United – Will Never Be Defeated." "Maggie Maggie Maggie – Out Out Out." A picket ironically inspects the ranks of coppers. Some stones are lobbed. A perspex barricade of riot shields forms, dogs defending its flanks. The pickets pile in and push – are pushed back. Then the barricade opens, and the first mounted police charge comes through, driving the pickets right up the field. Cries from watching crowd: "you bastards, bastards, fascists". A woman shouts: "They didn't trot, they galloped!" The cavalry withdraws, and the snatch squads with shields run out for some truncheoning and arrests. Drumming of shields. The police line advances. [...]

This Battle of Orgreave re-enactment was a one-off. But it allows you to imagine a situation where [...] the battles of Orgreave or Grosvenor Square, the Brixton or Poll Tax riots, Bloody Sunday even, become standards of the re-enactment repertoire. It couldn't happen, but what if? It would be intolerable – for the present. But at what point in the future would it cease to be intolerable?

Tom Lubbock, 'When history repeats itself too soon', *The Independent*, 19 June 2001

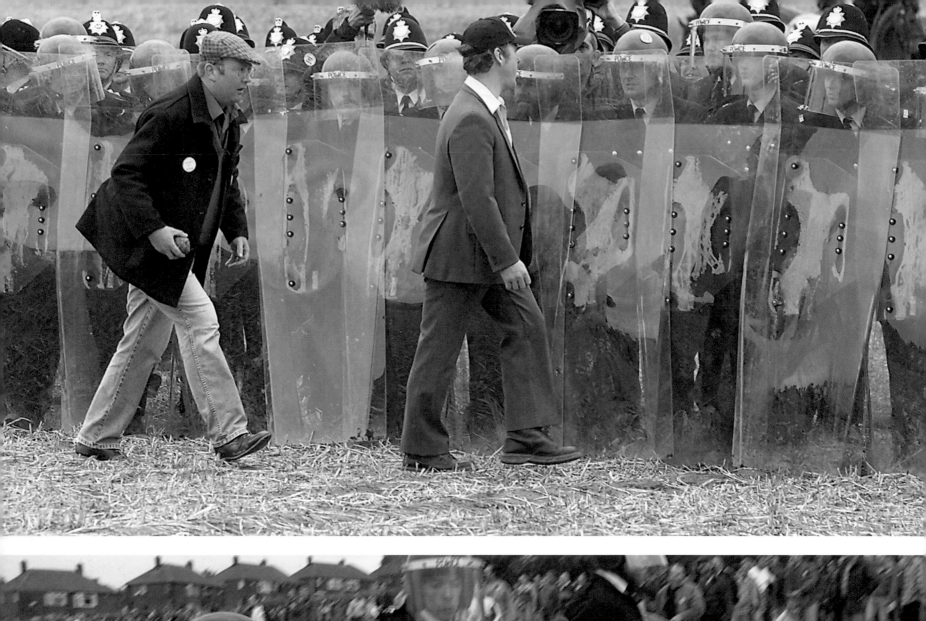

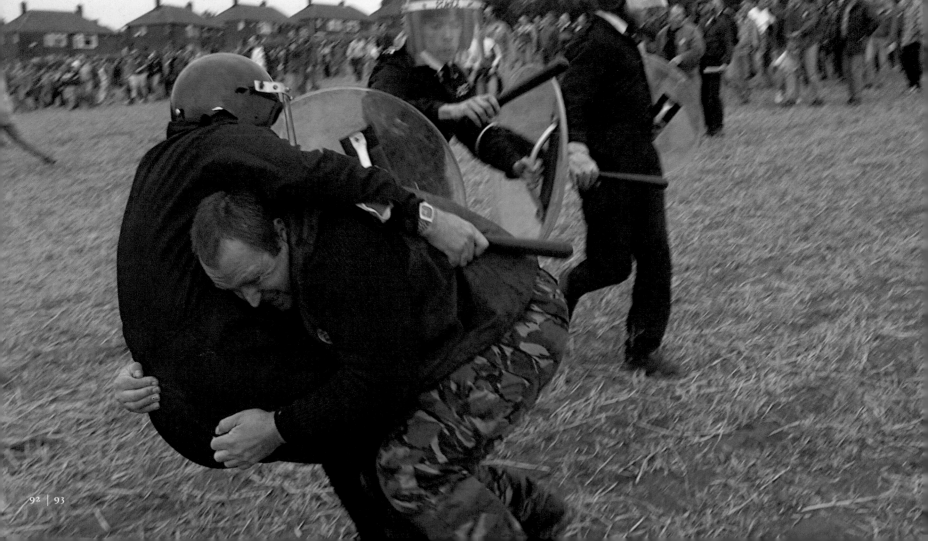

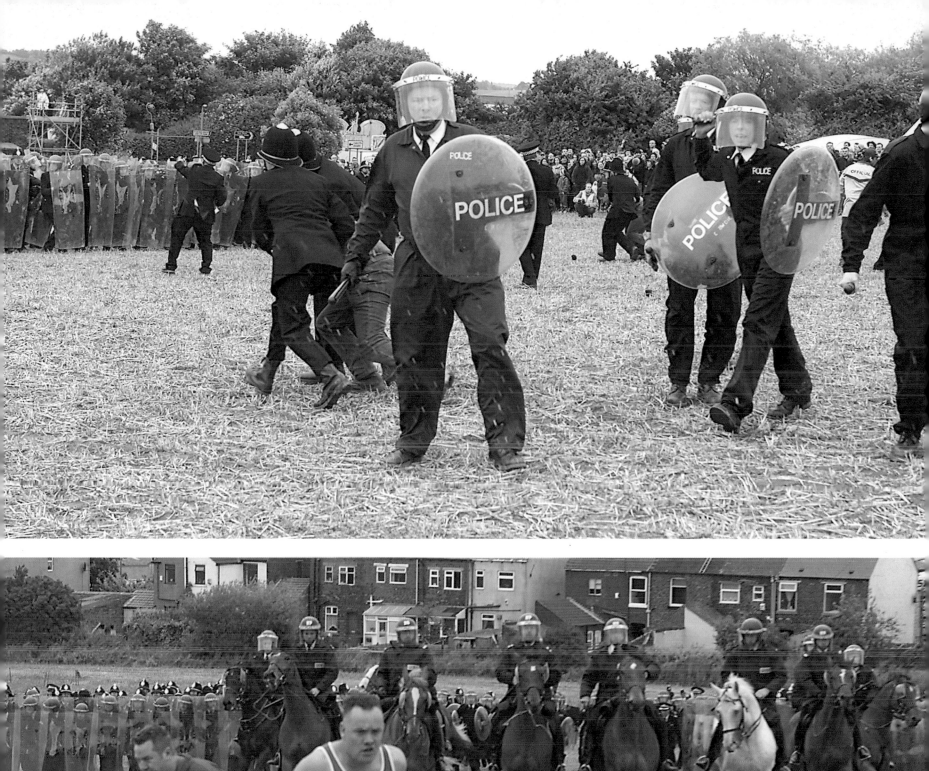
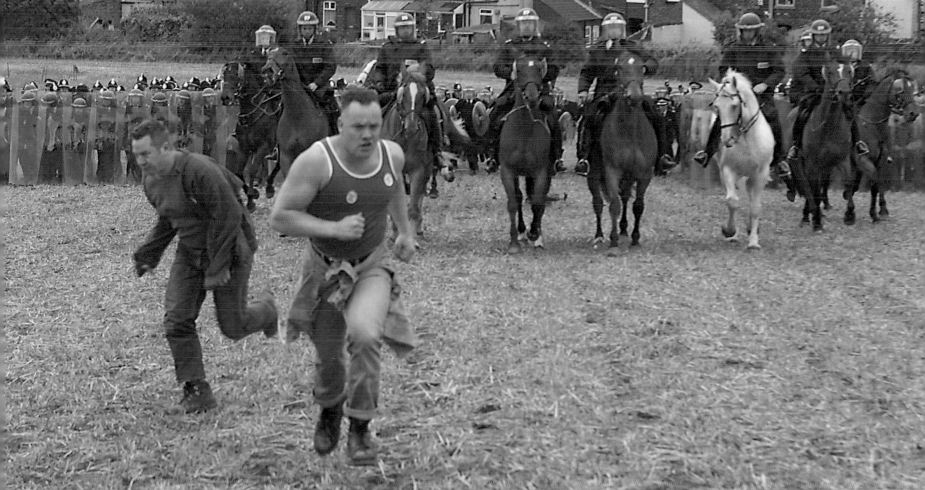

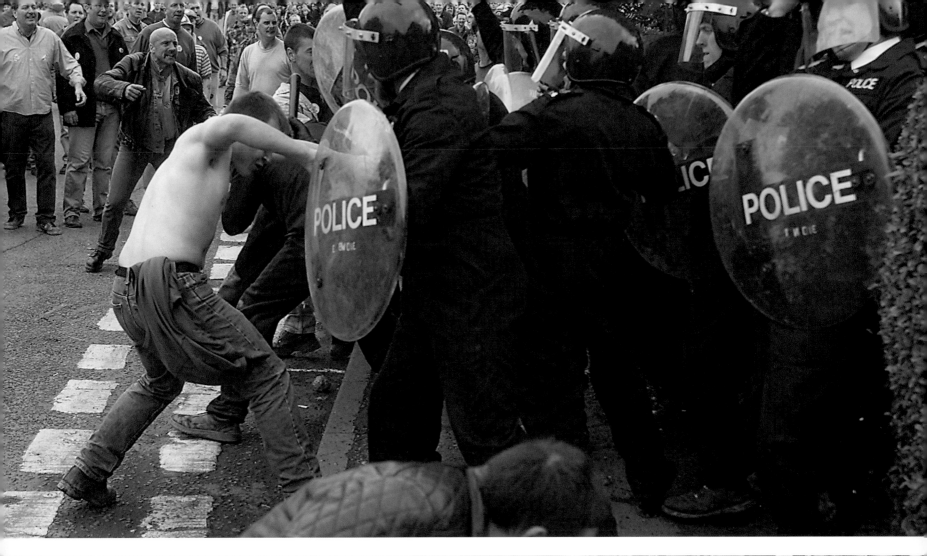

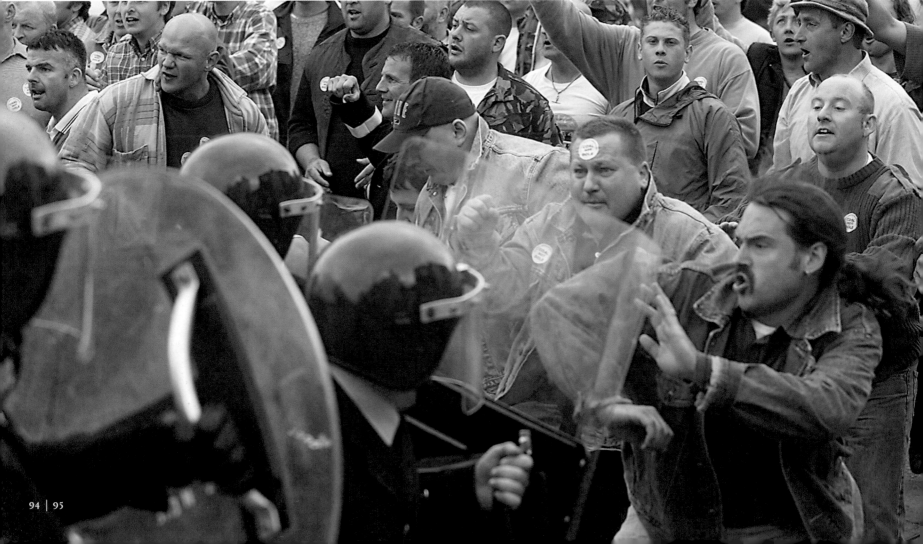

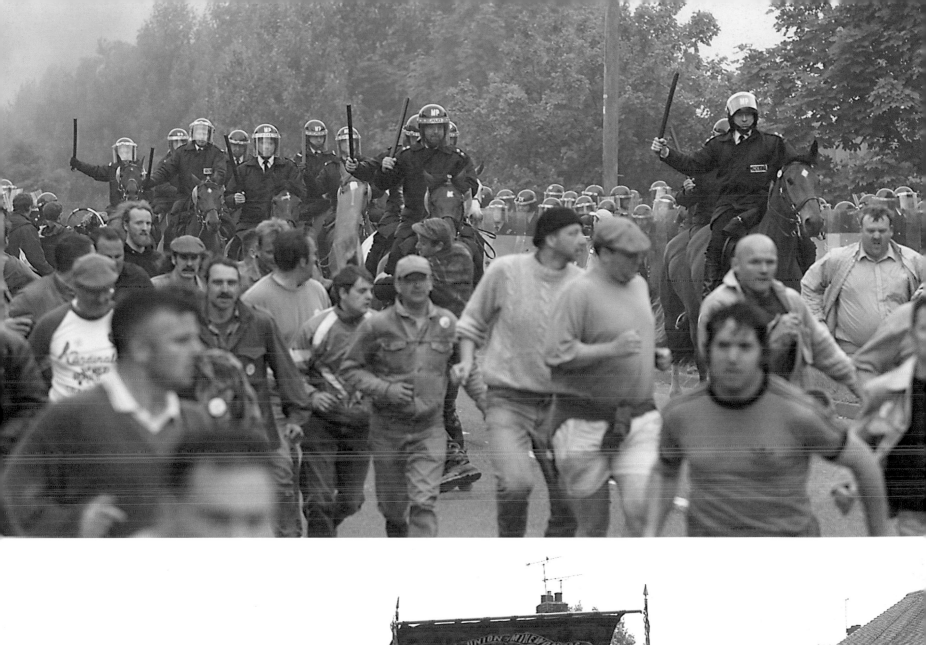

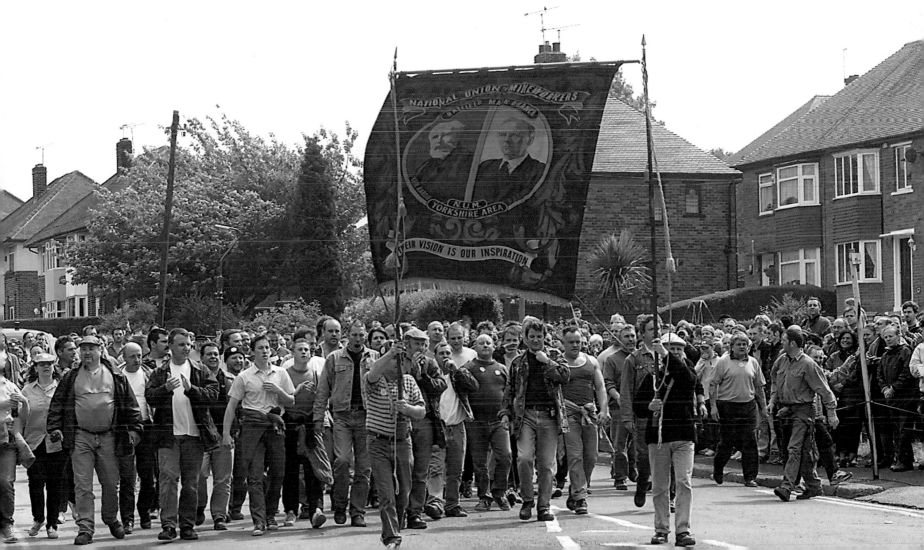

When I was invited by Artangel to participate in the show 'Doubletake' in 1992 I walked through the city, looking for a site for the installation of a sculpture, or an idea for a sculpture. Normally the place – the situation – gives me the idea for sculptures. London is a big capital with a long history, and therefore you find in the streets, on the squares, at houses, bridges and churches a lot of sculptures, which are telling you stories about this history.

It was in vain, looking for an empty spot. I got the impression that every square-foot was occupied. I didn't want to add another sculpture to this crowd of storytellers.

When I came to the River Thames, I was glad to find this huge and silent space, maybe the only 'empty' space of this size in this town – except for the parks.

This 'natural square' or 'natural avenue' immediately inspired me. When I decided to put a sculpture of a human figure (on a buoy) in the river, I didn't think of telling a story again – I just wanted to create a relation between the sculpture and the river. Maybe also between the river and me. An important point is the scale. I didn't want to make a monumental piece in the physical sense. It may be monumental by the 'smallness' of the sculpture in relation to the river, in relation to nature. The big head on the Blackfriars' Bridge isn't really big when you see it from far away. It is a small head in relation to the whole situation, in relation to the architecture around.

I was surprised by the reactions to my sculptures, especially to the buoy piece. Many people called the river police, telling them that someone was standing on the buoy

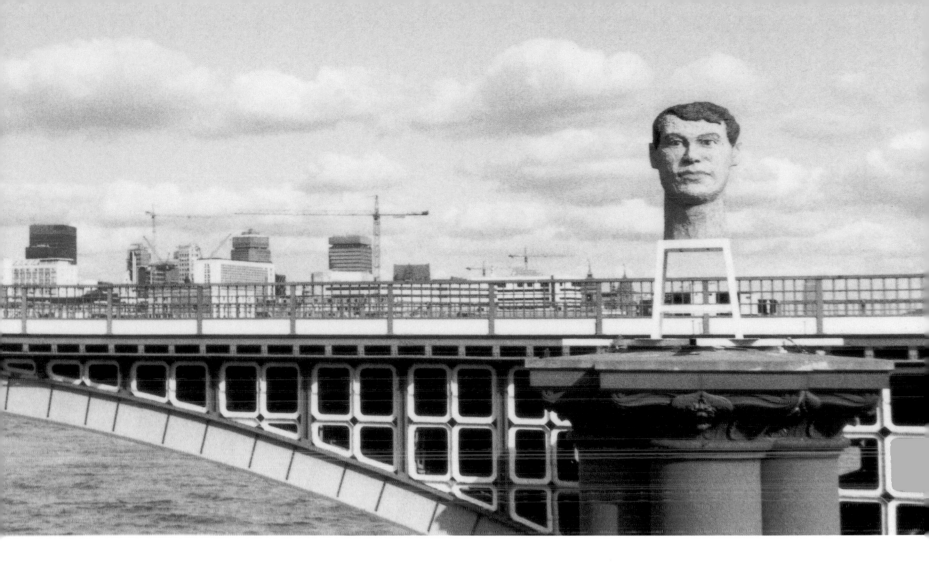

and that he had asked for rescue. Although the figure could have been identified clearly as a sculpture, I think people didn't want to accept what they saw. They were asking for a story, for a meaning just as all the monuments in London have a meaning. They immediately gave nicknames to the big head. And they invented a story, or different stories for the lonesome man on the buoy. Maybe your mind doesn't allow meaninglessness This irritation may be a necessary part of the game: the vacuum is a challenge which makes you go further.

STEPHAN BALKENHOL March 2002

Stephan Balkenhol's two sculptures for the River Thames came about through a collaboration with the Hayward Gallery in relation to one of their exhibitions called 'Doubletake', which took as its starting point the idea of collective memory as expressed in contemporary art. Both Stephan and Juan Muñoz were invited to consider the possibility of realising temporary monuments or memorials in the vicinity of the South Bank Centre as a way of reflecting on the relationship between the monument and memory in the modern metropolis.

Stephan realised two projects. One was *Head of A Man*, a large wooden sculpture, which stood on top of a pier next to Blackfriars' Bridge. The other one was a sculpture called *Figure On A Buoy* moored in the River Thames between Hungerford Bridge and Waterloo Bridge. Bobbing up and down, the mobility of the sculpture posed questions about the relationship between stability

and fixed meaning, or permanence. Permission from the Port of London Authority was secured – buoys are in mapped positions because of navigational channels. The sculpture was installed. Then the press got hold of it. There appeared to have been a deluge of people either contacting various authorities, some of whom just reporting the existence of this alien object, some complaining, some reporting that there was a figure drowning, or a figure waving The police were impatient because of the number of calls they were getting. We managed to persuade them that after the first couple of weeks, the media attention would die down. But a few days after the last discussions with the police and the Port of London Authority some have-a-go hero dived off a river cruiser to rescue the sculpture, and of course then he had to be rescued, at which point we were compelled to make its status a little less ambiguous. It was relocated onto a kind of pontoon. The original idea of the work was predicated on its vulnerability – this figure out there in the middle of the river – and its mobility. It didn't look right away from its buoy, and we agreed to take it down. JAMES LINGWOOD May 2002

There he stands in his white shirt, unruffled by the breeze, hands hanging limp by his sides, gazing upstream. He rises and falls on the tide, through a long watch. Lighters, launches and barges, pilots and pleasure boats pass him by. Strollers on the bank point him out. Tourists take his photograph. He seems both watchful and oblivious, a man transfixed. Downpours and river mists, gales and frosts do not deter him. Brown fogs of winter dawns drifting into lilac-time; and then, one fine day, he's gone.

He is no mariner, floating there on his pontoon. In his white shirt he looks more like a stranded waiter. When he first appeared he was perched on a buoy, but the river police moved him on. People kept calling the cops about the bloke in the river. Someone decided to attempt a rescue, and dived in. So they gave him a pontoon, where he stands erect, raised on the floating dais. [...]

Adrian Searle, 'Not Waving, Not Drowning', *frieze*, April–May 1992, p. 18

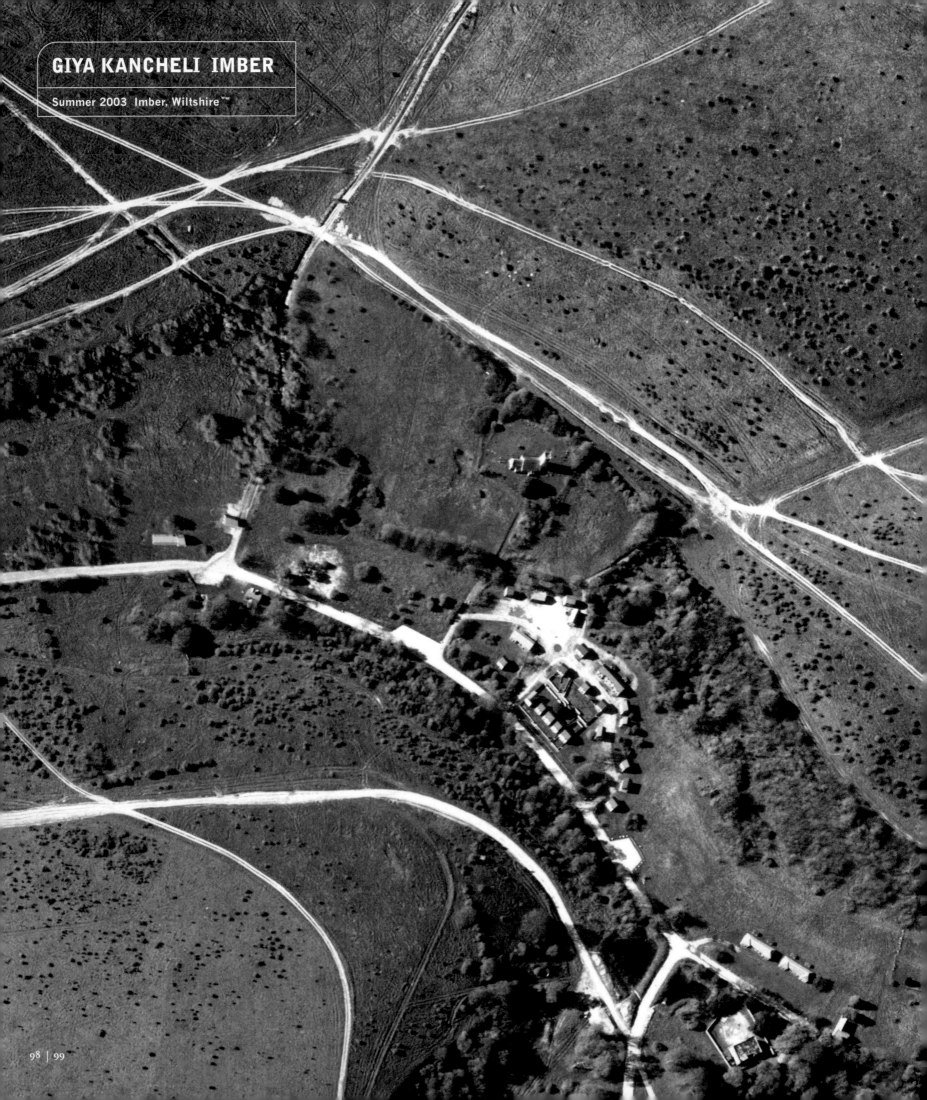

Until 1943, Imber was a lively – if a little remote – rural community in Wiltshire. With scarcely a few weeks' notice the population of a few hundred was told it would have to move out by the village's landlords – the army.

The army has always claimed that Imber was a declining community, five miles from the nearest other human settlement. But for those who lived there, Imber was home: a village with a church, four farms, a blacksmith, two big houses, about 40 cottages and newly-built council houses.

Most of Imber's inhabitants had lived there for centuries and the idea of abandoning their homes came as a terrible shock. The village was situated on the western side of Salisbury Plain, an area that had been increasingly used by the army for military training. In 1943, Imber stood in the way of military manoeuvres deemed essential to the war effort. The Americans needed space to prepare for D-Day. Most villagers accepted their fate as a contribution to the Allied victory.

Those evicted were told that they would be able to return after the war, but following the defeat of the Germans and Japanese, they were unable to do so, and were told that they would have to wait for a decision. The village remained empty.

Some of the villagers started new lives far away, while others stayed close by in the hope of returning. This dragged on until the late 1950s when public protests led to an official enquiry, chaired by the Secretary for War, John Profumo. The protesters were supported by Sir John Betjeman who sent a message: "Success to your campaign! Wiltshire and the rolling downs forever! God save Imber!" But even Betjeman's plea left the Ministry of War unmoved.

By this stage, much of Imber had deteriorated, and the army's need for undisturbed firing ranges and tank practice ground had increased. The dream of a return to Imber was never to be fulfilled, and the village remained abandoned, and subject to the decay of passing years and destruction wrought by army shelling and infantry manoeuvres.

If you go to Imber today, only the Church and a few other buildings remain, all of them in various stages approaching ruin. Almost all sense of human habitation has vanished. The army has constructed Lego-style houses out of breezeblocks – all of them bare shells, with only openings for doors and windows. The houses have been placed – bizarrely – along the course of the village's former lanes, the whole fake village laid out to facilitate the practice of urban infantry warfare. The breezeblock structures, bombed and re-constructed on a regular basis, bear the signs POST OFFICE; JOB CENTRE; THE ANGEL INN.

Once a year – the third Saturday in September – surviving inhabitants of the village (now less than ten in number) are allowed to return for a service in St Giles

church – the only place on Salisbury Plain not owned by the military – and to tend family graves.

MARK KIDEL Director of *Imber* film, spring 2002

I first heard the Imber story from Helen Marriage, then Director of the Salisbury Festival, during our project with Graeme Miller and Mary Lemley in 1994. It immediately felt like fertile ground for an Artangel commission. We rarely begin thinking about a project without an artist at the table, but this one grew in the imagination for a further five years. Until Simon McBurney played me *Mourned by the Wind* and suggested it for the opening of *The Vertical Line* underneath Aldwych Station in 1999.

It was a fragment of music by Giya Kancheli, who I learned was a Georgian composer now living and working in Antwerp. Listening to more of Kancheli's haunting music brought Imber to mind all over again.

We invited the composer to visit Salisbury Plain with filmmaker Mark Kidel, believing that an Artangel Media film might grow out of this project as it had with *Because I Sing* and *The Battle of Orgreave*, both in pre-production at the time.

Kancheli, drawn to a story that evokes themes of memory and displacement, wandered around the abandoned village clutching a short wave radio through which crackled (along with the gunfire on the Plain) the voice of Boris Yeltsin on Radio Liberty. Giya doesn't speak any English at all but his daughter Natalie was able to convey how much Imber brought to mind a monastic mountain community outside Tbilisi that had undergone a similar transformation at the hand of Soviet forces. Some months later, Mark and I accompanied Giya to David Garedji Monastery, which he visited many times as a child. Hundreds of miles from Wiltshire, the similarities of landscape and circumstance were indeed uncanny.

Imber once again plunged Artangel into uncharted territory with the Diocese of Wiltshire and the Ministry of Defence as unexpected partners in an event to re-address notions of community and the meaning of place.

MICHAEL MORRIS June 2002

NAVIGATION

MAPPING WITH LATITUDE

Joe Kerr

That which changes our way of seeing the street is more important than that which changes our way of seeing a painting.

GUY DEBORD, inaugural meeting of the Situationist International, 1957

Mapping a route through the city depends not only on the intended destination, but also on the purpose of the journey. When routinely travelling to a predetermined destination, navigation is largely an unconscious act, in which the means is wholly subservient to the end. To accomplish such a journey requires a certain kind of fixed knowledge, acquired only with practice, patience and memory, and the ownership of such knowledge implies a certain control over the city. But contemporary discourses on the city emphasise a different and less quantifiable form of urban understanding, concerned more with the process of travelling than its purpose, and predicated on subjective systems of navigation that defy inscription through conventional mapping techniques.

Le Corbusier contemptuously dismissed the arbitrary, rambling street plans of pre-industrial cities as the "way of the donkey", while the new grids and broad thoroughfares of the modern city represented "the way of man". Today the superiority of one way over the other is far less clear; indeed the meandering bridle-paths buried beneath the modern city seem rather analogous to the kinds of subjective navigation that interest certain contemporary artists. This essay considers these contrasting perceptions of urban knowledge, and then examines the idea of navigation as an artistic practice in the work of several artists who have devised and implemented alternative strategies for mapping and moving through the city.

The great Modernist project of the city was at its heart concerned with bringing clarity, order and legibility to the chaotic mass and muddle of the teeming metropolis. It sought to remove ambiguity and conflict from the spaces simultaneously inhabited by the objects and subjects of urban life. Through the medium of the plan, the intricate mechanisms and rituals of industrial society were exposed and regulated, creating the seductive illusion that the whole construct of the city could be encapsulated in a diagram that was decipherable and hence *knowable*.

This desire to reduce the urban terrain to a comprehensible form has been expressed with a particular clarity in London, no doubt because in every other respect it confounds the modernist paradigm, a city that has struggled for the last two centuries to resist the creeping confusion and indeterminacy that uncontrolled growth and haphazard reconstruction have brought. Given that all attempts to recast London on modern lines have come to nothing, the alternative has been to reorder the city in symbolic, diagrammatic form. We are justly proud of the extraordinary cartographic achievements that make it possible to comprehend, and thus negotiate, its bewildering inconsistencies and illogicalities. Beck's

underground map of 1931 is justly celebrated for redrawing the tangle of sub-
terranean lines that arbitrarily and unequally section the city above with the
rationality and discipline of a technical diagram, of the kind an electrician or a
car mechanic might use. An even more impressive product of this conquest by
abstraction is the London A-Z, that has effectively reduced the whole, unwieldy
mass of the metropolis to the size of a pocket book. Its densely printed pages
can reliably guide one to any point across the city, courtesy of the miraculous
transmutation of the physical landscape into a simple notation of lines and letters,
each square like a pictogram in a universally understood Esperanto.

A mental map of the city that is sufficient to permit navigation without constant
reference to the A-Z, and that is built up patiently through years of daily skir-
mishes with the traffic-clogged streets of the capital, is a treasured possession
for Londoners, a personal indicator of social superiority, as Ian Parker has
brilliantly described:

"London's congestion and fury has a possible compensation – and this is the
chance to swagger, to take credit for technique and local expertise. Because the
roads are complicated and full, because 140,000 people come in to the centre of
London by car every morning, because accident rates are way above the national
average, a journey well-executed can be paraded as a kind of athletic success.
London drivers prize exquisite rat-runs behind Harrods, as they do a magical
Covent Garden parking space, or a neat, anticipatory lane change in the
Wandsworth one-way system. If you are driving into the West End on the Westway,
there comes a point where you must decide whether to stay with the flyover, or
swoop down through Paddington. If you leave the road unnecessarily, you have
tossed away a rare minute or two of romantic, Americanized motoring. But if
you stay and hit a jam, you will be unhappy, because escape is impossible
Driving in at speed, you must choose Paddington or not-Paddington. But you
cannot see if there is a queue ahead until you are almost upon the slip road.
You have a second, or maybe less, to react; and – if things go well – the rest
of the day to feel shamefully victorious."[1]

Driving in the vanguard of this daily struggle between Londoners and London
is an unlikely hero, the London 'cabbie'. The black cab driver is the measure
against which to gauge one's own grasp of the complex puzzle of the London
street map. Other citizens can only marvel at the extraordinary self-sacrifices
which trainee cabbies willingly make in order to be initiated into that elite fellow-
ship of the 'knowledge'; surrendering every Sunday to the gruelling task of
learning every conceivable destination and the best routes to it, and every elusive
cut-through and tortuous back-double, armed only with a clipboard and a scooter.

Yet in reality the taxi driver is only an abstract hero, for in person the ordinary
cabbie is habitually vilified as a villain in the drama of the modern city, the person-
ification of the intolerance and antagonism that haunts the dream of the liberal-
minded citizen. Universally type-cast as reactionary right-wingers, and the bane

of more cultured and considerate motorists, the cabbie epitomises the person who, in knowing everything about the city, understands nothing. And herein lies the central paradox of this impossible desire to master the city through comprehensive knowledge: for the 'knowledge' is equally its opposite. By reducing our comprehension of the city to its physical shape, we cast aside what we might actually desire to know most. The loss of complexity that the map requires, actually means loss of understanding when the diagram is overlaid on its purported subject, and our ability to navigate with ease through the city's streets means that we no longer inhabit them in any significant sense. It is this simultaneous state of comprehension and incomprehension, symbolised here by the heroic / anti-heroic figure of the taxi driver, but shared more dangerously by developers, planners, and politicians alike, that is the pervasive legacy of Modernism.

If the multiplicity of Post-modern critiques of the modernist city share one thing in common, it is the desire to confound the misguided dream of rendering the city comprehensible. However, the problem then arises of exactly what kind of understanding can possibly replace this illusory logic of the city. For given that it is the false unity offered by modernist meta-narratives of the city that has been challenged, it follows that it cannot be replaced with just another imposition of an artificial semblance of clarity. And as it is the very legibility of the city that has been rejected, then the only tenable course is to accept and embrace an urbanism of complexity and disorder.

For anyone in a position of control and authority within the city, this is clearly not a feasible position to hold, which is why artists who are not in the service of the urban authorities have a crucial role to play in articulating effective strategies of resistance to the dominant codes of urbanism. For many contemporary artists the challenge has been to formulate new strategies of navigation to overcome the limitations of the conventional linear map. Narrative structures and sequences, however defined or constructed, have become the companions and guides for their urban traverses, and have determined the ways in which those journeys have been documented and disseminated.

In the case of the artists whose work is considered below, mapping is of prime importance to their modes of navigation; their work travels predetermined routes that can be – indeed must be – followed (not necessarily literally) by their audience. But they do not produce diagrammatic maps that reproduce only the information that is necessary to make the journey. Instead, it is the addition of information rather than its subtraction that gives meaning and use to their maps. They record what changes rather than what remains constant, and their respective mappings of the complexity and confusion of city life are not predicated on the desire to impose any kind of logic or understanding on it.

Richard Wentworth has obsessively documented twenty-five years of constant journeying along the Caledonian Road. Taken as a whole, his huge collection of images represents an archive of the everyday that documents the constant processes of change, decay and appropriation that have characterised the economy of this bedraggled and unimpressive street. But when Wentworth sorts and organises these images into the narrative of an exhibition or a lecture, they become a record of his personal navigations of this highly specific terrain. In this form, they constitute a particular kind of mapping of this routine journey, but clearly this map offers little in the way of direction to anyone outside of his particular audience.

Given that his route is a simple and predetermined one from which there is little significant deviation, it is evident that Wentworth is not concerned with the act of navigation as a means to an end. Instead, he is more interested in the kinds of incidental choices that inflect or deflect the unconscious routines of a repetitive journey. Of course the A-Z map can indicate the basic parameters of such a straightforward route, but it cannot suggest or describe the detailed decision-making that is necessary to actually accomplish it:

"Our habits of movement within cities are very telling – they may not be consistent but they are full of patterns based in accumulated choice and necessity. They contain preferred routes, whose whim may hinge on 'the sunny side of the street' or an expectation of things or people to see or to avoid. The 'accident of where I live' presents me with one very specific option – a run of nearly a mile on a single road whose various characteristics combine under the one heading, 'the Cally'.... As to why the Cally means something to me, I'm one of those people who lives somewhere where I would never turn left outside my house, and that means I come down here. We all have those habits of bias."[2]

So there is this extra layer of "habits of movement" that he imposes on the familiar map of the area. But this new stratum of navigational information is not what Wentworth is actually mapping in his images of the journey, it merely precisely prescribes the route that takes him past the objects and incidents that hold his attention. And it is the serial repetition of the journey past the same places and people that allows him to record the tiny variations and interventions that constitute a continuous record of human occupation. For although the physical fabric of the city is in a constant cycle of change, this process is slow and pre-dictable enough to make it worth mapping. However, if the ambition is to repre-sent the patterns and traces left by people rather than the buildings they occupy, then every single act of recording will be unique, and also useless as a map of any-thing that can actually be followed through the city. But this perhaps is one clue to the logic of Wentworth's mapping; namely that there is an inverse relationship between the solidity of things and their actual value and interest to us as citizens.

With the right-brained logic of an artist rather than a cartographer, Wentworth is delighted to discern patterns in the urban landscape that are not based on

topography or geography, but rather on the movement and flow of objects and people: "I like my working process to be like the one which arranges the world anyway: the one which parks the cars so that they seem to have a kind of defined order about them, although you know there's no one out there with a peaked cap saying where they should be I am intrigued by all those practices which are actually world forming, and which in turn we respond to – how cars are parked affects how you are as a pedestrian – all those kind of essentially urban conversations between people and objects."[3]

Thus for Wentworth, navigation is a personal negotiation through the singular situations that confront him every time he retraces his familiar route. His images record not only his observations of the daily life of the Cally, but equally his interventions in that life. However, the addition of this body of ephemeral data to the familiar map of his environs is matched by the crucial omission of other, more substantive data, namely the map itself. For his images remain inert and lifeless until he marshals them into a coherent narrative, and only then do they start to resemble a navigational guide to an actual journey.

But the superimposition of other kinds of information onto the sparse line drawing of a map is not intended merely to flesh out that diagram into something that more accurately represents the place it is intended to depict; for that would imply that it represents a more complete understanding, a more sophisticated knowing of that place, and that is certainly not Wentworth's ambition. In fact the opportunity that this repetitive journeying provides to explore and to examine more closely this single fragment of a London street has a very different outcome: it serves to render the seemingly familiar shockingly and emphatically strange. The success of Wentworth's project lies in its ability to evoke the strangeness and surprise of the taken-for-granted minutiae of urban life, and in so doing it exposes the delusion of ever hoping to know the city at all.

For Wentworth, the narrowly defined territory of the Cally Road seems to serve as a prism through which he can observe the whole life of the city. In Rachel Lichtenstein's mapping of Whitechapel, there is an even tighter focus; for her explorations of this evocative but bedraggled territory originally emanated from a single room. The story of David Rodinsky, the reclusive Jewish scholar who mysteriously disappeared one day in 1969 from his room in the former Princelet Street Synagogue, became widely known following the reopening of his former lodgings in 1980. However, of the various writers and historians who were attracted to this mysterious space, none pursued their interest as zealously as Lichtenstein, who eventually assumed Rodinsky's former position as caretaker of the synagogue. From here she embarked on an exhaustive exploration of the surrounding streets, and eventually became a tour guide to the area.

Rodinsky's Whitechapel offers a précis of that local knowledge, in the form of a walking map of this area, annotated with a commentary that highlights certain buildings and quotes from the recollections of older and former residents. On the face of it, this seems little different from the standard local history pamphlet that one might expect to pick up at the nearby library. But Lichtenstein's text would soon frustrate the ordinary tourist, for it seems to offer a highly arbitrary selection of often undistinguished buildings, whilst wilfully ignoring many more obvious local landmarks. But a closer reading of the text reveals that this is actually a mapping of sites of significance for two different lives – Rodinsky's and the author's – that have a common reference point in the history of the now dispersed Jewish community that formerly occupied this area. Lichtenstein's map is as much a navigation of the past as the present, guiding the walker through an accumulation of memories in order to briefly evoke extinct patterns of life, whose traces can barely be read in the physical evidence of the contemporary landscape. Mapping layers of time in this way challenges the reductive formulas of conventional cartography, but more than that it turns the logic of mapping on its head: for it is not a guide to what can be found, but to what has been lost.

Rachel Lichtenstein / Iain Sinclair,
Rodinsky's Whitechapel, 1999

For Richard Wentworth the narrative device that underpins his Cally project is imposed by external circumstances; the need to make a simple journey to and from his home. It is not a journey many other people are likely to undertake, and that is not the point. His audience participate in his journey only to the extent that they are witnesses to his depiction of it. In one sense they have not been exposed to a detailed representation of a physical place at all; they have instead observed the mapping of a particular sensibility that in theory could equally be applied to any other area of London.

In the case of Janet Cardiff's project *The Missing Voice (case study b)* the relationship between author and audience is wholly different, despite a sense of parallel concerns between the two artists' work. Cardiff's piece, an audio-walk through a small area of the inner East End around the Whitechapel Library, provides the walker with a detailed set of navigational instructions, sufficient for them to follow every step of the prescribed route. It is thus a form of mapping, in which the artist's voice, and the recording of her footsteps on the same route, provide the equivalent notation to the lines and symbols of a drawn map. The walker plunges into potentially unknown territory, surrendering themselves to the instructions provided by Cardiff, and obliged to rely on her as much as they would on any normal street map.

But as with Wentworth's journey, it is not the physical terrain that is actually being charted. For Cardiff's narrative does not merely describe the route or the things that are being passed. Although the listener also hears the sound of traffic and voices evidently recorded at the places they are passing, interspersed

Janet Cardiff, *The Missing Voice*
(case study b), 1999–present

with these located sounds are also strands of disembodied fictional narratives spoken by different voices, that drift in and out of this layered texture of sound. In effect, it is the mental space of the artist that is being delineated, that space of thought and reverie that expands beyond the physical space we occupy as we walk through the city, when our minds are only tangentially engaged with the physical environs we are traversing.

At least that is, the walker might surmise that the sounds they hear bear some relation to the artist's thoughts when she herself made the walk, but the multiple narratives are confusing and inexplicable. Accents and music that are recognised as belonging to *film noir* intrude on their attempts to follow the route, and the walker can only guess at their origin. Do they allude to prior events that are beyond the reach of the walker, or have they infiltrated the space of their walk from the thriller they were invited to pick up back in the library where their journey started? The walker has become an unwitting participant, conspirator even, in a drama they scarcely comprehend. And yet through all of this Cardiff's voice continues to guide and to reassure, talking as if she were a companion walking alongside.

The walker becomes aware that they have been led into a paradoxical encounter with the city, for they are receiving conflicting strands of data that cannot be easily reconciled. Thus while they are physically immersed in the city, they have also been placed at a distance to it by the headphones they are obliged to wear. Moreover, the ambient sounds that they would normally expect to hear have been substituted for by the sounds that are being played to them, some of which are familiar and in accordance with their immediate location, while others are clearly discordant with this or any other perceivable context. But more disturbing is the ambivalent relationship between the walker and their guide. A fiction is played out that Cardiff is walking alongside or ahead of them, yet actually she has intruded on the internal space of the walker's imagination. As Cardiff says:

"*The Missing Voice* was partly a response to living in a large city like London for a while, reading about its history in quiet libraries, seeing newspaper headlines as I walked by the news stands, overhearing gossip, and being a lone person getting lost amongst the masses I was trying to relate to the listener, the stream of consciousness scenarios that I invent all of the time in my mind as I see someone pass or walk down a dark alley."[4]

Being forced to participate in her reverie means that the walker's own has been excluded; there is no space left for the thoughts and dreams that they might otherwise indulge in. Once more, the addition of new layers of information to the map that they are following has entailed an equivalent subtraction. Cardiff has taken a simple and familiar navigational aid, the audio tour, but has removed it from its normal context of gallery or museum. But given that it is also not a conventional tour of the territory it traverses, the inference is that the city itself has

been constituted as a space of display and reflection comparable to those more bounded spaces. Whilst one moves through defined spaces, it is the city generally that is being offered up for inspection, and introspection.

Wentworth, Lichtenstein and Cardiff incite their audiences into acts of non-compliance with the accepted codes and practices of urban mapping and navigation. They do not offer conventional or quantifiable benefits as inducements to participate. There is no obvious accumulation of empirical knowledge, and while new layers of subjective interpretation are added to their mappings, potentially valuable objective information is simultaneously subtracted. They reject the conventional view of navigation as an act of discovery, for they tread well-worn paths, and everything they offer up for consideration is already on display. Instead they impose a new frame on our view of familiar places and situations, that in Debord's phrase "changes our way of seeing the street".

The projects described are descriptive of a model of urban navigation and are not precise guides to actual places. Specificity of place is determined through authorship, yet it seems obvious that this work could develop elsewhere: the patterns of behaviour and occupation traced by Wentworth are observable in locations across London, whilst Cardiff barely names the things she invites you to observe and enter.

The desire to map the city is intrinsically linked to the desire to control it through knowledge. These projects serve to expose the pointlessness of that ambition by complicating their representations of the city, rather than abstracting them. We can't use their itineraries to explore what we don't yet know, nor even to illuminate the already familiar. For each new act of navigation we undertake erases traces of the previous one, leaving us perpetually on the verge of discovery, as we simultaneously abandon the places we have only just come to know.

1 Ian Parker, 'Traffic' in *London: the lives of the city*,
Granta 65, spring 1999, p. 12
2 Richard Wentworth, '"The Accident of Where I Live" –
Journeys on the Caledonian Road' in Borden, Kerr, Rendell,
(eds.), *The Unknown City: Contesting Architecture and Social
Space*, Cambridge, Mass.: MIT Press, 2000, pp. 389–393
3 Ibid., p. 389
4 Janet Cardiff, *The Missing Voice (case study b)*,
London: Artangel, 1999, p. 66

In 1998 Artangel contacted me for their new series of commissions, 'innerCity'. They knew about the book *Rodinsky's Room* I was writing in collaboration with Iain Sinclair and we began discussions on a project based around this story. Over a number of months we devised an artist's guidebook called *Rodinsky's Whitechapel*. For me it was a fantasy project, working with people who encouraged and supported me to combine my skills and experience as a writer, artist, researcher and tour guide of the Jewish East End. I especially enjoyed working with the designer, Mark Diaper, who sensitively translated my ideas into a truly beautiful product. The resulting book, which fits neatly into the palm of your hand, is designed to take the reader on a personal tour inside the geography of the Rodinsky story. The map inside the front cover marks out a circular route that crosses paths with my own walks, my family history and the remnants of the Jewish East End. You visit places like Rossi's Café where Rodinsky played the spoons and my grandfather's former jewellery shop in New Road, now an abandoned Kebab house. The final stop on the tour is Elfes Stone Masons, one of the only functioning Jewish businesses still left on Brick Lane.

Early in our discussions I suggested that we should put Rodinsky's headstone in the budget for our project. We laughed at the time, aware it would be the only piece of permanent work Artangel had ever commissioned.

But a few days later Michael Morris called, saying he thought it was imperative that the headstone should be laid. I was introduced to one of Artangel's patrons or 'Angels'. We met once, briefly, in a West End club. I told him Rodinsky's story and how I had tracked down his pauper's grave in Waltham Abbey Cemetery. He told me he was from an orthodox Jewish background and at the end of our conversation said, "it will be a great *mitzvah* (good deed) to pay for the tombstone of this lonely *tzaddick* (righteous individual)".

I chose an appropriate stone at Elfes Stone Masons and throughout the month of June 1999, they kindly allowed people into their showroom to see the headstone before it was finally laid to rest. My project was completed with a private consecration service for David Rodinsky.

The consecration service was one of the most memorable and important days in my life. I could not have imagined when I began my discussions with Artangel over a year previously that this is how the project would end. I think Artangel's involvement in this project shows extreme bravery, vision and something that you rarely find in contemporary life, never mind the contemporary art scene, that is *Neshama*, soul.

RACHEL LICHTENSTEIN 6 March 2002

Michael Morris was very confident, it was his area of expertise – accessing secret spaces, granting them fresh and unexpected narratives. Brokering tentative relationships between artists (ego, doubt, megalomaniacal expectations) and property owners, civil servants, politicians (suspicious, slippery, what's-in-it-for-us?). The former synagogue at 19 Princelet Street, Spitalfields, defeated him. Defeated us all. It had its own inviolate agenda.

Artangel understood the pitfalls, expected them, enjoyed them. The impossible was their starting point. The meeting like a conference of disputing mafiosi. The follow-up phone-calls. The event. The backlash. Impresarios of the imagination haunt the purlieus of the city in direct competition with developers, retail estate pirates. They practise the same black arts. They are rivals. They operate like psychics; mediums tapping erased myths, searching out the room, the tunnel, the arch, the vault, the municipal swimming pool, still squatted by a legion of unoptioned ghosts. The thing that exists to be exploited.

My obsession was always with the set, the fabric. The mystery of a cold garret heaped with the rubbish of a lost life. It took Rachel Lichtenstein to go beyond the trappings of Gothic fiction, to recover the footfalls of a real man, a living, breathing human. She disclosed David Rodinsky's extraordinary and unexceptional history.

Princelet Street moved on, drifted through time. The story we had to tell was no longer required. The former synagogue became a charity case. Its business was the acquisition of public funds, imposed and approved versions of the past: Hawksmoor's carpenter, Huguenots, multicultural displays. Rachel, confronting this difficulty, devised a book of memory: photographs, fragments, maps of a territory that was vanishing as she transcribed it.

A friend from Uppingham, Mike Goldmark, published a book that I put together in a few days: *Dark Lanthorns (David Rodinsky as a Psychogeographer)*. The project was off-the-cuff, improvised. A series of walks based on markings found in Rodinsky's yellowing and battered London *A-Z*. Dagenham, Claybury, a zigzag from Liverpool Street that carried me to Regent's Park and the zoo. Films were made of these walks and they were shown on monitors in hidden Whitechapel locations.

The interesting aspect was the afterburn. How other people followed Rodinsky's trail: recording sound, making compositions from columns of words in the books, undertaking pilgrimages to compensate for their failure to gain access to the Princelet Street building, the room that had been cleaned, emptied, drained. "Just because you can't see a thing", the poet Ed Dorn said, "it doesn't mean that it's no longer there". Rodinsky's room had dissolved. Its boundaries thinned to naked air. He had been released into a landscape of potential or actual journeys.

A Swiss-based architect, Liat Uziel, begins her quest in Spitalfields. She is refused entry to the synagogue. She records a conversation in which the fee for a visit to the 'improved' room is set at £ 2,000. She constructs, elsewhere, her own version of this place, a "memory for the absent body". There are machines that scratch patterns of dust from the wall. Photo-sensitive plates that catch shadows and plot the movements of the conjured presence. Liat finds herself at the point where the red line on Rodinsky's map breaks off at a complex motorway interchange, beneath the asylum colony where Rodinsky's sister dies. Liat conceives a building that enfolds the road, a museum of memory. Sensors monitor traffic, affecting the fabric of the building, influencing the dreamers in their alcoves. The walls are thin as paper or they are thick as the masonry of the Tower of London. The wonder is that such resonant projects begin with a tatty map, rescued ephemera from a building that remains suspicious of its own legend. The chaos of Artangel's high-summer event, the monitors in borrowed or rented spaces, achieves a second act that goes far beyond the original remit. That continues, inventing its own terms, rescuing the memory of the room from the oblivion of sponsorship or bureaucratic approval. IAIN SINCLAIR 12 March 2002

Artangel had explored ways of collaborating with filmmakers, sculptors, choreographers and composers but hadn't found a way of inviting a writer to imagine what happens when you put language on location. The series 'INNERCity' would focus on this area of work.

Frances Coady, then head of Granta Books, recommended I meet Rachel Lichtenstein who was preparing *Rodinsky's Room* with Iain Sinclair about a legendary recluse who lived above a synagogue in Spitalfields, his attic room re-discovered after many years.

Talking to Rachel we came up with the idea of tracing Rodinsky's paths in and around Brick Lane. *Rodinsky's Whitechapel*, was a beautifully produced guidebook containing a map, a legend and a commentary.

You could stop off at the café where Rodinsky played the spoons, visit Mr Katz's string shop and see the site of the former Kosher Luncheon Club, finally arriving at Elfes Stone Masons where Rodinsky's headstone was displayed in the window. Rachel finally discovered Rodinsky's unmarked grave in Waltham Abbey. The headstone, consecrated as the final chapter of our project, remains the only permanent monument commissioned by Artangel.

Lichtenstein's walk ran alongside a series of Sunday excursions mapped out by Iain Sinclair, which took their cue from markings in Rodinsky's personal copy of the London *A-Z*, left behind in his attic room on Princelet Street. MICHAEL MORRIS June 2002

Rodinsky was caretaker of a Hasidic synagogue off Brick Lane. He vanished without a trace one day in 1969. When his flat at the top of the building was broken open, it turned out to contain writings in Hebrew and Arabic, a variety of bizarre lists, an annotated London *A-Z* and cigarette packets marked with Chinese characters. [...] He has come to stand for the lost world of the Jewish East End. [...]

For this project, Sinclair collaborated with Rachel Lichtenstein, an artist and Whitechapel walk guide who has researched Rodinsky's life more throroughly than anyone. She presented her version of the project as an act of *Kaddish*, of ritual mourning, but the walks staged by Sinclair on Sunday afternoons were something else again, a Borgesian joke disguised as history. [...] The more frustrated the walkers became in their quest for a vanished Jew [...] the better the walks worked. It became a detour. [...] Sinclair's walk acted not as an elaboration but as an avoidance of the Rodinsky myth.
Jonathan Jones, 'East Side Story', *frieze*, issue 48, pp. 55–56

Dear James,

You asked me for a title. How's *An Area of Outstanding Unnatural Beauty*? King's Cross is baffling. We've been chasing it for three years and it's still eluding us. I both admire and fear it, but in the right proportions that's exactly the combination which makes a project take off.

This week all the magnetic filings are beginning to line up – meetings with table tennis manufacturers (French, of course), organisers of table tennis tournaments, people who make stairwells in second-hand shipping containers, periscope makers, the people who used to draw the *A-Z* freehand, street by street, and, vitally, you securing our use of the abandoned plumber's merchants on York Way. Coincidentally, demolition began yesterday in Railway Street, so the feeling of instability is moving to the next phase. 'Lost Property' writ large and physical.

King's Cross's grand reputation for transience is so powerful that I have sometimes wondered if perhaps the place itself could be fugitive, like a very speedy geology. Can a place migrate? Deserts do it. A disappearing act.

London was described to me as a Brownian Motion, all jostling molecules. Maps try to steady us, but you can see that London still behaves like a shaken game of Scrabble, or a dropped puzzle. Some of the city is pinned down by punctuation marks like St Paul's, the Monument, Canary Wharf, Marble Arch, Big Ben, Archway, Nelson's Column too. But the names of London's parts slip and slide over each other. There is a moiré of possibilities for locating anything, which is why, perhaps, I think of the *A-Z* as a binder in which every page (and every page edge) is notched with a million map reading tantrums.

Like all mature cities, London is made of absences. All these objects which have gone missing, or are only semi-visible, which cast a shadow across a district and make it into a place: Chalk Farm, Crystal Palace, Swiss Cottage, Limehouse, Knightsbridge, Highgate, Shepherd's Bush, Temple, World's End. Add the Elephant, and the Angel.

The long gone King's Cross casts a shadow so permanent it's like a stain with an unfixed edge. Using our episodic approach over several months *AAOOUB* promises, I think, to beat the bounds, making new edges, picking up what it finds as it goes.

Till tomorrow.

Richard
20 June 2002

Creating *The Missing Voice* was an intense experience. There was the excitement of being able to work on the most ambitious walk to date and also to have it anywhere in London. The reverse of this was that every option created a new option and every minute added to the walk seemed to increase the production time exponentially. Many times I doubted whether I would finish it on time.

Initially I worked very much in collaboration with the Artangel production staff. They arranged visits to special places like the hidden spaces in St Paul's Cathedral, closed underground tunnels, libraries and government houses. I had tours around London and was provided with books, maps and directions to areas that I wanted to explore. One day we even went to the sea because I thought one of the characters should go there. Meetings with people that could possibly help the project were arranged. What was especially crucial was that a great relationship with the staff of the Whitechapel Library, who have voluntarily continued to care for the piece, was negotiated.

I think I must be one of the more frustrating artists Artangel has had to work with because I'm very private about a piece until it's finished. It's difficult for me to share the creative process with anyone other than George, my husband and editor. Usually a curator or commissioner doesn't even hear any of the piece until it's pressed to CD. Artangel was very subtle in pushing my barriers around this issue and I'm glad they did.

At moments of crises they helped by stepping in and listening to what I had and giving me honest feedback. Emotional support and conceptual input made the piece much better. JANET CARDIFF 2 April 2002

We offered a possibility to Janet Cardiff that perhaps had not been opened up before. The point of departure for her previous walks had always been an art institution, and the point of return had always been the same as the starting point. We discussed the possibility of a work which would leave the listener in the city rather than return them back to where they had come from. We were also interested in seeing whether Janet could conceive of a work of a greater length and a different kind of linearity. This demanded an exceptional commitment of time, many weeks walking and many months recording and editing. The time Janet – and her partner and editor George Bures Miller – gave themselves to make the work, and the time necessary to experience it enabled *The Missing Voice* to evolve into a work with several layers and narrative threads.

Janet was interested in libraries. We visited quite a range and in the end she really liked the feel of the Whitechapel Public Library, which is a prosaic, regular, slightly down-trodden public library in an area of London where your experience changes dramatically from one street to the next, almost as if you are moving backwards and forwards in time. The work choreographs a route

from the library out into the back streets of Spitalfields, across Commercial Street and then into the City of London, ending up in the concourse at Liverpool Street Station. Janet recorded *in situ* – the sound of a Bangladeshi procession down Brick Lane, or an opera singer in Christchurch Spitalfields – and then edited other material that she had recorded elsewhere.

We negotiated a six month period with the library and within that period there were times when the use of the work was very heavy. The library, with the best of intentions, sometimes struggled to cope with the large groups of people who were coming. But they liked it, it helped quietly to animate the library and they enjoyed the relationship with Janet.

At the end of 1999, the Library agreed that the work could remain there, like a book amongst the books, unadvertised. But it continues to be 'borrowed' on a regular basis. Like a book, it is for an audience of one person at a time. And it's built a following, just like a book, by word of mouth.

The city changes year by year, and the disjunctures between what the listener hears on the soundtrack and what he or she sees become more pronounced. The uncanny synchronicities between the voices in your head and the encounters on the street remain as startling as ever. The lime-green Ford Capri is still often parked in Fashion Street JAMES LINGWOOD May 2002

[...] Cardiff's calm directions guide me through the library. I try to match my gait with the sound of her Lethbridge saunter. Her legs are longer than mine; my stride changes. She sits me down at a table and tells me she's going to fetch a book to show me. Then her footsteps return. The book is not on the shelf right now, she tells me, but it is about how the library used to look, with glass cases lining the walls. I can see the old library in my mind. I hear voices beside me, girls laughing. My head spins around, but the girls aren't there. The man at the issue desk winks knowingly at me. Cardiff's work is ghostly. The people in her narrative are missing; different people have replaced them. "Have you ever had the urge to disappear? Escape from your own life?" she asks. [...]
Carol Peaker, 'The Voice of a Friend', *National Post*, London, 3 July 1999, p. 7

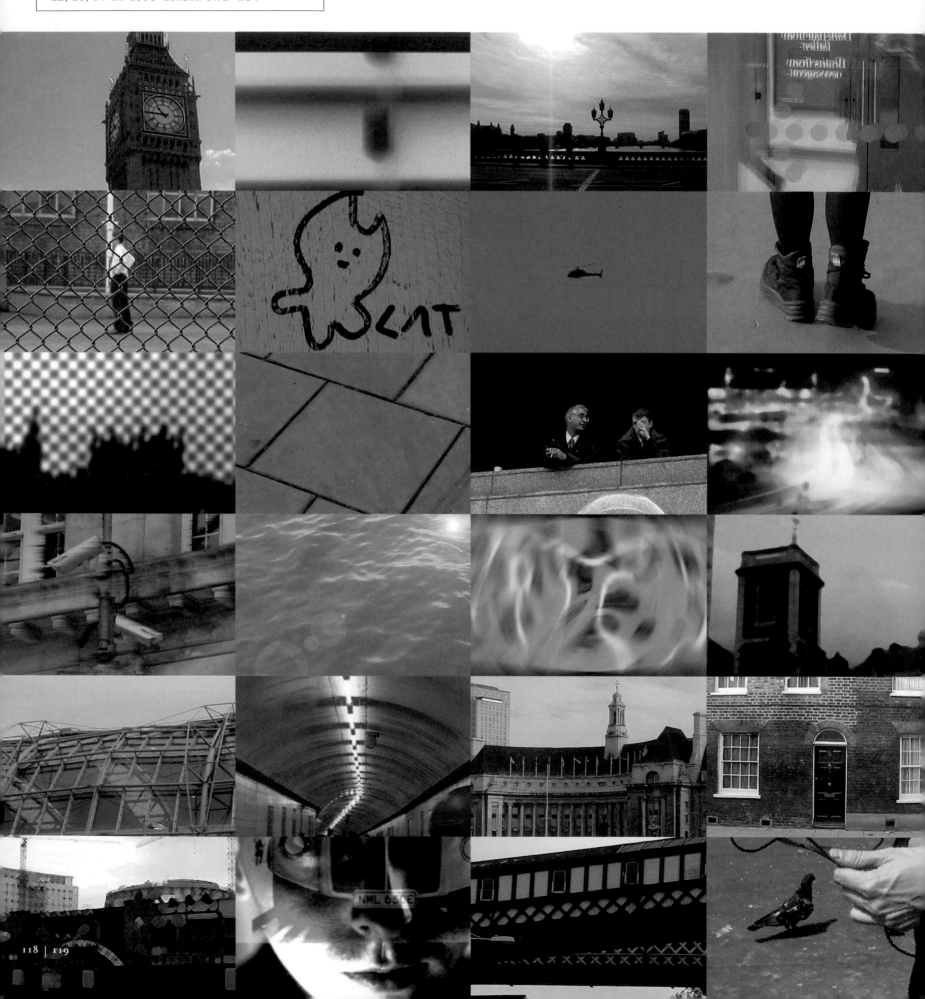

It was a quiet Saturday afternoon in South London when the telephone rang. I playfully answered with "Scanner Pizza" only to discover the voice of Artangel's Michael Morris expressing interest in collaborating with me on a project. Still blushing, I listened to him inviting me to create the first of the 'INNERCity' projects, exploring the resonance's of the urban sprawl of London.

Taking a year to develop *Surface Noise* was many abandoned adventures: at junctures it was to be a way to control the lighting systems of the Docklands business district from afar, it was a swimming pool awash with teddy bears, postboxes that read letters back to you and even a media virus, Godzilla, that devoured the data of all central London office computers.

It resolved itself into a sound tour on a red double-decker bus. Making a route determined by overlaying the sheet music from *London Bridge is Falling Down* onto a map of London, I recorded the sounds and images at points where the notes fell on the cityscape. These co-ordinates provided the score for the piece and by using software that translated images into sound and original source recordings, I was able to mix the work live on each journey through a speaker system we installed throughout the bus, as it followed the original walk shuttling between Big Ben and St Paul's Cathedral.

My work has always explored the relationship between sound and architectural space and the spaces in between information, places, history, relationships, the places where one has to fill in the missing parts to complete the picture. The public nature of this work brought together a mixture of people who have all learnt to look at a city in a manner in which they have almost become blind to it through familiarity, revealing another layer of skin, peeling the surface away.

It attempted to transform the everyday into something baffling and intriguing, taking the ordinary and seemingly benign and making it extraordinary.

Like the wow and flutter of a needle on a record, I am interested in the distillation of sound into acoustic disturbance, collapsing the legibility of a city into a fresh texture. Through the brief space of a bus journey the work drew upon many of our common reserves of sonic recognition, mingling the folk memory of the nursery rhyme, the background roar of traffic and the private sounds we make, secure in the knowledge that no one else is listening. SCANNER 10 March 2002

In *Surface Noise* Robin Rimbaud, aka Scanner, did six trips an evening in a double-decker equipped with mixing deck, very loud speakers and a bunch of passengers. [...]

The sounds and music mixed on the bus route were the result of Scanner's walk through the city [...], his route was based on laying the sheet music to *London Bridge is Falling Down* over a map of the city. At the points where notes from the music fell across his map, Scanner took photographs with a digital camera and made recordings with a DAT machine and devices which allowed him to eavesdrop on, for instance, mobile phone conversations. The resulting images were fed into a computer which translated them into sounds, and these Scanner mixed in with the DAT recordings while sitting on the bus. Each trip had a different live mix, and hence a different feel. [...]

What *Surface Noise* did was to provide a soundtrack through the living city. Gradually the journey began to feel like sitting inside a film; in the half-light of street lamps, the familiar outlines of London took on a particular resonance. A half-finished car park developed an unexpected, ethereal beauty, the closed funfair beneath St Paul's looked curiously sinister, and two vintage Citroëns behind Waterloo Station suggested a larger, more ordered narrative.

It was fun trying to decipher which sounds had been born of which pictures – was that noise like something hitting the bottom of a plastic dustbin really a response to the visual stimulus of the Houses of Parliament? Above all it was interesting, if a little Truman Show-esque, to make the step from seeing film as real life to seeing real life as film.

Hettie Judah, 'Fare idea of the city', *The Times*, 17 November 1998

A line. A mean.

Is what a line means what a line meant?

Alignment.

Pedalling up the City Road, as one does, dodging traffic, a glimpse over to the right, as I usually do. Here the City Road Canal Basin opens out the view to the plush hill of Islington. Two spires are moving in the opposite direction – presumably tracking off to Old Street – although I never see if they ever get there as this is a short excerpt from their journey. The further church makes a stately transit across the stage, while in front, the nearer and faster steeple glides powerfully from behind with a speed and determination that means overtaking is inevitable. The churches enact their usual chase with the same result, but at the exact moment their pointy-bits come together, there's a keen flash of exactness. It is my snapshot of the landscape taken at the exact same moment that an ultra-long lens sniping from the far distant point of parallax captures me struggling up the hill.

It is a habit held from walking and re-walking the line of 18 transmitters in Salisbury eight years ago. I still retain snaps from this time and can see the cathedral spire intersecting Old Sarum's mound. It is also a snap of me in a line of beech and holly trees looking out.

Marking a straight line on the ground, the surveyor lines his eye against two sticks and, in doing so, becomes a kind of third stick. Measurer measured. Experimenter part of the experiment. Spy spotted.

Hindsighting, *Listening Ground*'s steel-rule line and map-eye view yielded in its walking to the pervading sense of *Lost Acres*' shuffleable guidebook and scattered markers – that you were always centre to a new frame. GRAEME MILLER 25 March 2002

The act of remembering, going down Memory Lane, corresponds with the research into memory, attention and consciousness that I am engaged in for a new piece of work.

A beginner's knowledge and enthusiasm in the exploration of the map of the brain has a parallel with my own physical exploration of an O.S. map of Wiltshire eight years ago.

Maps are only possibility on paper needing to be sketched out, then fleshed out to become internal. It is good to start the journey with simplicity. Brain maps make use of cross-sections to reveal the functions of brain. The cut clarity of cross-sections I can compare to walking the ley line in *Listening Ground*. Yet to let go of the sliced image and try to encompass the whole pattern of brain activity, is to glimpse the exquisite phenomena that is within this moment of thought. That is what I aimed at in *Lost Acres*. By tracing and re-tracing the countless combinations of routes and places that the guidebook ensured – walking the work would generate long-term memories. Functioning as a kind of metaphor of the mind while altering its internal pathways.

For an audience, *Listening Ground, Lost Acres* was a 100-square-mile memory-theatre of place, which they had to enact. The further they went, the more time they took to trod the map, the closer they came to the work itself. It was not to be found in a mere three hours. *Listening Ground, Lost Acres* was elusive, being the sum of its markers and listening posts.

I am not sure if anyone, including Graeme, made their way through all the paths to all the places on our map. I almost did. Is it possible that *Listening Ground, Lost Acres* never truly existed? Maybe it is still only a map waiting to live on in another's consciousness.

MARY LEMLEY 25 March 2002

If you happen to be near Salisbury this weekend, you may notice something strange about some of the weekend walkers. They will be dressed in their usual sensible boots and anoraks, but they will also be wearing a rapt expression. Look closer, and you will see that they have a headphone clamped to one ear, and they will be puzzling over a most unusual guidebook: they are taking part in an exciting and absorbing piece of art. [...]

Salisbury and its plain are rich in earthworks and historic sites. A straight line drawn between Clearbury Ring to the south and Stonehenge to the North passes through the cathedral and the abandoned city of Old Sarum. All sorts of magic proportions have been attributed to these proposed alignments of psychic force, so called ley lines; this one was first noticed by the Ordnance Survey in the last century.

To walk along this line is tempting, but impossible, for it passes through hedges and rivers, as well as the Salisbury Woolworths. But Graeme Miller, best known for his theatre pieces *A Girl Skipping* and the *Desire Paths*, and Mary Lemley, a visual artist, have found a way to make the line vibrate with hidden harmonies. While Lemley spent six months seeking out all the special places along and around the line, tracing meandering paths for her cabbalistic guidebook, Miller has sited 20 radio transmitters along the line, which broadcast loops of sound – a mixture of music and voices – into the earpieces of suitably equipped walkers.

The only visible manifestation of this 20-square-mile landscape, other than the walkers – who, in choosing their own lines to trace, enact the performance for themselves – are 29 fine glass colums, created by Jonathan Andersson, placed like magic markers at key sites. These prismatic trig points focus the light and colours of their surroundings, visual counterparts to the transmitters, which fill the walker's landscape with the words of Salisbury inhabitants, from the dean of the cathedral to people in the night shelter in the Cattle Market, held in a prism of music. [...]
Robert Hewison, 'Walk me through it', *The Sunday Times*, 11 September 1994

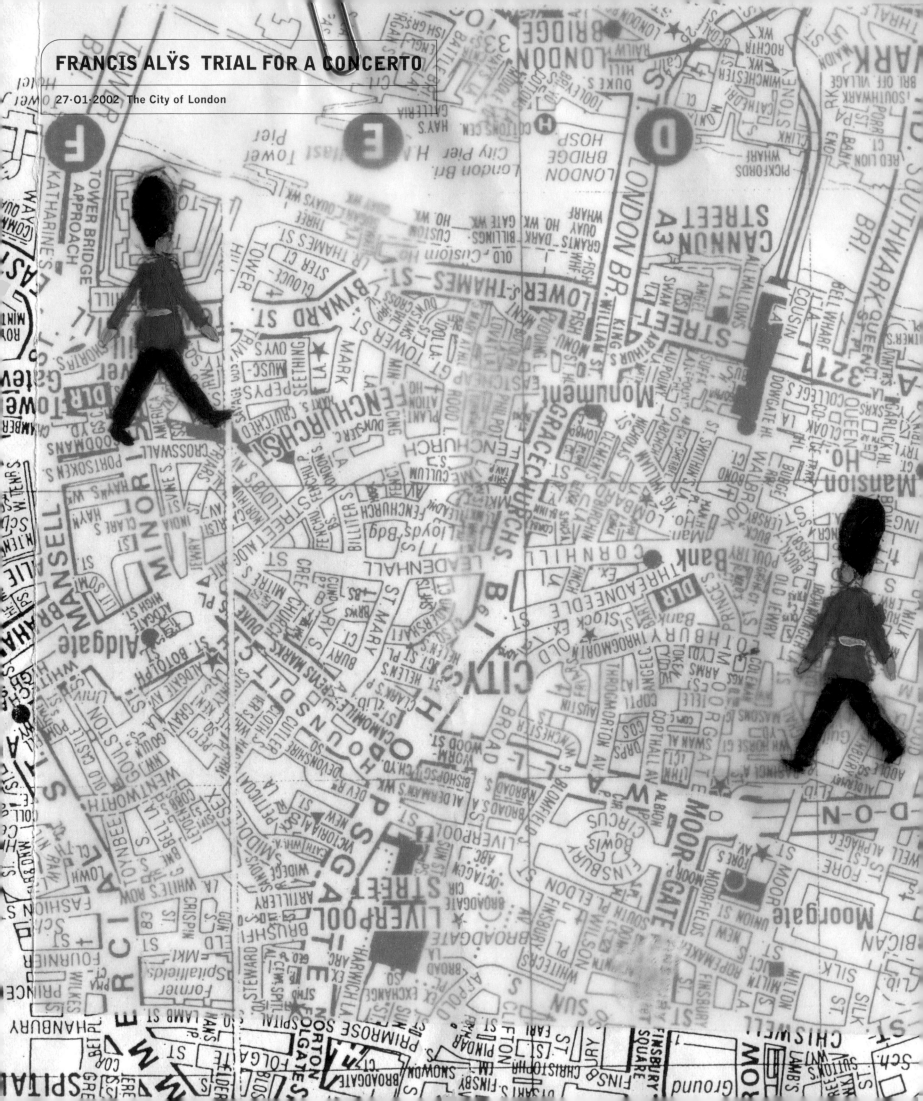

Concierto for a marching
regiment
and a fly

Draft / London Project
(after Duett)

Protagonists : professional musicians in fanfare uniforms
 (Brass Band, District Fanfare, ...)

Duration : from sunrise to sunset

Occasion : on a national holiday

Location : The City - Financial District and areas in
 close proximity which are equipped with a
 surveillance camera system (to be further
 investigated).

Score : I. Apertura
 Each member of a Band (min of 15) arrives at
 a particular location at the periphery of the
 District at a set time (morning).
 Each member is unaware of the other Band mem-
 ber's departure points.
 Each member is given preliminary instructions
 directing the following situations :

 2. Andante
 Each musician wanders within the Financial Dis-
 trict, playing his/her assigned music score.
 Although dispersed, their echoes operate as
 bird calls.

3. Crescendo / scenario I.

Each musician corresponds to a musical phrase.
the number of possibilities of encounters fol-
lows the equation :

$$\binom{n}{k} = \frac{n!}{k!\,(n-k)!}$$

n = total number of musicians

k = number of musicians (involved) in the
 encounters

ex. the combined number of possibilities for
 different meetings for 3 musicians out of
 a Band of 10 is:

$$\binom{10}{3} = \frac{10!}{3!\,(10-3)!} = \frac{10\times9\times8\times7\times6\times5\times4\times3\times2\times1}{3\times2\times1\,(7\times6\times5\times4\times3\times2\times1)} = 120$$

subsequently, one would need 120 different
musical phrases for there to be a new phra-
se for every possible meeting of 3 musicians
out of 10.

Crescendo / scenario 2.

Each musician corresponds to a number,
Each number corresponds to a musical phrase.

ex. clarinet = I, tuba = 2, trumpet = 3,...
 if the clarinet meets the tuba: I + 2 = 3
 if the tuba meets the trumpet : 2 + 3 = 5
 if the Band is composed of 26 musicians,
 one would need 341 different musical phrases
 to cover all the mathematical probabilities
 of such scenario.

Crescendo / scenario 3

Each encounter corresponds to a musical quote
(fragment) appropriate to the musical genre
of the selected Band : the larger the number of
musicians in each encounter, the longer the du-
ration of the musical quote.
The system builds until all members of the Band
meet.

Crescendo / scenario 4

(most appropriate for a jazz Band)

I. Each musician wanders improvising.

2. Upon approaching each other, musicians mutu-
 ally take into account the other's performan-
 ce in an attempt to coincide with the other's
 melody.

3. Upon meeting, they reach harmony.

4. When continuing together, they play the re-
 sultant musical phrase.

The system builds until all members of the Band
meet.

Crescendo / scenario 5 ...

A, B, (and C) are dispersed in the city of L.
A will not know B,
B will not " A,
A will not know C,
B will not know A,

A will whistle the Melody
B will hum the
C will sing the

A, B, C will look for one another
in the city, calling each other
performing constantly the melody

) A, C will eventually recognise
themselves and

A, B and C are dispersed in the city

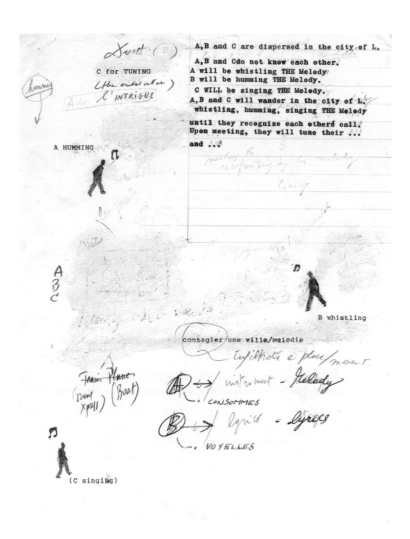
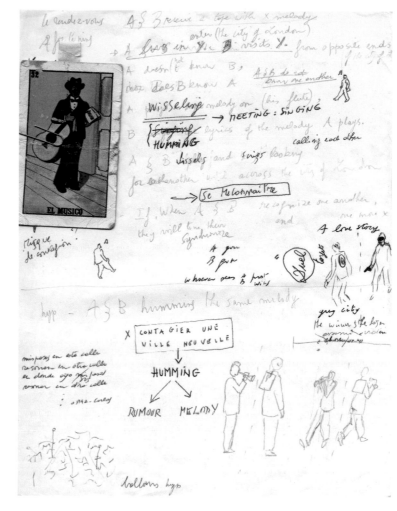
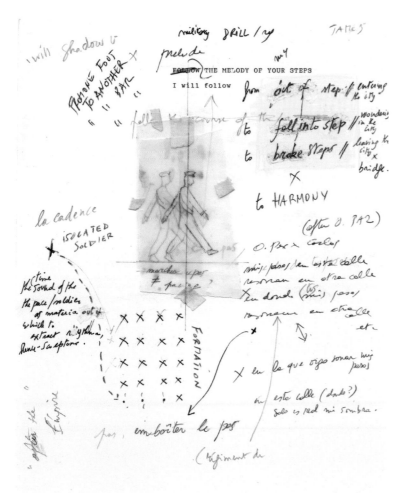

LAURIE ANDERSON / BRIAN ENO SELF STORAGE

4·04 – 7·05·1995 Acorn Storage Centre, Wembley

16 April 1995

Dear Michael,

Thanks again, a thousand times, for all your help in getting this project towards a successful conclusion. It's odd now, in the end, it did turn out to be about quite a few of the things we talked about all those months and even years ago. It was 'song-storage', it was something new in London's cultural landscape, it was a new kind of collaborative work – though I think a lot of the significant collaboration was between the two of us.

I really enjoyed that part of it. You're a great person for ideas, and a great midwife for the ideas of others – not least because you're unafraid to kill off the weaklings at birth as well as wholeheartedly encourage and nurture the strong. I really hope we get a chance to work together further on some future adventure, and if you think I could be a helpful voice on anything you're working on, please do ask.

Personally I was pleased about two things: first, generally, that I can make installations without many of the things I had previously thought essential (including various bits of technology and total darkness), and secondly, in particular, *Plato's Cave*. For me that piece has real quality and confidence. I like the fact that it's made from near-junk, and I love its relationship to the voice. This idea of narrative installations is really strong and I hope to develop it further. Since the show I've been flooded with cheap, low-tech, site-specific ideas

Of course, and as always, I wish I'd had time to develop a few of the other things in the show a bit more, and that I hadn't got so bogged down in making tapes. I dream at night of what could have happened in that wedge room. There was a brief 15 minutes on Sunday morning when I knew I had something great going on in there, but I just didn't have the composure to ignore all the other bits and pieces that still needed doing and carry it through. I will one day. I dream also of what else could have happened in the Ballroom, how that could have been a story room too (but it would have required making a whole new sound-piece – at least a day's work – and would have used several bloody machines).

Oh well, oh well But on the whole, it felt really convincing as a show. I got very good reactions – ones that seemed genuine – from the people I spoke to. I haven't of course seen any reviews or suchlike, but no doubt I will.

Please give my thanks and best regards to the other Artangels and to Sko. They were bricks.

Regards,
Brian

Self Storage was one of those projects that seemed to come together quite magically. And by this I mean that other people did all the groundwork. So by the time I joined, *Self Storage* was not just a realized concept but a place as well. Artangel and Brian Eno had made all of the arrangements, thought about how to get people out to the site, spooked around and found interesting caches of belongings that were already there and enlisted a number of young artists to work on installations.

I joined in the spirit of last-minute collaboration and all I actually provided were some stories that Brian very cleverly made into an audio narrative that drew the visitors through the space. I was on tour at the time and so after just a visit or two to the space and a few conversations, this magnificent show appeared. Probably my favorite room was a closet-sized space that contained *The Vizir of Memphis*, a mummy on loan from The British Museum.

For me it was a bit like writing some music for a film without knowing the plot or the action or any of the characters. Fortunately for me, Brian is a genius and made these small stories into narrative lines; he gave them structure and drama. I've always been a bit leery about 'acoustiguide' tours but this had the function of linking the space and connecting some of the secrets with a rambly strand of sound.

LAURIE ANDERSON 2 April 2002

Self Storage itself is as much about where it is as what it comprises or who is behind it. The gargantuan Storage Centre on Wembley Way comprises 650 units, ranging in size from box to bungalow, in which most people lock away things they can't fit in their homes – the RCA team, however, have occupied a few, filled them with art, and left them open.

Arriving in this North London wasteland is a crucial part of the experience. [...] Most who tread this famous path have come to watch football or lock away crates of shop-soiled longjohns. You have come for art.

It takes the form of 'sculpture' – rendered here in sound and smell as well as in solid form. A yellow line on the floor guides you round the dim corridors, and among countless locked doors are those that open into exhibition spaces.
[...] Never before have the corrugated plastic suburbs of DIY land seemed so full of poetry.

Giles Coren, 'A few surprises in store', *The Times*, 14 April 1995

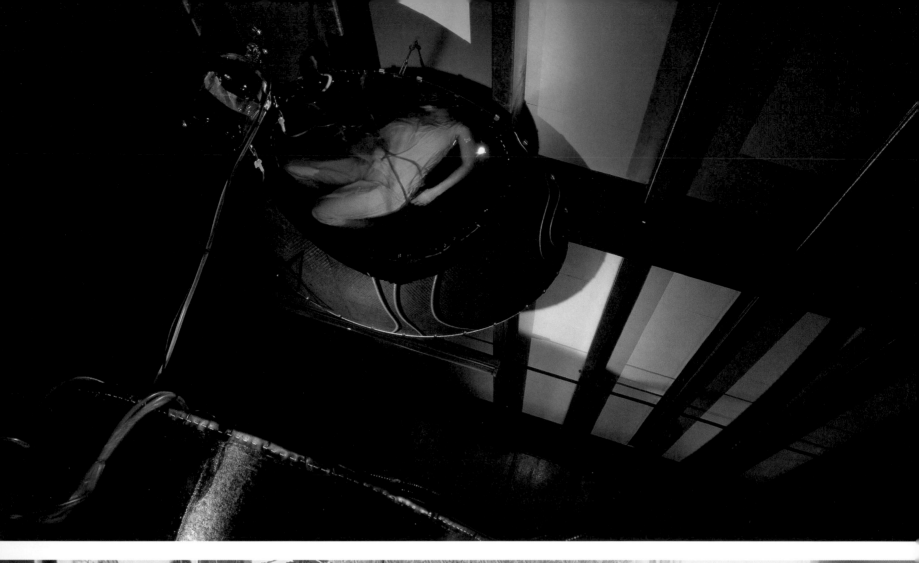

"I used to spend some time seeing a psychiatrist. I would get there around eight in the morning and come into the office and she sat in the corner and on one side of her was a window and the other a mirror and she could tell by slight movements of my eyes whether I was looking at her or at the mirror. I looked at the mirror a lot and one of the things I noticed was that on a Monday it was perfectly clean and clear but by Friday it was covered with these lip marks. This was a process that seemed bizarre at first and then predictable and finally more or less inevitable.

Then one day in passing, I said, 'It's like the lip marks that appear on your mirror.' And she turned around and said, 'What lip marks?'

And I realized that because of the way the sun was coming through the window and hitting the mirror at an angle that she couldn't see them. So I said, 'Why don't you sit in my chair? You can see them from here.' And I'd never seen her get up before but she got up (she could actually walk!) and she came and sat in my chair and she said, 'Oh! Lip marks.'

The next time I saw her was the last time. She said she had discovered that her twelve-year old daughter had been coming into the room during the week and had been kissing the mirror and that the maid would come in on the weekends and wash off the marks. And realized that we were seeing things from such literally different points of view that I wouldn't have to see her again."

"My friend Gordon died really fast. He got sick suddenly and then they told him he had only twenty-four hours to live so since he was a Buddhist he asked two lamas to come and help him. When his heart stopped, the lamas started to shout into his ear. Because supposedly your hearing is the last thing to go – for about half an hour after your heart stops – you can still hear, it's falling away quickly but you can still hear things and so the lamas are shouting things into his ears.

'Gordon! You're dead! You're dead now! You'll see two lights. Go towards the one that's farther away. Don't go to the close one.' And they yelled these instructions for about an hour and they told us we were supposed to be sending him on his way, not calling him back."

"There are Eskimos who live above the timberline. There's no wood for the runners of their sleds. So instead they use long frozen fish which they attach to the bottoms of their sleds to slip across the snow."

LAURIE ANDERSON 'Storage Stories', March 1995

RCA ACORN RESEARCH CELL
David Blamey, Elaine Brechin, Michael Callan [OPPOSITE BOTTOM], Jason Coburn, Jason Edwards, Michelle Griffiths [OPPOSITE TOP], Rachel Hale, Patricia Hepp, Tim Hutchinson, Janek, Chris Jones, Bettina Kubanek, Louise Lattimore, Danny Lavi, J.E. Lewis, Lucy McDonald, Natasha Michaels, Tim Noble, Hannah Redler, Simon Waterfall, Sue Webster

In a windowless room in a Wembley storage warehouse, a woman is lying in a giant bucket of water, fully immersed as more water drips on to her from tubes stretching into the dimly lit corner.

Upstairs in a different locked room, strange smells come out of a door, a goose egg lies smashed on a floor, 49 clocks are suspended in a darkened room and a hologram candle flickers and dies if you try to blow it out. This is *Self Storage*, a joint exhibition by Brian Eno and Laurie Anderson, and students from the Royal College of Art. [...]

It may not be everyone's idea of art, but few would disagree that the one-hour mystery tour through its corridors and rooms is great fun.

Tim Cooper, 'Meeting a mermaid in a mystery tour around warehouse of wonders', *Evening Standard*, 5 April 1995

PULSE

WHEN ALL THE DUST HAS – SETTLED

Alan Read

The grain, now what I wonder do I mean by that, I mean ... (hesitates) ... I suppose I mean those things worth having when all the dust has – when all my dust has settled; I close my eyes and try to imagine them.

<small>SAMUEL BECKETT</small>, *Krapp's Last Tape*[1]

Atom Egoyan, *Steenbeckett*, 2002

There is no forgetting. Different states of remembering maybe: John Hurt's hands spooling back the years, a reversed alabaster-white fireplace, a hospital illuminated by divine performative painting, an impossible billiard table in an architectural anomaly where privacy met publicity, a second un-civil war battle for the soul of England, the aural seduction of noir ethnic streets, the falling play of seriously grown up children, a community choir with nothing in common, longplaying sound with the time of light, the poetic archaeology of an urban underline, a spiral of utopias in the locomotive round, the remorseless logic of a catalogued identity crisis.

These are the things worth having when all the dust has settled. They do not account for what the name Artangel stands for, nor do they stand in for the memories of others whose itinerary might have taken them as far as these are wide in a reverse vertigo of spiralling attractions. But they do remind us, as if we had forgotten, how material is the grain of realised imagination. How tactile was the eye-aching presence of Krapp, in our face, as next-door how melancholically did flow and decompose the material of his first-time tears. For here, in Atom Egoyan's *Steenbeckett*, the dust *is* the grain and as the dust hurtles to and through and from the projector gate, the film is veiled by the material violence of its exhibition. To watch the technicals splicing this volatile creation is to witness the uncanny, fearfully familiar underside of all real artistic illusion. And here in *Steenbeckett*, the dust is my dust, as it is John Hurt's dust, and Krapp's dust and your dust: "Just been listening to an old year, passages at random. I did not check in the book, but it must be at least ten or twelve years ago."[2] Can it have only been ten years? Surely twelve or twenty for all this coming and going against the grain, there must have been more than a decade of life before this afterlife.

These images, here, now, induce recollections from elsewhere in an epileptic encounter with the excuse for this work. Epileptic in the best sense of the word, if the recovery of pathological states to the side of enthusiasm might be said to be one of the afterlives of cultural creation – in the sense of the origin of the word Epilepsy in Greek, 'surprise'. We are all too aware from the bouncy-castle the pleasure children take in turnings, spins and the dis-equilibrium, the sensations of vertigo and the pleasure of toppling over down, and into others. For Forsythe in *Tight Roaring Circle* for children, adults and other animals a choreography of social disorienation, of limit distantiation. But here the state of exception induced by this unstable floor to the world, we might say Artangel's 'trapdoor', in the melodic drama of nineteenth-century staging, becomes not the exception but the rule. As though a state of emergency were declared on gravity bringing into question all that we stand for.

The epileptic knows this state only too well and lives it daily. And for the picno-leptic (from the Greek picnos, frequent), the frequently surprised state becomes less the exception and more the equilibrium within the rocky rule. Paul Virillio described the state of the picno-leptic when he says: "The lapse occurs frequently ... the absence lasts a few seconds, its beginning and its end are sudden. The senses function, but are nevertheless closed to external impressions. The return being just as sudden as the departure, the arrested word and action are picked up again where they have been interrupted. Conscious time comes together again automatically, forming a continuous time without apparent breaks ... these absences, ... can be quite numerous – hundreds every day often pass unnoticed by others around ...".[3] A way of presenting ourselves to this work perhaps. For us, the picno-leptic flickering through the pages of a continuous past like the stroboscopic encounter with the material we have felt elsewhere, perhaps nothing really did happen, the time of these events never really existed but rather in each critical encounter with the work in its own place, just a little of our life escaped. Where *did* that time go?

We cannot in this continuous state of exception believe that our dust will settle, nor that all of it will be there when we come to it. For the economy of these works is such that we recognise the irregularity of the epileptic, surprising state into which we have entered, the unpredictability of the circulating forces there, not so much of the *attention* of dramatic encounters nor the *tension* of artistic approaches but the charged and alternating *suspension* of faculties we thought were secure from the confusions of culture. This might be because, in a condition articulated by Dostoevski, the inexplicable enthusiasm induced by these experiences "... precedes the accident of the shipwreck of the senses, that of the body".[4]

I am not so much interested in 'the body' here, as in the embodiment of these works over a duration, their grain, and the material presence they manifest through their accumulation of dust. Given that epilepsy and its way of seeing rests at the advent in Hippocratic texts of the absolute dichotomy between the magical and the scientific, and given my own treatment for *petit mal* when I was a child was undertaken at the interface between medicalised electricity and incantations, the *nervous system* might sum up a way of combining these mental and material conditions in which all artistic practice is conceived and received.[5]

Yes, as *The Battle of Orgreave, Fishtank* and *The Art of Legislation* showed, the system is nervous. But to determine that which is political in these works, while disconnecting those politics from their materiality would do grave injustice to the politics inherent in all these interventions. To engage with Beckett's invitation to (hesitate) when considering what we might be recollecting when we recollect the grain of something, is to (hesitate) to presume the political within these works. This hesitation would require another way of looking to the work and one which these photographic encounters exemplify in a second remove from their origins.

These photographs are not so much an afterlife as the granting of another 'lease of life'. This pleasing economic circuitry is itself reminiscent of the nervous system it seeks to mimic. The works here have made journeys from one destination to another, in another medium, they are cut out and turned over into a montage that has an implicitness with the matter of their creation, far closer perhaps than some would like us to think between the photograph and what it purports to represent. Contrary to what Jean Baudrillard said about mediatised images inviting us to think that "the Gulf War never took place", these images precisely invite us to consider the ways in which work *did*, precisely and with attention to material detail, take place.

So an ironic inversion of cause and effect has occurred. While in the original experience of the work on site in its place there has been the suspended disorientation of the epileptic state, the witnessing of the event as a flicker flash of consequential moments (sometimes broken as with the flying loop of *Krapp's Last Tape,* sometimes continuous but contradictory in the endless circuitous belt of Michael Landy's interminable, though it did terminate, *Break Down*) here these distillations of representation are contiguous with what we recall as the residue of the work's material, archaeological evidence of the work having happened. In this aspect looking at photographs of art can be like looking at the animal next to the actor, while one senses the nemesis of the one in the other, one cannot but help only understand the one through the other.

One knows from reading Walter Benjamin that the challenge to perception at critical moments in history is unlikely to be solved by optical contemplativeness but through the continuous disruption of habit through *tactile* appreciation. As he said, the decisive blows in history were likely to be struck left-handed, and in this sense the gestures of the work being considered here are decisively verso over recto. In a contrary formation, the conceptual enthusiasms of the second half of the twentieth century have been overturned here through an artisanal, imagistic and sensual approach to materials that *is* ideational but only in as much as it invites us to contemplate the material sense of the work itself. Even where there would appear to be a punning or ironic contemporaneousness at work, it is a peculiar kind of knowledge formation that derives from the work, one that is more seismic than semiotic, to borrow a phrase from Bertolt Brecht. It is not so much *what* this or that image means but its effects that would, for Walter Benjamin, have placed this work on the side of the angels *with* advertising and *against* criticism. For "What in the end makes advertisements so superior to criticism? Not what the moving red neon sign says – but the fiery pool reflecting it in the asphalt".[6]

These urban specific conditions of reception also apply to much that those 'botanists of the asphalt', Artangel, have engineered. But not in any facile sense of 'pedestrian poetics' or the fetishisation of the foot soldier in the campaign against aerial perspectives beloved of the last twenty years of thinking cultural practice, rather in the more primordial, truly epileptic state of 'hide and seek',

Michael Landy, *Break Down*, 2001

the only children's game worth playing. Janet Cardiff's ubiquitous work *The Missing Voice (case study b)*, was it ever missing from the Whitechapel Library issue desk, Rachel Lichtenstein and Iain Sinclair's *Rodinsky's Whitechapel*, a stone's throw away but occupying a wholly different generic and domestic realm where archaeology of dwelling met the politics of melancholy and exile, and perhaps most neatly here, Tony Oursler's *The Influence Machine* in its chiaroscuro of city-square Gothic menace, each of these ammendations to a pre-existent site, produced space in the best sense of the term, each pulse with the *fort-da* of 'now you see me, now you don't', a very diffferent kind of public-private partnership.

As stake-holders we are waiting to impale the shadowy figure behind or beyond this work, in the spirit of significance wanting meaning where there is merely material. We are happily doomed. The dominant critical practice of reading works allegorically in which "the surface phenomenon ... stands as a cipher for uncovering horizon after horizon of otherwise obscure systems of meanings".[7] ... cannot operate here. There are no codes at work, constructed for the decipherment of the jigsaw addict, but an event, staged very precisely for the distracted collective reading of the tactile eye. This, not that, is the typical engagement in an Artangel event. I am thinking here of the grazing of *Steenbeckett*, the herding of *The Influence Machine*, the drifting of *Empty Club*, the wandering of *The Missing Voice*, the falling of *Tight Roaring Circle* and the circling of *The Palace of Projects*.

These pulses of people coming and going, more or less audience, participant, observer and outsider at any one moment, take on the bigger epileptic charge we previously conceived as the perceiving of the individual in a distracted, suspended state. What both share and what makes for the coherence of this project, one's ease and pleasurable dis-ease in its company, is a regard for 'the thing itself', not the cultural project of criticism that spends too much of its time dwelling *close* to 'the thing itself' but philosophically and materially seeking the soul of 'the thing itself'. This material recovery of 'these things, themselves', into speech and into the writing of photographic record are acts, against the grain of memory loss: "To restore the thing itself to its place in language and, at the same time, to restore the difficulty of writing, the place of writing in the poetic task of composition: this is the task of the coming philosophy."[8]

The task of the work that follows, against the grain, will be to remind us, though we never forgot, of all those things worth having, when the dust – settles. We might wish to open our eyes and try to imagine them.

1 James Knowles (ed.), *The Theatrical Notebooks of Samuel Beckett*, Vol. III, 'Krapp's Last Tape', London: Faber, 1992, p. 5

2 Ibid, p. 5

3 Paul Virillio, *The Aesthetics of Disappearance*, New York: Semiotexte, 1991, p. 9.

4 Quoted in Paul Virillio, Ibid p. 33

5 Thoughts here are drawn from Michael Tausig's *The Nervous System*, London: Routledge, 1992

6 Walter Benjamin, 'This Space For Rent', *One Way Street*, London: Verso, 1997, p. 145

7 Michael Tausig, *The Nervous System*, p. 147

8 Giorgio Agamben, *Potentialities*, Daniel Heller-Roazen (trans.), Stanford: Stanford University Press, 1999, p. 38

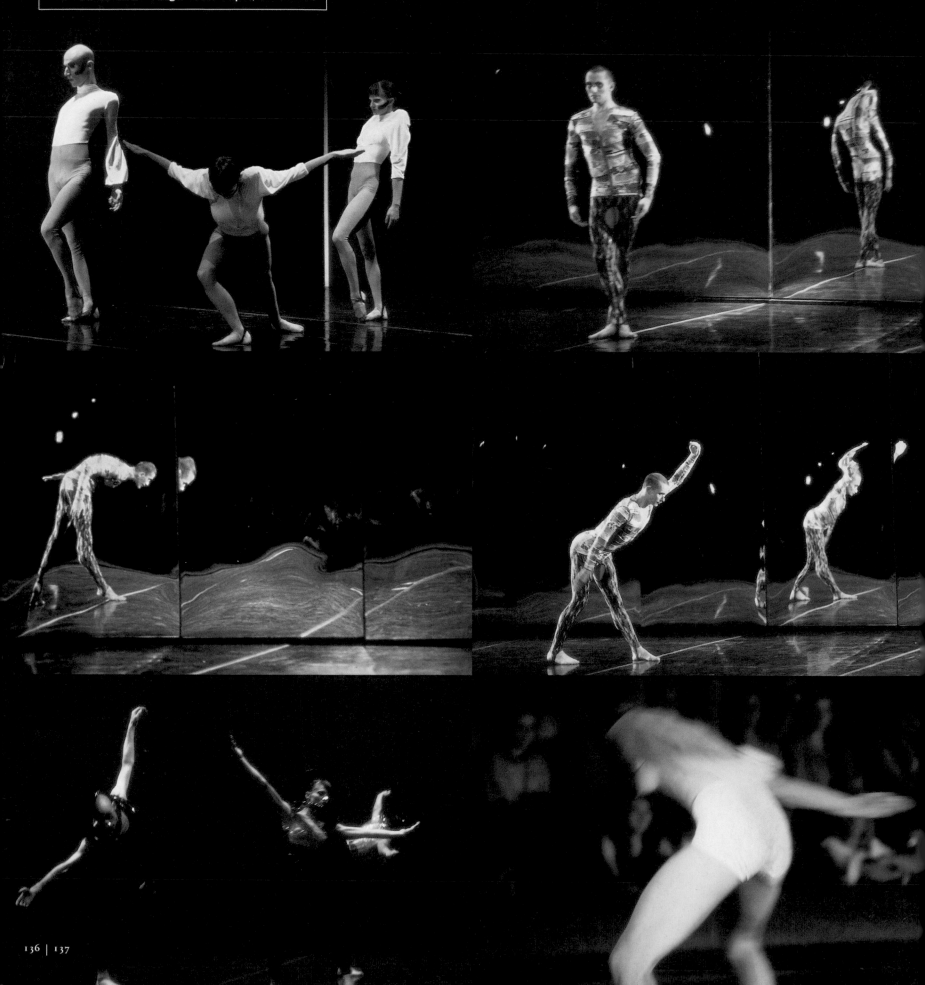

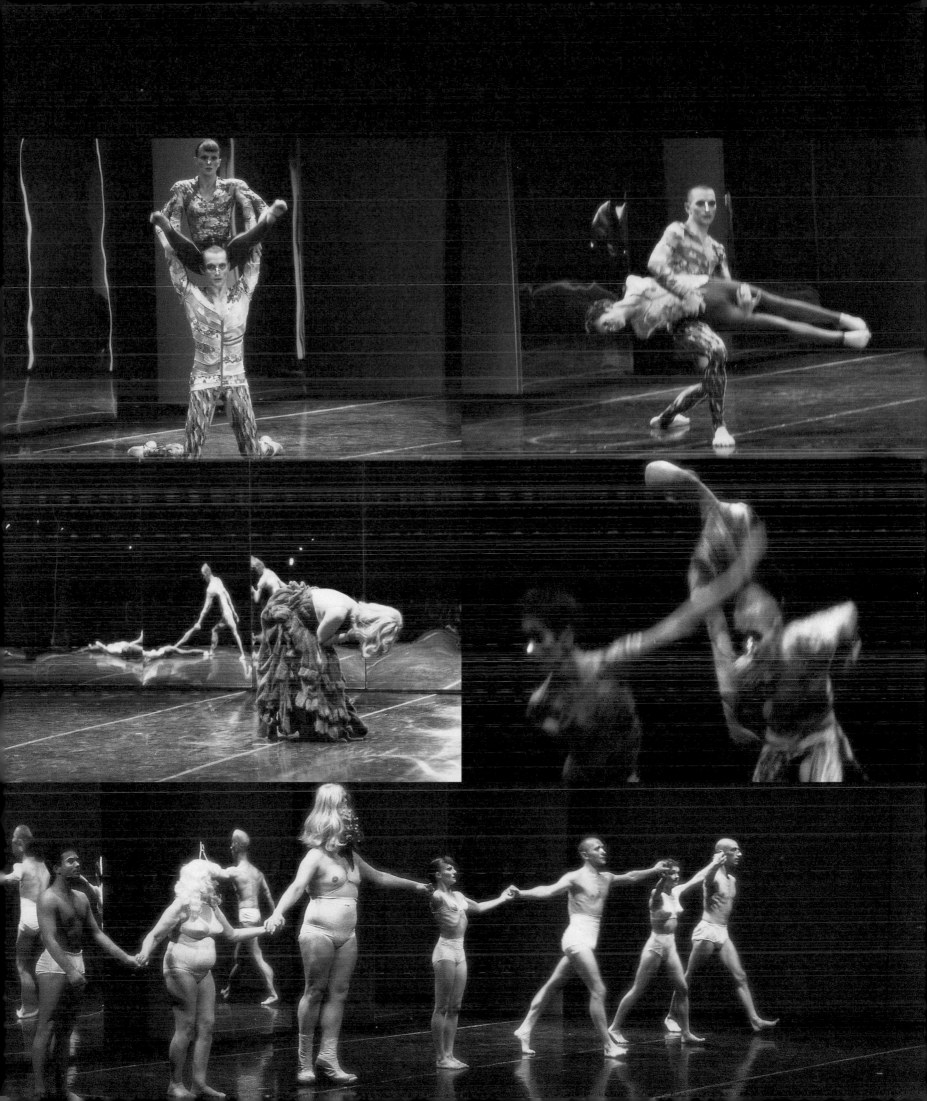

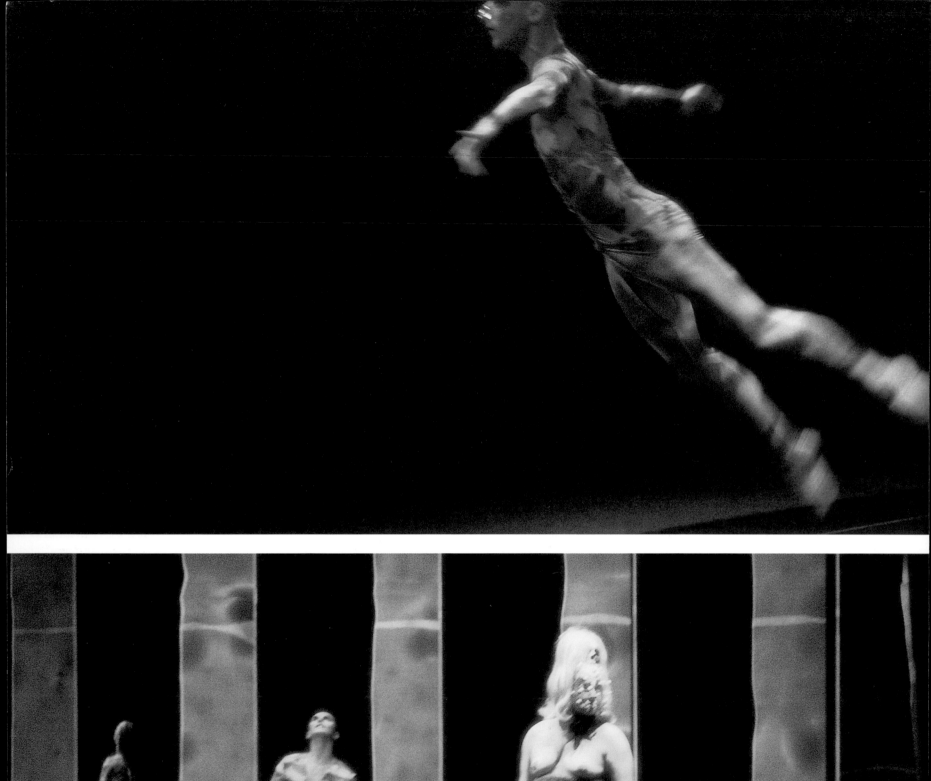
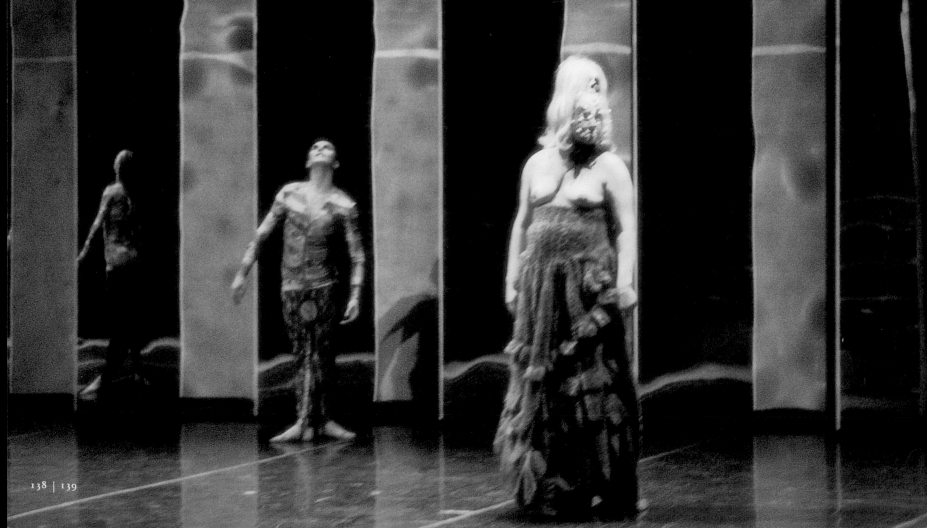

Michael Clark was calling me from Angers in France sometimes three times a day, sometimes in the middle of the night – "I want you to come and see what I am doing" – left plaintive messages; "Don't forget me dear".

I was working with filmmaker Peter Greenaway and met Michael when he played Caliban in Greenaway's *Prospero's Books*. Michael and I had connected immediately on account of our mutual ability to recite the complete lyrics to David Bowies' *Diamond Dog's* LP.

So following some TV post-production in Paris, I took a train to Angers where Michael was collaborating with New York choreographer Stephan Petronio on a dance to Stravinsky's *Rite of Spring* – they had each selected sections of the music to work with. Michael ran a sequence for me that afternoon – performed by a young American dancer called Joanne Barrett.

Despite zero knowledge of dance, I was instantly transfixed. This solo for the sacrificial chosen maiden who dances herself to death, played brilliantly with and against the bold dynamics of the music. There was a fusion of violence and vulnerability. I didn't fully understand it. It was elusive and strangely coherent. The experience held me, and after some seductive cajoling from Michael I dared myself to return to London as his 'manager'.

We resuscitated his relationship with the Arts Council sufficiently to hire a Territorial Army hall in Hammersmith for rehearsals and employ four dancers, including Joanne and two Michael Clark & Co veterans: Julie Hood and Matthew Hawkins. Michael and Stephen went their separate ways, but Michael, whose creative process is slow, cautious and almost hermetic, wanted to take his *Rite of Spring* further. Augmented by music including Sondheim's *Send in the Clowns*, T Rex's *Cosmic Dancer*, the Sex Pistols' *Submission* and an appearance by Michael's mother Bessie (who famously appeared topless and gave birth to Michael in the show) the performance was now called MICHAEL CLARK'S MODERN MASTERPIECE.

We bluffed our way through some fierce negotiations with a Japanese promoter and fixed a Japanese tour for December 1991. I soon developed an anxious awareness of the before and after effects of methadone, a taste for Bessie's slow-cooked beef and the ability to hold my own against the formidable Leigh Bowery, who designed the costumes and also appeared in the show.

The performance developed considerably through the Japanese performances. We had booked dates throughout the UK for the following spring–early summer, but for Michael the London run was a ritual. This audience had grown with him and loved him, and with a feeling of momentum behind the work, he wanted to do something special for London. As he put it, "I think its good for the audience to invest something of themselves when they come to see the work". He was concerned about the context for the work, the impact of the environment on the work. He wanted to do something site-specific and knew that the person who would have the knowledge and courage for this was Michael Morris.

The timing was fortuitous, as Michael had just become involved with Artangel and so under the specially abbreviated show title of *Mmm...* Michael Clark was born again on nine consecutive nights in a warehouse near King's Cross, London, in June 1992.

One significant development to the show following Japan was the introduction of *Theme* by Public Image Limited (PIL). The choreography was made with some urgency following several chaotic weeks in mid-March. The track itself is raw, slow and like a strangulated banshee wailing through leaden bass guitar notes, the voice of Johnny Lydon cries out words hard to distinguish, except for a moaning "I ... wish I could die". Out of the wings Michael appeared, his exceptionally arched foot followed by classically sculpted legs, his torso leaning impossibly far back obediently following his thrust pelvis, and his beautiful face held strangely expressionless. In this mesmerising dressage, he crossed to the diagonal corners of the stage collecting a dancer from each wing. The quartet proceeded to make formations in unison and then in simultaneous solos. PIL was always charged with a quality that I have never felt in any other situation.

All work is ephemeral, and live work is always hinged in its moment. The particular nature and staging of *Mmm...* has allowed it to live on in the imaginations of those who saw it, and become myth for those who didn't.

SOPHIE FIENNES 25 March 2002

PERFORMERS: Joanne Barrett, Leigh Bowery, Bessie Clark, Michael Clark, Mathew Hawkins, Julie Hood

B, bb... In act II, the contrapuntal synchronicity gave way to something richer and stranger. Much of this was due to the introduction of two non-dancers (Bessie Clark, the choreographer's 68-year-old mother, and Leigh Bowery, Clark's long-time costumer). Mrs Clark sported a tousled mass of platinum curls as well as an obi and maxi-skirt of foxy pelts. In a decision that I can only imagine took longer to reach than one's average phone call home to mum, Bessie Clark also appeared topless. [...] When Bowery appeared as Mrs Clark's distorted mirror image (wig, pelts, curiously defined breasts), *Mmm...* flickered with a poignancy that was almost Chekovian in its evocation of loss.

Bbb... Clark was theatrically birthed into Act II wearing woollybear arm cozies and nothing else. Successfully and ingenuously cupping his genitals for the length of Sondheim's *Send in the Clowns*, Clark performed a goofy, gentle solo that endearingly mediated between the audience's interest in innovative and Bbb... (Beefy balletic buttocks). [...]

Ccc... [...] Clark gave Act III to one of his dancers, Joanne Barrett. [...] devising a solo of such torturous length, intricate movement and call for technical bravado that Nijinsky's original conception never ghosted its way on stage. [...]

Richard Flood, 'Michael Clark', *Art Monthly*, July 1992

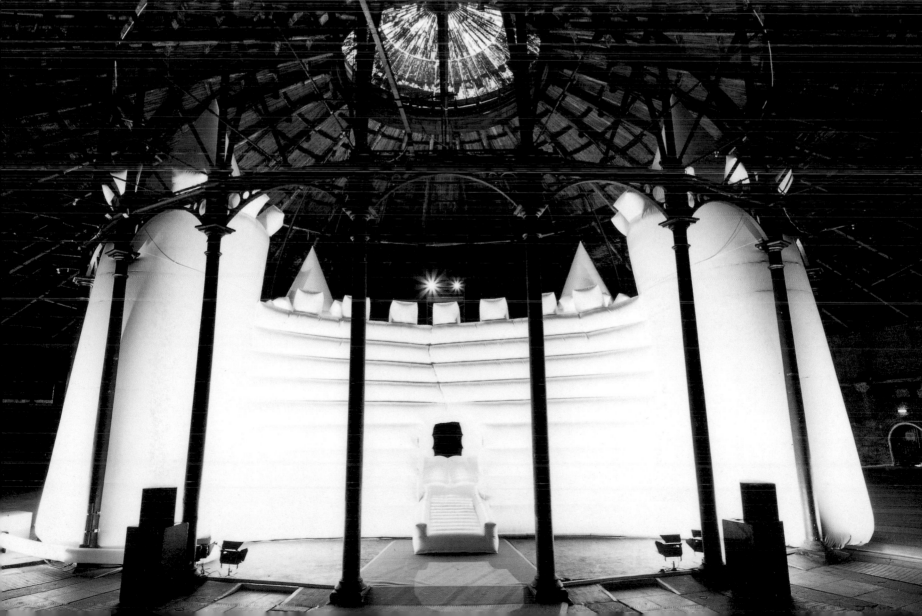

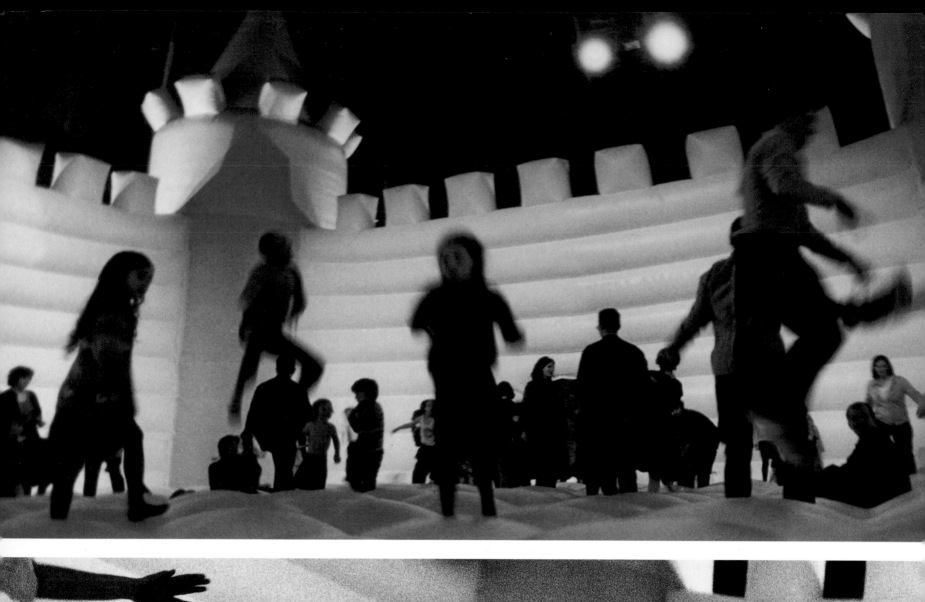
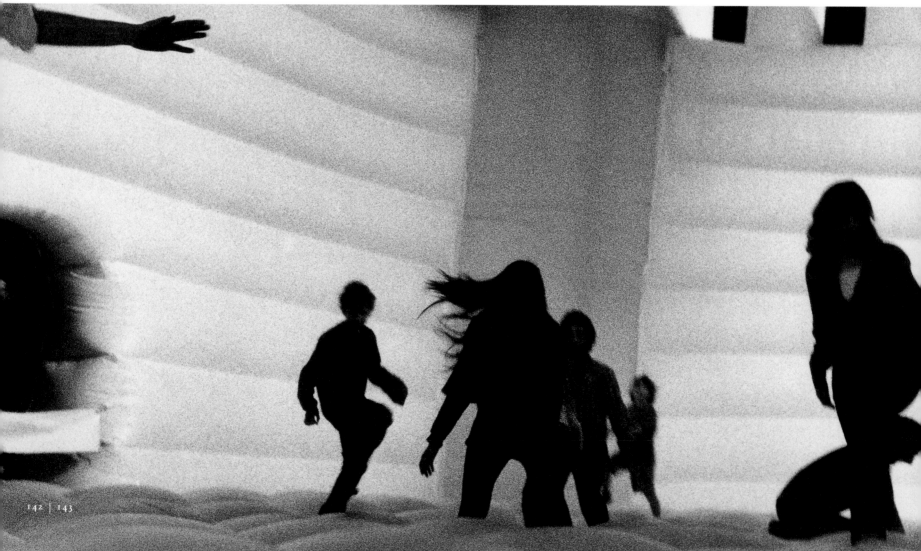

Choreography, to be a valuable thing, must be an utterly transparent vehicle, something which burns up in passage, making visible that which moves.

Tight Roaring Circle turned out to be such a thing. It is a choreographic environment which produces a specific and extraordinary kind of social interaction, sets people into motion informed by a delight in trajectory, a laughter invoking rhythmical relation to others and a kind of entrainment which takes place over longer stretches of time.

It was for us an extremely interesting and wonderful thing to be in the castle, in this room of no spectators, only participants, and experience the arising of a choreography which was incapable of being false. It was never false because the parameters of destabilization, unavoidable inclusion in the event, the sheer absurdity and the fact that the castle led you to move in a certain way created a situation where there was no room for actions that were not connected to the present. This is authentic reaction, something which often gets lost in the rigors of the ballet world, and yet without which ballet is utterly meaningless and, in fact, corrupt.

The castle continues to be an important and useful thing for us to think about; how the parameters of an event or a dance must be connected to the social, economic and psychological realities of the present in order to allow a response that is vital and meaningful. And then, how a dancer's response to the realities of a performance situation must be informed by an awareness that they are always in discourse with a great many things, among them historical tradition, learned physical and psychological patterns and the nature of the society around them. And how a dancer's work, then, is to react authentically in the complex energetic architecture that is choreography located in time, how they must consider where they are in order to become incandescent and burn away the form through which they are acting.

DANA CASPERSEN AND WILLIAM FORSYTHE 24 March 2002

From the first moment I walked into the Roundhouse it was clear that here was a sonic contraption of absolute brilliance, which would elaborate and assert itself on whatever I made. Though we could not have anticipated the dance spawned in the cloud-white invulnerability of *Tight Roaring Circle*, there were many attempts to predict some of its contours. I started with the belief that there were natural durations present in the setting which, if built into the music, could put it in tune with the dance. Some of these had to be quantifiable, intrinsic to the architecture and acoustics of the Roundhouse and the dynamics of a human body of so and so many kilos rebounding ballistically. I tried to extract from measurements of space, 'time constants' for calibrating the structure of the music. But knowing there were many more subtler, and harder to pin down, I decided to do the final mixing in the Roundhouse with the sound system in place.

Visits to the Roundhouse were undoubtedly the most fruitful source of ideas for everyone involved. I saw it first alone on a cold January night during a run of the Chinese State Circus complete with its famous *17 Girls on a Bicycle*. The building dwarfed the gymnasts and resisted the romance of the exotic, an important clue about the authenticity of its scale. But the band, thin reeds, strings and the barking gong of Chinese opera, provided as bewildering an initiation as could have been hoped for.

Later that year we all went together when the building was empty and began to grasp the scale of what was crouching behind the parking lot. The presence of the building refuted most of the ideas about the installation that had been imagined at a distance. The scale of the upper space, its round sky-eyed wooden roof, the wiry prosthetic iron work mystifying gravity, and the hidden plan of the undercroft, suggested an animist script concealed in this invention of industrial Britain. The symmetry of the scaling circles served the scope of a new mode of transportation, but traced the cosmology of a tribe grown away from magic. JOEL RYAN 9 April 2002

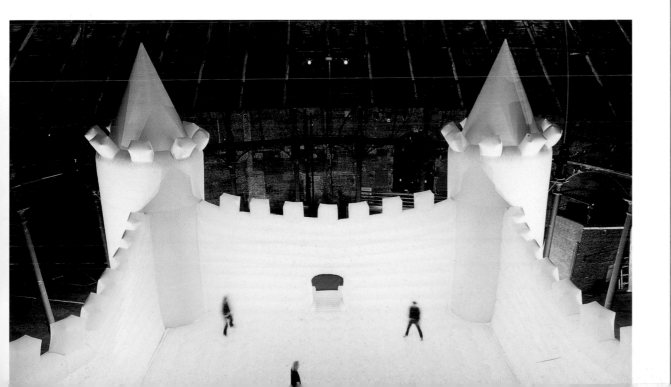

It started as nothing more than a comment at a dinner party. Asked what I would like to do next, having worked my way through most of The Royal Ballet repertoire, I said that before I hang up my toe shoes and mothball the tutu, I would really like to work with Siobhan Davies. Siobhan Davies – Sue to her friends – is arguably the UK's foremost contemporary choreographer. Although she has very little experience of the ballet world, I have long suspected that she is one of the few choreographers who could navigate the gulf between classical and contemporary technique and, what's more, make the trip worthwhile. A curly haired, bespectacled man across the table put down his knife and fork and turned his attention to me. It was Michael Morris, Co-Director of Artangel. "We'll do that", he said.

Thus it was that two years later, at 9 am on a Monday morning, five assorted dancers met – most of them for the first time – at the Mary Ward Centre in Euston. For Matthew Morris and Gill Clarke, regular members of the Siobhan Davies Dance Company, it was business as usual. For Peter Abegglen, Jenny Tattersall and me, all of us dancers with The Royal Ballet, it was distinctly foreign ground. The Royal Ballet's West London rehearsal studios may not be the epitome of luxury, but they are at least equipped with sprung floors, changing rooms, showers, on-site physiotherapy and, most importantly, a canteen. We were about to find out how the other 99% of the dance world live.

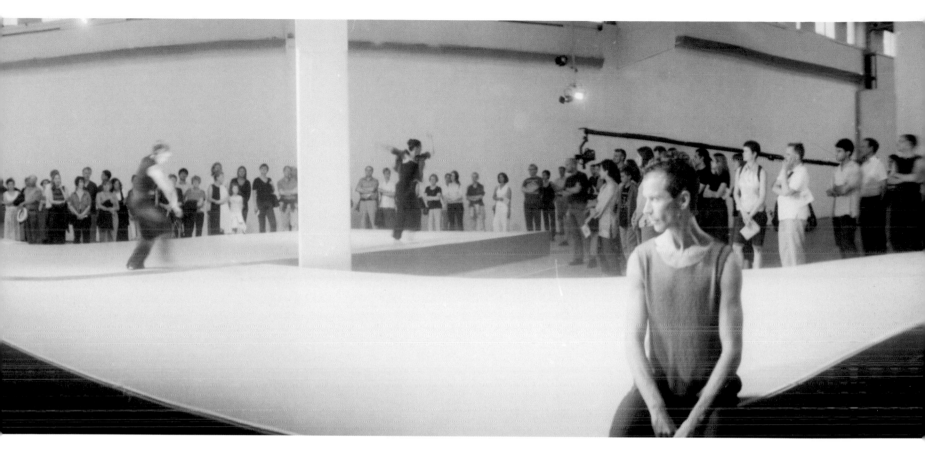

Our first day began with two dance classes taking place simultaneously. The ballet dancers – feet sensibly encased in shoes – stood upright at the barre and ran through the pliés, tendus and dégagés which constitute our warm-up. In the absence of a pianist, I meted out the rhythm in a monotonous, droning voice: "plié-two-three, stretch-two-three". The moderns, feet bare, lay on the floor at the other side of the room, Gill verbalising the exercise as it progressed: "Picture the greater trochanter as the body hinges forward". Peter, Jenny and I wondered just where our greater trochanters might be. An hour later, though our methods could not have been more diverse, we were all drenched with sweat and ready to work.

Sue arrived, her arms laden with books: designs, patterns, pictures, anything to spark the imagination and provide us with a starting point. She suggested we choose a motif from amongst their pages and set about recreating it in dance. Next, loading a CD into the stereo system, she asked us to absorb the music in our bodies and allow it to inspire sequences of movement reflecting its rhythms and contours. She then left us to get on with it while the CD played its entire repertoire at least three times.

Without rules, movement takes on a different quality. Traditional ballet places a high value on picture-perfect poses. The route between them, while important, is less significant than the end position and the effort

involved is always concealed. By contrast, in contemporary technique, the journey and the effort it takes are every bit as relevant as the destination. If classical ballet keeps its kitchen firmly below stairs, contemporary dance, like the Centre Georges Pompidou, wears its workings proudly on the outside.

Over time, the moments of despair became less frequent and a common and healthy curiosity drew our two worlds closer. Jenny was the first to kick off her ballet shoes and dance bare-foot and, despite a painful crop of blisters, Peter and I soon followed suit. I knew the frontiers were finally breached when I arrived late one morning and found Jenny and Peter lying on the floor alongside Matthew and Gill, locating their greater trochanters for the first time in their dancing lives.

The Atlantis Gallery, its vast space criss-crossed by interconnecting runways, provides a new landscape for Siobhan Davies' work and reveals the dancing body from a different perspective. Aside from that, *13 Different Keys* offers a rare opportunity to see ballet dancers as you've never seen them before; no proscenium arch, no conventions and, of course, no shoes.

DEBORAH BULL excerpt from *The Sunday Times*, 11 July 1999

In the centre of the vast white space of the Atlantis gallery, the five dancers moved on a platform shaped like a sharply angled cross. On another platform, two musicians fingered the muted intricacies of 18th-century French music for viola de gamba and harpsichord. And as dusk deepened, the minimal lighting was gradually intensified to spotlight the performers, all of whom were within touching distance of the spectators.

In terms of intimacy and elegance the whole conception was entrancing. The only problem was the audience. Despite the fact that *13 Different Keys* was a promenade event, most people raced for positions close to the platform and refused to budge.

[...]

Even viewed this way it was obvious that Davies, as choreographer had created a liberating chemistry between her two groups of dancers, allowing all five performers to discover their own identities within the fluid line of her movement.

Judith Mackrell, 'Take your platforms', *The Guardian*, 17 July 1999

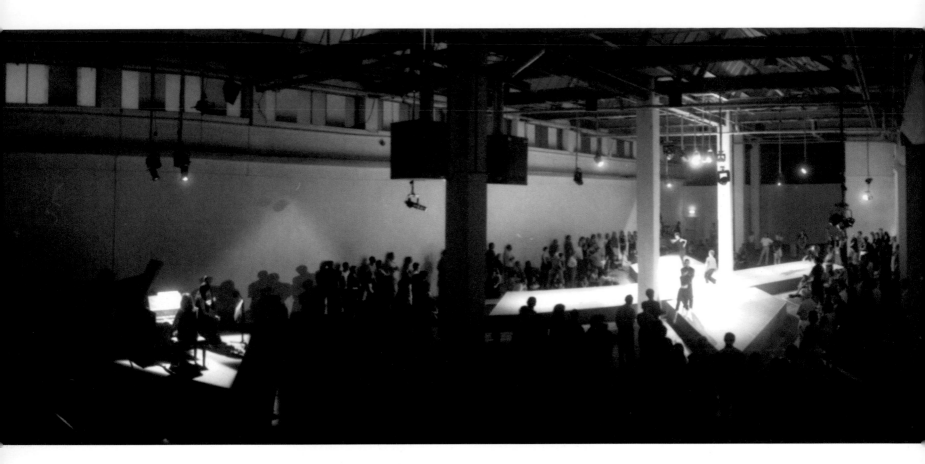

Two images of the meeting of worlds that took place over those weeks have remained vivid:

WEEK ONE:

A large hall where we've rehearsed frequently over the years with Sue – so definitely 'our patch'. I don't think it had seen a ballet barre before, but one was imported from somewhere!

Three tightly-clothed, shoe-clad dancers going through their paces on the barre, Deborah talking them through the exercises in shorthand, every now and then one of them remembering a teacher they had worked with and exercises they might borrow. I remember the snippets of other, 'real-life' conversation – something to do with estate agents, between exercises. It was a wonderful mixture of the serious, committed and casually functional.

Meanwhile, down the other end of the dance floor, comfy-clothed, barefoot, eyes closed in earnest concentration – the contemporary dancers, Matthew and I – lying, deeply intent, edging our way closer together so that my hushed directions could be shared between us. Not much 'real-life' entering here – more an attempt to filter it out for a while.

Both groups, in their own way going through the necessary and particular ritual to arrive at a place of beginning – the one seeming to trust the form to produce the results in the body, as it had done countless times before, the other more focused on clarifying an aware-

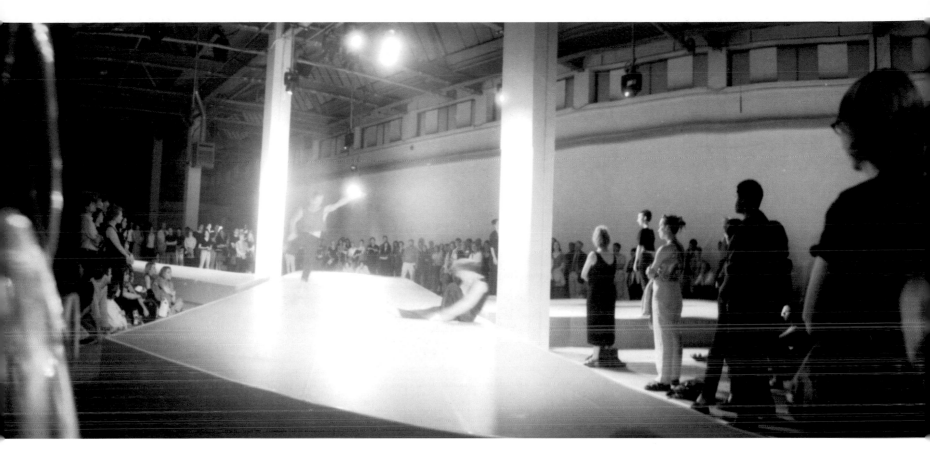

ness of the movement's journey through the body towards form.

THE OTHER IMAGE – A FEW WEEKS LATER:

A cavernous gallery space, the barre moved to one side, present only as a safety net: a body of dancers inhabiting the long and narrow X that was to be our 'stage', going through a ritual together, breathing, barefoot, sharing a common language – evidence of the journey we had embarked upon, discoveries made, doors opened, barriers broken and new friendships formed.

GILL CLARKE 14 April 2002

We had to leave our shoes above ground and put on steel capped boots and bright yellow hard hats. Then we descended into the Southwark underground station along a fire passage by the side of the escalator to reach a large hallway, a possible venue for the performances of 13 *Different Keys*. Producer, dancers, musicians and production technicians stood in this beautiful but unfinished space and we tried to imagine how to focus attention on a performing space with an audience that could move around. Dust filled the air, builders were criss-crossing the floor and shouting instructions. Reiko Ichise brought out her viola da gamba, someone miraculously found her a chair and she started to play in order to test the acoustics. Everything changed. Our imaginations shifted. Whatever linear thinking

that had been necessary to make decisions, involving the Artangel project or building a station, was suspended. Our timing changed. Every body slowed down, stopped or moved quietly, their eyes and ears on Reiko and her music. An artist at work, a space transformed from its original use and a group of people that became a curious and surprised audience. It all made complete Artangel sense.

In fact 13 *Different Keys* was never performed at Southwark Station. It was not going to be ready in time and we prepared our performances for the lager brewery in Brick Lane.

The preparations for these performances were extensive, unlike Reiko's improvised moment underground. But the planning did not take away that sensation of shift that seems so much part of Artangel events. Each one feels like the opening of a special box in which a totally unpredictable image appears and floods our imaginations before closing again.

Each time my imagination and therefore my work is shifted into new possibilities. I am so glad that I have been involved in Artangel's infectious vision.

SIOBHAN DAVIES 6 April 2002

DANCERS: Peter Abegglen, Deborah Bull, Gill Clarke, Matthew Morris, Jenny Tattersall
MUSICIANS: Carole Cerasi, Reiko Ichise

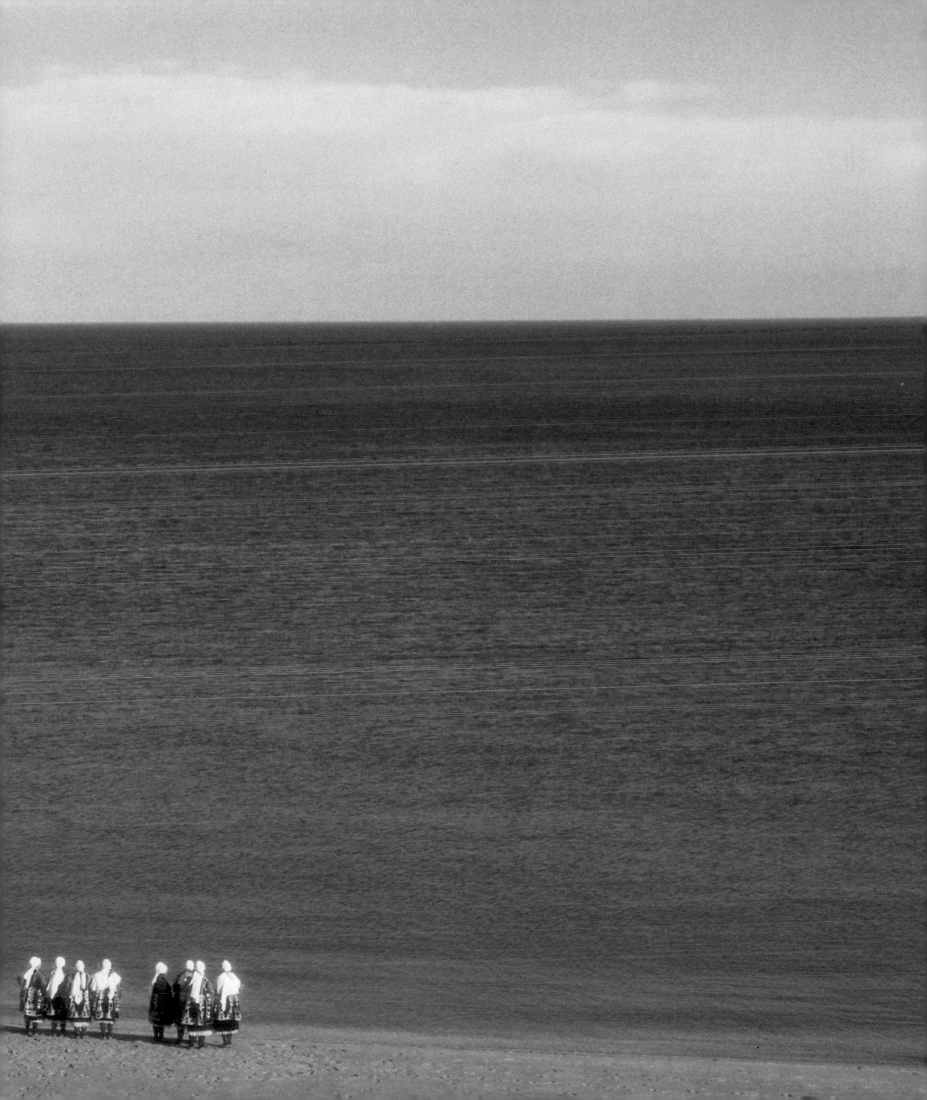

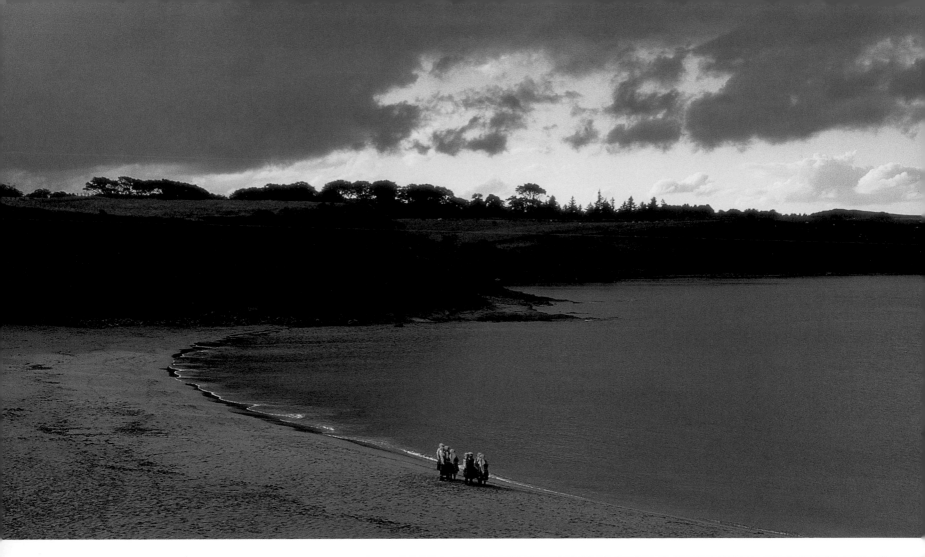

6 5 4 3 2 1 Hour 1 2 3 4 5 6 Hour 6 5 4 3 2 1 Hour 1 2 3 4 5 6 Hour

hours hours hours hours hours hour hour hours hours hours hours hours hour hours hours hours hours hours hour hour hours hours hours hours hours hour

Before Before Before Before Before Before After After After After After After Before Before Before Before Before Before After After After After After After

LOW HIGH LOW HIGH

6·00 AM → ◯ 12·00 PM → ● 6·00 PM → ◐ 12·00 AM → ◯

One DAY. 24 hours

1 hour after

+6 1 hour before the time of high tide is later (50 mins approx) each day.

 (because moon rises later each day corresponding by 0V15 YERA)

on the turning of the tide to SING

<u>NEAP TIDE</u> when the difference between high and low water is less than at any
other time during the month
. (when the pull of the sun and the moon are opposed we have moderate
tidal movements) sun moon earth in triangle.
a neap tide takes place at the quarters of the moon.

<u>SPRING TIDES</u> the highest flood tides, and the lowest ebb tides of the lunar month, the strongest
tidal movements high water on the beaches.
(when the pull of the sun and the moon is together) sun moon earth in line.
the spring tides take place twice a month; when the moon is full and when it is a mere
thread.

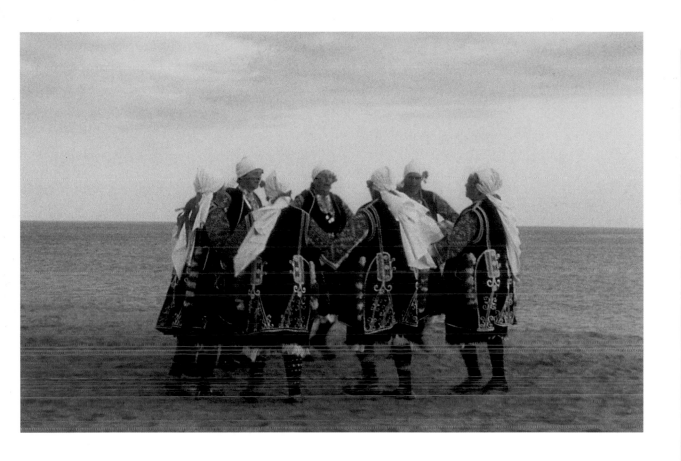

NEWCASTLE'S PROXIMITY TO THE SEA.

THE SEA . ON MASS . SOUND ✗ THE PEOPLE . ON MASS . SOUND = THE GROUP OF BISTRITSA VOCALISTS NOT ONE SINGLE SINGER THAT SING TO THE SEA . ON MASS . SOUND SINGER THAT SING TO

NORTH

NEWCASTLE

The act of contemplation of Huws' work never relinquishes its profane character, and because of this the business of getting to the Northumbrian beach on which the Bistritsa Babi were to sing appeared to be not a tiresome but unavoidable prelude to the work, but a necessary preamble, part of the way into it.

With only gentle waves and a light breeze, the singers were as clearly audible on the clifftop above as on the sand next to them and, although songs of the mountains, the music sounded appropriate to the setting. Sometimes in two quartets, swapping verse, sometimes arms linked in line abreast moving in simply choreographed spirals or circles singing in harmony or unison, and sometimes stationary, with the majority providing a drone-like accompaniment to a soloist, they sang first to the sea and then turned their face to the audience. Throughout the women gave a characteristic vocal leap at the end of a line which had the effect of casting the phrase adrift to move around with the wind and the noise of the sea.

The rain came after a quarter of an hour or so [...] but it merely dampened the land, bringing out its smells. [...]

At the end of the concert, the Bistritsa Babi turned and, still singing, moved off down the beach towards the waiting buses with the crowd following in a procession behind. The rainbow was complete by this time. [...]

Michael Archer, 'Bethan Huws, Bistritsa Babi, *A Work for the North Sea*', Art Monthly, September 1993, pp. 20–21

Four years it took Artangel to seduce me. And I never regretted it. You wouldn't believe it when you heard that I have travelled all over the world the last decade, being away sometimes for weeks and that, at the same time, I get homesick when I have to work abroad even for two days So when Artangel asked me if I wanted to make something for the Roundhouse, I first tried to explain in a polite way that it would be difficult because of my 'time schedule'. But then I gradually got so amazed by their initiatives, that I wanted to be part of it. That's when I said "yes".

From then on I came to London on a regular basis. Let's say once a month. For a weekend or so. That was the longest I could manage. London is too overwhelming. I get sad in these big cities. I feel like I lose my identity, my 'importance'. Of course it's also very exciting for a 'voyeur' like me to wander around. It took us a while before we finally decided to organise a musical event in the Roundhouse, inviting a selection of amateur-choirs who would sing their favourite song. Orlando Gough, one of the directors of the amazing choir The Shout, became the perfect musical director of the event. People thought we were brothers when we arrived together to witness choir rehearsals. We must have visited about forty choirs together, or apart.

The visits were a wonderful way for me to get used to the big city, to bring it back to a human dimension. And of course the way we were welcomed wherever we arrived was amazing. More and more we were concerned about the fact that we would never be able to translate these experiences to the event in the Roundhouse. We first had wild ideas about it. Maybe we could bring in an old train, use horses or construct an immense 'wip-plank' (see-saw) on which we could move the choirs. But the more we got to know the choirs, the more we were sure we had to "cut the artistic crap" and just listen to the voices.

The first miracle happened a week before the event. We had selected sixteen unique choirs and invited them for the (unique) rehearsal in the Roundhouse. All together there were about 600 people arriving from all corners of London. They entered a huge, empty and cold 'cathedral' as nervous and excited as we were (and we were VERY nervous). We just asked them to sing their song and listen to each other. It sounds very sentimental but most of us could not hold back their tears ... and we were not able to explain it. And here I also must confess you that I have NEVER in my whole career been involved in a complicated event like *Because I Sing*, where the support and the engagement of every single person involved in the project (and there were MANY people) was so ... full and perfect.

A second miracle happened on the 31st of March and the 1st of April when hundreds of people witnessed *Because I Sing* and got trapped in the same emotional effect of the singing. I couldn't rationally explain it. But it was there

And finally a third miracle was given to us. Sophie Fiennes, who made a documentary about some of the choirs and the event in the Roundhouse, was able to translate this strong two-year-long experience into the right images. So overwhelming that people who weren't there on one of those two days in the Roundhouse, could have a similar experience by watching 'the movie'. Sophie and I are sure we got a little help from the Holy Ghost.

ALAIN PLATEL 13 February 2002

The phone rings. Would I be interested to do an Artangel piece? Yes, please – with Alain Platel? Yes, *please* – involving masses of amateur choirs? Of course.

Our aim: to find 'choirs of character'. It's almost a mantra.

Our first choir visit: to the Italian church in Clerkenwell Mad Rococo décor, girls in sunglasses. The church is very full, people coming in throughout the service, kissing hello, chatting. An exciting sense of a hidden community for whom this is an important social as well as religious event. And a warning sign: the choir is miniscule, and old.

The Deaf Carol Service. Before the service, the church is almost silent, full of gesticulating people. A man next to me signs a dirty joke to his friends, roars of laughter. People converse easily with friends twenty yards away. The room is on a rake so that the congregation can see more easily. Vera Hunt, the leader of the choir (and one of the first women to be ordained as a vicar), is an immensely charismatic person – her very method of signing seems to carry with it an enormous moral authority. The organist is profoundly deaf, but everyone manages to keep up with the hymns somehow, the choir mimicking Vera's signing in unison (apparently they do counterpoint signing as well).

Studio 2 at the Drill Hall, off Tottenham Court Road. A rehearsal of ebullient, witty, committed Velvet Fist, twelve women and a man singing political songs with immense energy and charm – a secular choir who sing what they believe.

Each choir will sing a song (two songs? three songs?) from its own repertoire, and together they will sing something (a refrain?) which Richard (from The Shout) and I will write.

The basement of Cecil Sharp House in Camden. Our first encounter with the immense, powerful, ambitious London Gay Men's Choir – what a sound! They sing serious music and they sing cheesy music with enormous gusto. The arrangement of *Barbie Girl* is accompanied

Because I Sing assembled 16 London amateur choirs to perform a sample of the music they loved, linked by a refrain composed by Orlando Gough and sung by his superb professional group, The Shout. The show was flamboyantly staged by Alain Platel to take advantage of the dramatic possibilities of the Roundhouse, with the audience promenading and the choirs raised on terraces.

In classic Roundhouse style, it was all a bit chaotic, but how could one resist the sheer ecumenical glory of such a project? Children's choirs, gospel choirs, a refugees' choir, a deaf choir, a gay men's choir, a Maori choir, a Jewish choir, a Georgian choir, a Lloyd's insurance choir, a socialist choir, a WI choir (whose rendering of *Smoke gets in your eyes* was just about the highlight) came magnificently together, uniting at the end in a massive counterpoint of 500 voices that provided as overwhelmingly joyful an assertion of our diverse yet common humanity as the choral symphonies of Beethoven and Mahler.

Rupert Christiansen, 'Never mind the pantomime, listen to the voices', *The Daily Telegraph*, 3 April 2001

(enhanced!) by tongue-in-cheek choreography. The tenors sound like Jimmy Somerville.

A draughty church in Nowheresville, North-West London. Gagneurs d'Âmes, a Congolese Christian Choir, are rehearsing. The church lights up with the sound. I could happily listen to them singing for hours. Their leader Diakese is (understandably) quite wary of us. Like a lot of the choir leaders, he has a suspicion, I think, that we are a bunch of smart-arses that want to send up his choir. Fortunately he's quite wrong.

A room full of teenage girls at South Hampstead High School. The choir director Diana Kiverstein seems to break all the rules – there's no pandering to teenage taste (half the songs are in Latin for God's sake, and the arrangements are immensely sophisticated). But the girls clearly love it, and they sing with amazing expertise and commitment. Diana bullies them, cajoles them, has frequent tantrums.

On our first visit to Ngati Ranana, the Maori choir, famous for their welcome songs, we get more of a welcome than we bargained for. According to ancient Maori custom we must sing for them. We manage to stagger through our favourite gospel song *Soon And Very Soon*.

The London Jewish Male Choir is performing at the Sacred Voices Festival in Richmond, down by the river. Drizzle. They are dressed in blue shirts; they look like security men. Beautiful songs separated by terrible jokes. A strange Gilbert-&-Sullivan jauntiness to some of the songs, and a sentimentality, like a Welsh choir. The bass soloist David Hilton has one of the most moving voices I've ever heard.

A break in the morning's activities at the Swiss Music School. Christine Sigwart has been trying to firm up a rather tentative version of *Swing Low Sweet Chariot*. The children burst into a robust and immensely funky jam session.

A Greek Orthodox service in Camden, an Armenian Orthodox service in Kensington. Beautiful, mysterious, awe-inspiring.

The choir leaders gather together at the Roundhouse for the first time, sit in a circle and announce themselves – it's like a UN meeting. Great excitement and anxiety.

Even better than the Met singing *Gwahoddiad* is Gwalia, the Welsh male voice choir singing *Gwahoddiad*. As it should be.

Alain wants to know: "Who are these people? Where do they come from? Why do they sing?" And he finds

out by quiet, pertinent, extremely (to me terrifyingly) direct questions. "A Deaf Choir", he says to Vera, "isn't that a bit cynical?" She is not offended.

The Shout, the (professional) choir run by Richard and me, is becoming involved. A group of singers with a diverse range of backgrounds, they are, in a way, a microcosm of the whole project. They will be a kind of glue for the piece, providing short choral interventions, making connections between the songs of the amateur choirs, leading the refrains.

A late entry: Maspindzeli, the Georgian Choir. On the face of it, the choir is a nonsense – a Georgian choir with only one Georgian person in it. But the sound is wonderful – raw, gutsy, committed, folk-like but sophisticated. A must.

A sequence of songs is emerging – leading from the exotic, distant (Armenian liturgy, Renaissance polyphony) to the familiar (*Smoke Gets In Your Eyes, The Internationale*). A high proportion of religious music, but wonderfully varied. Very few love songs for some reason. We'll end with each choir singing a different well-known song, simultaneously, a choral Tower of Babel. But very quietly!

The first ensemble rehearsal at the Roundhouse. The choirs are initially (understandably) nervous, wary of each other; by the end of the day they are giving each other ovations. Particular support for the Swiss School. Ah, this is why we decided to do the project!

ORLANDO GOUGH 21 March 2002

On reflection, and in relation to the work I do – with *Because I Sing* being a part of that – the only words that make sense to me are a set of three questions, followed by a repeated command:
Who are you?
Where do you come from?
Where are you going?
Connect.
Connect.
Connect.

SOPHIE FIENNES 5 March 2002

PARTICIPATING CHOIRS: The Armenian Church Choir of St Sarkis, Côr Meibian Gwalia, Diocese of London Deaf Choir, Finchley Children's Music Group, Gagneurs d'Âmes, The Kingdom Choir, The Lea Valley WI Singers, London Gay Men's Chorus, The London Jewish Male Choir, Lloyd's Choir, Maspindzeli, The New Elmwood Singers, Ngati Ranana, The South Hampstead High School Choirs, Swiss Church Music School, Velvet Fist, The Shout.

With so many different choirs singing their favourite pieces, this was more like a choir festival, than a piece of theatre, and by the time we reached the alternating performances by the London Gay Men's Chorus (Rogers and Hammerstein's *Keep it Gay*) and the Lea Valley WI Singers (Kern & Harbarch's *Smoke gets in your eyes*) the audience responded with cheers and wolf whistles. Yet there was no sense of competitiveness – the choirs were of such different shapes, sounds and sizes that each song took you into a different musical world, from the delicate modernism of P. Lane's Gardener's *Nonsense Song* (by the glamorous South Hampstead High School Choirs) to the low frequencies of bass soloist David Hilton with the London Jewish Male Voice Choir.
John L. Waters, '500 sing their hearts out', *The Guardian*, 2 April 2001

I think it was in 1991 or early 1992 that the dancer Laurie Booth introduced me to a person in London who had just started producing, together with a partner. I told him about my work and that I was very interested in doing a new work in London. Unlike the usual 'business' meetings this case was seriously different. Not only was it really a very enjoyable lunch that we had together, the men I spoke to became very quickly serious and after I explained that I was looking for a 'non-museum' space – I was especially interested in an old grain storage or similar for a new installation – they got excited. Short after that meeting they had found a place that was actually much different, it was a newly built office building at the Angel tube stop. (I still do not know, if this was pure coincidence or if this was planned by some sort of mighty power – with Angels one never knows – that the name of the building 'Angel Square' was so much alike the name of the organization that these men were running, 'Artangel'). Anyhow, I am almost sure that some sort of celestial support was involved, since these two men not only became excited about the project but also managed to produce my piece not only in the most professional but also very human, friendly – really lovely – way. As I mentioned before, the building was indeed very different from what I was originally looking for, except it had the same structure as the kind of building I was hoping for. I had five almost identical floors and we could use them all. And that was exactly what I wanted. They found the perfect place, fitting and challenging at the same time.

A few years later they called me again and asked if I could help them to convince Bob Wilson to do a piece. And I have to admit, I pushed a little bit when I said: "knowing Bob, he will ask me anyhow to make the sound for it, so why not invite us together?" I was sur-

prised that they immediately agreed. (But that is obviously the way these two men are – direct, fast, personal, and always fully engaged.) So we did *H.G.* together. Again they found the perfect site. I am sure I can say this also in Bob Wilson's name, that the site was again inspiring and challenging. HANS-PETER KUHN 8 March 2002

People stay five minutes, other people stay hours. It's much more your individual decision I use sounds that are unnerving, but I put them in contrast or in relationship so that they have a function within the piece. I am not interested in provocation. I would invite people to come and simply listen, because I have the feeling that many people don't hear any more. Wherever you go, you have all this trash noise going on. Generally it's too much. Your brain blocks it off. So if there is something like an intention, that's the only intention, giving a chance to listen. I don't teach anybody to listen, I'm just giving a chance, I'm not the mastermind behind all this, there is no ideology You can be there and experience the situation of listening and looking. HANS-PETER KUHN *The Wire*, issue 139

The work could perhaps be approached as a series of five frameworks for mediation about our relationship to sound, exploring the different ways in which sound (or the memory of sound) can be related to and extended in space.

Floor 1 (*Elements*) [...] Entering a completely dark room of unknown size, the visitor was forced to wait until a brief flash of light accompanied by a short explosion of sound pierced the darkness. [...]

Floor 2 (*Formal*) [...] Through sequencing, fast repetitive patterns passed along the chain of speakers, communicating vividly the sense of movement across a large space.

Floor 3 (*Djungle*) was full of signals with clear human connotations. Sounds of discrete events (a car passing, a telephone ringing, a champagne glass falling) were repeated through a large number of speakers in endless overlapping sequences. [...]

Floor 4 (*Inside*) was the most effective part of the work and, by contrast with the rest of the floors, seemed designed to focus the attention of the visitor, both sound and vision working in parallel. Visually, red, green, yellow and blue stage lights projected onto a row of pillars made a strong statement, demanding attention. The rest of the floor was empty of objects but the whole space was filled with a continuous tape of the most haunting and well-integrated sounds of the installation, a composite of ambient sound from factories and other industrial settings.

Floor 5 (*Museum*) was a rude shock: a silent museum of more than fifty objects that produce sound or are associated with it (for instance wrapping paper, a photograph of the Beatles, a dead fly). The objects were fastidiously lit in glass cases, a line of sand separating the cases from the visitor, the listener moving through, inside and away from it.

Nick Cauldry, 'Five Floors', *Variant*, Winter/Spring 1993, pp. 24–25

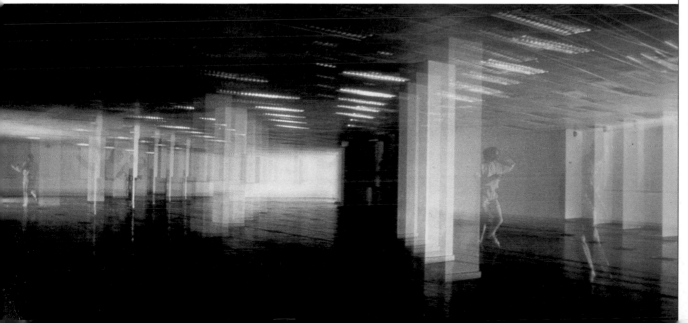

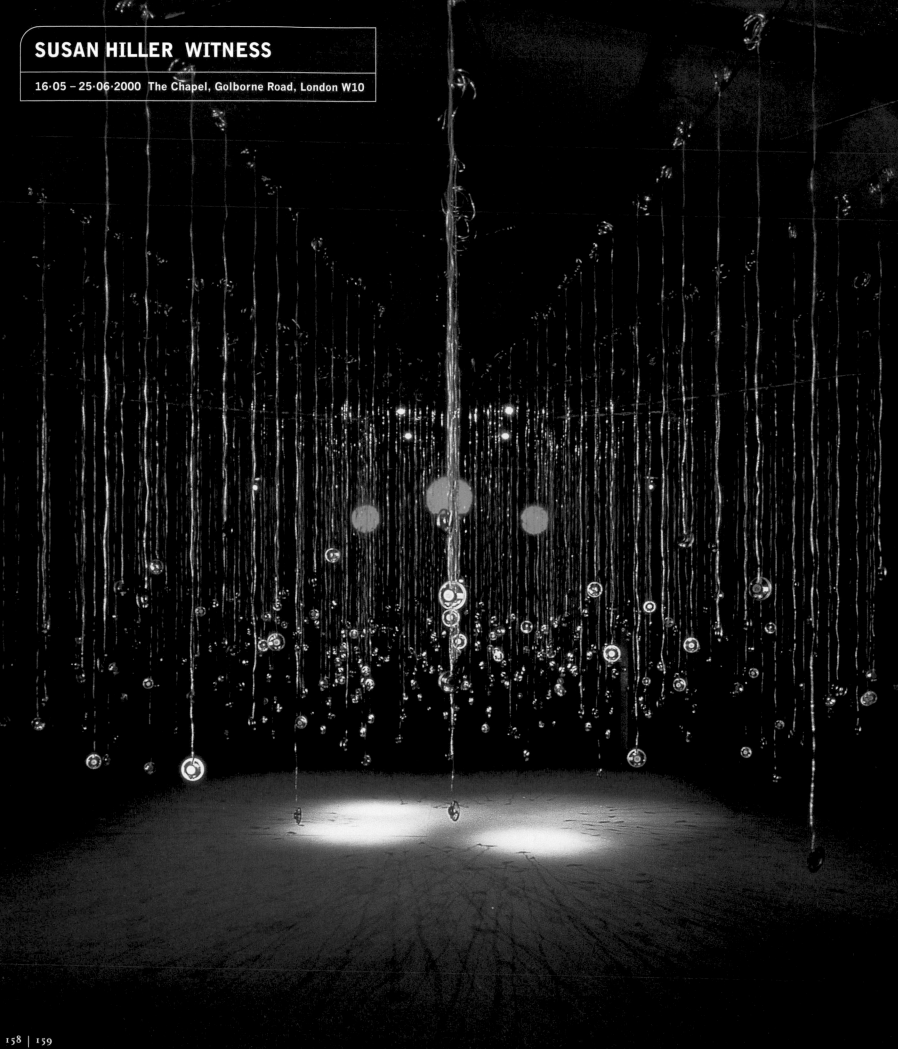

Initially, I was discussing a proposal with James called *Box of Stars*. This was a lovely, scientific idea that I could never figure out how to materialise – the idea was so elegant that any physical realisation seemed banal in comparison. Neither of us is interested in art that doesn't go any further than its starting point, so with regret, we agreed to allow *Box of Stars* to remain just words on paper. When I began to imagine a very different project, James went along with the suggestion although it was extremely tentative. *Witness*, unlike *Box of Stars*, began with prose and ended as poetry. I can't think of an organisation other than Artangel that would have been happy to talk about one project for quite a while, and then let that one go, so that we could embark on another with no idea where it might lead. It was a project about different kinds of belief and it was this belief that was critical to me. The support is critical as well as financial and organisational and it goes all the way

For quite a long time I've been looking at our culture's representation of the uncanny aspects of the so-called paranormal or supernatural. It's a position that questions our official version of reality, while not replacing it with any other orthodoxy. Formally, as with everything I do, I take a cultural artefact as a starting point and build up a work from that, keeping its original nature as a sign. In *Witness* I began with people's personal testimonies about these sightings and experiences as they appeared on the Internet – which I gradually came to realise was functioning as an international confessional. The idea of embarrassing secrets brought out to share in public is what a lot of my work seems to be about, and *Witness* offers us private experiences of what once would have been considered mystical or religious visions of angels or whatever I tended to be interested not in the famous examples, but in people who began their stories by saying something like, "Well, I'm embarrassed to say this happened to me but I feel I need to tell people about it" I'm not questioning the truth or falsity of the stories, they are simply social facts which exist. To place viewers in the position of listening to so many stories was to invite their co-operation. In fact, when I found what seemed to me to be the perfect tiny speakers to use, the whole formal shape of the piece very quickly fell into place, because it replicates the cross-in-a-circle design of the speakers on a much larger scale. This shape itself refers obviously to classic UFO design, and beyond that, to what is a widespread mystical diagram. The effect of so many voices all speaking at once is something like the sense I have of the vast sea of stories we live within, and the option to listen to individual stories is a choice left up to viewers as they wander through it.

To see *Witness*, the new installation created by Susan Hiller for Artangel, you step out of the busy market on the Golborne Road and into the scruffy ground-floor room of a dismal chapel. A table and some chairs, a visitors' book, exhibition information on the bulletin board: for an exhibition of contemporary art, everything looks normal. It's only when you stumble up a spiral staircase to an attic room running the whole length of the building that you begin to feel that something extraordinary is about to happen.

And it does. As your eyes adjust to the dark at the top of the stairs, what you see is the spectacle of 600 circular microphones suspended by wires from the chapel's rafters, each crackling with the muffled sound of people speaking in half a dozen different languages. Overhead, spotlights beam down on this susurrating forest of sound. [...]

What now happens is even more extraordinary. By placing each microphone to your ear, you hear a man, a woman or a child talking. Each is telling the story of their own experience with extraterrestrial beings. Sometimes they simply report the sighting of a UFO, at other times a close encounter with an alien. [...] And what is so compelling is the earnestness of the testimony, the absolute conviction with which these anonymous, ordinary people tell us of their meetings with men whose skin is blue or metallic, whose craniums are huge and who have slits for eyes, or no mouth. Then, for a few electrifying moments, all the voices fall silent except for one who, speaking in English, holds the room spellbound. [...]

The more I thought about *Witness* the more I felt that its ostensible subject, UFOs, is beside the point. These people could have been fundamentalist Christians talking about miracle cures, or psychiatric patients discussing their therapy. It's true that listening to them makes you ask yourself whether what they say could possibly be true. But what is important is not whether we believe, but that they do.
Richard Dorment, 'Close encounters of the aural kind', *The Daily Telegraph*, 31 May 2000

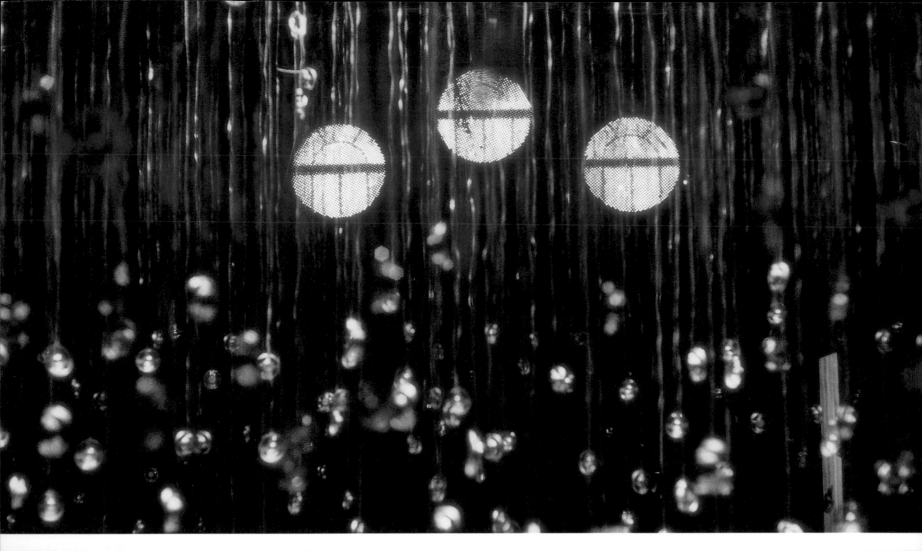

I want the viewer to become complicit, to take on the role of detective, analyst, collaborator, activator or whatever. The main thing that interests me in my large public works is to become, once something is 'finished', a participant myself. So I make the works for myself as 'an other'. The idea is to find out something new through a focused experience that only the work can provide. If I knew ahead of time what it might mean, how it would affect my feelings and thoughts and the feelings and thoughts of other people, I suppose I wouldn't bother. What I think art provides is something like an instigation or provocation of an enhanced awareness of how we are all collaboratively and creatively implicated in making a culture

SUSAN HILLER April 2002 and excerpts from an interview

with Mary Horlock for *Palletten* issue 245 – 246

Susan Hiller is constantly collecting – not so much objects as contemporary rituals and patterns of thinking and feeling. This is the raw cultural material, the social fact, from which she forms her work.

One consistent area of interest for Susan has been the paranormal, and she had begun to collect testimonies from around the world from people who had seen or felt what they considered to be extraterrestrial presences or apparitions. She gathered an extraordinary range of this material over a relatively short period of time, classified both by origin but also by species of apparition. We then gathered together a group of willing accomplices to help read the witness statements in their original language or dialect. There were several hundred witness statements in over 30 different languages. Each and every one of them was individually recorded before being mixed by David Cunningham.

I recall going to Susan's studio one day and her showing me a very simple cheap mylar speaker. She wanted a dense forest of speakers but she also wanted a shape to the piece, so that it would be more than simply an immersive environment. The final form of the installation echoed the shape of the speakers: it was a kind of oval with a cross running through it and it also echoed the form of a flying saucer

In essence the work explored the necessity of believing and how and why seeing becomes believing. At what point do rational systems of explanation fail to account for an experience?

Susan worked with her sound engineer Adrian Foggarty, who came up with an installation that worked acoustically, so that you could hear a murmuring of language as you entered the room. As you went into the work, you could identify individual testimonies, and could pick up and put individual speakers to your ear. Adrian also worked with Susan to orchestrate the rising and falling of the babel of voices. As the voices died

away, the audience seemed to be rendered immobile. *Witness* was one of those projects where the research preceded the location. But when the right place, an abandoned empty Baptist chapel on Golborne Road, was finally found, then the form began to be resolved and the encounter with the work was finely tuned. The chapel was directly off a street, which could not have been more culturally diverse: a mix of Afro-Caribbean, North-African, Portuguese, Asian and British, which reflected the diversity of origins of the witness statements in Susan's piece. Every Friday and Saturday, a man from Yorkshire set up his stall to sell fundamentalist Islamic pamphlets JAMES LINGWOOD 20 February 2002

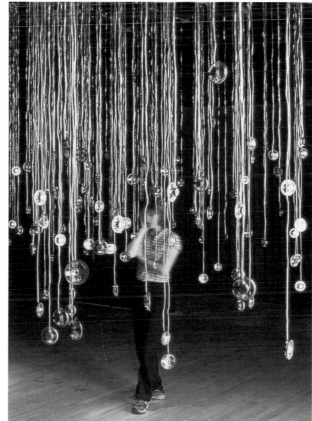

The piece plays with our ideas about faith. What can we believe in? Is there anyone out there? Is religion just another form of superstition? For sceptics, listening to these stories will be a challenge to their reason, such as the directness with which these stories are told.

Hiller enjoys exploring things that are beyond recognition, that are invisible or are out of her control. Here she adds to her anthropology with impressive sculptural atmosphere, giving us stories that will linger in the head like a weird dream.

Simon Grant, 'Testing our faith with tales of aliens', *Evening Standard*, 24 May 2000

MICHAEL LANDY BREAK DOWN

10 – 24·02·2001 Former C&A Store at Marble Arch, Oxford Street, London W1

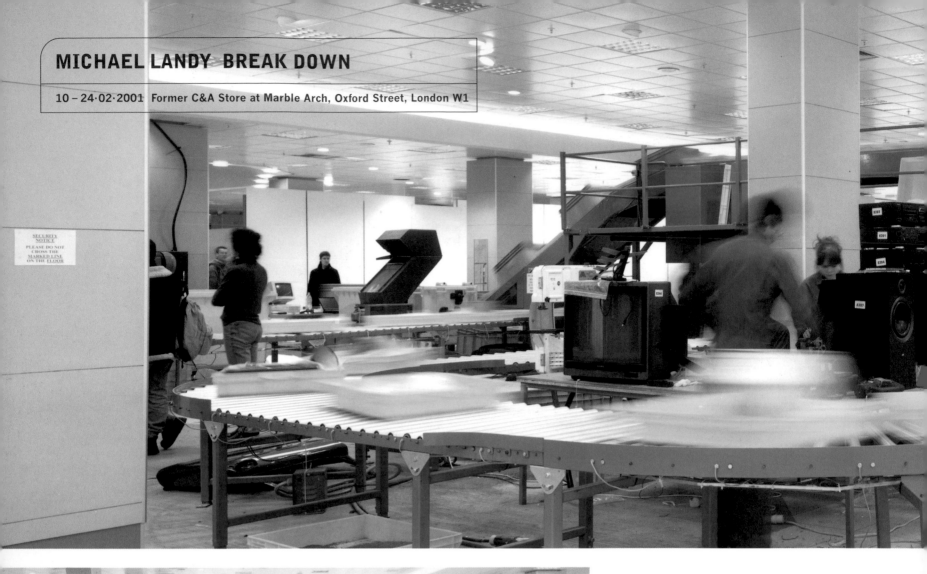

"Mike, is there life on Mars?" This is what Dave Nutt, my Buddhist Saab mechanic would shout at me standing on the platform, as he was ripping through my Saab 900 16S turbo 16S, and we listened to the umpteenth David Bowie record on my B&W speakers.

For two weeks, and two weeks only, we had set ourselves the task to destroy my worldly possessions, all 7,227 of them. I hadn't really considered whether we could do it or not, since, to the best of my knowledge, no-one had attempted this feat before.

Within no time at all, dismantling my belongings or watching them travelling around in the yellow trays on the 100 metre conveyor belt in front of would-be shoppers became normal.

This is what I did along with 12 of my operatives – whom I now call 'disciples'.

Morning: put my blue Artangel overalls on; walk to London Bridge station to catch the Jubilee Line to Bond Street; walk along Oxford Street, looking at the new, never used DVDs and digital cameras in the shop windows; go into the former C&A building (Marble Arch branch); re-stock the yellow conveyor belt trays. Clive Lissaman (janitor) then switched on the power.

We would always start with the same song in the morning – *Breaking Glass* – and finish with the same song every evening – Joy Division's *Love will tear us apart*. Standing on the nine foot high platform from which I could oversee the whole process, it was my job

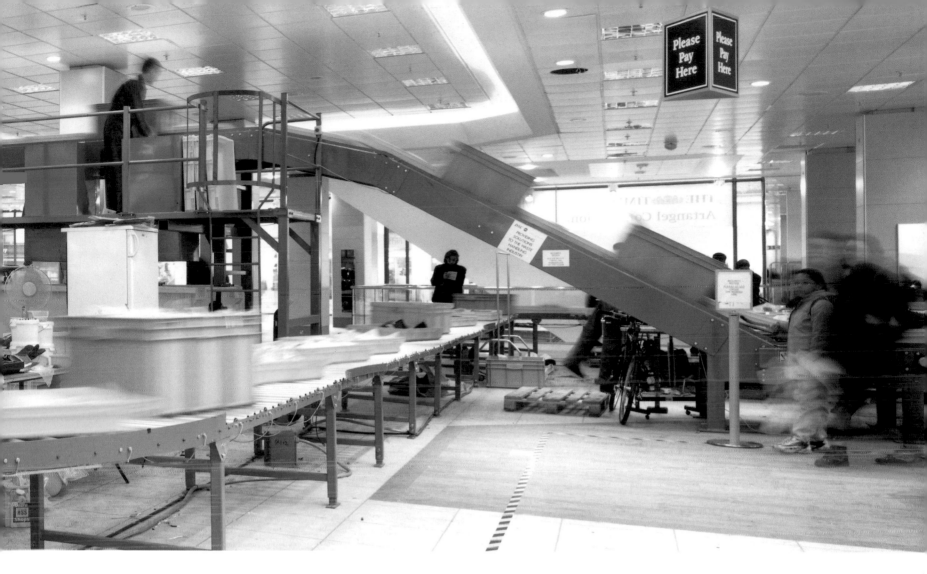

to separate the dismantled materials into their individual containers, i.e. paper, metal, plastic, as well as look out for potential shoplifters.

I really enjoyed being on my high platform. It separated me from the activity down below. When I walked on the ground floor, I felt vulnerable. That is not something one should be doing in the consumerist mecca of Oxford Street.

Certain people criticised *Break Down* for being a spectacle, but a spectacle is passive, and this wasn't. Shoppers wanted to know what was going on; you could divide them into two groups. People who had heard about the project (knowing faces) and people who walked in from the street (quizzical faces). Certain shoppers would offer me money for parts of my car, little old ladies would bring back clothes, which they had bought at the C&A closing down sale. We would have to explain to them that that they wouldn't be able to get their money back or exchange with other items. Basically we could have spent the whole time talking to people about what we were doing. The invigilators were usually exhausted by the end of the day.

At 6 pm a gang of us went to the pub to unwind and exchange stories about what had happened that day One of the stories was about a man who took my Chris Ofili print – which I had won in a *Time Out* competition, in which the question was: "who won the 1997 Turner Prize?" I know that one, since it was my girlfriend – from

its yellow tray and started to walk away with it. But Clive had spotted him doing it so he grabbed the other end of the print and managed to grab it from him. "He doesn't really want this, he's getting rid of it anyway", was the man's response.

I was amazed that we managed to secure C&A as a venue. The Production Manager, Tracey, had spotted the headlines that C&A was closing down and managed to have Artangel meet up with C&A's property manager. The whole deal was almost blown out when a headline in the *Evening Standard* appeared just before we opened. 'Madman at C&A' suddenly seemed to jeopardise the project. Artangel saved it with a quick charm offensive.

Nearing the end of the two weeks, apart from expecting Health & Safety to come and close us down any minute, there was a tense atmosphere. I spotted my mum crying and it started to feel as if I was preparing for my own funeral. So I had to come down the ladder and throw her out.

I gave an average of six interviews a day. I talked to people from the Brazilian radio to a reporter from *The Baltimore Sun*. During the two weeks the project lasted, it seemed as if pure adrenalin surged through my veins. The only thing I didn't give up was smoking. When I felt the need I would ask one of the operatives to take over the platform as I went around the back for a cigarette.

In the late afternoon we had the daily ritual of drinking a cup of tea inside what was left of my Saab 900.

Only a few weeks ago, the C&A store near Marble Arch in London was closing down for good, and the thick black capitals screaming from the windows insisted, as if in a giveaway frenzy, that "EVERYTHING MUST GO!"

No wonder Michael Landy has seized on this location and installed, in the now empty building, his alarming and aptly entitled *Break Down*. For this uncompromising young artist decided to make the former C&A emporium the site of an unimaginable sacrifice. From today, anyone making their way on a shopping expedition along Oxford Street will be able to step inside and witness his extraordinary act of willful yet coolly organized dispossession. For Landy is ridding himself of everything he owns. And no setting could ram home the full meaning of his recklessness more powerfully than this deserted temple of consumerism.

Richard Cork, 'A Brutal End To All Worldly Possessions', *The Times*, 10 February 2001

We would have a bit of a gossip. At the beginning of the stripping down of the car, it didn't feel like it was mine, until I sat back down inside it and started playing with the steering wheel.

In the first week our mascot was Rocky the Lobster, which I had bought from the Gadget shop on Oxford Street. He chirpily sang, from 10 am until 6 pm, the two songs *Dowhadiddy* and *Don't Rock the Boat* until his time was up when we dismantled and granulated him.

For the most part I was hung over, exhausted, and kept myself going on solpadeine. For those fourteen days it was like a holiday from everyday life, destroying your belongings in front of complete strangers. C&A became this exclusive anti-consumerist holiday resort as all around us shoppers purchased the latest consumer durables.

After *Break Down* I really got the taste for dismantling objects. My value system was without value. I would sit on a bus (since that was my only form of transport then) and think about what the best way of taking it apart would be. Talking about value: the only time I even thought "Christ what am I doing?" was when I set about blow torching the gloss paint from Gary Hume's painting in front of Canadian and German TV crews.

One day a young woman approached me whilst I was on the platform. She asked would I consider swapping my dad's sheepskin coat for what she had in her duffel bag. I told her I couldn't swap it, but she was more than welcome to try and steal it.

Eight months later, I was with Gillian in Tesco's in Bethnal Green and I saw exactly the same sheepskin coat, worn by a man, maybe one size smaller than my dad's. I wondered whether she did steal it in the end and it was having a second life. MICHAEL LANDY April 2002

There are a large number of 'dream' projects out there, projects artists have spent a long time developing in their minds or on paper. We set up *The Times / Artangel Open* to try and bring some of these paper projects into the world. The two commissions we selected from this process, Jeremy Deller's *The Battle of Orgreave* and Michael Landy's *Break Down*, arrived in very different forms. Jeremy's could not have been more concise – a one-paragraph submission and a photocopy of a poster, Michael's came as an idea already developed through a series of drawings and blueprints.

Michael had been living with the idea that he would systematically destroy all of his possessions in a kind of customised waste disposal facility for two or three years. One of the key things that emerged from our initial conversations was his desire to make an inventory of everything he owned. We thought it might take a few weeks. In fact it took Michael and his assistant, Clive Lissaman, over a year. They itemised and categorised over 7,000 possessions. This list of a life-time's gatherings became an important part of the project, and it formed a mute counterpoint to all the destruction.

Michael visited several disposal facilities and recycling plants. We then realised we needed to custom-build a mechanised structure – so that Michael could find the right form for the work. It needed to be circular with two figures of eight looping around four bays in which the operatives would work. The second issue was that we needed to commission the structure before we had secured the place in which to present the project.

It was difficult to find the right situation in which the full force of Michael's idea, now called *Break Down*, after he had initially called it *Michael Landy's Lifestyle*, could be released. We had been aiming for a high street presence at the time of the Christmas rush or the January sales, but that proved impossible. Oxford Street was obviously the prime site, but it quickly became apparent that there were very few places big enough to accommodate the project. Then Tracey Ferguson, our Project Co-ordinator, found out that C&A were closing down their London stores and we approached the head of their property company. They agreed to lend us the building for four weeks. There were some very nervous moments as the publicity began to kick in. The *Evening Standard*'s piece headed 'Madman at C&A', which came out a few days before the opening was particularly unhelpful

JAMES LINGWOOD May 2002

MIG WELDER

10

14 | Arts

Arthur Smith

© Amplar tatals

Sept - Oct

The SAAB Enthusiast!

Pile of Manure!

the online GOONER

BRAUN
EP 60

Exact Power

Madman at C&A

19/04/01 15:41 NO.228 001
Fax sent by : +44 0163683423424 +44 0163683813424 • DE BERRY
18/04/81 03:34 Pg: 1

Rev Andrew de Berry
The Vicarage, Southwell Road
Thurgarton, Notts. NG14 7GP
Tel & Fax 01636 830294
e.mail: de_berry@totalise.co.uk

CHURCH NEWS-SHEET

Thurgarton with Hoveringham and Bleasby with Malloughton

March 2001

Dear Friends,

From time to time we all enjoy a minor clear-out of things. Spring time is often such a time. But rather than getting rid of more, we invariably end up getting rid of less! Try as we might either out of sentiment, or because something may just come in handy in the future, we hold onto so much which if the truth be told is more clutter!

Last month in London I visit the extraordinary exhibition of an artist called Michael Landy, who in the old C&A store on Oxford street decided to get rid of everything he owed! In an exhibition called 'Breakdown', and by use of series of conveyor belts, shredders and crushing machines, he and his assistants remorselessly got rid of all his possessions. His inventory included 7,006 different items: cam corders, kitchen utensils, clothing, stereos, bed, mountain bike, footwear, books, letters, paintings, photographs along with his Saab 900 Turbo. All within a fortnight were reduced to powder! Only his cat was spared!

I managed to speak briefly with Michael and askede him what it felt like....to say goodbye to everything. He said that it was sad in one way, but joyful and liberating in another. The purpose of his experiment wasn't so much a moral one (his critics might protest. Why not give his possessions to charity?), more a statement about consumerism. Porsche used to advertise their product by say 'You are what you drive'! But Michael's statement was that all consumerism shapes who we are. Take it away and what's left?

Michael Landy referred to his project as 'Break-Down'. In a real sense it was also a mental break-down of himself; a stripping away of what he had to see who he was, and what was left!

One of the statements in the Funeral Service, and which isn't morbid so much as declaring a fundamental truth is that which says 'We brought nothing into the world, we take nothing out. Blessed be the Name of the Lord'. I love the naked reality of that statement. God does not look upon us by the possessions we own or lose. He doesn't measure us by whether we are captains of industry or in lowly circumstances. He doesnt look at the size of our house or how well we tend our gardens. Nor does He look upon our worldly success or lack of it. He looks pure and simply at one thing: our HEART!

Michael Landy's spectacle had other ends in mind than to preach a sermon, or to moralise. But what he did last month was something most of us - even with our attempts to have a spring clearout - would find it well nigh impossible to imitate.

Andrew

19-APR-01 16:54 G3 P.01

THE EXPRESS

Ludgate House 245 Blackfriars Road London SE1 9UX
020 7928 8000

Direct Line: 0207 922 7145

FAO: Mr Michael Landy, c/o James Lavender
FAX No: 0207 729 4113

8th February 2001

Dear Sir,

I have read with interest a number of articles on 'Break Down' and I writing a piece for tomorrow's Daily Express on the general reaction to the project.

Your idea - as I am sure you are aware - will obviously provoke a huge amount of controversy and renewed discussion of the hackneyed 'what is art?' debate. I am writing, now, however, to ask whether you would be prepared to comment on the reaction of other artists to your work

I understand, from The Times, that Gary Hume and Abigail Lane, have expressed their horror at the impending destruction of their work. Tracey Emin this morning told me, "there should be a restraint order on Michael Landy. But it's none of my business and you can't take it all to heaven"!

Do the views of former colleagues and friends affect your intentions or feelings? Would I be right in assuming this work will affect relationships or friendships, and does the public debate interest you? Finally, are you aware that destroying your passport is an illegal action?

I realise how busy you may be preparing for Saturday, so please feel free to jot down any comments on this letter and fax it back to me on 0207 922 7560.

Many thanks,

Michael Leventhal

Michael Leventhal

PS Is this fax possession 7,007 and will it be destroyed?

un

BBC
Love
Nadia

My dad's sheepskin coat

Dad bought the sheepskin coat in his mid-seventies...

EUROPEAN UNION
UNITED KINGDOM OF
GREAT BRITAIN
AND NORTHERN IRELAND

PASSPORT

to:
Dear Michael & Gillian.

Hope everything turns out great.

I hope everything is fine for you. I am so proud of you, as so is your dad. You must be so tired. Gillian said you were enjoying every minute of it. Anyway will see you soon.

With love,
Mum
X

love luv

MUSEUM OF CONTEMPORARY ART

John W Kaldor AM
Chairman

140 George Street, The Rocks
PO Box R1286 Sydney 1223 Australia

Telephone 61 2 9250 8416
Facsimile 61 2 9241 5654
www.mca.com.au

THE CRITICS

John Fardell 2001

CRUNCH GRIND

28

Inspiration born of destruction

From Mr Derek Gale.

Sir, With reference to your review of Break Down, the show by artist Michael Landy ("The creative process of destruction", February 1): Mr Landy will in fact be destroying only 7,000 objects in his exhibition. I visiting it on the first Sunday I was moved to steal one of them.

It is my intention to write to Mr Landy next week informing him of this fact and to make my own little artwork out of the stolen object, the exhibition flyer, and this and the letters and display it in my kitchen alongside the poster of Casablanca (he film). Am I the only person to have done this?

Derek Gale,
Stable Cottage,
Whitakers Way,
Loughton, Essex IG10 1SQ

The arts editor's quiz
Compiled by The Times arts department

25 Which artist had a breathing time in a C&A on Oxford Street?

Liberation

My sister and I went to see the Artangel/Michael Landy 'Breakdown' at the old C&A shop on Oxford St. We found the whole thing very thought-provoking and it threw up interesting questions. We liked the idea of him in a totally empty home starting again; from scratch, reassessing what is consumer necessity and what is a luxury. Did he rent his accommodation or own his home and, if the lease wasn't that too something which needed to be destroyed?

We also wondered if the project was still 'live' while the show was on. If so, he must be having to buy food, eat, go to toilet, paper etc. So at what point does he throw these items out? Are he consume them when they are empty? He thought that a cut-off date perhaps the day the show would have been a good idea. As we spoke to the actually shared his home with his girlfriend and therefore is not losing everything as he can prove why still he needs them for...

JANE PARKER, BY EMAIL

TimeOut

Please Pay Here

Evening Standard

61 I'm wearing Gillian's knickers at the moment. Out of personal reference? No, it's all I've got. Michael Landy 2002

CONSUMERISM

As a Way of Life

Steven Miles

To Michael:
Commodity? Jesus?
... or artist?
"Just do it."
Steve Miles

SAGE Publications
London • Thousand Oaks • New Delhi

THE MIRROR, Saturday, February 10, 2001 PAGE 15

ART BREAK

DEMOLITION: Michael with girlfriend Gillian

I'm smashing up all my worldly goods

By MARTIN EVANS

ARTIST Michael Landy will today watch while all his possessions are put on a conveyor belt and smashed to pieces in a snub at consumerism.

Michael, 37, has spent a year making an inventory of his 7,000 worldly goods from his Saab 500 car to odd socks and pieces by award-winning artist Tracey Emin and Damien Hirst.

By the time his installation art project called Break Down is finished all he will have left will be his own Saab and girlfriend Turner Prize-winner Gillian Wearing.

Michael said: 'It's about the amount of raw material that goes into making objects and about the lifespan of things. The title also reflects emotional break down.

He added: 'I see this as the ultimate consumer choice. Once Break Down has finished... a more personal break down will commence — life without my self-defining belongings.'

For two weeks, 10 people will go about systematically shredding his things at the old C&A flagship store in London Oxford Street until only dust is left.

CONSUME LESS!

BUY NOTHING DAY NOVEMBER 24TH
www.buynothingday.co.uk

Gerrie Van Noord

From: Fran Laws
Sent: Tuesday, May 22, 2001 2:19 pm
To: Gerrie Van Noord; James Lingwood
Subject: FW: Landy stole my life.

-----Original Message-----
From: Matthew page [mailto:matt.page@brann.com]
Sent: 22 May 2001 14:27
To: info@artangel.org.uk
Subject: Landy stole my life.

The artist Michael Landy's January 2001 event on Oxford Street in central London saw him catalogue everything he owned and then have it systematically destroyed by a group of art students, a work of art he has since sold for a ridiculous amount of money.

In my 1996 Degree Show at Reading University I catalogued everything I owned and then piled it into a gallery, forcing myself to live without any possessions for the 3 month duration of the show. The similarities between the two shows were obvious to everyone. Pure coincidence I hear you say, until you appreciate that Landy's then girlfriend Gillian Wearing had been to my degree show.

I hope he can sleep at night on his expensive new bed.

Page 1

When Michael Landy spent £100,000 of our money trashing his possessions in a blaze of publicity, the last of the 7,007 items to pass up the conveyor into the shredder was his own head, seen here (above) seconds before becoming bone meal for ruminants. Although every afternoon he made during his three-week publicity-fest suggested that he keeps what passes for his brains somewhere adjacent to his rectum, he auto-decapitated and threw in his own head as a symbol of the intellectual property he'd amassed over his decade as an artist.

If Landy was concerned about material inequality he would have given away his possessions to those who needed them or, otherwise, sold them and donated the money to a charity for the indigent. Instead, he went ahead with his stunt making such a name for himself in the process (not to mention earning five grand for the stunt) that tax prices will rise and he will be able to replace what he pulverised in a short time. He is the personification of the Careerist equation:
STUNT = PUBLICITY= CASH

BREAK DOWN 499-523 Oxford Street

Michael Landy 20/3/01

Stephen Miller (my son - not the geeky one) sends his best wishes. He's in Cologne, working for Tony Cragg in Wuppertal - Sincerely, Gordon Miller

PEOPLE WHO $HOP FOR LIFE$TYLE HAVE NO LIFE$TYLE

Code	Description
E31	Sony U-Matic BVU 800P video recorder, a gift from Sean Kimber
E32	Sony U-Matic BVU800P video recorder, a gift from Sean Kimber
F251	Blue plastic mesh vegetable storage tray used for storing correspondence, a gift from Sean Kimber and Marta Nowka
L81	Wooden hurling stick once owned by Sean Kimber, picked up from Anchor Yard
L82	Wooden hurling stick once owned by Sean Kimber, picked up from Anchor Yard
L684	Small photograph of Michael Landy, Sean Kimber and Brendan Quick in a autobahn service station on the way to Frankfurt
R1	Wooden postcard with carved text: 'Work fascinates me, I can sit and look at it for hours', a gift from Sean Kimber
R717	Kimber/Nowika' change of address card with the details of their new residence in Old Street
R968	Wilson to Callaghan Conceptual Art Practice 1974–1978, chronology - Philippa Beale and Poster Studio, a gift from Sean Kimber
R1871	A4 sheet of paper with the telephone number of Police Constable Scollay, relating to Sean Kimber crashing Michael Landy's car
R2205	Photocopy of a car accident questionnaire completed by Sean Kimber
R2207	A4 photocopy of a statement from Sean Kimber who collided with a Vauxhall Astra on 18 June 2000 at 17: 10 in Cropley Street
R2210	Drawing made by Sean Kimber of a car accident scene, after he impacted the door of a parked Vauxhall Astra car in Cropley Street
R2213	Norwich Union temporary car cover note for Sean Kimber dated 10 May 2000, insuring him to drive a Saab 900 Turbo 16s
R2219	Bundle of assorted estimates and statements relating to Sean Kimber's car accident

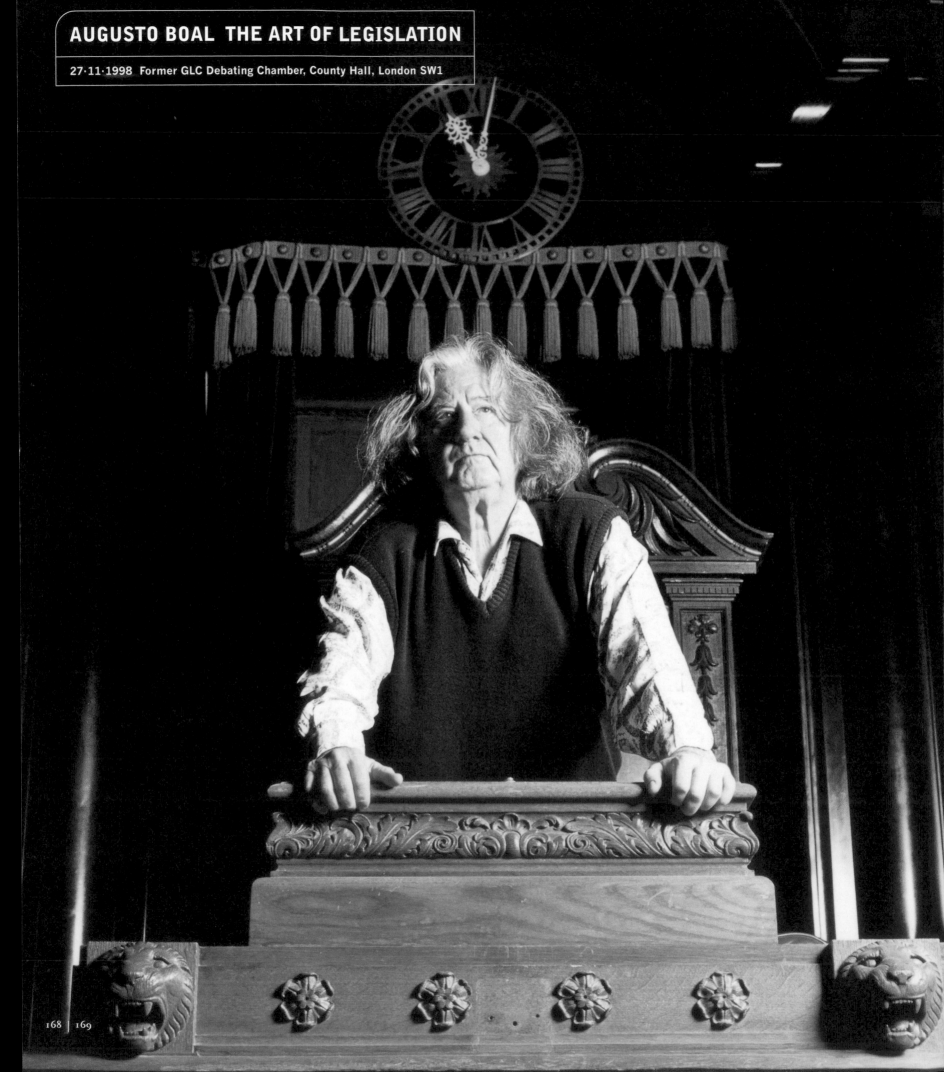

In London we convened a Solemn Symbolic Session. Organised by Artangel, it was a condensed session of Legislative Theatre. Three subject groups – directed by Adrian Jackson (Transport), Paul Heritage (Homelessness) and Ali Campbell (Education) – presented short pieces in the former Debating Chamber of the Greater London Council, which was closed down during Mrs Thatcher's reign. I presided over the session, seated in the imposing Chairman's Chair, so heavy as to be immovable, surrounded by well-known public figures and writers – Lisa Jardine, Tariq Ali and Paul Hallan – and a lawyer (Mark Stephens). Julián Boal and a young woman linked the table to the public, who were installed in the seats of the councillors. At my side, Orlando Seale, an actor from the Royal Shakespeare Company, and Tim Wheeler, director of Mind the Gap, an arts and disability organisation, dressed as my guardian angel. A band improvised music.

The Solemn Session consisted, first, of the invocation of divine protection; this was followed by the presentation of each of the three scenes, with spectators intervening in search of legal solutions. At the end of each forum, spectators drafted the laws in their own manner, writers gave them a literary form, lawyers added the legal trappings; at the end of the evening I put these to the vote.

It was theatre, fiction. Even so, it showed possible paths: by means of theatre, law can be made. Theatre as politics, not just political theatre.

Excerpt from AUGUSTO BOAL, *Hamlet and the baker's son: my life in theatre and politics*, London / New York: Routledge, 2001, pp. 335–336

In the name of Thespis, the first Actor who dared to jump out of the religious Chorus and improvise his own profane words, think his own thoughts, realise his own actions and, by so doing, invented the Protagonist and created Theatre; under the protection of two excellent Gods: Dionysus, who invented Joy and Happiness, and Apollo, who invented Beauty and Order;
in deep respect for Ken Livingstone and all the Legislators who made the Law in London until 1986, those men and women who made this building to be the House of Words and the House of Reason, before it became the House of Silence; in the name of the people of London, who have the right to let their own hearts beat in their own rhythms, to speak their own diverse voices and minds freely;
in our own name, all of us, we who take the responsibility to propose this Solemn Symbolic Session of Legislative Theatre; we, who believe that the "purpose of theatre was and is to hold, as it were, the mirror up to nature, to show virtue her own feature, scorn her own image, and the very age and body of the time his form and pressure", and further, we who believe that, if we don't like our image reflected in that magic mirror of the theatre, we have the right to invade that mirror and transform those ugly features into more agreeable ones – and, in so doing, transform ourselves and invent our future instead of merely waiting for it – we have the right to come back to real life to create a new and more humane reality around us; finally, in the name of Democracy, in the name of Freedom, in the name of Desire, in the name of Good Sense, we declare open this Solemn Symbolic Session.

AUGUSTO BOAL 27 November 1998

The great debating chamber in the old County Hall lies [...] empty. Mothballed in 1983 when Mrs Thatcher abolished the Greater London Council [...], the 94-year-old symbol of London's civic democracy is now owned by a hotel corporation.

But tomorrow evening 300 people – including, it is hoped, Ken Livingstone, Jeffrey Archer and the other would-be mayors of London will occupy it for a piece of interactive theatre led by a few professionals but mainly by housing and transport activists. The audience will be asked to turn into actors, to 'express their desires' and to enact solutions to the social problems the players express.

Three hours later, with the help of lawyers and writers including Tariq Ali, Lisa Jardine and Mark Stephens [...], a set of new laws for the capital should be drafted. Some will be playful, others serious, and no one knows what will emerge – except that none are expected to be enacted [...] over the ditch at Westminster. It will be one of Britain's few experiences of 'legislative theatre'.

John Vidal, 'This man could give Archer a few tips...', *The Guardian*, 26 November 1998

TIME

TIME

Adrian Searle

We do not need to understand time, although we think that we do.
But we are living it. TATSUO MIYAJIMA

Ten years ago, I sat one rainy February morning in the Clock Room in the British
Museum with Juan Muñoz. We were spending the day wandering between
Bloomsbury, Lincoln's Inn and the South Bank with a tape recorder, as a preamble
to a radio conversation which we were going to hold later that same year. He said
that this room, with its dozens of functioning timepieces and clocks that hadn't
moved in centuries, had "a beautiful futility".

At the time he had begun working on his *A Man In A Room, Gambling*, a series
of ten five-minute radio vignettes, in which Muñoz, in the guise of an expert, explained
the mechanics of a number of card tricks, set to music composed and performed
by Gavin Byars. It wasn't to be for another five years until he took part in a live per-
formance of this work, with Bryars, at a 1930s BBC radio studio in West London.

That morning, we had also visited the work he had made for the exhibition
'Doubletake' at the Hayward Gallery, which was about to open the following week.
The monument, a plain stone structure, whose form was in part derived from
Edward Lutyens's Whitehall Cenotaph, stood at some distance from the gallery on
the riverside walkway, and lacked any commemoration or dedication whatsoever.
Three short bronze flagpoles emerged from one face of the stone. The monument's
purpose was unfixed, though there were those who imagined, erroneously, that it
commemorated the tragic sinking of a Thames pleasure cruiser, which was much
on people's minds at the time. This sculpture – if it is a sculpture, though we
might see it more as an image of a monument than a monument itself, stood at
a tangent to time. It stood – quite literally – apart from its context as a work in an
exhibition, as well as from all the other monuments which occupy public spaces
in our cities. And one day, it vanished.

There is no such thing as a 'timeless' art work. There is always this time and
that time. No-one can predict how future viewers will regard a work, whether in
five hundred years or even ten or twenty, or even if they will look at all. All we
can be sure of is that it will be viewed differently. Its presence will have changed,
as will have the demands made on it, the things it will be required to stand for.

Speaking about his Artangel project *Longplayer* – a piece of music programmed
to last for a thousand years of continuous play, without repetition, and which
began at midnight last Millennium Eve, in the unlikely setting of the Trinity Buoy
Wharf Lighthouse, across the Thames from the ill-starred Millennium Dome –
Jem Finer said that "It's impossible to say what people are going to consider music
in 200 years or even 20". Somewhere Finer's *Longplayer* is still working its way
through its own, inner permutations and drawn-out cycles. It has barely begun.
Imagining its continuation is perhaps its most important aspect – as a counter-
point, not to the brevity of a three-minute song, or even to the rather more extend-
ed entirety of Wagner's *Ring* cycle, but to the shortness of lives. *Longplayer* is an

Juan Muñoz, *Untitled (Monument)*, 1992

impossible work. One day soon, it will sound dated, and the computer technology that was used to produce it is probably already nearing obsolescence, if it hasn't actually achieved it. There is a certain poignancy in the fact that Finer considered transferring the electronic programme which was running *Longplayer*'s operation to punch cards, the most ante-deluvian computing storage system of all.

Finer told a journalist that he liked how the air was filled with radio waves – from mobile phone signals to exploding stars. One imagines *Longplayer* joining this chorus, and perhaps that's the most important thing about it.

Tony Oursler's haunting in the park, *The Influence Machine*, manifested just such ethereal traces – from the ghost of eighteenth-century inventor of optical phantasmagoria, Etienne-Gaspard Robertson, to John Logie Baird, whose first experiments in television took place in an upper room just down Frith Street from Soho Square, where Oursler's *The Influence Machine* took place in London, during an inclement few nights just after Hallowe'en in 2000.

Projected faces loomed in artificial smoke. A head span amidst the dripping, decaying leaves. A man beat his head against a tree trunk. Oursler's disembodied talking heads, projections onto the surrounding buildings, the trees in the small park, and onto billowing clouds of dry ice, tapped into the rackety histories of communications with the dead, optics and alchemy, the blurring between science, technological research, spiritualist fervour and fakery. In one sense, *The Influence Machine* dealt with the history of communications, and in another with our longing to conquer both time and death: the wish to find proof of an afterlife. This 'research' continues amongst Internet fringe groups, who discern the traces of ghosts in the machine. *The Influence Machine* was also in part about the clairvoyance of modern communication systems, and how they mediate our lives. Of course *The Influence Machine* was an absurd, spectacular theatre of a fundamentally old-fashioned kind, bought up to date by modern digital technology. So many voices, I thought, trying to get through, insisting on their perpetuity.

Artists, even the most fatalistic, worry about posterity, and hope posterity will worry about them. Muñoz's monument was not fixed to any temporal event. He even considered artificially ageing the stone, to give it the appearance of having been permanently situated there at some indeterminate time in the past, to make the work look old. It stood, if it stood for anything, for the forgetting of the symbolism of monuments, as much as for their commemorative use – in the same way that we forget who all those bronze generals are on horseback, what battles they won, in the name of who or what they fought.

I don't know what eventually happened to Muñoz's monument. Nor do I know if *Longplayer* is, somewhere, still playing. I also thought that the recording of the conversation which Muñoz and I had had, that day in 1992, had also disappeared, leaving little more than the phrase, "a beautiful futility", hanging in the air, like

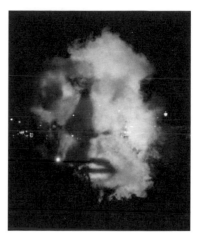

Tony Oursler, *The Influence Machine*, 2000

Bethan Huws, *A Work for the North Sea*, 1993

the smile on the Cheshire Cat. Until, that is, the tape turned up whilst I was rummaging through a box of unmarked and discarded audio cassettes at home.

Also amongst the cassettes was an almost inaudible public talk, given by whom or about what I couldn't tell. Another mystifying tape consisted only in the rustle of clothing, footsteps, wind in the microphone. Finally I came across a recording, from 1993, of a group of Bulgarian singers, the Bistritsa Babi, chanting to the North Sea. This peculiar, plaintive and dissonant chorus, transposed from Eastern European hillsides to the North East coast of England, was already out of place and out of time before it had got lost amongst these old tapes. Bethan Huws, with the help of Artangel, brought the singers to England, and had them face the empty coastal horizon and sing.

The room filled with voices, the singers bringing with them their own sense of displacement, in time as well as space. Listening again to the Bistritsa Babi, I was aware of the music occupying time: not the time it took to listen, or the intervening years since the music was recorded, not clock-time or the time-line of either recent history or the much longer history of the form of this particular vernacular, folkloric music itself, but time, as something palpable but slippery and ungraspable – like that wind in that microphone, or like water, or something like the volume of the emptiness which surrounded and threatened to engulf the singers where they sang, that day in 1993.

Like the cards in Muñoz's invisible hand, palmed, dropped, slipped up the sleeve and shuffled to the bottom of the pack, time by turns revealed itself, hid, concertina'd. It slid off in several directions at once. Somewhere, parts of my own life went with it. Is it possible to think about time and not think about death, and everything that has already been lost?

It is impossible to pass the flat stretch of municipal grass on the corner of Grove Road and Roman Road in London's East End, and not notice the place where Rachel Whiteread's *House* once stood, and to be led back, not to *House* itself, but to the real house which once occupied the spot. It was a house I once entered, standing amongst the steel joists which temporarily held up the ceiling while Whiteread and a bunch of hardhats went about their work. I felt like Jonah in the whale. One of the things which was said about *House*, when the dispute with the local council about whether it should stay was at its height, was that, finally, *House* should exist as a memory, and that this was – paradoxically – the condition the work aspired to. This was its ontological destiny, not just as an art historical curiosity (a dubious fate in any case), but also in relation to the demolished dwelling whose space it occupied. Its disappearance was a signal to its condition, as sculpture and as metaphor, as had been its appearance, in the place of a terraced house in the middle of a demolished row.

If *House* was itself a representation – and one might easily get side-tracked by such questions – one might ask whether it still exists, amongst the other representations, descriptions and images of itself which have been archived, and amongst

the snapshots and memories of those who saw it. Perhaps it is more a case of where *House* is now. The patch of grass where it stood bears the imprint of something razed, and even now, turning that corner, there is too much light on that side of the street.

House could almost have been one of those strange, unrealised projects, which only ever existed as notes, drawings and perhaps a little model, in Ilya and Emilia Kabakov's *The Palace of Projects*, which filled London's Roundhouse between March and May 1998. A spiralling, luminous white edifice of translucent walls, it was a truncated Tower of Babel, a geometric snail's shell of timber and fireproofed white fabric. *The Palace* rose towards the pinnacle of the old railway turntable shed, designed by Robert Stephenson, glowing with light.

Just about all the 60 or more projects which filled the labyrinthine edifice with their models, annotated descriptions and instructions for use, laid out on tables, in vitrines, on the walls, on the ceilings and floor, were entirely imaginary escape routes for the denizens of the old Russian Soviet system. *The Palace of Projects* was a palace of impossible dreams. The imagination, perhaps, provided the only respite from the mundanity of daily Soviet life for most of its inhabitants. These people, too, are imaginary, the invention of the artists. *The Palace of Projects* told us something about the recent past, in a way which is sometimes burlesque and funny, at other times touching and more than a little sad and desperate, and it also told us something about the utopian fantasies Soviet propaganda might actually have generated, fantasies which were as unrealistic, and unworkable, as the society itself turned out to be. Of course, none of the projects were real, nor were the characters whose inventions they supposedly were. They were the Kabakovs' projects.

I asked the artists, at the time *The Palace* was being erected in London, what it was like, exchanging life in Russia for America. Emilia answered. "I live in America", she said. "Ilya lives in the airport". It was as if, I thought, *The Palace* was not just a fantasy model of Russia, but an exploration of the effects of displacement, of alienation from history, and of the collapse of a sense of rootedness and place. The projects seem to grow in the cracks between the realities of everyday life and the social fantasies which promise, but fail do deliver, a better world. What does the peripatetic artist, shuttling from country to country, do but sit in the unreal nowhere-zones of airports, imagining an elsewhere that might be different?

At the bottom of a 30-metre-deep shaft, 734 horizontal yards (notice the change, from the metric vertical to the imperial horizontal) from Holborn Underground Station, is another world. In 1999 John Berger and Simon McBurney designated the abandoned Aldwych Station, on a closed Piccadilly Line spur, as being 80 kilometres west of the Nile, and somewhere inside a cave in a gorge of the River Ardêche in France. It's a century or so after the death of Christ, and we are amongst the Egypto-Roman painters of Fayum; but we are also with the 32,000-year-old painters of the Chauvet caves. How can we say that we are with the long dead – perhaps it is more that they are with us.

Emilia & Ilya Kabakov,
The Palace of Projects, 1998

The time is also our own time, the time we bring with us. Stories accumulated like soil, and the riverine strata over our heads. Berger asked why it was that the portraits of the Fayum look – to paraphrase – forever young, while those by Rubens or even Giacometti look old. "Paintings by Rubens", he said, "look old because they were painted for posterity", while in the Fayum "something different happened".

That something different was that the painter "submitted to being looked at" by his client, while the sitter looked back at the jobbing portraitist as "death's painter", a painter of passport portraits for the Kingdom of the Dead. The freshness and vitality of those encaustic portraits is for us at odds with their intended place and symbolic purpose, to accompany the dead, entombed sitter into the dark: into the dark, never seen, hidden.

And so it is for those pigment bison, bears, mammoth and ox, painted onto the limestone walls of the caves in the Ardêche, whose indisputable liveliness was hidden for so long, then discovered, then hidden again in order to preserve their existence. Our passage down the 122 spiral steps to the bottom of *The Vertical Line* buries us, but disinters the spectre of these images.

We are all doing time, living it, as Tatsuo Miyajima said, doing time. Living it, we know it will end. Life without a horizon would be intolerable, even if we never know quite how distant that horizon might be. Was this also what the Bistritsa Babi were singing to?

And in the little death of each illuminated sequence of digits counting down from nine to one, over and again, the numbers sweeping across the darkened floor of Inigo Jones's Queen's House at Greenwich on the Meridian line, in Miyajima's *Running Time* was it this distance they were counting? They too had a beautiful futility, in a clock room all their own.

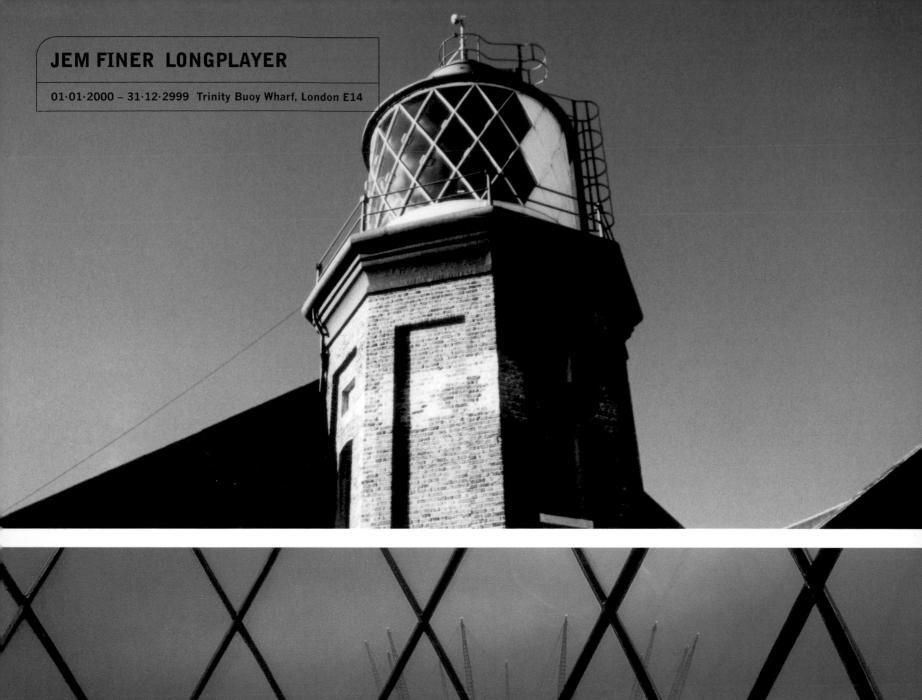

A millennium is to all intents and purposes an event of the imagination, based on the powers of ten and a calendar common to only one third of the world's population. The only certainty is that the earth has spun around the sun one thousand times. In an attempt to make sense of the impending millennium and to engender a feeling of deep time, one possibility is to start something that will take a long time to complete. JEM FINER 1999

I could never quite figure out the big deal about 'the millennium', except that it would be 1,000 years long. All else seemed arbitrary, and the signs, in the mid-1990s, were that the government would pour millions down the drain, we'd have one big party night with fireworks and all that would remain would be the odd architectural nightmare.

Longplayer grew out of the collision between my pre-millennial ranting and the desire I'd always had to make something that made time, as a long and slow process, tangible. Sitting in the back of a bus, in the autumn of 1995, with these thoughts in mind, it occurred to me that one possibility would be to write a piece of music exactly 1,000 years long.

At first it was simple, and within a few hours I'd written such a piece. It wasn't the most compelling thing to listen to for a millennium but it was the 'right' length.

In the end *Longplayer* took over four years to 'compose' and in that time the simple little idea grew to

encompass physics, architecture, technology, communication, history, space, musical theory, hyperspace, computer science, programming languages, digital music theory, superstition, cults and religions, number theory, inept quasi-governmental agencies, landscape, the science of sound, mechanics, the history of music, radio transmission, tuning systems, artificial life, complexity and time

Now the thing is to keep it playing JEM FINER

The 'performance' of *Longplayer* started at the new year. The final notes will be played, disasters and forgetfulness allowing, on January 1, 3000. It will not repeat itself during these 1,000 years. [...]

The core of *Longplayer* is a 20-minute recording of Tibetan music, that has been manipulated to create a 1,000 year-long loop. He has described the process as like "six copies of the same gramophone record at different speeds with different bits playing at the same time".

Longplayer is thus more like a soundscape, or a piece of installation art, than a conventional piece of music. You can never experience it all, it will outlive you. If you listen to a fragment of it, you can but imagine the rest: the unknowable, ineluctable expanse of time stretching before you.

Charlotte Higgins, 'Music for an eternity', *The Guardian*, 9 September 2000

♫

to trigger
drums
random

TO RAND
DRU
TRIG

#TIMESIG
4/4 3/4

4/4

MON

MON

♫

3/4

MON

MON

SOURCE
A→B

A→B
CONDUIT

through
all notes
into

A→B→

A
RDM
STREAM1

B
♫

#
RANDOM
PRESET
MANUAL

A→B INIT
=0 for counters

COUNTER

IN8

=○→

A→B
COUNTER
adds 1

A→B
LESS THAN
if less than
target no.

♫

A→B
SWITCHER
if = target no.
switches

TARGET

MONITOR dead

♫ ♫

TO FILTER

A
INIT
B
NEW

A→B

A→B
KEEP SW. OPEN

for
note
following
module

A→B
switch
switches
if notes passes
REYNIT through
if note = target no. re-initialises note.

INIT.

random A⇒B
GENERATOR → A⇒B ↙ RANDOM
generates CONDITION TRIGGER
random set
Path stream condition

manual ↓
of A⇒B
INIT NEW
Path ⌄ set new ⇒∅⇒ → INST
ich init value → Delay
repeats
w transpose, etc
↗

RANDOM
TRIG 1 ♫ CHORDS 1
INST. ♫ chord memor
FILTER chord memor
♫♫ 1
FILTER ♫ NOTES
CHOICE CHORD|NOTE
SWITCH SWITCH

♫ ♫ CHORD|NOTE
FILTER SWITCH
2

♫
RDM SW1
A⇒B → A⇒B → ∅
GEN1 CONDITION DUMMY
random MON
range A⇒B TO
♫ B FILTERS ♫
♫♫ SWITCH
this keeps RANDOM
switch open

When Artangel proposed I should create a site-specific exhibition I started to think about what could be possible for such a project. In the end it actually took more than three years to decide on a place. For me, the site in which to exhibit my work had often been a museum, gallery or a special space that was decided upon in advance. So it was my first time of choosing a place by myself, which took a long time. Artangel suggested some locations but these did not motivate me. After several more years I asked them to look for a place which would be more linked with my work, that is, a place related to Time. They suggested a list of some new locations that included a site near Greenwich.

Greenwich is 'the place where time was born' so it was the ideal site for me. Through my research I learned that Greenwich Time was set in an artificial way. GST was set at around 1884, an important period for international physics, economics and politics because it was an era in which global standards were being set for those fields.

Essentially, in Greenwich, a centre of time and place in the world, that is o (zero), was founded and this idea led to another thought: "to decide on a centre and then to apply it to all other areas", which spread quickly.

By the way, o does not exist in my work. There is no centre in my work. So this is why I thought Greenwich was the ideal site for the project. I thought I would try to do an installation which "criticizes o as the centre". I went several times to institutions near Greenwich to negotiate and explain my project. However, I could never tell them my concept of criticizing the centre, o, because doing so in Greenwich would be as if I were denying its history. We continued the negotiations with due courtesy until they approved my installation.

Finally, The Queen's House, which commands a view of the Royal Greenwich Observatory, gave their approval. I exhibited the performance work *Clear Zero* as well as an installation work entitled *Running Time*. Both are works which deny o, and their concept did not have a centre.

The difficult part was *Clear Zero*, a performance work, which I had not done for ten years – rather than *Running Time*, which was completed as an installation. This work, *Clear Zero*, is a work that involved people from 45 different countries counting down (without saying o) in their own language. Even in London, a large international city, it was not easy to gather people from so many different countries. However, it was important to have various languages to make my concept clear; there is no centre. It was hard to collect volunteers who would participate, but thanks to Artangel it did happen.

My project at Greenwich brought about a big change in my artistic life. It taught me that a specific site could, first of all, provide the most important motivation for

an installation work. In addition, in what I want to say, it may be a performance work which can represent my message directly. Furthermore, all the difficulties and pleasures I experienced through making a work involving a lot of people led to my actual way of working now. That is to say, my actual work style has an attitude that loses even the centre of the artist.

TATSUO MIYAJIMA 10 April 2002

There are times when an artist chooses a site, and other times when a site seems to choose an artist. Though we'd been talking to Tatsuo for some time, it was only after a visit to Greenwich that the project quickened and we moved from an idea for an optional project to one which seemed necessary ….

On a visit there, we looked at a small observatory and a planetarium as well as the displays of astrolabes and clocks and time-pieces of various kinds. But the spaces were all too small or too full.

Initially, we didn't think about the Queen's House because we imagined there would be too many restrictions to a transformation of the building. But the National Maritime Museum were responsive to our proposal and we were able to create a dark space inside the perfect cube of the Queen's House without much trouble.

You viewed the moving tableau of time looking down from a balcony overlooking the darkened central hall. At first, you could see nothing but blackness and moving numbers and only gradually, as your eyes adjusted, did you have any sense of the shape or depth of the space below.

Running Time was a contemplative questioning of the rationality which both the Queen's House (the first Classical building in England) and the Greenwich Meridian embody. The performance *Clear Zero* was more immediately subversive to this ideal. It was by necessity improvisational, involving some 40 individuals counting from nine to one in different languages at different volumes and at different speeds. They also chose in what direction they walked. The red numbers were switched off one by one and removed from the space. Then the light was abruptly turned on and gradually the space filled to become a babel of language.

Tatsuo was the last performer. He began to count in Japanese from the balcony, then moved downstairs to join the other 'counters'. Then, as the sound built up, he led the performers out of the building and on to the actual Meridian Line in the park behind the Queen's House. JAMES LINGWOOD May 2002

The canvas for *Running Time* is the marble floor of the Great Hall at the Queen's House, designed by Inigo Jones in the early 17th century. A perfect 40-foot cube, the room has been blacked out for the duration and the work is observed from a gallery running around the hall about two-thirds the height of the ceiling.

On the floor, constrained within a shallow wooden threshold, Miyajima has placed 45 small electric cars, each about nine inches by six and with a red counter on its roof. As the visitor looks down, the cars crawl slowly and silently across the floor, counting out the digits from 1 to 9 as they go.

They do not collide, or crash into the walls, because they are fitted with sensors which detect the approach of an obstacle and put the motors into reverse. Mostly they run in perfectly straight lines, but immediately after reversing, they seem to curve gently before setting off on a new path.

Nigel Hawkes, 'The ultimate time-and-motion study', *The Times*, 1 February 1995

Taking the passage of time as his theme (Greenwich, of course, is where official time, or GMT, begins and ends), the artist has blacked out the windows and set time (red, digitalised and ever-changing) coursing round the floor of the perfectly proportioned hall on the back of tiny, invisible electronic dodgem cars. Time is represented as a kind of hypnotic chaos, a lovely conceit in a building where absolute and permanent mathematical ratios and proportions rule.

Where Jones's work is, in part, an artistic play on the nature of mathematical perfection and the Platonic Ideal, Miyajima's installation is a celebration of randomness and time. It is mesmerising, evidently popular and rather beautiful.

Jonathan Glancey, 'The Art of conjuring new tricks out of old buildings', *The Independent*, 16 February 1995

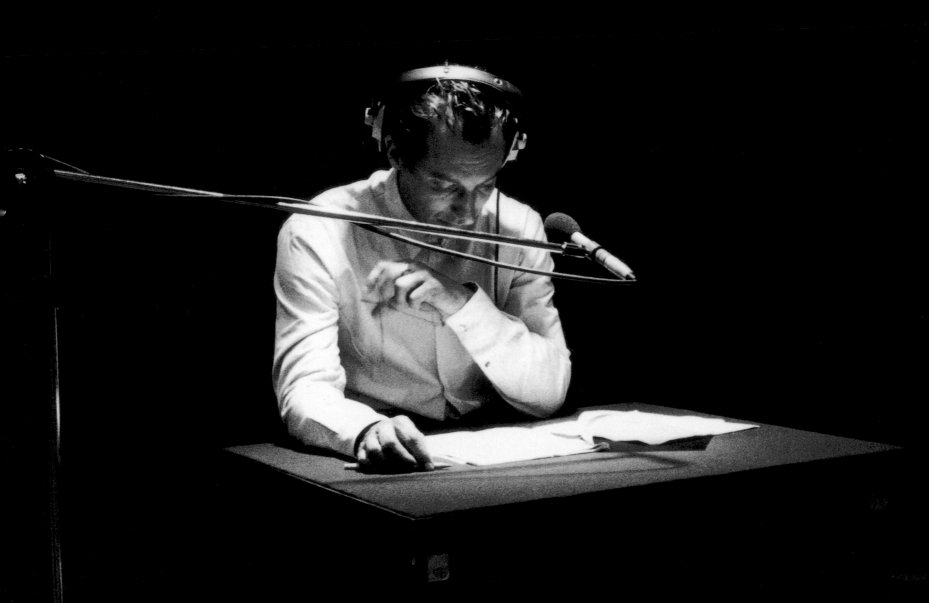

Programme 3

Good evening As on every day of the week at the same time, from Monday to Friday, we present: *A Man in a Room, Gambling.*

This evening we are going to show the easiest and most daring solution to a problem that has been called the card-player's 'black hole'. It is the problem of cutting.

The professional gambler knows how to fix his cards before dealing. The false riffle and the palmed top packet are just two of the many subtle tricks of the trade But every gambler, not just a professional, can fix some cards while he is shuffling All you have to do, as you collect the cards from the table, is remember the order of an openly discarded hand – either the discard itself or the last card played on the table Fifteen or twenty seconds are then more than enough to arrange three cards as you shuffle If no one at the table cuts, you just have to deal from the bottom ... but people do cut ... at every gambling table the pack is cut after being shuffled.

Now we will explain two ways of coming out of a cut with the cards in the same order that they had when the pack was shuffled. ... the first method should be used if you are cutting for a companion ... others would say a buddy – who is on your side ... the second false cut if you are gambling on your own

Now, as on every evening, take your pack of cards ... shuffle it and arrange some of the cards at the top ... hold the pack by the sides near the end between the thumb and middle finger of each hand ... but hold the lower part with your left hand and the upper part with your right ... draw the bottom packet up and forward with your left hand ... bring it towards you and drop it ... move your right hand up a little and slide the upper packet back on top ... the moves have to be quick and clean

Take the pack again ... shuffle it ... lay it on the table Cut yourself as if you were going to be your own victim ... good ... now pay attention to the moves ... they are so simple that they need some audacity to be performed. Remember that you have to shift the cards about openly, casually and without haste ... the important thing is that your movements should look quite normal.

Pay close attention ... take the lower packet with your right hand and, instead of putting it on top of the other, slide it along the table up to your left hand ... now, take the second packet ... and put it on top in the same way You now have your pack cut to your own taste, so to speak. Amazing.
Good night and thank you.

JUAN MUÑOZ 1992

It was through Alberto Iglesias – Juan Muñoz's brother-in-law, a composer – that Juan began to think about making a collaborative work with Gavin Bryars.

The starting point was the medium of radio, and the idea of a listener, in a room on their own, late at night. I think this most intimate of audiences was the one that Juan liked the most. They talked a lot about the possibilities of radio, and Gavin introduced us to some extraordinary work made for the medium – in particular Glenn Gould's *The Idea of North*.

I can't remember precisely when the idea of a collaboration based on card tricks emerged, but certainly Gavin and Juan shared a mutual admiration for the Canadian trickster Erdnase, who'd published a book about card tricks in the 1920s.

There were ten five-minute pieces, based on descriptions of deceptions, conceived specifically for the space of late night radio. Juan loved the idea that these works should inhabit a similar space and time to the Shipping Forecasts on BBC radio. Initially, he imagined that a professional actor should read the works, but fortunately Gavin persuaded him that he should read himself. The voice and the music, originally scored for a string quartet and then enlarged for live performance, married beautifully.

The work was initially recorded and broadcast in 1992. Five years later, a CD of the recordings was released and we decided to present some live performances. The BBC Recording Studios in Maida Vale, with all of the paraphernalia of microphones and booms for live broadcast scattered around the studio, offered a possibility to do something more than a straightforward concert. Again, Juan was persuaded to read the pieces live. He was positioned, reading his script from a green baize covered card table, towards the back of the studio, as if in a world of his own. The Gavin Bryars Ensemble was positioned closer to the audience.

Peter Donaldson, one of the most familiar voices on BBC radio, introduced the evening with a gentle fiction that we were about to go live on radio, which we weren't. He then ended the concert by reading the Shipping Forecast JAMES LINGWOOD May 2002

The performances were introduced by Peter Donaldson, whose voice was as familiar from radio news broadcasts and public announcements as his figure was unknown. Standing at the front of the vast studio he announced the evening's programme and told the audience that when the small red lights went on they were to be quiet, for that meant that they were on air. He then went on to his microphone at the side of the studio, waited for the lights to glow, and proceeded to pretend to introduce the programme to the nation. That the programme was not really being broadcast turned the situation into an illusory spectacle with which the uncertain audience seemed pleased to play along. [...]

Sitting at a green baize card table with headphones on and illuminated by a single lamp that hung above his head, Muñoz appeared to perform five programmes from the series – he was actually only performing one of them, the rest being played from recordings while Muñoz mimed the words to them. [...]

His voice, with the hard, short vowels of the Spanish accent, gave an appropriately sinister tone to his words; the voice of an old card-harp who has seen it all and who has only limited patience with his students. [...] As people in the audience shuffled around with imaginary cards, struggling to keep up with his instructions, he ploughed on relentlessly towards the conclusion of the trick. One would, in order to be able to follow the instructions, have to be already quite adept at handling cards. The instructive nature of the monologue was therefore quite limited and instead the words became part of the music – an evocative and even confessional warm, sultry and intriguing voice which spoke of shady dealings.

Juan Cruz, 'Gavin Bryars & Juan Muñoz', *Art Monthly*, November 1997, pp. 30–31

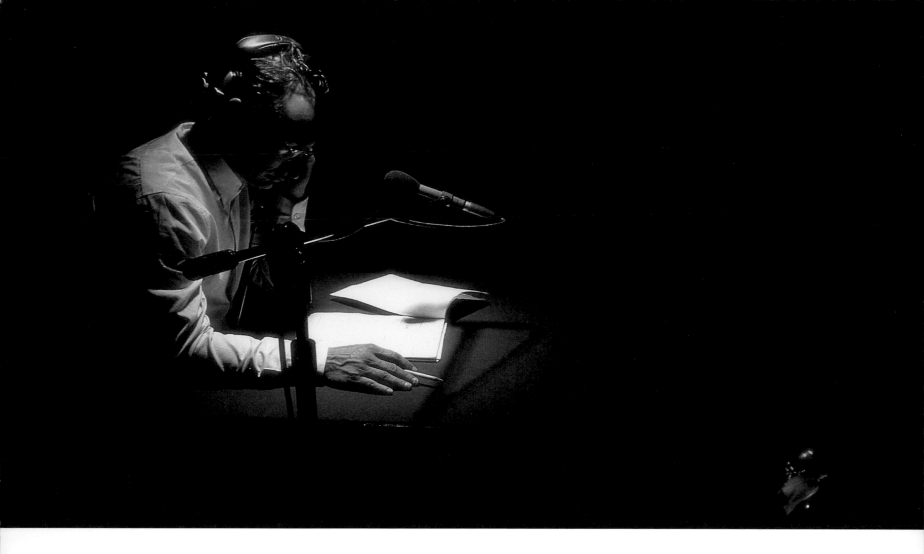

Juan and I first met when Artangel asked me to speak
with him about a possible collaboration. He was in
England for an exhibition at the Hayward Gallery and,
simultaneously, he was undertaking projects outside
the gallery confines.

The project which we developed, however, was for a
sound piece and I was initially curious that a sculptor
should be interested in working with a musician. We
met and found inevitably that we had many things in
common – he had studied at Croydon Art College with
Bruce MacLean at about the time I was teaching in the
Environmental Design Department; there were details
in his iconography which mirrored my passion for
Twin Peaks (the recurring dwarf, the patterned floors)
and so on. Coincidentally, in 1992 I found myself
devising a project for the Château d'Oiron in France,
only to find that Juan had a piece in a collective work
already installed there, the *Jardin Bestarium* – his *siffleur*
(theatrical prompter), yet another example of the dwarf.
In that year we both, along with Cristina Iglesias (his
wife) contributed to the Seville exhibition 'Los Ultimos
Dias', designed as a counterbalance to the potentially
excessive millennium celebrations already in the offing.

The idea that Juan had in mind for our collaboration
was for us to create a series of pieces for radio. Radio is
a beautiful medium for many reasons. It stimulates the
visual imagination; the listener can move between
casual and attentive modes of listening; it moves inex-
orably through time, as well as being used as a way of

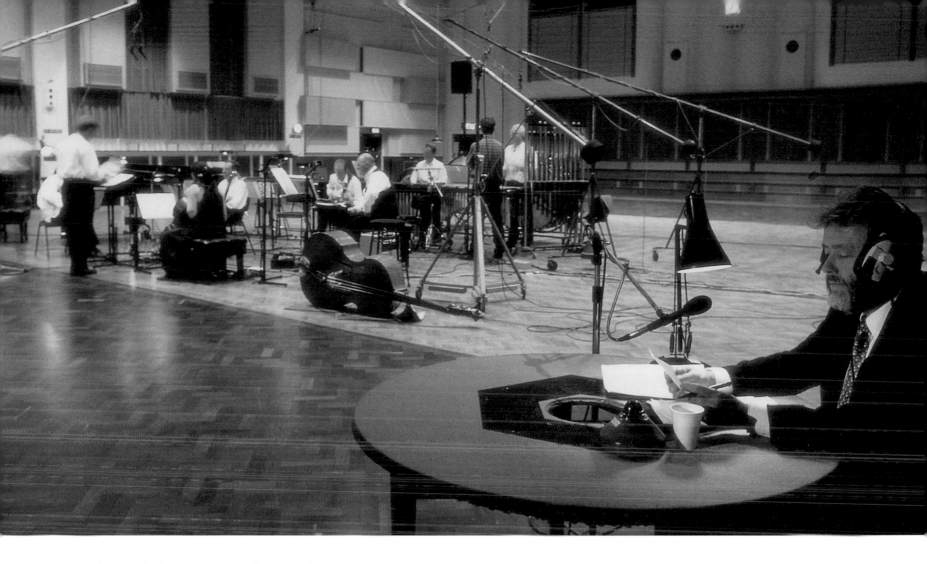

measuring clock-time (timing an egg to the duration of a medium duration news bulletin). It can also function as ambience, and indeed this is often the preferred mode of attention for radio 'listeners'. On the other hand everyday-life can equally serve as an unfocused (ambient) activity while the radio itself is playing – the preparation of a meal during a radio play for example.

For our project, which was called eventually *A Man in a Room, Gambling*, Juan wrote ten texts, each one describing the manipulation of playing cards: dealing from the bottom of the pack, avoiding failure in the Three-Card Trick, how to palm a card and so on. Some of this material was culled from the writings of the extraordinary Canadian, S.W. Erdnase, and especially his book *The Expert at the Card Table* which contains some of the most perfectly constructed sleights of hand in card manipulation. We decided that each would last exactly five minutes and should be broadcast before the last News of the evening so that the programme would be encountered, in Britain at least, in the same way as we encounter the Shipping Forecast. For his part, Juan imagined a listener driving along a motorway at night, bemused by this fleeting and perhaps enigmatic curiosity – in fact precisely the way in which most listeners encounter the Shipping Forecast.

In recording the speaking voice, Juan read each of the texts at his own pace and each one lasted a different length of time, varying in length from 3 minutes to 4 minutes 30 seconds. Each text therefore had to be manipulated both to make it fit the five-minute format in terms of the overall duration and to establish the conventions whereby after 4 seconds after the start of the programme Juan would be heard to say "Good Evening" and at precisely 4 minutes 52 seconds he would say "Thank you and Good Night". In addition, and perhaps crucially, each of the ten five-minute texts was accompanied by a string quartet, playing at exactly the same tempo for each piece, giving an overall unifying texture to each five-minute piece and to the sequence of ten programmes. The presence of the music also serves the extra function of intensifying the trickster's duplicity.

Five of these programmes, in revised orchestrations for my ensemble, were eventually released on CD (*A Man in a Room, Gambling*, Point Music). We also started to perform them with Juan reading the texts live. This was a new departure for him, and was something that made him extremely nervous but which he did with great professionalism and style.

He was on good form when we last met and we talked about meeting up to talk about my plan to issue the full set of the original versions of *A Man in a Room, Gambling*, and also to develop ideas we had spoken about for a chamber opera (provisionally called *Erdnase? Who was Erdnase?*). His tragic death put an end to this, but I have gone ahead with the release of the full set of *A Man in a Room, Gambling* on GB Records. I will also make the chamber opera at some time in the future.

GAVIN BRYARS 26 March 2002

JOHN BERGER / SIMON McBURNEY THE VERTICAL LINE

Even the dust on the piles of papers is different in Artangel's office. It's more volatile, without resistance. It seems to me – but that may be an illusion – that the right angles are different too. More adaptable. Less Euclidian. Anything between 87° and 93°? This is not to say the place is slip-shod. On the contrary. It is simply adapted. Energetically adapted, to the changeability of life and the accidents of art. It also has a lot to do with investigating forgetfulness and what has been pushed aside, which is where the unsmart solutions and treasures are to be found. It operates not like the mainstream, but more like the rain – without which there wouldn't be many streams at all! They travel cheap, and, most of the while, they're looking for what they believe will turn out to be the best. No certainties. No house fucking style. Of all the art institutions I've had to do with during my long life, it's the only one where, when you go inside and the door shuts behind you, there's still freedom.

JOHN BERGER 3 March 2002

Artangel's 'INNERCity' commissions were about matching artists to places. Artists reacting to place. To places. In the city. In 1998 Artangel asked John Berger and I to create something together. So they took us to the deserted tube station in the Aldwych, at the end of Kingsway. We descended the steps, into the dark.

When they discovered the Chauvet cave, in the Ardêche in France, it was dark. The drawings in the Chauvet cave, painted 32,000 years ago, are of animals. The first people to enter the space after 32,000 years were potholers, who did so by accident in 1994. When Eliette shone her torch and saw the painted bison running on the walls she did not speak. She cried out.

– "I went to Art school not far from here", said John. I looked at the platform, and the bricked up access at either end.
– "It would be good if we could get a train here", I said.
– "Yes", said Michael Morris, "it might be a little costly though to reinstate the line and open up the station".

The lights flickered.

– 1942
– There are 125 steps down.
– The Blitz was on then. At night people slept on mattresses laid on this platform.
– Once George Formby sang for them.

We turned the lights off in the deserted tunnel. After 10 minutes we could still not see our hands in front of our faces.

– "This is perfect."
– "For what?"
– "I'm not sure, but it is perfect."

The animals on the rock at Chauvet are extraordinarily present. But looking closer you can see (in the photographs I have seen) that the strokes are sure. Certain. Even when lines are drawn and drawn again. Confident. Anything that is an 'attempt' is indistinguishable from 'result'. The doing IS the result. The rock and the cave seem also to be a part of that confidence. There is intimacy as well as surety in the drawing. Intimacy with the rock. With the animals drawn. And with us who look. The conjunction of attempt and certainty, form a kind of path, a map, bringing us closer.

– "What is the title?" said Michael.

I grew up in a draughty Victorian house without central heating, television and plentiful in 40 Watt light bulbs. It was a marvellous place to imagine. On the wall of my father's study hung earth. A vertical section taken from a cave in Libya called the Hauh Fteah. He would point to the different coloured deposits.

– "It gets older when you go deeper, and"
And then amongst the deposits of paper that formed the sections of thought in his room, one of his papers would take his attention and I would be left to dream.

– "The Vertical Line."

– "Marvellous", said Michael as John, he and I ate pastries in an Upper Street bakery, and we felt uplifted. We had no idea as to what we would do. Absolutely none. We were in the dark. And roared with laughter on the way home. But we felt uplifted. We were given confidence to attempt.

Artangel does this not only by bringing people together and encouraging artists to go to places they might not otherwise dare to (which it does marvellously). Artangel not only suggests places, it is a place. It is a place in which to imagine. In which the attempt is indistinguishable from the result, because confidence is given and underpinned. Artangel. Aptly named. I have always associated angels with those who protect and who live in another time to ours. I am not suggesting that if you lift the shirts of any of the band of Artangel collaborators you will discover proto-avian growths.

But we live in a period that, partly as a result of the way it views time, is increasingly intolerant of anything that stands outside. Whatever enables the improbable to become possible, is terribly important for us surrounded as we are by ideologies represented by phrases such as "You are either with us or against us". Imagining the possible is what keeps us from despair. It is often difficult to make it happen. And Artangel do precisely that. We must celebrate their courage in giving us a place, a rock shelter, under which we can work.

SIMON McBURNEY 4 April 2002

[...] if you descend 30 metres below the Strand to the murky innards of a disused Tube station, you will find that the Underground has been commandeered for somewhat less gloomy considerations. A collaboration between writer John Berger and Theatre de Complicite director, Simon McBurney, *The Vertical Line* takes you on an imaginary journey backwards in time and downwards in space to the Chauvet cave in France. It was here, in 1995, that paintings of animals were discovered, which dating back 32,000 years, constitute the oldest images created by man yet found.

A spooky combination of intrepid potholing and reverberating meditations on time and art, this powerful experience begins with saturation bombardment of images flashed up on a bank of television screens and ends in a tunnel of palpably dense darkness where we join in the attempt to recapture what it was like to discover these ur-paintings, collapsing the concept of 'then' and 'now'.

In between, the journey takes in a huge circular shaft where ghostly images of Berger lecturing on the astonishingly well preserved and life-like Egyptian funerary portraits from Fayum are projected on the bleak walls. It also includes an episode where you lie on mattresses by a defunct line and look up at lonely cloudscapes shifting across the barrel vaulting while Berger, aping the tomes of a foreign correspondent, offers a front-line report on Corsica 3,000 BC.

Paul Taylor, 'Going underground to search for artists lost in time', *The Independent*, 6 February 1999

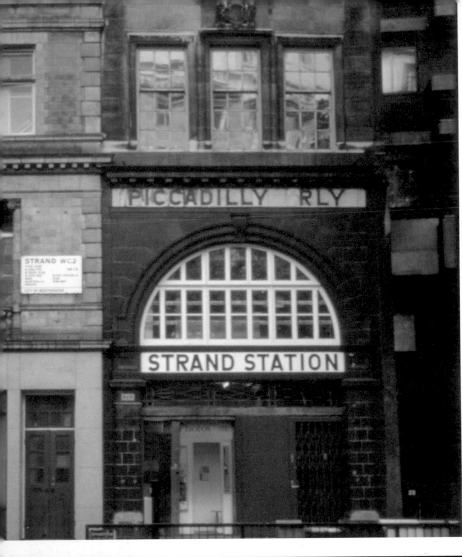

Can you hear me in the darkness?

I am standing here, 30 metres away from you.

But we must go to another time and another place.
So I need your help.

Help us now to imagine that we are surrounded by stone
walls, rock walls, rocks, and that above us there are one
hundred metres of solid limestone.

It is the eighteenth of December 1994 and in the chilly air of
a winter's evening, in a gorge of the river Ardêche in France,
three French speleologists have been crawling through a tunnel
30 inches high and 10 inches wide. Claustrophobia is a ques-
tion of context. They have been crawling for a long while.
And suddenly they feel a slight breeze. Do you?
Can you feel it? Blowing, very softly?

They pull away a stone around the gap from which the
breeze seems to be coming. And then they go down through
the gap on a ladder, a corded ladder and they sense in the
darkness that they are in an immense chamber, dozens of
metres long and tens of metres high. The darkness is like
the darkness in this railway tunnel where I'm standing,
and the silence ... the silence is the same. Listen to it.

Is it like the silence of the desert?

No, not really, not at all.

For the silence in the desert is as thin as a blade.

And this silence is deeper, deeper than we can imagine.

Fragment from *The Vertical Line*, CD, 1999

HELEN CHADWICK / DAVID WOJNAROWICZ MUNDO POSITIVE

1992 and 1994 inserts in record sleeves and magazines

David Wojnarowicz *Something from Sleep II* [OPPOSITE]
Something from Sleep II, along with Chadwicks's
Mundo Positive, was designed to be inserted into record
sleeves and CD boxes. Also containing extensive infor-
mation about AIDS and demonstrating concerns, by
visualising the experience of AIDS and HIV, the idea was
that artists could perhaps help us to better understand
and come to terms with the dilemmas and challenges
of the AIDS phenomenon.

The late artist David Wojnarowicz had become
known through his provocative works in which he
raged against the injustice and oppression within a
diseased American society. He used his writing, perfor-
mance, painting, photography and collage to speak out
for the socially, sexually and economically outcast.

The limited edition 12" x 12" prints were inserted in
the sleeve of the record and CD *Closet Classics – Volume 1*,
Virgin records, 1992.

Helen Chadwick *Mundo Positive* [ABOVE]
Helen Chadwick's work features a figure made out of
daisies against a luscious red background, and carries infor-
mation about the relationship between daisies and HIV.

Researchers at Kew Gardens showed that powerful
chemicals extracted from some tropical plants were
able to prevent the production of HIV by infected cells.
It was not possible to grow these plants in large quanti-
ties, however, Steve Dealler and Eileen Lees from the
Bradford Royal Infirmary decided to search for similar
chemicals in British wild flowers. These plants are
often thought of as weeds and grow rapidly in agricul-
tural environments. After a year of searching, an extract
from daisy leaves was found to work against HIV.
Schoolchildren from Bradford picked 30 bin liners
of daisy leaves for the research to continue.

The late Helen Chadwick's contribution to *Mundo Postive*
was disseminated as an insert in the magazine *The Face*.

TONY OURSLER THE INFLUENCE MACHINE

01 – 12·11·2000 Soho Square, London W1

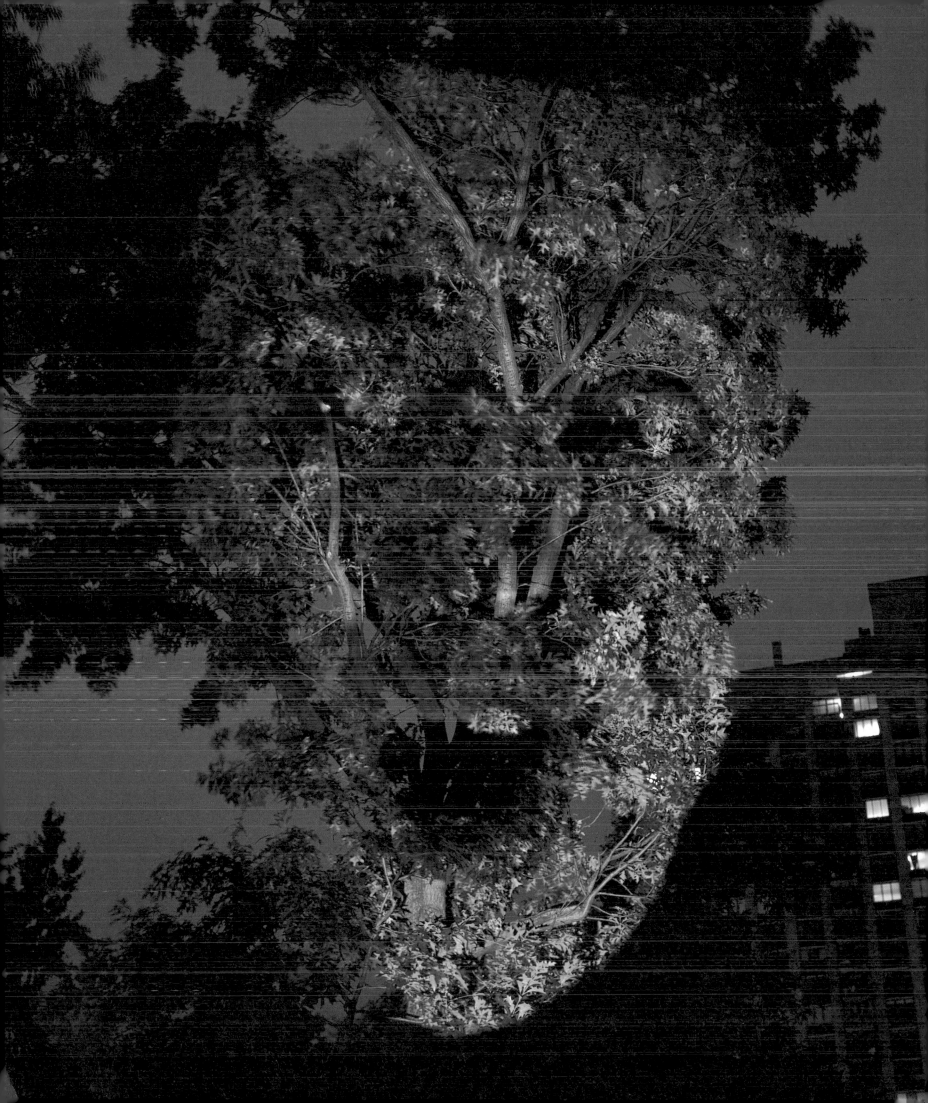

It's always interesting to try something new. A roll of the dice, but always interesting. This was the premise and the spirit of *The Influence Machine*, our project for Artangel. In my first discussions with Artangel it was made clear to me that the scope of the work could take on virtually any dimension as long as it was outside of the parameters one would expect from traditional art venues. Not only is this an incredibly generous offer for an artist to contemplate but a challenge of sorts. Artists labor in a world of restrictions which are frustrating yet comforting in some perverse way. You do what you can do and that's how it gets done. Reality often simplifies, clarifies; leaving utopian visions in a dust heap of receipts, timetables and speculation of what could have been.

Artangel presented me with a chance to do a dream project. They facilitated a fluid working process that would find its own dimensions through a journey of research and development, spanning a number of years and culminated in 13 nights in New York and 13 nights in London.

The first year was contemplative, even cinematic, as I found myself visiting various parks in London and populating them with projections in my mind. Then there were the trips to moving image museums where I became fascinated with simple early production of virtual images and developed the time-line. Our project remained abstract in the discussion of possibilities with Artangel and the Public Art Fund, New York, who became co-producer. We joked about hanging out in parks and libraries. Slowly things began to take shape,

as they encouraged and supported the meanderings I call research. Locations were secured with great effort on both sides of the Atlantic. Historic figures, such as Robertson, Baird, and Kate Fox materialized as important inspirations. After viewing and shooting thousands of images, reading piles of photocopies, two trips sharpened my focus, one to the Harry Price Library in London, the other to Lilly Dale, a psychic community near Buffalo (with Tony Conrad).

Then the hard work began of distilling thought and talk into something tangible. This is a fragile and personal process that defies description, yet I felt fully supported. Finally, we entered into the physical world of production, which involved elaborate empirical tests that were very exciting but also don't really translate into words. What I can put into words is the ongoing sense of gratitude I feel towards the people and the institutions I had the pleasure to work with on *The Influence Machine*. It was truly a once in a life time experience. Thank you.

I apologize to the crews for exposing them to arctic wind while wielding heavy electronic equipment. I especially apologize for combining electricity and water when it rained. Although I think some of them enjoyed it; I apologize to the crews for exposing them to nocturnal park-life; drunks, human excrement, junkies having sex, clouds of malathion, buzzing west nine mosquitoes, and an alarming number of very active rats. I want to thank them for overlooking such obstacles and many others too vast, embarrassing and numerous to mention here for the higher goals of art. TONY OURSLER 29 March 2002

The origins of Tony Oursler's *The Influence Machine* lay in some initial conversations between Tony and Louise Neri in 1997. Tony had become interested in the development of various media technologies, in what he called the 'deep history of media'. He was particularly fascinated by the phantasmagoria that had been staged by Gaspar Robertson in Paris in the late eighteenth century in France, as well as the pioneering research of John Logie Baird, which led to the prototype of the television.

Given that most of his work had strongly related to the idea of an interior, we talked about what it might mean to try and use the city as a screen or stage for the work. The idea of a *son-et-lumière* projection onto a site emerged – Tony had seen one such show at the Parthenon. Initially the idea of a distressed post-industrial landscape was aired, but Tony was also interested in the architecture of parks and squares in London – miniaturised versions of a landscape in the city. However, parks and gardens in London are amongst the most heavily regimented spaces in London.

Having thought about a range of different parks in the city, we thought again about Soho Square, which initially I'd discounted as being impossible to get permission to use. The little gardener's cottage in the middle of the square (which apparently Samuel Beckett said would be the place he would like to live in London) gives the square a very surreal feeling, particularly at night. The square is surrounded by tall buildings,

many of which house film and media companies. It had the requisite amount of tall trees. The BT tower can be seen to the North (could we turn that into a talking tower?) and the place where John Logie Baird first made a public demonstration of the Television was 100 yards down the road in Frith Street in Soho.

JAMES LINGWOOD May 2002

It is not unusual to wander about Soho Square at night and see ghostly faces in the trees or hear disembodied voices emerging from the lampposts. [...] What makes the faces and voices that Oursler has installed in Soho different is that they are real. This time the trees are really talking to you. [...] "Where are you? I'm going to kill you Ha ha ha", guffaws a face in a tree. "Mommy, mommy, I'm here, don't leave me", begs a ghostly head emerging miraculously from some smoke. Oursler has turned the whole of the square into a psychiatric *son et lumière*. A giant face bangs itself against a tree. A doctor consults himself in that spooky, two-characters-equal-one-voice manner popularised by Anthony Perkins in *Psycho*. The interface between sanity and dementia has always been Oursler's terrain. Here, he also seems keen to blur the dimensional divide between whatever it is that silicon chips do and the action of ectoplasm. [...] You will remember it because it is hilarious, brilliantly achieved, inventive and full of sights you never thought you would see.
Waldemar Januszczak, 'Strangers in the night', *The Sunday Times*, 5 November 2000

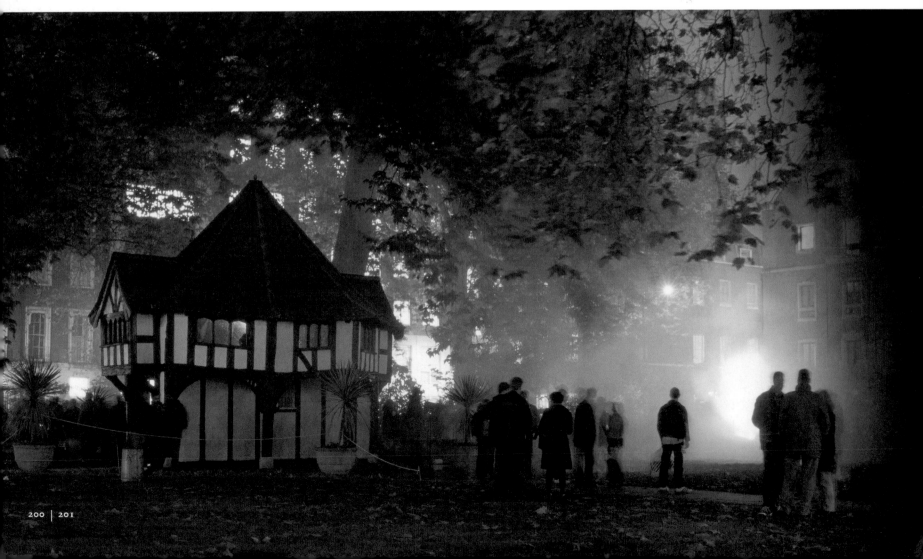

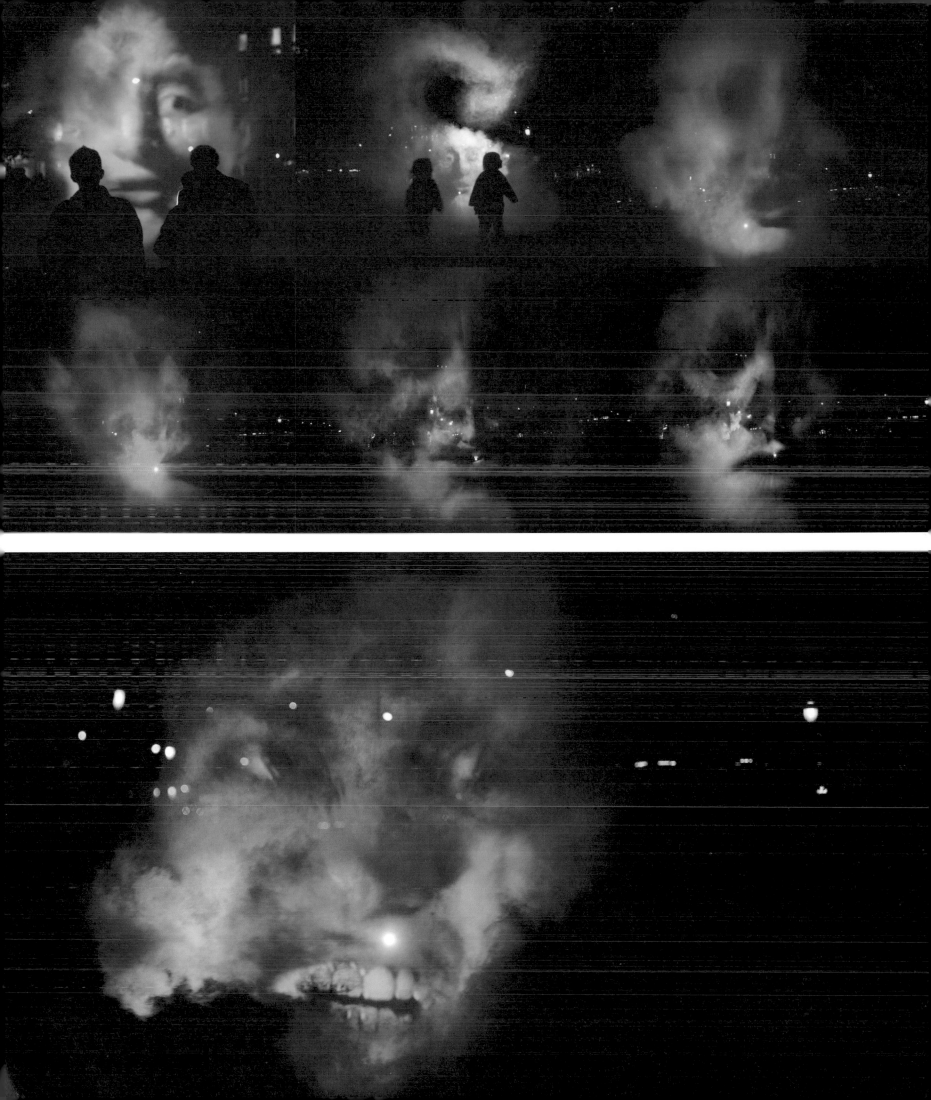

„НА ЗЕМЛ

Общеизвестно, что экологическая ситуация на поверхности нашей Земли складывается таким образом, что от перенаселения, развития промышленности и транспорта и общего отравления окружающей среды, жизнь большинства населения не только в городах но и в так называемых экологически чистых районах скоро станет не только не безопасной но попросту невозможной. В этих условиях расселение в двух, до этого не освоенных, зонах: на больших океанских глубинах и высоко над поверхностью Земли становится не только желательным, но, по существу, и неизбежным. Интересно, что обе возможности напрямую оказываются могут быть связаны друг с другом. Основная трудность жизни в воздухе – преодоление гравитационного поля земли – может быть решена самым неожиданным и тем не менее технически вполне осуществимым образом, о чем рассказывается в предлагаемом проекте.

Уменьшение гравитационного поля земли вполне возможно при создание огромных по размеру энергетических колец переводящих массу (или что тоже самое, гравитационный вектор) из направленности вверх в направление ему противоположное. Подобные герметично изолированные кольца можно построить только в глубине океана а внутри них естественно огромные зоны для проживания. Человечество, тем самым „потерявшее в весе" может свободно осваивать глубины воздушного океана, приспосабливаясь к новой открывшейся среде, пользуясь для средств существования или самой земной поверхности или устраивая жилища или „поля пропитания" в самой воздушной среде, в ее чистом незагрязненном

ЖИТЬ НЕЛЬЗЯ!

Михаил Журавлев
г. Липецк

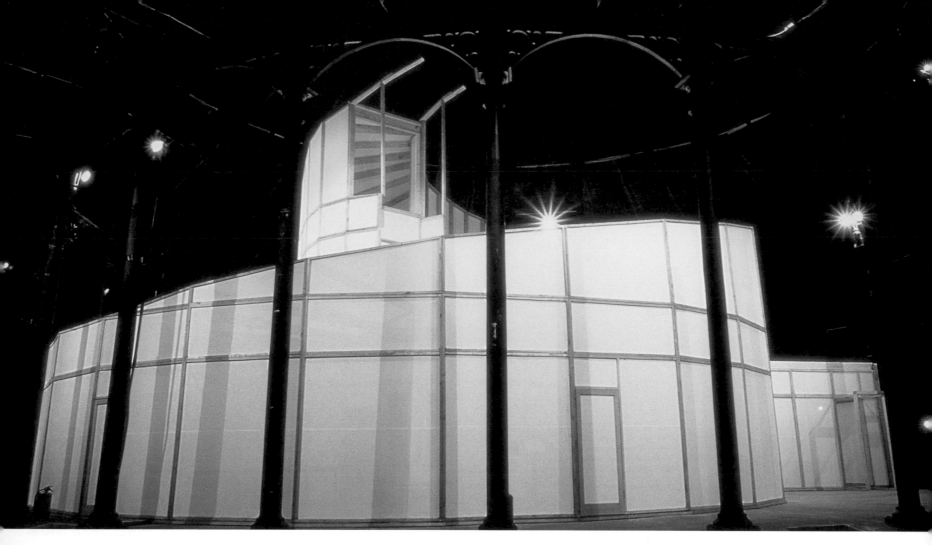

It is difficult to go back and try to describe your feelings, impressions after almost four years. Of course you can say: "Everything was wonderful and Artangel was angelic." But there is so much more

First there was a BIG DREAM. Actually, artists can be divided into two categories: artists with a BIG dream and artists with a SMALL dream. The first always are in a nervous state of mind: will their dream be realised?

Someone said that an angel is always standing behind us and in order to see him, you must turn very quickly. Which of course, we are never able to do.

The Palace of Projects was a HUGE dream, a collective fantasy: impractical, idealistic, naïve. But Ilya and I got lucky: one day, we felt a strange tugging and quickly turned round to face our angel.

I think we got him at a time when he was most vulnerable: cold, sneezing, in a light jacket. And the answer to the question "to be or not to be" was "to build".

After that: tons of faxes, telephone calls, fights, reality. (Surprisingly angels nowadays handle this as well). The palace was built.

The moral: there are angels.
We just have to believe in them.

EMILIA & ILYA KABAKOV 25 March 2002

When Ilya and Emilia first talked to me about *The Palace of Projects*, they had a very clear vision for a very big project. Not long after, they showed me an album in which the architectural structure was already completely designed and all the projects were already elaborated in considerable detail. With *The Palace of Projects* there was no need for any change – nothing was edited out and nothing much was added.

We needed to find a building which embodied an idea of progress. Artangel had formed a relationship with the Roundhouse through the commissioning of *Tight Roaring Circle*. When we visited it together, the Kabakovs could not have been more excited about this circular, secular cathedral.

The oculus in the middle of the roof of the Roundhouse was perfect. The temporary wooden structure reached up towards it. A lot of the individual projects in *The Palace of Projects* represent a desire to leave the world. Others deal with more pragmatic ideas to improve things one way or another on earth. The Roundhouse seemed to embody these twin realities, the dream of flying and the reality of being grounded.

The structure was built in Manchester and rebuilt on site. Most of the paintings and models were made at the Kabakovs' studio in New York and shipped over. They completed other maquettes, and models in Delfina Studios in London. JAMES LINGWOOD May 2002

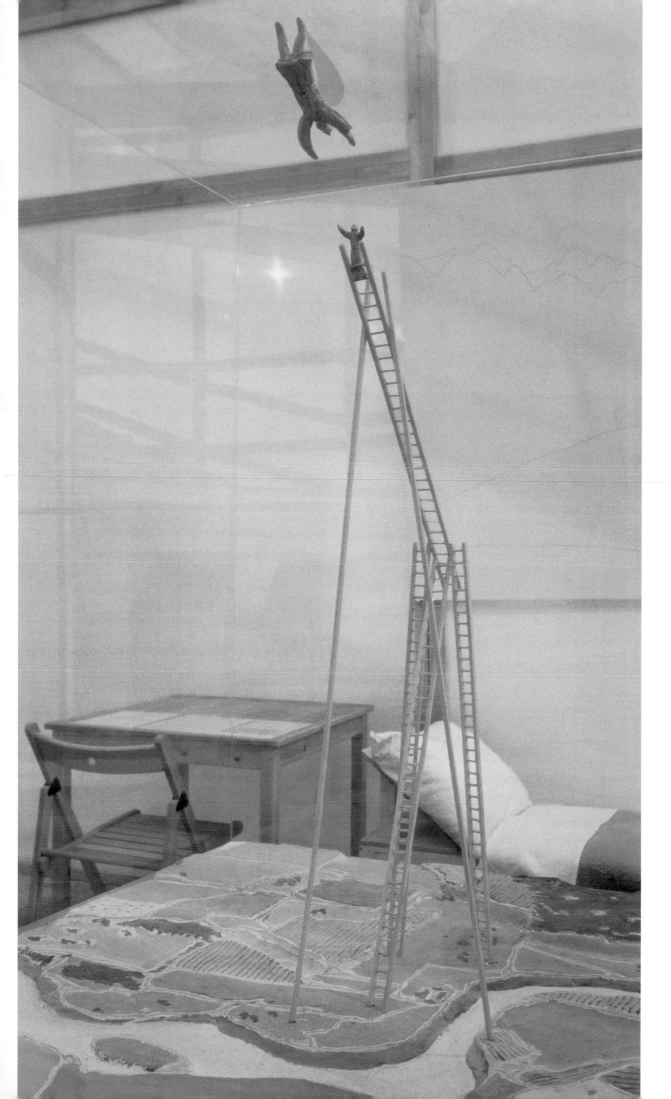

At a moment when all ideologies would appear exhausted, the Kabakovs' *The Palace of Projects* recovers the possibility of utopian thought. [...]

[It] evokes diverse precedents from the utopian architecture of Ledoux to Tatlin's Constructivist tower to the Tower of Babel and, even, the provisional structure of circus tents. The Kabakovs' point is not so much a return to utopian styles or an attempt to recover an ideological mode of thought, but that we should reject the cynicism explicit in both the Soviet and capitalist manipulations of art. [...]

The projects are just that: projects. They are housed in a large spiral-shaped tent structure through which we move to view them. Each project exists as text, and alongside it is a model demonstrating how it might be realised. A simple desk and chair sit beside each of the projects. We are invited to sit down and read. [...] The projects focus on three sections corresponding, more or less, to the spaces we must negotiate in working our way through the spiral Palace: 1) Projects concerning the improvement of the life of other people, 2) Projects stimulating creativity, and 3) Projects aimed at perfecting oneself as an individual. The first two sections are on the ground floor, so, as we pass through the sections, we must eventually go upstairs in a process of physical and metaphorical elevation. [...] Each project is like a spiritual exercise in which we concentrate on rethinking our situation in the world. Whether it is wearing a pair of angels' wings in the privacy of our apartment ('How can one change oneself?'); imagining a system for diminishing the gravitational field of the earth so as to inhabit the air environment ('It is impossible to live on this earth!') [...] the Kabakovs invite us to engage with carefully structured approaches to the irrational sources of creativity. [...]

While the Kabakovs are by no means latter-day Surrealists, they do seek to gain a mental space outside of the neo-liberal pressures increasingly dominating creative production today, and in doing so have perhaps realised the most important exhibition in recent memory in London.

William Jeffett, *Untitled*, spring/summer 1998, p. 22

Studying a boundless area of utopias and projects, at first you begin to drown in the gigantic sea, not only of all kind of proposals and beginnings, but also in the abundance of the goals and ideas which guided their inventor and authors. Gradually, it is possible to discern a few groups of such intentions.

An enormous quantity of projects fall under the heading which could be designated as "Power and Control": all possible forms of management, regulations, observations, etc. The main idea that dominates in all these projects is the complete mastery of the situation, the gravitation of everything to one center, to the author of the project himself and to the place where the author or the one using it is located.

Another group of projects is guided by the ideas of blackmail and threats of total annihilation. The authors invent possibilities for subjecting as many people as possible, all of humanity in their extreme forms, to fear and desperation with the aid of special mechanisms or directed cosmic rays. The authors are inspired by the idea of the destruction of this world, moreover, destruction that is total and instantaneous.

A large group of projects is connected with the idea of movement guided by the principle: "farther, higher, faster." Here belong not only all types of new methods for terrestrial transportation, but also an enormous quantity of fantasies about space flights, the reaching of extra-terrestrial civilizations, travels around the Universe, etc. To the "transportation" projects we can also add a gigantic group

of projects involving all possible kinds of connections and contacts, an area that is truly developing today at phenomenal speed. Furthermore, today, we can already say that many of these "communications projects" cannot really be called projects, since virtually all of them are already in a stage of technical development or have already been realized or will be in the very nearest future.

There are still a few other types and groups of projects which could be described and analyzed, but this is not how we see our goal and task. The concept of the work proposed by us – which of course also has to be treated as yet another project – is to turn one's attention to the type of concepts and proposals in which one main characteristic dominates: the transformation and improvement of the world, furthermore, it is not important whether this concerns others, "distant" people or one individual person and his "relatives." In all the projects of this type exists the idea of freedom and the expansion of social or personal opportunities, and no matter how unrealistic and utopian they may appear, the dream and the hope inherent in them give the authors the right to return to them again an again, to analyze and discuss them. But in addition to all of this, they, in our opinion, deserve even more. These projects, guided by such criteria, should not only be collected, described and catalogued, but they should also be arranged in a specially constructed space where these projects can be exhibited along with their descriptions for a general overview.

Excerpt from the book *The Palace of Projects*, 1998

Л. Ковальчук. Преподаватель ВКПО. Москва

1. Город Будущего
-дворец.

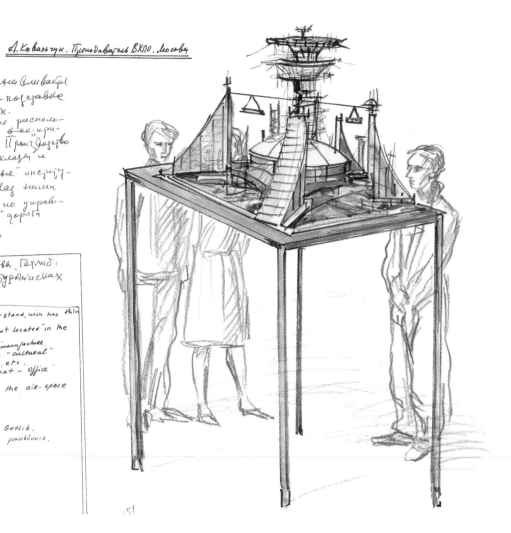

Город-дворец будущего. Проект устанавливается на высоком металлическом столе-подставке на тонких металлических ножках.

Проект-фантазия идеального города не расположен на "природе", а включающего все при-роду" в "себя" город "висит" над полем. Производство внизу, над самой "природой", над ним склады и коммуникации, над ними "культурные" институ-ции: музеи, библиотеки, кино и т.д. Над ними жилая часть, над всем этим - "бюро" по управ-лению городом. Над городом "кольцевая" дорога для воздушно-космического транспорта.

Авторы: Зимянин, Кравчук, Фуркасова, Готлиб. Научн.-исслед. Ин-тут изучения футуроло-гических проблем. Москва 1982г.

1. THE CITY- PALACE OF THE FUTURE.

The City- Palace of the Future. The project is arranged on the tall metal table-stand, wich has thin metal legs.
This is a project-fantasy of an ideal city, wich is not located in the nature", but include "the nature" inside itself.
The city "hangs" over the field. First level - manufacture, second: warehouses and communications, over them "cultural" institutions: museums, libraries, movie theaters, etc.
above them dwelling space, and above all that - "office" of the city management.
Over the city is located - "the ring-road" for the air-space transportation.

Authors of the project: Zimyanin, KRavchuk, Furkasova, Gotlib.
Institut of the Sientific Research of the futuristic problems.
moscow, 1982.

СОСРЕДОТОЧЕННОСТЬ В ШКАФУ

В. Корнейчук.
Писатель.
г. Улан-Удэ

Огромное количество проблем, которые касаются возможности концентрировать свое постоянное вни-мание, особенно когда это касается не отдыха, а какой-нибудь важной, принуждающей работы (особенно над разработкой сложного проекта) - возникает в семье, если в ней существует недоста-ток жилплощади или, даже когда имеется отдель-ная комната для работы, в ней из-за постоянно доносящегося шума также невозможно сосредоточиться.

Проект предусматривает место такой концентрации внимания в шкафу. В пользу такого решения могут быть выдвинуты следующие аргументы:

1. Шкаф внутри комнаты может создать дополнительную звуковую изоляцию.

2. Пространство внутри шкафа, небольшое по сравнению с любой комнатой и где нет отвлекающих побочных объектов, более чем комната, концентрирует внимание на предмете разработки.

3. Определенный дискомфорт стимулирует креативный процесс, как контраст к реальной повседневной жизни, как противопоставление несчастности, трагичности экстремальности нормальному существованию.

4. Установление в шкафу автономного освещения (лампы 25w) позволяет полностью изменить время сна и бодрствования, отключаться от времени и ритма жизни семьи, создав свой распорядок, удобный для работы.

5. Если запастись всем необходимым для длительного пребывания в шкафу - едой, водой, радиоприемником, кни-гами - то пользуясь "внутришкафной" ситуацией и по согласованию с другими членами семьи - кроме продук-тивной длительной творческой деятельности можно за-ниматься медитацией и проводить другие эксперименты, находясь внутри капсулы космического корабля и при этом не используя все превратности полета в космос. 67

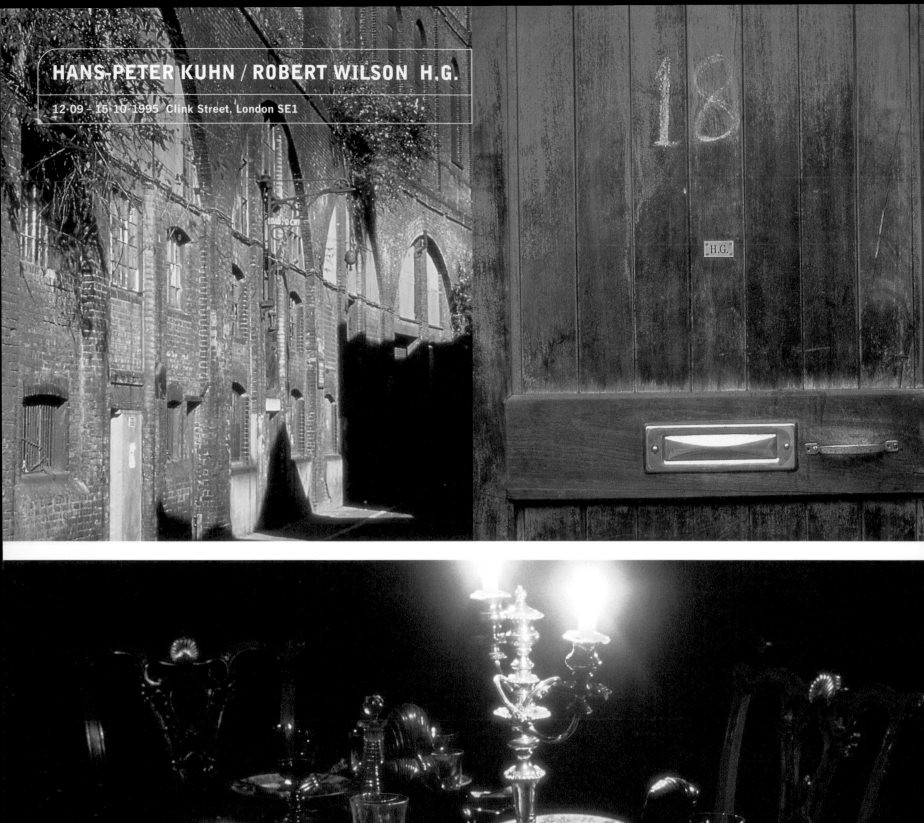

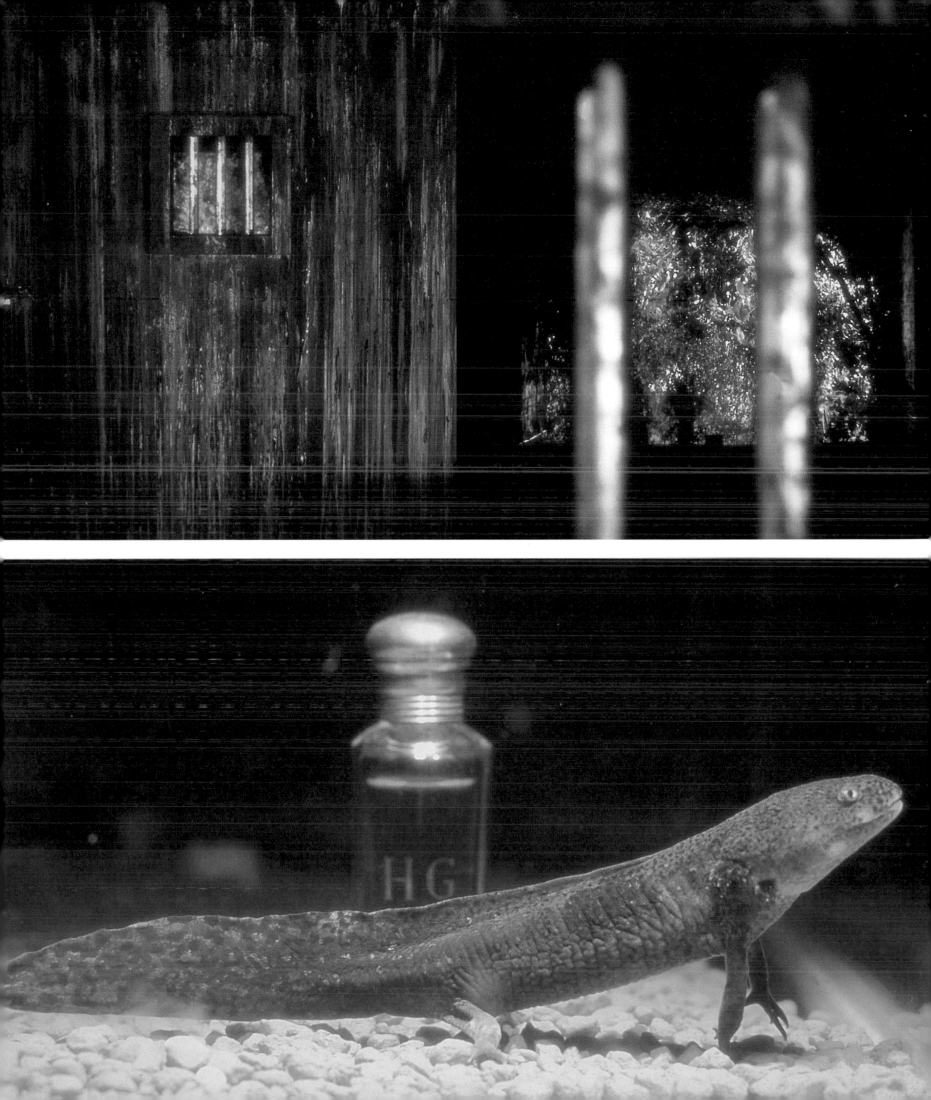

Sum SOME FOR SOME A SOM
Some FORM OF A TESTIMONY
I ROBERT WILSON A TEST I OR
COM MENT + COMMENTARY
FORM FROM YOURSELF MYSELF
About SOME FORM Sum Summ
SUMMARY COMMENT COM
MENTARY About MY CO lab
O ORATORY WITH HANS Peter
KuHN ANd WITH AND NOT WITH
out ARt AND ANGELS ARt A
A ARt ANGELS ARt ANGEL tHe
MAKING OF A celebRATION
OF H.G. WELLS' 100 TH b B
BIR+HDAY OF A time with
AND NOT WITH 9ND NOT WITH —
out time AND MACHINE I AM
GRAteFuL to JAMES AND MICHACL
LoVe BOb WAteRMILL Center 2·16·02

The mid 1990s was still a good time to search out unused, unwanted spaces in London – not as good as the early 1990s, but a lot better than now. The Clink Street vaults were like a huge underground street, in a part of London very near the City and very near the River Thames, but which every development boom had passed by (until the last one). From the street outside, it was impossible to have any idea of the scale of the spaces behind the façade.

Precisely when H.G. Wells entered the equation is unclear. 1995 was the 100th anniversary of *The Time Machine*, but the relationship was always understated, even if the first room did create an explicit connection with the first chapter of the book. The space was the starting point, rather than the book

The audience was only allowed to go in one or two at a time, entering through an unprepossessing door. The transition from the street into the first room was startling. You came into a Victorian dining room from which the guests had departed, leaving the food on the table. There was the sound of a grandfather clock ticking.

On your way out of this room, you passed a copy of *The Times* newspaper from 100 years ago and then travelled down into the dark spaces beyond. It was only after a minute or two that you had any sense of how cavernous the space was. Following the choreographed beginning to the work, the audience was then free to wander through time and space at will.

Most of the time tableaux were open for people to walk around and through, but two or three were closed off.

The skills of a film production designer came into full play here – using an economy of means to create extraordinary vistas onto inaccessible places, a glimpse of some pre-lapsarian paradise through some bars in a door, some Classical ruins with a shaft of golden arrows seen through some broken brickwork.

H.G. was a collaborative project all the way down the line. Michael Morris had known Hans-Peter for a while and through him Bob too. Following their first visits to London, we decided to work on *H.G.* together.

It was illuminating to see how they made the work, how they collaborated with Michael Howells, the film production designer to whom Michael Morris introduced them, as well as with a large group of artists and technicians. Bob would visualise an idea – a medieval figure lying down, illuminated by a shaft of blue light, for example and then Michael Howells gave a particular form to the idea. Things were added or taken away or shifted around – as if the images were being made and then edited. In the meantime, in parallel, Hans-Peter was working on the sound.

Hans-Peter Kuhn's sound was as important as Wilson's vision. On occasion the sound was very forceful – for example a train rushing through the vaults. But in most of the spaces it was localised and subtle. There was one room with a hole cut in the ceiling and a globe made out of cotton wool. What made that room work was the sound of footsteps slowly walking around the space above.

JAMES LINGWOOD May 2002

[...] Located in the dank cellars of the old City Clink, "the prison from where all others get their name", in Southwark south of the Thames and within spitting distance of the Globe theatre, *H.G.* is a journey through time and the mind. There are experiences of decay, insanity, distance, conflict, war, heaven. In the vaulted roofed spaces you turn a corner to find a huge space filled like a hospital ward with a dangling light bulb above each bed, the sound of a plaintive, Yiddish violin weaves above this, but it is very hard to locate the sound[s] [...] you can hear them in all their purity, but they seem to happen around you, with no locatable source. [...] The sounds reflect and enhance the visuals in the nearby spaces. A room full of pairs of shoes, including flippers and callipered boots, is soundtracked by a strange dissonant crush of chords, turn the corner and from somewhere you can hear the cadence of a choral work drop with a dying fall as you walk past a supine mummy bathed in synthetic sunlight.

Mark Espiner, 'Multimedia', *The Wire*, issue 140

DEALING WITH SPECIFICS

Alex Coles

Where there was once a business man puffing on a size five Montecristo, wearing a snap pin-stripe suit and sipping brandy older than most of his secretarial staff, there now stands an oval billiard table. Above the table sways a suspended red ball, underneath which spin two white ones. This is on the first floor of a somewhat austere building in St James's, the land of musty gentleman's clubs. On the top floor sits a model of the Oval Cricket Ground populated with players and trees, flanked by plush leather armchairs. On the next floor down, cheap deckchairs face a bowling alley cut out of choice pin-stripe fabric; the bowling lane is lined on the other side by fake trees punctuated with white paper disks. Below this floor, there are grainy blown-up images of figures from the sporting world, playing rugby, cricket and so forth. Below again, and a computer screen flickers with screen savers.

But this multi-layered installation, aptly titled *Empty Club*, is no more. The St James's building is currently home to pin-stripe suits once again – the only difference being that now Richard James rather than Gieves & Hawkes tailor them. Gabriel Orozco's installation was, indeed, just a temporary intervention in the summer of 1996. Even though elements of it were later reused in other venues, *Empty Club* was undoubtedly site-specific: it tapped into the politics and poetics of the space. The project ran parallel to a renewed fascination with notions of space and site-specificity that continues to be active in both practice and theory today. To the extent that Orozco does not work neatly out of the site-specific tradition of art practice, though *Empty Club* announced a reappraisal of the very terms of this enquiry.

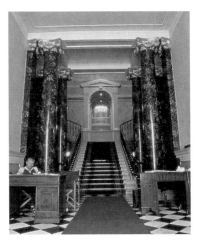

Gabriel Orozco, *Empty Club*, 1996

Earlier interpretations of site-specificity purported that it was something to do with a certain object being fixed in a certain place for a certain period of time, or, likewise, a certain activity, taking place in a certain place for a certain period of time. Because this place was often a public place – i.e., not a private gallery – it followed that site-specificity was often linked to so-called public art. The output of Richard Serra is exemplary here, because it clearly demonstrated how the two definitions came to be interconnected. Serra's rather limited definition of site was however soon exploded by his contemporary, Robert Smithson. From his first *Non-Site* in 1968 onwards, Smithson's version of site-specificity involved the mapping and indexing of *absent* spaces. In the mid-1970s, Dan Graham extended Smithson's inquiry into notions of absence and presence in architectural spaces. Works such as *Opposing Mirrors* and *Video Monitors on Time Delay*, 1974, and *Yesterday / Today*, 1975, foregrounded both the psychology and the physiology of built space. Enkindled by both Smithson's and Graham's examples, but with urban leanings, Gordon Matta-Clark introduced an interventionist slant to site-specific practice. His *Splitting*, 1974, was a fugitive endeavour to use buildings as a means to expose a particular set of urban issues before they irretrievably disappeared. In the same period, Mierle Laderman Ukeles placed the performative process behind Matta-Clark's work on display. In *Transfer: the Maintenance of the Art Object*,

1973, she cleaned the inside of a museum in Hartford, Connecticut. The later project *Touch Sanitation, 1978–81*, similarly conceived of the city and its institutions as social systems of maintenance to be intervened in. The elaborate orchestrations with garbage that constituted the piece questioned the status of maintenance work, ecology, and waste management in the city.

Recent extensions of the site-specific paradigm have tended to favour the paths of inquiry taken by Smithson, Graham and Ukeles. Consequently, rather than assuming that the site must be a fixed place, both Mark Dion and Renée Green conceive of it as a series of *transitive* spaces to be mapped.[1] Dion's *On Tropical Nature*, 1991, traces his own movements from a site in a tropical jungle to an art gallery. Throughout the transition from one site to another, the performative activity of travel is on display. Green works with many of the same principles as Dion but through more diverse media. By example, *Partially Buried*, 1996, is a melange of video and installation fragments through which Green revisits the place of a site-specific work by Smithson, namely, *Partially Buried Woodshed*, 1970. In the video component to the work, Green's own story is interwoven with Smithson's in numerous ways, highlighting her autobiography whilst simultaneously reflecting on her present activity as an artist working within the same domain as Smithson, yet in quite a different epoch and under quite different conditions.

Given the nature of the radically expanded definition of site developed by these contemporary artists, it is not surprising that fresh theoretical models were needed to reflect on them. Eventually the theories of non-place and space put forward by urban geographers, anthropologists and sociologists were absorbed and tested by artists and critics alike. The writings of Henri Lefebvre and Michel de Certeau from the 1960s and 1970s, and Marc Auge and Ed Soja from the 1980s and 1990s, are just a few of the numerous names that could be cited here.[2] In *The Practice of Everyday Life*, a book that has acted as something of a cornerstone to these recent debates, de Certeau emphasises how the movement of the individual's body is fundamental to any current definition of space. He further explains how place can only be realised through the body's quotidian activity. In *Non-Places: An Anthropology of Supermodernity*, Auge revisits and condenses de Certeau's ideas when he construes that today "space [is a] frequentation of places rather than a place ...".[3] Both their theories of place thus refreshingly turn on how the individual – call them the beholder – actually alters space through the very activity of viewing.

What the otherwise inchoate group of artworks collected above share is a tendency to provoke analysis in the form of critique from the beholder. There is, of course, a flip side to this genealogy of practice. Hans Haacke, for one, focused exclusively on the mechanisms that buttress institutional critique over the entire period sketched out above. As a result, the work he produced tended to ape the very processes of pure reason they aimed to debunk, leaving no aesthetic space

for the beholder to operate in after the desultory process of decoding was completed. Alternatively, some of the artists who piloted the purely critical aspects of site-specificity have managed to extend their initial insights, open their practices out, and so maintain a relevance to the present. Much of the contemporary output of Daniel Buren and Lawrence Weiner could be included in this category. Interestingly, their later output is often left out of contemporary accounts of their oeuvre – its difference from their canonical work is apparently all too alarming for some commentators.[4]

So much, then, for the genealogy of site-specificity and the movement towards institutional critique. Today, the output of too many artists operating under the umbrella of this paradigm follow Haacke in producing work of a didactic and tautological nature. Others, succeeding the likes of Matta-Clark – and Orozco is certainly amongst them (quite literally so if you take his 'cut' in the *La DS* from 1993) – are much more flexible. So as to renew the site-specific paradigm, they bring previously irreconcilable media into collision. For example, in much of his work, Orozco gleans conceptual elements from the site-specific paradigm but fashions them through a sensibility based on the haptic aesthetics of the Arte Povera group. The sculptural objects of Michelangelo Pistolleto, for example, have been crucial to Orozco, particularly his *Ball of Newspapers (Minus Object)*, 1966. As a direct result of the paradigm shuffling and medium scrambling inherent to Orozco's approach, *Empty Club* was site-specific more by way of its highly-tuned aesthetic sensibility rather than because of any singular point it attempted to drive home. It follows that the relationship of *Empty Club* to the tradition of the English gentleman was far more ambivalent than a canonical work from the paradigm of institutional critique would permit. By detaching the formal make-up of this privileged cut of society from its political prejudices, Orozco developed a more open-ended approach: one in which the elegance of pin-striped flannel could be relished and a game of billiards entertained, and yet the ideological premise underpinning both ever so gently gibed. Even so, while Orozco grasped how vital it is to court the beholder, he maintained his distance from straight-laced notions of 'generosity' spun by artists such as Rirkrit Tiravanija and Tobias Rehberger, both of whom are expanding the site-specific paradigm today by, quite literally, providing food and cushions. The beholder of *Empty Club* did not leave amused and relaxed by the games on offer and the chairs from which they could be viewed. Rather, they came away from the installation bemused by them. Orozco's desire to court the beholder was also played through in both Michael Landy's *Break Down*, 2000, and Tony Oursler's *The Influence Machine*. Therefore, it is not surprising that like Orozco's *Empty Club* both *Break Down* and *The Influence Machine* should suggest two more of the many possible futures for the site-specific paradigm.

The Influence Machine in fact recalled Graham's earlier attempts to tap into the psychological aspects of space. Still, where Graham tended to fix upon a generic

type of place, such as a corporate atrium or a shopping mall, here Oursler selected a space with a specific history. Soho Square, where *The Influence Machine* was staged, is near to where the inventor John Logie Baird's laboratory was when he invented the mechanical television, a key precedent for the work. Oursler fore-grounded this and other aspects of the site's history as a way to trigger a more complex, layered, response from the beholder. Alternatively, to achieve a more direct contact, Oursler invited the audience to send in their own messages via e-mail. They were broadcast the next evening through the gazebo that assumes centre stage in Soho Square. Nevertheless, site and beholder were more generally connected by the way Oursler enveloped both with a rich theatre of images; whether using the trees and bushes in the gardens, or the surrounding build-ings, the myriad projections presented different characters in the story Oursler chose to present. The installation was like a piece of live theatre in which the spirit world of the information age came back to haunt. Vast faces, barbed by anxiety, were beamed on to the skeletons of trees to harangue viewers. On one tree in particular, a balding head banged itself repeatedly against the trunk, as if wanting to escape from the past. In pressing the medium of video into the service of the site-specific paradigm, Oursler assembled an installation that summoned a specific set of histories and narratives. At the same time, it was open enough not to curtail the beholder's response to them.

Michael Landy, *Break Down*, 2001

Landy's *Break Down* was a gruelling fourteen-day performance in which over 7,000 of his personal possessions were dismantled and eventually crushed by a giant shredder. Strategically sited in a recently closed C&A store near London's Marble Arch, each of Landy's personal possessions were displayed on a circuitous conveyor belt. Throughout the fourteen days the project spanned, Landy was on hand to oversee the proceedings, kitted out in blue overalls and safety helmet, the trademarks of the foreman of a disposal unit. The theatricality inherent to the act of taking over another professional role recalled the way Ukeles had pre-viously cast herself as a cleaner or refuse collector – the difference surely being that Landy injected a more deliberate sense of playfulness into his approach. Then, too, where the complex installations of, say, Peter Fend from the early 1990s recapitulated the earnestness of Haacke's project, *Break Down* instead amplified the very eccentricity inherent to such an endeavour. To stop here would be too simple though. For to some extent *Break Down* did imply a critique of the more invidious aspects of consumer culture. In the catalogue that accompanied the project, Landy even included a checklist of questions previously used by 'The Buy Nothing Day Campaign' that took place in 1999. These questions pressed the consumer to ask themselves: "Do I need it?"; "How much will I use it?"; "Can I do without it?" and so on. Yet rather than simply dragging the beholder through the gruelling ritual of guilt-ridden self-questioning, *Break Down* enabled them to look a little closer at their relationship with the everyday objects through which their personalities and relationships are bespoken. To be

sure, many of the objects to be shredded in *Break Down* were personal letters, photographs and memorabilia. Other objects, even those with the most generic appearance, like a plastic lighter and a toilet brush, had been personalised in being gifted to Landy from a loved one or friend. Such is the extent to which the work incited the beholder into producing their own analysis of the artefacts on display.

Whilst these Artangel projects provide quite distinct futures for the site-specific paradigm, each one formulates a space in which critique must originate from the beholder's creative process of reading rather than the artist's tendency to lecture. To a large extent, this invitation is granted through the very aesthetic experience offered to the beholder. By incorporating perceptual elements from the media of sculpture, video and performance, Orozco, Oursler and Landy all effectively catapult the site-specific paradigm into the future – which is no mean feat. Especially in a place like St James's.

1 For example, see the contributions of Miwon Kwon and James Meyer to both; Erika Suderburg (ed.), *Space, Site, Intervention: Situating Installation Art*, Minneapolis: Minnesota University Press, 2000 and Alex Coles (ed.) *Site-Specificity: The Ethnographic Turn*, London: Black Dog Publishing, 2000. See, too, 'On Site-Specificity: A Roundtable Discussion' in *Documents*, 4/5, spring, 1994
2 In particular, see Rosalyn Deutsche, 'Uneven Development: Public Art in New York City', *Evictions: Art and Spatial Politics*, Cambridge, Mass: MIT, 1996, and also Pamela M. Lee, *Object to be Destroyed*, Cambridge, Mass.: MIT, 2000.
3 Marc Auge, *Non-Places: An Introduction to a Theory of Supermodernity*, London: Verso Books, 1995
4 The prime candidate has to be Benjamin Buchloh in his 'Conceptual Art: From the Aesthetics of Administration to the Critique of Institutions', *October* 55, Winter, 1990. Happily, in an interview with Buchloh, Lawrence Weiner thwarts his attempts to press his practice to the service of institutional critique. *Lawrence Weiner*, London: Phaidon, 1999. Buren's learned comments on the necessity of updating the paradigm of institutional critique are certainly appropriate here. See his 'Can Art Get Down From Its Pedestal and Rise to Street Level?' *Sculpture Projects in Münster*, Verlag Gerd Hatje, 1997. More recently, Liam Gillick has also commented on the necessity of adopting a more flexible approach towards the paradigm in his interview in the catalogue *Renovation Filter: Recent Past and Near Future*, Bristol: Arnolfini, 2000

CHRONOLOGY 1985 – 2002

1985

January 1985
ARTANGEL FOUNDED

Artangel was founded in January 1985
by Roger Took to provide a professional
platform for and to realise projects with
artists who do not necessarily produce
work that fits within the regular exhibition
venues, and to commission and support
new public art works in unusual locations.

June 1985
THE ARTANGEL ROADSHOW

Interim Art's gallery space on Beck
Road, Hackney, was transformed
by five artist working thematically
throughout the house, using and
manipulating the main architectural
constituents of windows, walls, ceil-
ings and floors to create the 'Window
Wall Ceiling Floorshow'. Outside,
the 'Artangel Roadshow' featured four
artists, extending the theme of the
interior to the context of the street.
Participating artists: Hannah Collins,
David Mach, Boyd Webb, Julia Wood.

—

Biographies
Hannah Collins was born in London in
1956. She exhibited extensively through-
out Europe and the USA. Collins made
a contribution to the 1992 'Istanbul
Biennial' and was nominated for the
Tate Gallery's Turner Prize in 1993.

David Mach was born in Scotland in
1956. His sculptures, collages and instal-
lations have been exhibited extensively
throughout the world and include
numerous public commissions. He was
nominated for the Turner Prize in 1988.
He is currently Professor of Sculpture at
the Royal College of Art in London.

Boyd Webb was born in New Zealand
in 1947. He attended the Royal College
of Art in the early 1970s and came to
prominence alongside contemporaries
such as Richard Wentworth, Richard
Deacon and Alison Wilding.

Project Bibliography:
Patricia Bickers, 'Artangel "Roadshow"
& Interim Art "Window, Wall, Ceiling,
Floorshow"', *Art Monthly*, September 1985

August 1985
KRZYSZTOF WODICZKO CITY PROJECTIONS

Krzysztof Wodiczko's work – projections
onto buildings and monuments –
expose the nature of that architecture
often from a critical political perspec-
tive. They demonstrate that it has
a physical, real exterior space and
a psychological interior space. Both
are open to appropriation and reinter-
pretation. In London, Wodiczko realised
projections onto the Duke of York
memorial on the Mall and onto
Nelson's Column, Trafalgar Square.

A collaboration with the ICA, London,
and Canada House.

—

Biography
Krzysztof Wodiczko was born in Poland
in 1943. In the last decade, he has
realised more than seventy large-scale
slide and video public projections in
Australia, Europe and North America.
His work has been exhibited in
'Documenta', the 'Paris Biennial', the
'Lyon Biennial', the 'Sydney Biennial',
the 'Venice Biennale' and numerous
other major international art festivals
and exhibitions. He now lives and
works in Cambridge, Mass., where
he is Professor of Visual Arts at the
Massachusetts Institute of Technology.

Project Bibliography
Steve Rogers, 'Territories 2:
Superimposing the City', *Performance*,
August–September 1985, pp. 37–38
Sarah Kent, 'Profiles', *Time Out*,
29 August–4 September 1985
'Making Light of Nelson', *The Times*,
28 August 1985

September 1985
LES LEVINE
BLAME GOD

At sites around Chalk Farm and Elephant & Castle in London, Les Levine's billboards were prominent even amongst the plethora of consumer marketing imagery. Levine's works pointed out the absurdity of strife and genocide world wide in the name of God, deriving their inspiration mainly from the situation in Northern Ireland. The billboards highlighted hypocritical standards and dubious righteousness.

A collaboration with the ICA, London.

———

Biography
Les Levine was born in Dublin in 1935 and currently lives and works in New York. His billboards, posters and video installations have been exhibited internationally.

Project Bibliography
Thomas McEvilley, '... What is Political Art ... Now? ...', *The Village Voice*, 19 February 1985
David Orr, 'Dublin artist upsets pious London', *The Irish Tribune*, 9 September 1985
Michael McNay, 'Danger on the city streets', *The Guardian*, 14 September 1985
Nigel Pollitt, 'Blame God?', *City Limits*, 13–19 September 1985
Michael Archer, 'Blame God', *Art Monthly*, October 1985

October 1985
STEPHEN WILLATS
BRENTFORD TOWERS

Brentford Towers was an installation of photo and text panels inside the 22 storey tower block Harvey House in Brentford, West London.
The residents of Harvey House had been actively involved with Willats over several months in the making of the work, creating thematic connections between their lives and the objects inside their homes and the views from their apartments. The work focused on personal fantasy and patterns of modern urban life.

———

Biography
Stephen Willats lives and works in London, where he was born in 1943. In addition to editing and publishing *Control Magazine* since its inception in 1965, he has exhibited his work in numerous solo and group exhibitions around the world. 'Stephen Willats – Printed Archive' was established at the Victoria & Albert Museum, London in 1991. Recent group shows include 'Live in Your Head' and 'Protest and Survive' at the Whitechapel Art Gallery, London.

Project Bibliography
Marina Vaizey, 'Painting hot off the easel', *The Sunday Times*, 20 October 1985
Sarah Kent, 'Stephen Willats', *Time Out*, 24–30 October 1985
Waldemar Januszczack, 'The other flat earth society', *The Guardian*, 26 October 1985
Stephen Willats, 'Brentford Towers', *Journal of Art and Art Education*, 1985

November 1985
MARK INGHAM
PARADISE IN PECKHAM

During his Henry Moore Foundation fellowship at Camberwell College of Art, in London, Mark Ingham explored the topography and history of the neighbourhood and conceived a presentation for several sites along the former Surrey Canal in Peckham. Small sculptural items were placed in trees along the old canal route, which is now a concrete walkway.

———

Biography
Mark Ingham worked as Schools Co-ordinator at the Whitechapel Art Gallery between 1990 and 1994. His recent work investigates the relationship between art and mathematics and has been exhibited in the Whitechapel and the Norwich Art Gallery.

December 1985
KUMIKO SHIMIZU
145 BOW ROAD

145 Bow Road was a derelict early nineteenth-century detached house on a busy car and pedestrian highway. Kumiko Shimizu adopted the building and revitalised the façade with colourful decoration which involved the painting of certain areas and the arrangement and attachment of abandoned and salvaged objects from the neighbourhood.

———

Biography
Kumiko Shimizu was born in Kyoto, Japan in 1952. She has lived and worked in India, Nepal, Thailand, Indonesia, Europe and Australia and currently lives and works in Bali. Her paintings and multimedia works incorporating music, dance and theatre have been exhibited throughout Asia and Europe. Shimizu's controversial sculptures chronicling the life and death of Princess Diana were featured in the London exhibition 'Abused' in 2001.

Project Bibliography
Guy Brett, 'Kumiko Shimizu', *City Limits*, 29 November–5 December 1985
Angus McGill, 'Portrait of the artist as a bent twig', *The London Standard*, 22 January 1986
'Derelict Church', *Artswork*, August–September 1987, p. 7
Guy Brett, 'Kumiko Shimizu', *Art Monthly*, April 1988

December 1985–January 1986
ANDY GOLDSWORTHY
ON HAMPSTEAD HEATH

For six weeks from December into January, Andy Goldsworthy daily braved the elements on Hampstead Heath, creating inventive and magical sculptural works from materials he found in their natural surroundings.

The residency was organised in collaboration with the group Common Ground and ran concurrently with an exhibition of photo-works at the London Ecology Centre.

—

Biography
Andy Goldsworthy was born in Cheshire, England in 1956 and currently lives and works in Dumfriesshire, Scotland. He has exhibited extensively in Europe, North America, Asia and Australia. Most of Goldsworthy's sculptures have been made in the open air, in locations as diverse as the Yorkshire Dales, the Lake District, the Northwest Territories of Canada, the North Pole and the Australian Outback.

Project Bibliography
Nigel Pollitt, 'Love in the open air',
City Limits, 10–16 January 1986, p. 16
Waldemar Januszczak,
'The Heath Robinson', *The Guardian*,
13 January 1986
Andy Goldsworthy, 'Hampstead Heath',
Aspects, spring 1986
Sarah Howell, 'Kingdom of the iceman',
The Sunday Times, 2 July 1987
Fay Sweet, 'Bright Lights, Big City',
Design, July 1990

April–May 1986
LAWRENCE WEINER
PARADIGMS FOR DAILY USE

Coinciding with an exhibition of his poster-works from 1965 to 1986, at Air Gallery, Lawrence Weiner produced two special works that were fly-posted throughout Central London during April and May of 1986. The works were pasted across every eye-level space in the city. One poster read: "We are ships at sea not ducks on ponds", the other: "My house is your house, your house is my house. If you shit on the floor it gets on your feet".

A collaboration with Air Gallery, London.

—

Biography
Lawrence Weiner was born in New York in 1940. He currently lives and works in New York and Amsterdam. Weiner has had recent solo exhibitions at the Hirshhorn Museum and Sculpture Garden, Washington, D.C., the Dia Center for the Arts, New York, Musée d'Art Contemporain, Bordeaux, the San Francisco Museum of Modern Art, the Walker Art Center, Minneapolis, the Philadelphia Museum of Art and Museum Ludwig, Cologne.

Project Bibliography
William Furlong, 'Lawrence Weiner',
Art Monthly, July–August 1985, pp. 11–12

June 1986
STATION HOUSE OPERA
A SPLIT SECOND OF PARADISE

For a public project during the 1986 'Venice Biennale', Artangel invited proposals from artists and selected a performance piece from the London-based group Station House Opera. Every night during the opening week of the 'Biennale' they presented *A split second of paradise*, a one-hour piece, with a cast of five and hundreds of building blocks.

The piece was originally commissioned by Midland Group in Nottingham.

—

Biography
Founded in 1980, Station House Opera has developed into an internationally-renowned performance company with a unique physical and visual style. Described as "visionary as it is stunningly visual", the company has created spectacular projects in a variety of locations all over the world, from New York's Brooklyn Bridge Anchorage to Dresden's historic Frauenkirche and the Salisbury Cathedral. More recently their work has been created for more intimate spaces throughout Europe including the Orangerie in Dijon, an old electrical factory in Weimar and a nineteenth-century music hall at Hoxton Hall in London.

Project Bibliography
'Block grant', *The Sunday Times*,
22 June 1986
Minna Thornton, 'Psychological Architecture', *Artscribe International*,
September–October 1988, pp. 62–65

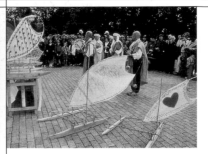

August 1986
HOUSEWATCH

In *Housewatch* six artists presented
a combination of cinema and archi-
tecture by projecting from inside a
house onto translucent front windows,
animating the street façade. Each
artist explored different aspects like
voyeurism, but also abstract concerns
relating to the flow of film through
architecture. *Housewatch* took place
at three different locations in London.

———

Biographies
Ian Bourn studied at the Royal College
of Art, London. His work has been broad-
cast and shown at festivals around the
world.

Lulu Quinn was commissioned by Contact
Theatre to produce her first piece of per-
manent public artwork in 1998.

George Saxon studied at the University
of Wolverhampton and the Royal College
of Art, London. He is currently Head
of Time-Based Media at the Hull
School of Art

Tony Sinden began working with film,
sound and expanded cinema in 1966.
His work was featured in the 'Sydney
Biennial' in 1982 and he has exhibited
installations in spaces such as the
Hayward Gallery and the Serpentine,
London.

Chris White is a painter who currently
lives and works in New York.

Alison Winckle was born in 1953 on
the Isle of Man. After her studies at
Newcastle upon Tyne Polytechnic, she
has been living and working in London
since 1974. She currently teaches at
the University of East London.

Project Bibliography
Naseem Khan, 'Window pain', *New
Statesman*, 12 September 1986, p. 26
Ian Bourne, 'Housewatch', *Performance*,
October–November 1985
'Housewatch at Spitalfields', *Artscribe*,
November–December 1986, p. 71

September 1986
TIM HEAD
CONTRACTS INTERNATIONAL

Artangel commissioned billboards, fly-
posters, newspaper ads, postcards
and bus ads that all appeared in the
Manchester area bearing the phrases:
"Acceptable levels of CONTAMINATION /
STARVATION / RADIATION / INSEMINATION
/ EDUCATION / PRIVATISATION / EXPERI
MENTATION / RATIONALISATION". The
posters bore a logo and a phone num-
ber for Contracts International, a ficti-
tious agency. A recorded message invit-
ed the caller to come to a public dis-
cussion about "the Unacceptable Face
of Art" at Manchester Town Hall.

A collaboration with Manchester Festival
and Cornerhouse, Manchester.

———

Biography
Tim Head was born in London in 1946.
His installations, paintings, photography
and slide and video projections have
been exhibited in the Whitechapel Gallery,
the ICA and the Serpentine, London. His
work was featured in 'Documenta 6' in
1978 and the 'Venice Biennale' in 1980.
Head's diverse commissions include
producing artwork for the Tate Gallery
Centenary in 1997 and acting as
Artistic Director for the Eurythmics
Peace-tour in 1999.

Project Bibliography
Jim Aulich, 'The Unacceptable Face of Art',
Artists Newsletter, March 1987, p. 22
Louisa Buck, 'Angel in the street',
The Guardian, 13 June 1988

September 1986
GODBOLD & WOOD
APPEARANCES IN SOHO

Under the flashing sign announcing
"Free Viewing" at 118 Old Compton
Street, Soho, three discreet eye-level
slits invited passers-by to peek inside.
What they saw was almost certainly
unexpected; an elusive flickering
image of an ever-changing figure,
sometimes resembling the resurrected
Christ and at other times looking like
a comic book super-hero.

———

Biographies
David Godbold and John Wood are
London-based artists that have collabo-
rated on a number of installation-based
projects, including the 1988 'Sydney
Biennial'.

Project Bibliography
'Peepshow in 'Soho shock',
Creative Review, October 1986
Jonathan Watkins, 'Artangel,
Chisenhale, Godbold and Wood',
Art Monthly, April 1987

August–October 1986
IAN HUNTER
PACIFIC – HEART OF EARTH

This event took place during the
United Nations International Year of
Peace, in support of a nuclear free
and independent Pacific. The major
focus was a ceremonial launch of
a fleet of model Pacific outrigger
canoes on the Thames and their
passage from the Peace Pagoda
at Battersea Park down-river to
Greenwich. The model canoes were
constructed at workshops by volun-
teers ranging from individuals of
all ages to school groups.

———

Biography
Ian Hunter was Curator and acting
Director with the National Art Gallery
in New Zealand until 1980. In the
early 1980s he set up the ANZART
Australia / New Zealand artist
exchanges, and after moving to London
was employed as Arts Officer at the
National Council for Civil Liberties
until 1984. In 1989–90 he established
Littoral/Projects Environment as an
arts trust for social and environmental
change.

Project Bibliography
'Pacific-Heart of Earth', *Artists Newsletter*,
September 1986, p.19
Michael Fathers, 'Kiribati bans Russian
boats', *The Independent*, 16 October 1986
'Canoeing to nowhere', *The London
Standard*, 17 October 1986
Jill Nunn, 'Ian Hunter: Project Arts
Centre. Dublin', *Circa*, January–February
1987, pp. 17–18

January–February 1987
BARBARA KRUGER
WE DON'T NEED
ANOTHER HERO

March–October 1987
CONRAD ATKINSON
CONSUMING CULTURE

We don't need another hero was a billboard artwork by Barbara Kruger that appeared simultaneously on sites in fourteen different cities in Britain and Ireland in January and February 1987. The showing of the billboard coincided with the broadcast of the Channel 4 / Illuminations series 'State of the Art – Ideas and images in the 1980s'. Barbara Kruger's combinations of image and text challenge initial apparent meaning, analysing power relationships between male and female, and between political and cultural systems and the individual.

Conrad Atkinson's poster-works featured large-scale re-worked front pages of the *Financial Times* and *Wall Street Journal* for display in the London Underground and Tyne & Wear Metro. Bogus headlines and fictitious snippets of news made humorous references to relationships between the worlds of art, politics and commerce. The work examined the ethics and power of culture in an advanced technological society, mocking our addictive consumption of information through the major media systems.

A collaboration with Projects UK (Newcastle Media Workshops).

Biography
Barbara Kruger was born in Newark, New Jersey in 1945. After attending Syracuse University, the School of Visual Arts, and Parson's School of Design in New York, Kruger worked as a graphic designer, art director and picture editor. In addition to being shown in museums and galleries world-wide, Kruger's work has appeared on billboards, buscards, posters and in public parks, train station platforms and various public commissions. She currently lives and works in New York and Los Angeles.

Biography
Conrad Atkinson was born in 1940 in West Cumbria, England. He attended Carlisle College of Art, Liverpool College of Art and the Royal Academy Schools, London. He has participated in numerous solo and international shows, including the first 'Liverpool Biennial' in 1999. He lives and works in Northern California and Northern England.

Project Bibliography
Sarah Kent, 'We don't need another hero', *Time Out*, 7–14 January 1987, pp. 36–37
James Baldwin, 'Images for the Eighties', *City Limits*, 15–22 January 1987, pp. 16–19
Mo Dodson, 'Post code', *New Statesman*, 30 January 1987
Elizabeth Hillard, 'Art on TV', *Arts Review*, 30 January 1987, p. 38
Jon Bird, 'State of the Art', *Artscribe*, March-April 1987, pp. 11–12
Peter Culshaw, 'The Singing Critic', *Performance*, March–April 1987, p. 22

Project Bibliography
Sarah Sands, 'Hitting the headlines', *The London Standard*, 12 March 1987
Oliver Bennett, 'The Big Bang', *Performance*, March–April 1987, p. 23
Mo Dodson, 'In opposition', *New Statesman*, 8 May 1987
Beth Summers, 'Phew! What a Scorcher!', *i-D magazine*, May 1987, p. 32
Brandon Taylor, 'Conrad Atkinson', *Art Monthly*, April 1988

June 1988

ANNE CARLISLE ON SPECTACOLOR ANOTHER STANDARD

The Spectacolor screen on Piccadilly Circus is primarily used as an advertising vehicle for national and multinational corporations. Via this high profile computer-animated screen, Artangel enabled artists to intervene in a major commercial context. *Another Standard* made witty comments on the Union Jack by pulling it through a series of fast changing graphic forms relating to its use on tacky London souvenirs and its symbolic power as the national flag.

—

Biography
Anne Carlisle was born in Templepatrick, Northern Ireland in 1956. She studied at Ulster Polytechnic, the University of Ulster and Chelsea School of Art, London. She was Managing Editor of *Circa* art magazine from 1983–89 and is currently Head of the Department of Art and Design at University of Wales College, Newport. Carlisle's work has been featured in numerous exhibitions and installations world-wide. Much of her recent work involves the use of electronically controlled interactive and multimedia systems.

Project Bibliography
Louisa Buck, 'Spectacolour', *The Face*, June 1988
Sacha Craddock, 'Ironising the Union Jack', *The Guardian*, 22 June 1988
'Art by Eros', *The Daily Telegraph*, 2 June 1988
'Electric Eye', *City Limits*, 2–9 June 1988
'Art up in Lights', *Circa*, June–July 1988

June–October 1988

KEITH PIPER CHANTING HEADS

The travelling audio sculpture *Chanting Heads* by Keith Tyson toured Britain from June until October 1988. Four massive sculptural heads were mounted on a customised lorry trailer. Through their loud speaker mouths the heads broadcast a collage of speech, songs and chants, exploring elements which link the struggles of black and Third World peoples around the globe. The sculptures made nineteen one-day appearances at seventeen different locations around the country.

—

Biography
Keith Piper was born in 1960 and attended Trent Polytechnic School of Art and Design, Nottingham and the Royal College of Art, London. He first exhibited in 1981 as a member of the BLK Art Group, an association of black British art students based in the West Midlands. His recent multimedia installations have increasingly explored the implications of digital technologies within an issue-based fine art practice. Piper is currently working on a major project commissioned by InIVA (The Institute of International Visual Arts), London.

Project Bibliography
Noelle Goldman, 'Chanting Heads in Public Places – Artangel Trust Focus on Multiracial UK', *Artswork*, June–July 1988
Keith Piper in conversation with Paul Gilroy, 'Chanting Heads', *AND Journal of Art*, number 21, 1990

August 1988

KRZYSZTOF WODICZKO EDINBURGH PROJECTIONS

Onto six of the columns of the unfinished copy of the Parthenon at Carlton Hill in Edinburgh, Wodiczko projected images that represented the disenfranchised of the city. Personifications of homelessness, single parenthood, unemployment, alcoholism and drug addiction loomed over the city. The text "Morituri te Salutant" (those who are about to die salute you) was projected onto the lintel above. Across the hill the face of Margaret Thatcher and the words "Pax Brittanica" were projected onto the dome of the observatory.

A collaboration with the Fruitmarket Gallery and the Edinburgh District Council.

—

Biography
See *City Projections*, August 1985.

Project Bibliography
Louisa Buck, 'Bright lights', *The Face*, June 1988, pp. 48–51
Clare Henry, 'Throwing some new light on an old folly', *Glasgow Herald*, 15 August 1988
David Lee, 'Spotlight on the festival,' *The Times*, 15 August 1988
'Krzysztof Wodiczko in Conversation with William Furlong', *Art Monthly*, October 1988
Paul Wood, 'Projection', *Artscribe International*, January–February 1999, pp. 12–13

September 1988

JOHN FEKNER ON SPECTACOLOR SLAVES OF LABOUR

John Fekner's narrative *Slaves of Labour* placed into 60 seconds the history of the sweatshop phenomenon from ancient times to the present day, comparing symbols of labour achievement, then and now, from pyramid to computer terminal.

—

Biography
John Fekner is a New York artist currently living and working in Long Island City. His work includes a variety of media, both traditional and computer-generated. Fekner has had many solo and group exhibitions in Europe, Asia and North America, including shows at the Bronx Museum of Art, the Massachusetts Museum of Contemporary Art and the Technische Museum in Vienna.

Project Bibliography
'Slaves of Labour', *Artists Newsletter*, November 1988

December 1988–February 1989
JENNY HOLZER
MESSAGES

Holzer's terse one-liners and aphorisms were introduced to the London audience during the Christmas and New Year period of 1988–1989. Her messages appeared on the Spectacolor board in Piccadilly Circus, in Belfast, Plymouth, as art breaks on cable channel MTV, on video monitors in night clubs and Leicester Square tube station, as stickers in *The Face* magazine and on cash till receipts in Virgin record shops.

These public interventions coincided with an exhibition of Holzer's work at the ICA and Interim Art in London.

———

Biography
Jenny Holzer was born in 1950 in Gallipolis, Ohio. She studied at Ohio University and the Rhode Island School of Design in Providence, USA. Whilst participating in the Independent Study Program at the Whitney Museum of American Art, New York, in 1977, she began to create text-based work, including the 'Truisms' series. She has published several books and exhibited her work in institutions such as the Guggenheim Museum, New York, the ICA, London and the Centre Georges Pompidou, Paris.

Project Bibliography
Sarah Kent, 'Signs of the times',
Time Out, 30 November–7 December 1988, pp. 26–27
James Danziger, 'American Graffiti',
The Sunday Times, 4 December 1988
Andrew Graham-Dixon, 'Lost for words',
The Independent, 13 December 1988
Sacha Craddock, 'In the end was the word',
Weekend Guardian, 14–15 January 1988
James Odling-Smee, 'Jenny Holzer',
Circa, March–April 1989
Steven Evans, 'Not all about death',
Artscribe International, summer 1989, pp. 57–59

March 1989
JEREMY WELSH ON
SPECTACOLOR
ABC – BABY SEES

Jeremy Welsh's *ABC – Baby Sees* was a 30-second sequence contemplating the first reactions of a child to the visual world and suggesting the difficulty of dealing with the complexity of visual bombardment to which we are subjected in the media age. The colour graphics gently interplayed with the flashing neon signs, cinema lights, video screens, window displays, amusement arcades and electronic signboards in the Piccadilly Circus area.

———

Biography
Jeremy Welsh was born in Gateshead in 1954. He studied at Jacob Kramer College of Art, Leeds, Trent Polytechnic School of Art and Design, Nottingham and Goldsmiths' College, London. During the 1980s, Welsh worked at London Video Arts and the Film and Video Umbrella, London. He has written extensively on art and technology and curated exhibitions of electronic art. He is currently Professor of Fine Art at Bergen College of Art and Design, Norway.

Project Bibliography
'Exhibitions', *The Independent*, 28 March 1989
'Spectacolor: ABC – Baby Sees by Jeremy Welsh, An Artangel Production', *Independent Media*, July–August 1989, p. 28

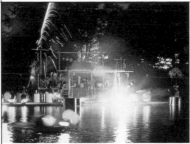

July–September 1989
RON HASELDEN
DOGFIGHT

Dogfight was a neon sculpture featuring a scramble of wrestling and running dogs. The apparent movement was created by a phased switching-mechanism. The work was designed to be suspended from a cluster of tower cranes in the night sky above London, but ultimately a small-scale version was installed high on the wall of offices in Camden Town in the late summer of 1989.

—

Biography
Ron Haselden was awarded an Andrew Grant scholarship to study sculpture at Edinburgh College of Art between 1961 and 1966. He has been teaching sculpture at Reading University since 1970 and currently lives and works in London and Plouer sur Rance, France. Haselden's sculpture brings together light and sound within the context of different sculptural environments. He has shown his work in galleries, large-scale outdoor events and performances throughout Europe and North America.

Project Bibliography
'Running rings around Cullinan',
Astragal: Architects Journal,
4 October 1989
Louisa Buck, 'Ron Haselden',
Arena, March–April 1990

August 1989
BOW GAMELAN ENSEMBLE
FANFARE FOR BIRMINGHAM

A week of 'Art in the open' at Cannon Hill Park in Birmingham climaxed with a spectacular lakeside concert by the Bow Gamelan Ensemble. Sounds were ingeniously created from such unlikely musical sources as tin baths, vacuum cleaners, broken glass, old washing machines, oil drums, glass cylinders and blow torches – the discarded junk of our industrial age.

—

Biography
The Bow Gamelan Ensemble was formed by Richard Wilson, Anne Dean and Paul Burwell in 1983 as a radical experiment in music, sound sculpture and the performing arts.

Project Bibliography
Trevor Parsons, 'Bow Gamelan
Ensemble', *Rhythm*, July 1989,
pp. 38–41
'The Bow Gamelan Ensemble',
The Birmingham Post, 11 August 1989

October 1989
TINA KEANE ON
SPECTACOLOR
CIRCUS DIVER

Circus Diver by Tina Keane used seductive and fluid images of female divers to lure the viewer into a story in which one diver becomes heroine. The pool changed into a TV screen showing a grinning ringmaster. The diver shattered the TV screen with one graceful dive.

—

Biography
Tina Keane currently lives and works in London, where she is Professor of Fine Art, Film and Video at Central St Martin's College of Art and Design. Working in installation, film, video and digital arts, Keane has exhibited world-wide, including solo British Council tours of Australia and Japan, as well as shows at the Hayward Gallery, Tate, Serpentine and ICA, London and the Museum of Modern Art, New York.

Project Bibliography
Emmanuel Cooper, 'On Tina Keane
and Artangel Trust', *Time Out*,
11–18 October 1989
Mike Jones, 'Circus Diver',
City Limits, 12–19 October 1989
'Sign of the times', *Videographic*,
November 1989, p. 6

1990–91
RASHEED ARAEEN
THE GOLDEN VERSES

Rasheed Araeen's full-colour billboard used a mix of Urdu calligraphy, oriental carpet design and English subtext to consider the ironies of being British, yet from another country or civilisation. The work asserted the presence and contribution of non-European cultures within multiracial Britain. The translation hidden within the rug reads: "White people are very good people, they have very white and soft skin, their hair is golden and their eyes are blue, their civilisation is the best civilisation, in their countries they live life with love and affection, and there is no racial discrimination whatsoever, white people are very good people." *The Golden Verses* was shown in London and subsequently toured in the UK and abroad.

———

Biography
Rasheed Araeen was born in Karachi and is a civil engineer, artist, writer and inventor. Araeen is founding Editor of *Third Text* and the founding Director of BLACK UMBRELLA (formerly PROJECT MRB), an organisation established in 1982 to research and promote the modernist work of Afro-Asian artists. He has shown his art, curated (including the 'Indian Triennial' in New Delhi) and delivered conference papers throughout the world.

Project Bibliography
Margaret Garlake, 'Rasheed Araeen', *Art Monthly*, February 1988, pp. 18–19
Jean Fisher, 'Rasheed Araeen', *Artforum*, March 1988
Andrea Rehberg, 'Rasheed Araeen', *Flash Art*, March–April 1988
William Feaver, 'The Empire strikes back', *The Sunday Observer*, 3 December 1989
Tim Hilton, 'Collusion culture', *The Guardian*, 20 December 1989
Guy Brett, 'Rasheed Araeen's London Billboards', *Art in America*, March 1991

May–June 1990
SITESPECIFIC ON
SPECTACOLOR
OBJECTS OF DESIRE

Objects of Desire was a rapid sequence of flashing warnings, an amalgam which sampled, plundered and scratched symbols and information graphics to grab attention and trip the imagination.
Sitespecific were Andy Parkin, Bruce Williams and Christopher McHugh.

———

Biography
Andy Parkin is a sculptor who lives and works in Chamonix, France.

Bruce Williams attended Kent Institute of Art and Design and currently lives and works in Whitstable, Kent. His work includes paintings, murals and fine art commissions.

Christopher McHugh is a painter, writer, curator and a lecturer at the University of Sussex and the Chichester Institute of Higher Education. He has exhibited his work throughout the UK. He is co-founder and co-curator of Fabrica Gallery, Brighton and a founding member of Red Herring Studios.

Project Bibliography
Dalya Albere, 'The buzz in the community', *The Independent*, 8 May 1990

June–August 1990
ZARINA BHIMJI, GRAHAM
BUDGETT, KEITH DOWNEY,
BOB LAST, JANINE ROOK
PASSING GLANCES

Video- and photo-works by five artists were displayed in glass-fronted display boxes set into the hoarding around the new British Library development site on Euston Road, London. Passers-by were invited to make their own connections between the offerings of the five artists.

The street gallery exhibition was created in collaboration with the British Library.

———

Biographies
Zarina Bhimji was born in Mbarara, Uganda in 1963 and currently lives and works in London. She has exhibited widely including shows at the Ikon Gallery, Birmingham, the Walker Arts Center, Minneapolis, the Guggenheim Museum, New York and 'Documenta XI' in Kassel.

Graham Budgett studied at Central St Martin's College of Art and Design, London and Stanford University, California. He has taught photography and sculpture and is currently a Lecturer in Digital Art and Theory at the University of California, Santa Barbara.

Keith Downey studied at the California Institute of Art and is currently Adjunct Professor of Motion Graphics, 3D and Video Art at Otis College of Art and Design in Los Angeles.

Bob Last is a video artist who has produced films such as *The House of Mirth* and *The Century of Cinema*. He has also worked as Musical Supervisor for a number of television and film productions, including *Orlando* and *Little Voice*.

Project Bibliography
'Hoarding art is a public act in adland', *Creative Review*, June 1990, p. 11
'Passing Glances', *City Limits*, 26–29 July 1990, p. 75

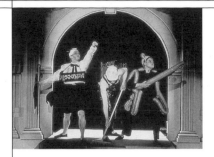

August–September 1990

MARTY ST JAMES & ANNE WILSON CIVIC MONUMENT

Civic Monument was presented in Birmingham, Glasgow and London in August and September 1990. Eight performers enacted a series of thematic tableaux ranging from classical idealism, work, war, leisure, to love and life in Britain today. The 45-minute performance began with a soundtrack and slide projection onto monumental structures, gradually incorporating live elements. The grand finale was a final atmospheric tableau with smoke bombs and explosive music.

———

Biographies
Marty St James and Anne Wilson worked together between 1982 and 1995. Their art includes video installations, live performances and two-dimensional works and has been presented in Britain, Europe and North America. St James and Wilson have produced videos for television, including a commission for Channel 4 for the 'Time Code' international film and video project.

Project Bibliography
Sarah Jane Checkland, 'The fine art of checking into the Grand', *The Times*, 5 January 1989
Rob La Frenais, 'Learning to Fly', *Performance*, March–April 1989
Steven Bode, 'Hotel', *City Limits*, 2 February 1989
Annalena McAfee, 'Artwork hotel', *Evening Standard*, 2 February 1989
Sam Willets, 'St James and Wilson', *Elle*, September 1990
Tony White, 'Live Art Week', *Performance*, March 1991, p. 49–50

December 1990

WHY NOT ASSOCIATES ON SPECTACOLOR YULETIDINGS

Yuletidings by Why Not Associates was a 30-second animation aimed directly at a Christmas consumer audience. The spiritual and material aspects of Christmas were humorously interwoven via snappy graphically manipulated texts.

———

Biography
Founded by Andrew Altman, David Ellis and Howard Greenhalgh, Why Not Associates are a multi-disciplinary design studio based in London. Established over a decade ago, the company has designed for projects ranging from postage stamps to large-scale exhibitions and installations, via publishing, corporate identity, public art and moving image.

1990–91

VERA FRANKEL ON SPECTACOLOR THIS IS YOUR MESSIAH SPEAKING

This is Your Messiah Speaking by Vera Frankel instructed shoppers to shop enthusiastically without worry. Frankel's work focused on the implications of manipulation by marketing forces overriding individual freedom of choice.

Biography
Vera Frankel is an interdisciplinary and multimedia artist based in Canada. A former Professor of Interdisciplinary Studio Art at Ontario's York University, Frankel has concentrated full time on her studio practice since 1995. She has also worked as artist-in-residence at venues such as the Academy of Fine Art, Vienna, the Leighton Artists' Colony, Banff, the Royal University of Stockholm and the Slade School of Art, London. Her video works have been screened at international film festivals and in solo screenings on five continents.

Project Bibliography
'Eyes up for video art', *The American*, 11 January 1991

Spring 1991
James Lingwood and Michael Morris were appointed part-time Co-Directors of Artangel in spring 1991, when it was based in a single room just off Oxford Street in London.

20 February–19 April 1992
JUAN MUÑOZ
UNTITLED (MONUMENT)
Jubilee Gardens, London SE1

As part of the exhibition 'Doubletake', which explored the relationship of collective memory to contemporary art at and around the Hayward Gallery, Artangel commissioned two projects. In Jubilee Gardens on the South bank of the River Thames, Muñoz placed a sculpture whose form was loosely modelled on Lutyens' Cenotaph on Whitehall, London. Made from artificial stone with flags of bronze, without inscription or sign, it stood as a monument to the idea of memory itself.

——

Biography
Juan Muñoz was born in 1953 in Madrid. He studied in London and New York and settled in Torrelodones in Spain. Major exhibitions of his work included surveys at IVAM in Valencia in 1992, the Irish Museum of Modern Art in Dublin in 1994 and the Palacio Velazquez, in the Retiro Park in Madrid in 1996. A retrospective of his work opened at the Hirshhorn Museum in Washington D.C. in 2001, and travelled on to the Art Institute of Chicago, and The Museum of Contemporary Art in Los Angeles. Juan Muñoz died in 2001, having recently completed *Double Bind*, a large-scale sculptural work for the Turbine Hall at Tate Modern, London.

20 February–19 April 1992
STEPHAN BALKENHOL
HEAD OF A MAN
Blackfriars' Bridge, London SE1
FIGURE ON A BUOY
River Thames, London SE1

Stephan Balkenhol realised two sculptures as part of 'Doubletake'. The first, a life-size sculpture in wood of a figure on a buoy was placed in the middle of the River Thames between Waterloo and Hungerford Bridges. It was removed after three weeks, following discussions with the Police and the River Authorities. The second, a large head of a man on a white table, was placed on one of the pillars which had once supported a railway line across the river next to Blackfriars' Bridge.

——

Biography
Stephan Balkenhol was born in Germany in 1957. He has had many one-person exhibitions in museums across the world including the Irish Museum of Modern Art in 1991, Witte de With in Rotterdam in 1993, and the Hirshhorn Museum in Washington D.C. in 1998. He has realised outdoor works in cities including public sites in Spain, Germany, Denmark and South Africa. He lives and works in Karlsruhe, Germany and Meisenthal, France.

Project bibliography
Richard Cork, 'Do you see what they see?', *The Times*, 18 February 1992
Andrew Graham-Dixon, 'Dismembered vision', *The Independent*, 3 March 1992
Peter Fleissig, 'Art Reviews', *City Limits*, 5–12 March 1992
Adrian Searle, 'Not Waving, Not Drowning', *frieze*, April–May 1992, pp. 17–20

Publication:
Doubletake: Collective Memory and Current Art, Hayward Gallery, London, 1992

19–28 June 1992
MICHAEL CLARK
Mmm...

King's Cross Depot, London N1

Choreographer and dancer Michael
Clark's *Mmm...* hailed the return of
this 'wunderkind' to London. In a per-
formance that opened with the artist
being 'born' by his real mother Bessie
and included artist Leigh Bowery –
who also designed the costumes –
Clark and his company performed in
a former depot behind King's Cross
Station.

—

Biography
Michael Clark was born in 1962 in
Aberdeen, Scotland. Graduating from
the Royal Ballet School in London at the
age of 17, he declined a place with the
Company, opting for Ballet Rambert
instead. He formed his own company at
the age of 22 and has since had several
departures from and returns to dance.
Clark lives and works in London.

Project bibliography
Christopher Bowen, 'Stepping Out',
Time Out, 17–24 June 1992, p. 16
Andrea Phillips, 'Come Dancing',
What's On, 17–24 June 1992, p. 19
Nadine Meisner, 'Even more rite, second
time', *The Times*, 22 June 1992
Judith Mackrell, 'Living up to his
promise', *The Independent*, 22 June 1992
Jann Perry, 'Mmm ... that's very good',
The Observer, 28 June 1992
Richard Smith, 'Cosmic Dancer',
Gay Times, June 1992, pp. 37–40
Richard Flood, 'Michael Clark',
Art Monthly, July 1992

13–25 October 1992
HANS-PETER KUHN
FIVE FLOORS

Angel Square, London N1

In the 40,000 square feet of a new
office development near Angel tube
station, Kuhn created five different
floors of sound and light, intercon-
nected by several lifts and a flight of
stairs. On two nights during the resi-
dency, dancers responded to Kuhn's
environment by performing a series
of choreographic works entitled
Five Dances under the direction of
Ian Spink.

—

Biography
Hans-Peter Kuhn was born in 1952 in
Kiel, Germany. A prolific sound and
visual artist, Kuhn has shown extensively
around the world. He has undertaken
several residencies and won many
awards, including the 1993 Golden Lion
at the 'Venice Biennale', in collaboration
with Robert Wilson for the installation
MEMORY / LOSS.

Project bibliography
Ellen Cranitch, 'Business with pleasure',
The Independent, 13 October 1992
David Hughes, 'Arch Angel', *What's On*,
14 October 1992
Robert Hewison, 'Light in the Darkness',
The Sunday Times, 18 October 1992
Sophie Constanti, 'Experimenting –
Space for Dance – Five Floors',
The Dancing Times,
December 1992, p. 272
Nick Cauldry, 'Five Floors', *Variant 13*:
winter-spring 1993, pp. 24–25

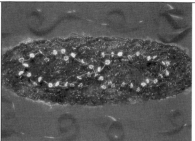

1992 and 1994
HELEN CHADWICK
DAVID WOJNAROWICZ

Mundo Positive was a series of art-
works by artists expressing concern
about AIDS. Rather than using typical
forms of communicating through
public health advertisements, *Mundo
Positive* used unusual images to
heighten AIDS awareness. These
specially commissioned full-colour
images were inserted into major
record releases and publications

—

Biographies
Helen Chadwick was born in 1953. Her
20-year career was cut short by a heart
attack in 1996. From the early 1980s
she produced work in which themes such
as flesh, sex, femininity and the place
of the body in society were explored.
Her later work was increasingly sensual
and colourful. She was nominated for
the Turner Prize in 1987. In her memory,
the Arts Council of England awards an
annual Helen Chadwick fellowship.

David Wojnarowicz was born in 1955. He
produced his first body of work in 1978.
In the 1980s he became part of the East
Village art scene in New York as a writer
and artist. He celebrated his homosexual-
ity with explicit imagery of homo-erotic
passion. When he was diagnosed as hav-
ing AIDS, he did not hide his illness but
used it to challenge prejudice and indif-
ference. In the decade between his first
solo show and his death of AIDS in 1992,
he took part in 19 solo exhibitions and
participated in close to 200 group shows.

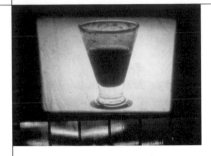

23 March–12 April 1993
**MELANIE COUNSELL
CORONET CINEMA**
93–95 Mile End Road, London E3

Melanie Counsell was commissioned
to transform the abandoned but still
grand interior of a former cinema in
East London – the eponymous Coronet
Cinema. Within this historic space,
which began as a music hall and was
later converted into an Art Deco cinema,
Counsell installed two screens – one
glass and one for film. Using black
and white footage of the accelerated
evaporation of a glass of liquid, the
work evoked a concentrated experience
of the passing of time.

The installation was supported by
The Henry Moore Sculpture Trust.

———

Biography
Melanie Counsell was born in 1964
in Cardiff. She studied at the South
Glamorgan Institute of Higher Education
and at the Slade School of Fine Art,
London. She has had solo shows at
Galerie Jennifer Flay, Paris and at Matt's
Gallery, London. Group exhibitions
include 'British Art Show', 1990, 'Sydney
Biennale', 1992 and 'Century City: Art
and Culture in the Modern Metropolis',
Tate Modern, London in 2001.

Project bibliography:
Michael Archer, 'O Camera O Mores',
Art Monthly, May 1993, pp. 14–16
Rob Legg, 'Signals', *The Independent*,
10 April 1993
Helen Sloan, 'Evaporation in the Dark',
Creative Camera, June–July 1993
Caroline Smith, 'History's Collapse',
Women's Art, May–June 1993, p. 25
Michael Corris, 'Melanie Counsell',
Artforum, October 1993, pp. 109–110

Publication:
Melanie Counsell, *Annette / Catalogue*,
Artangel and Matt's Gallery, London,
1998; *Catalogue* with an essay by Patricia
Falguières

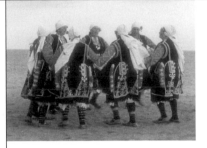

22–24 July 1993
**BETHAN HUWS /
THE BISTRITSA BABI
A WORK FOR THE NORTH SEA**
Near Alnwick, Northumberland

A choir of eight Bulgarian women
from the village of Bistritsa were
positioned by Bethan Huws by the
edge of the North Sea near the
village of Alnwick in Northumberland.
The work involved the women singing
out to sea, and then towards the audi-
ence, which watched and listened
either from the beach, or the cliffs
overlooking the bay. A film was made
with the choir on the same location
a day before the first performance.

The work was assisted by the New
Collaborations Fund of the Arts Council
of Great Britian, Northern Arts, Balkan
Airlines and Antwerp '93.

———

Biography
Bethan Huws was born in 1961 in Bangor,
Wales. She studied at Middlesex Polytechnic
and at the Royal College of Art, London.
She lives and works in Paris. Selected
solo exhibitions include the ICA, London,
1991, Kunstmuseum, Bern, 1998–99
and The Henry Moore Institute, Leeds,
2001. Group shows include 'On taking a
normal situation ...', Museum van Heden-
daagse Kunst, Antwerp, 1993; 'Life / Live',
Musée d'Art Moderne de la Ville de Paris,
1996; 'Skulptur Projekte Münster', 1997
and 'House Party', Florence, 2001.

Project bibliography:
Tom Lubbock, 'Between the devil
and the deep blue sea',
The Independent, 27 July 1993
Robert Hewison, 'On a different wave-
length', *The Sunday Times*, 1 August
1993, p. 23
Michael Archer, 'Bethan Huws, Bistritsa
Babi, A Work for the North Sea', *Art
Monthly*, September 1993, pp. 20–21
Gregor Muir, 'Bethan Huws,
A Work for the North Sea', *frieze*,
September–October 1993

25 October 1993–11 January 1994
RACHEL WHITEREAD HOUSE
Grove Road, London E3

House was the concrete cast of the last remaining house in what had been a Victorian terrace at the East side of Mile End Park in Bow, East London. Permission to transform the house into a sculpture was given by Bow Neighbourhood Council in the early summer of 1993. The interior was stripped out over the summer, and a new foundation laid in August. The cast was then created through concrete sprayed at high speed onto the interior walls of the house. Permission was initially given for *House* to remain on-site until the beginning of December. Whiteread was awarded the Turner Prize the same evening as Bow Neighbourhood Council refused a request to extend the life of the sculpture. Following a vociferous debate in the locality and in the media, a short further lease of life was secured for the sculpture, before it was demolished on 11 January 1994.

House was the first in a series of co-commissions by Artangel and Beck's which continued until 2000. The project was co-sponsored by Tarmac Structural Repairs and further assistance was received from the Arts Council of England, the London Arts Board, the Business Sponsorship Incentive Scheme and The Henry Moore Foundation.

Biography
Rachel Whiteread was born in London in 1963. One-person exhibitions include 'Ghost' at Chisenhale Gallery, London in 1990, the Stedelijk Van Abbemuseum, Eindhoven in 1992, the British Pavilion at the 'Venice Biennale' and the Palacio de Velazquez in Madrid in 1997 and the Serpentine Gallery, London in 2001. Major public projects include *Water Tower*, commissioned by the Public Art Fund in New York, in 1998 and the Holocaust Memorial completed in Vienna in 2000.

Project bibliography
John McEwen, 'The House that Rachel unbuilt', *The Sunday Telegraph*, 24 October 1993
Richard Cork, 'Monuments to a great adventure', *The Times*, 5 November 1993
Andrew Graham-Dixon, 'This is the house that Rachel built', *The Independent*, 2 November 1993
Lynne MacRitchie, 'House that Rachel Built', *Financial Times*, 6–7 November 1993
Adrian Searle, 'Rachel doesn't live here any more', *frieze*, January–February 1994
Deyan Sudjic, 'Art attack', *The Guardian*, 25 November 1993
Jonathan Glancey, 'Not rubbish, and perhaps tomorrow's masterpiece', *The Independent*, 30 November 1993
Alison Roberts, 'Art house propped up by benefactor', *The Times*, 15 December 1993
Tom Lubbock / David Thorp, 'Two responses to Rachel Whiteread's *House*', *Untitled*, winter 1993–94

Publication
James Lingwood (ed.), *House*, London: Phaidon Press, 1995
With essays by Jon Bird, Doreen Massey, Iain Sinclair, Richard Shone, Neil Thomas, Anthony Vidler and Simon Watney

Rachel Whiteread, *House*, video, 26 minutes, Artangel, 1995 / 1998
Filmed and edited by John Kelly and Helen Silverlock, Hackneyed Productions, London

September–October 1994
GRAEME MILLER / MARY LEMLEY LISTENING GROUND, LOST ACRES
Salisbury

Listening Ground, Lost Acres took place as part of the Salisbury Festival. In sound, speech and music Graeme Miller evoked the lives and places touched by the uncannily straight line between Stonehenge and the North of Salisbury and the Iron Age enclosure of Clearbury Ring to the South, via a series of transmitters. Listening to Miller's audio guidebook the visitors walked along Lemley's route that weaved in and out of the straight line. The meandering path was marked by tall glass triangulation points, revealing the Wiltshire landscape in which the line was set.

Co-commissioned by Artangel and the Salisbury Festival, supported by the Arts Council Live Arts Commission Fund and Southern Arts.

—

Biography
Graeme Miller was born in 1956 in London where he works as a theatre-maker, composer and artist. He co-founded Impact Theatre Co-operative in the 1980s and has created for theatre and dance as well as making installations and interventions. Stage works include *Dungeness, The Desert in the Garden*, 1987 and his award-winning production *A Girl Skipping*, 1990. Sound installations include *The Sound Observatory*, 1992 and *Overhead Projection*, 2000. *Lost Sound*, 2002, is his recent film with John Smith.
He has collaborated with his partner, Mary Lemley, on numerous projects.

Project bibliography
Robert Hewison, 'Walk me through it', *The Sunday Times*, 11 September 1994

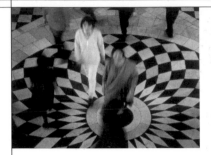

1 February–5 March 1995

TATSUO MIYAJIMA RUNNING TIME / CLEAR ZERO

Queen's House, London SE16

Tatsuo Miyajima created two comple-mentary works inspired by the time and place of Greenwich and the rational architecture of the Queen's House. In *Running Time* Miyajima transformed the Great Hall of Inigo Jones's build-ing into a moving tableau of time, using electronic counters that glided through the darkened interior. The performance *Clear Zero* took place on 4 and 5 March, the installation's last weekend. In it some 50 individuals – including Miyajima – counted back-wards from 9 to 1 in their own language. Starting quietly, the counting became gradually louder, finally becoming a hubbub of noise. The performance ended with the counters standing and shouting on the Meridian line.

Presented in association with the National Maritime Museum, Greenwich, supported by the Japan Foundation and Visiting Arts.

Biography

Tatsuo Miyajima was born in 1957 in Tokyo, where he still lives and works, and studied at the Tokyo National University of Fine Arts and Music. Solo exhibitions of Miyajima's work include the Hayward Gallery in London in 1997 and the Japanese Pavilion at the 'Venice Biennale' in 1999.

Project bibliography

Nigel Hawkes, 'The ultimate time-and-motion study', *The Times*, 1 February 1995, p. 35
Richard Dorment, 'The chaotic and magical march of time', *The Daily Telegraph*, 8 February 1995
Jonathan Glancey, 'The Art of Conjuring New Tricks out of Old Buildings', *The Independent*, 16 February 1995
Ian Gale, 'This one will run and run', *The Independent*, 24 February 1995
Godfrey Worsdale, 'Tatsuo Miyajima', *Art Monthly*, March 1995
Liam Gillick, 'Art by numbers', *Blueprint*, March 1995, pp. 12–14
Janice Hart and Alan Woods, 'Tatsuo Miyajima Interview', *transcript*, 03: 01 1997, pp. 4–19

Publication

Running Time / Clear Zero, Artangel, video, 20 minutes, Artangel, 1998
Filmed and edited by John Kelly and Helen Silverlock, Hackneyed Productions, London

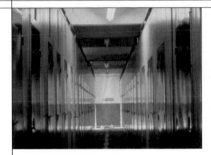

4 April–7 May 1995

LAURIE ANDERSON / BRIAN ENO / THE RCA ACORN RESEARCH CELL SELF STORAGE

Acorn Storage Centre, Wembley

In a self-storage warehouse in Wembley, West London, housing some 650 storage units, Brian Eno and a team of collaborators from the Royal College of Art in London created a surprising environment. Selecting a sequence of un-let units of varying sizes, interspersed throughout the depot, they generated an intricate journey through corridors of stored items, sounds and visions, punctuat-ed by Laurie Anderson's whispered stories.

———

Biographies

Laurie Anderson was born in 1947 in Chicago and lives in New York. Brian Eno was born in 1948 in Woodbridge, Suffolk. Both have international standing in the fields of music and the visual arts. *Self Storage* was Eno's and Anderson's first site-specific project together.

Project bibliography

Mick Brown, 'Eno puts art in a box', *The Daily Telegraph*, 1 April 1995
Kevin Jackson, 'Open wide: this won't hurt a bit', *The Independent*, 6 April 1995, p. 26
Kevin Kelly, 'Gossip is Philosophy', *Wired*, May 1995, pp. 86–92, 113
Sarah Kent, 'True stores', *Time Out*, 19–26 April 1995
Tim Cooper, 'Meeting a mermaid in a mystery tour around warehouse of won-ders', *Evening Standard*, 5 April 1995
Giles Coren, 'A few surprises in store', *The Times*, 14 April 1995
Mark Espiner, 'Multimedia', *The Wire*, issue 140, p. 73

9–14 May 1995

**MATTHEW BARNEY
CREMASTER 4**

The Metro, Rupert Street, London W1

Filmed on the Isle of Man and in
a studio in New York, Barney's 42-
minute film incorporates the island's
landscape and its annual TT motor-
bike race into a pulsing drama of
competitive drives and desires. Barney
plays the Loughton Candidate, a half
man / half indigonous Loughton sheep
satyr, who is aided by three faeries,
played by women body builders. Two
teams of sidecar racers, played by
experienced TT riders race around
the island on the 37-mile course.
Cremaster 4 is the first in a cycle of
five films, numbered by geographical
relation from West to East. *Cremaster
1* has its primary location in Barney's
home-town football stadium in Boise,
Idaho. *Cremaster 2* shifts from the
glaciers of the Rocky Mountains to
the salt flats of Utah. *Cremaster 3*, the
final film completed in 2002, is based
in the Chrysler Building and the
Guggenheim Museum in New York.
Cremaster 5 has as its primary loca-
tion Budapest and the Gellert Baths
there.

Artangel has presented each of the
Cremaster films in London, culminat-
ing in a special presentation of *The
Cremaster Cycle* in November 2002.

Commissioned by Artangel and Barbara
Gladstone Gallery, New York in associa-
tion with the Fondation Cartier, Paris.

Biography
Matthew Barney was born in San Francisco
in 1967 and lives and works in New York.
Following his first solo exhibitions at the
Stuart Regen Gallery in Los Angeles and
the Barbara Gladstone Gallery in New
York, he participated in 'Documenta IX'
in Kassel and the 'Venice Biennale' and
the 'Whitney Biennial' in 1993. The pre-
sentation of *Cremaster 4* in London coin-
cided with a show at the Tate Gallery's
'Art Now' space in 1995.

An exhibition based on *The Cremaster
Cycle* opened at the Ludwig Museum
in Cologne in 2002, before travelling
to the Musee d'Art Moderne de la Ville
de Paris and the Guggenheim Museum
in New York.

Project bibliography
James Lingwood, 'Keeping track of
Matthew Barney', *tate*, summer 1995
Stuart Morgan, 'Of Goats and Men',
frieze, issue 20, pp. 35–38
Adrian Searle, 'Art with balls',
The Independent Magazine, 29 April 1995
Francesco Bonami, 'Matthew Barney',
Flash Art, May–June 1994
Nicola Baker, 'Perfect body language',
The Observer, 30 April 1995
Mark Sladen, 'Assault course',
Art Monthly, June 1995, pp. 8–11
Richard Cork, 'Games reveal a new
winner', *The Times*, 9 May 1995
Sarah Kent, 'A gut instinct',
Time Out, 10–17 May 1995
Gregor Muir, 'Matthew Barney',
Art + text, issue 45
Jerry Saltz, 'Matthew Barney',
Art in America, October 1996, pp. 82–91
Richard Dorment, 'The making of
a man', *The Telegraph*, 26 January 2000

Publications
Cremaster 4, Artangel, in association
with Barbara Gladstone Gallery, New York,
and Fondation Cartier, Paris, 1995.
With an essay by James Lingwood

12 September–15 October 1995

**HANS-PETER KUHN /
ROBERT WILSON
H.G.**

Clink Street, London SE1

In the vaults of the former Clink
Prison on the South Bank in central
London, director / designer Robert
Wilson, in collaboration with sound
designer Hans-Peter Kuhn and produc-
tion designer Michael Howells, created
a series of tableaux in a range of
darkened chambers, based on notions
of time travel.

Presented with the financial support
from the International Initiatives Fund
and the New Collaborations Fund of the
Arts Council of England, the London Arts
Board, The Henry Moore Foundation and
the Goethe Institut.

Biographies
Robert Wilson was born in Waco, Texas
and was educated at the University of
Texas and Brooklyn's Pratt Institute.
He studied painting in Paris and later
worked with the architect Paolo Solari in
Arizona. Wilson subsequently moved to
New York City and by 1968 he had gath-
ered a group of artists known as The
Byrd Hoffman School of Byrds and start-
ed working and performing together.
He has designed and directed numerous
operas including Wagner's *Parsifal*,
Hamburg, 1991, Mozart's *The Magic
Flute*, Paris, 1991, Wagner's *Lohengrin*,
Zürich, 1991, and Puccini's *Madame
Butterfly*, Paris, 1993–97. He has also
presented innovative adaptations of
works by writers such as Virginia Woolf,
Marguerite Duras, Henrik Ibsen and
Gertrude Stein. Wilson's drawings,
paintings and sculptures have appeared
in many solo exhibitions

For a brief biography of Hans-Peter Kuhn
see *Five Floors*, 1993.

Project bibliography
Sarah Kent, 'Tableaux manners', *Time
Out*, 6–13 September 1995, pp. 26–27
Lynn MacRitchie, 'Clinks of light',
The Guardian, 7 September 1995
John O'Mahony, 'To the pictures',
The Independent, 11 September 1995
Richard Dorment, 'Daring time in the
Clink', *The Daily Telegraph*, 13 September
1995
Robert Hewison, 'A liberating experience',
The Sunday Times, 17 September 1995
William Feaver, 'Ghost trail',
The Observer, 17 September 1995
Tom Lubbock, 'Beyond caverns beckons
the darkness lit in pools', *The Independent*
19 September 1995
Mark Harris, 'Robert Wilson and Hans-
Peter Kuhn', *Art Monthly*, November
1995, p. 191

Publication
Robert Wilson / Hans-Peter Kuhn, *H.G*,
video, 56 minutes, Artangel, 1998
Camera Mike Figgis, edited by Joe Ann
Kaplan

25 June–28 July 1996
GABRIEL OROZCO
EMPTY CLUB
50 St James's Street, London SW1

In a former gentleman's club in central London, Gabriel Orozco presented a series of installations / interventions, that formed a subtle meditation on movement and stability, centre and periphery, rules and etiquette within an imposing British context. Using the grandeur of a gone era, the work uses imagery from typically British sports.

Supported by the International Initiatives Fund of the Arts Council of England, The Henry Moore Foundation, Visiting Arts, the Elephant Trust, the Secretaría de Relaciones Exteriores, Mexico and the Mexican Embassy.

—

Biography
Gabriel Orozco was born in 1962 in Jalapa, Veracruz, Mexico and lives and works in New York and Mexico. He studied at the Escuela Nacional de Arte Plasticas, Mexico City and Circulo de Bellas Artes, Madrid. He has had a variety of solo exhibitions at a range of venues in both Europe and the USA, and has participated in a large number of group exhibitions, including 'Documenta X' and 'Documenta XI' in Kassel.

Project bibliography
Robert Hewison, 'Games of enchantment', *The Sunday Times*, 30 June 1996
Charlotte Mullins, 'Come in and contemplate', *The Times*, 5 July 1996
Richard Dorment, 'Games artists play', *The Daily Telegraph*, 10 July 1996
Simon Grant, 'Gabriel Orozco', *Art Monthly*, September 1996, p. 33
David Ebony, 'Improbable Games', *Art in America*, November 1996, pp. 104–105

Publication:
Gabriel Orozco, Empty Club, Artangel, 1998. With essays by James Lingwood, Guy Brett, Jean Fisher and Mark Haworth-Booth

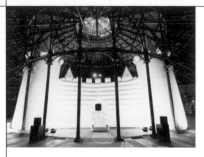

26 March–4 May 1997
DANA CASPERSEN / WILLIAM
FORSYTHE / JOEL RYAN
TIGHT ROARING CIRCLE
The Roundhouse, Chalk Farm,
London NW1

Ballett Frankfurt performer Dana Caspersen, choreographer William Forsythe, and composer Joel Ryan created a 'choreographic machine' – an immense bouncy castle, the biggest ever produced, which even led to a mention in *The Guinness Book of Records* – where the audience were invited to become the performers, and explore their body and its movements. Created for the Roundhouse in North London, a circular building from the mid-nineteenth century, originally built to swivel locomotives around.

Presented with the support of the International Initiatives Fund, Combined Arts and London Dance Network Strategic Programming funds of the Arts Council of England, the London Collaborations and London Calling Funds of the London Arts Board, the Quercus Trust and Camden Leisure and Community services.

—

Biographies
Dana Caspersen was born in Minneapolis, Minnesota. After three years with the North Carolina Dance Theater she joined Ballett Frankfurt in 1988 as a dancer, actress, author and choreographer. In 1999 she was commissioned by Klapstuck Festival to choreograph her first full evening piece, co-produced by Kunstencentrum Vooruit, Festival van Vlaanderen and Ballett Frankfurt. She was given a Bessie for Outstanding Creative Achievement in 1999.

William Forsythe was born in 1949 in New York City. He studied dance at Jacksonville University, Florida and later at the Joffrey Ballet School. In 1973

Forsythe joined the Stuttgart Ballett as a dancer, and later began choreographing works for the company. During the next seven years he made over 20 ballets for the Stuttgart Ballett and for other leading companies. In 1984 he became the Director of Ballett Frankfurt where he set out to create challenging works removed from conventional ballet and to build new audiences. Key works include *Artifact*, 1984, *Impressing the Czar*, 1988, *Limb's Theorem*, 1991, *The Loss of Small Detail*, 1991, *A L I E/NA(C)TION*, 1992, *Eidos:Telos*, 1995, *Endless House*, 1999 and *Kammer / Kammer*, 2000.

Joel Ryan was born in Danbury, Connecticut. He is based in Amsterdam. He studied music with Mexican film composer Jose Barroso and later with Ravi and Laxshmi Shankar. Subsequently Ryan began to fabricate electronic instruments in San Francisco with the help of hacker artists and garage engineers in what was becoming Silicon Valley. He went on to study music technology at Stanford University and joined the Mills College Center for Contemporary Music. Ryan has collaborated extensively with composers and artists including George Lewis, Steina and Woody Vasulka, Malcolm Goldstein, Michel Waisvisz and Evan Parker.

Project bibliography

Sarah Greenberg, 'Poetry in motion', *The Art Newspaper*, March 1997
Adrian Searle, 'Boing, boing', *The Guardian*, 29 March 1997
Ismene Brown, 'A big bouncy fragment of reality', *The Daily Telegraph*, 29 March 1997
Richard Cork, 'Is it a bouncy castle, or is it art?', *The Times*, 31 March 1997
Hugh Stoddard, 'Blue skies and Tight Roaring Circles', *Contemporary Visual Arts*, issue 15, 1997, p. 63

Publication

Tight Roaring Circle, video, 21 minutes, Artangel, 1998. Filmed and directed by Nicola Bruce, edited by Rod McLean

1–7 July 1997

NEIL BARTLETT
THE SEVEN SACRAMENTS
OF NICOLAS POUSSIN

Royal London Hospital, Whitechapel, London E1

In 1644 Nicolas Poussin accepted a commission to create seven paintings depicting the seven sacraments of the Christian church. Over seven nights, writer, director and performer Neil Bartlett traced the history of the body through seven moments in time at the Royal London Hospital in Whitechapel, referring to Poussin's series of paintings. He was assisted by artist Robin Whitmore.

Produced in collaboration with Gloria.

Biography

Neil Bartlett was born in 1958 in Hitchen, Hertfordshire. He works as a performer, director, translator and writer and is Artistic Director of the Lyric Theatre Hammersmith and was also a founding member of the independent music theatre production company, Gloria. For the Lyric, Bartlett has adapted and directed Robert Louis Stevenson's *Treasure Island*, 1997 and translated, designed and directed Marivaux's *The Dispute*, 1999. Among his works for Gloria are *Sarrasine*, 1990 and *The Game of Love and Chance*, 1992. Other works for the theatre include *More Bigger Snacks Now*, Theatre de Complicite, 1985 and *In Extremis*, National Theatre, 2000. He has written several novels, including *Mr Clive and Mr Page*, 1996, which was shortlisted for the Whitbread Prize.

Project bibliography

Neil Bartlett, 'Open art surgery', *The Guardian*, 1 July 1997
Paul Taylor, 'Ritual reality', *The Independent*, 2 July 1997
Michael Billington, 'Life, death and theatre as a form of holy communion', *The Guardian*, 3 July 1997
Charles Spencer, 'Moving laments for lost faith', *The Daily Telegraph*, 4 July 1997
Ian Shuttleworth, 'Poussin in hospital drama', *Financial Times*, 5–6 July 1997
Maggie O'Farrell, 'In sacramental hospital I sat down and wept', *The Independent on Sunday*, 6 July 1997

Publication

Neil Bartlett, *The Seven Sacraments of Nicolas Poussin*, Artangel, 1997

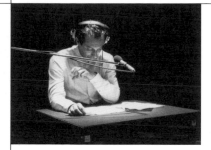

1992 / 18–20 September 1997

GAVIN BRYARS / JUAN MUÑOZ
A MAN IN A ROOM, GAMBLING

BBC Studio One, Delaware Road, London W9

Spanish sculptor Juan Muñoz collaborated with British composer Gavin Bryars on a series of ten five-minute pieces conceived for late night radio. The pieces were based on the spoken descriptions of card trick deception and were initially scored for a string quartet. They were recorded by the Gavin Bryars Ensemble with Juan Muñoz in London and subsequently broadcast on radio stations in Britain, the United States, Canada, France, Germany, Denmark et al. To coincide with the launch of the CD, live evenings were presented at the BBC Radio Studios in Maida Vale in London.

—

Biographies

Gavin Bryars was born in 1943 in Yorkshire. He lives in England and British Columbia, Canada. He was Professor of Music at Leicester Polytechnic between 1986 and 1994. He has composed prolifically for the theatre and for dance as well as for the concert hall and has written three full-length operas.

For a brief biography of Juan Muñoz, see *Untitled (Monument)*, 1992.

Project bibliography

Adrian Searle, 'Hush! Listen to the sound of sculpture', *The Guardian*, 18 September 1997
Paul Driver, 'Playing the joker', *The Sunday Times*, 28 September 1997
Juan Cruz, 'Gavin Bryars and Juan Munoz', *Art Monthly*, November 1997, pp. 30–31
Mike Barnes, 'The Gavin Bryars Ensemble with Juan Muñoz', *The Wire*, November 1997

Publication:

Gavin Bryars Ensemble, *A Man in a Room, Gambling*, Point Music CD, 1997

24 March–10 May 1998
**ILYA & EMILIA KABAKOV
THE PALACE OF PROJECTS**
The Roundhouse, Chalk Farm,
London NW1

In a large-scale structure built from wood and translucent fabric, the Kabakovs presented 65 projects by fictional Soviet citizens. Each project was presented in the form of a model, accompanied by a drawing of the proposal on a basic wooden table with text in Russian and English. The structure had two levels. The second level was reached via an expansive wooden staircase. The visitor then descended via a tight circular staircase back to the ground floor.

The projects were organised into three themes: How to make the world better, How to make yourself better, and How to stimulate the appearance of the projects.

The Palace of Projects was first presented at the Roundhouse in London in the spring of 1998, and subsequently in Upper Campfield Market, Manchester (as part of 'Art Transpennine') in the autumn of 1998, the Palacio Cristal in the Retiro Park in Madrid from December 1998 to March 1999 and in the Armoury Building in New York in June 2002, organised by the Public Art Fund. *The Palace of Projects* is now on permanent display in the Kokerei Zollverein in Essen, Germany.

A collaboration with Museo Nacional Centro de Arte Reina Sofia, Madrid and 'Art Transpennine'. Produced with the support of the National Lottery through the A4E scheme administered by the Arts Council of England, the International Initiatives Fund and Special Projects Fund of the Arts Council of England,

London Arts Board, the Gulbenkian Foundation and The Henry Moore Foundation and The Stanley Thomas Johnson Foundation. Constructed by MANCAT, Manchester. Presented in London in association with *Time Out*.

Biography
Ilya Kabakov was born in 1933 in Dniepropetrovsky in the Ukraine. He studied at the Moscow Art School and subsequently worked as an illustrator of childrens' books.
He began to work with Emilia Kanevsky in 1988, and they married in 1992. His many one person exhibitions include Kunstverein Cologne, 1992, Stedelijk Museum, Amsterdam, 1993, Centre Georges Pompidou, Paris, 1995, Museum für Moderne Kunst, Frankfurt, 1995, the Hamburger Bahnhof and Museum für Gegenwartskunst, Berlin, 1998 and the Kunsthalle Bern in 1999.

Project bibliography
Adrian Searle, 'Ministry of silly ideas', *The Guardian*, 24 March 1998
William Feaver, 'Look and learn', *The Observer*, 29 March 1998
Richard Cork, 'The palace of fantasy unchained', *The Times*, 31 March 1998
Tom Lubbock, 'At home with the World Exhibition', *The Independent*, 31 March 1998
Sarah Kent, 'Escape root', *Time Out*, 1–8 April 1998
Ian Hunt, 'The people's palace', *Art Monthly*, May 1998, pp. 9–12
Stuart Morgan, 'Ilya and Emilia Kabakov', *frieze*, issue 41
William Jaffett, 'Ilya and Emilia Kabakov', *Untitled*, spring–summer 1998
Barry Schwabsky, 'Ilya & Emilia Kabakov' *Art / Text* 62, 1998, pp. 78–79

Publication
Ilya & Emilia Kabakov, *The Palace of Projects*, Artangel and Museo Nacional Centro de Arte Reina Sofia, 1998

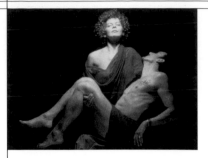

13 & 15 May 1998, St Bartholomew's Church, Brighton; 22 & 23 May 1998, Southwell Minster, Nottinghamshire; 28–30 May 1998, Southwark Cathedral, London SE1
**NEIL BARTLETT /
NICOLAS BLOOMFIELD /
LEAH HAUSMAN
SEVEN SACRAMENTS**

An unexpected developement of Bartlett's 1997 solo work, *Seven Sacraments* used old words, new music and an historic cathedral setting (the work was performed in three different cathedrals) to create a dramatic oratorio featuring 150 performers, including the East of England Orchestra, conducted by Nicholas Kok, with singers David Barrelll and Emma Selway, dancers Maxine Braham, Selena Gilbert, Wendy Houstoun, Jason Lewis, Elis Linders and Bob Smith, the Thomas Tallis Choir and 60 schoolchildren.
In each performance local children participated together with the dancers, the musicians and Neil Bartlett.

A collaboration with the Brighton Festival, Gloria and Stages.

Biography
For further details on Neil Bartlett, see *The Seven Sacraments of Nicolas Poussin*, 1997.

Project bibliography
Richard Morrison, 'An agnostic in search of faith', *The Times*, 18 May 1998
Jenny Gilbert, 'How Neil Bartlett registers birth, marriage and death', *The Independent on Sunday*, 17 May 1998
Jonathan Keates, 'Seven Sacraments', *The Times Literary Supplement*, 12 June 1998
Rupert Christiansen, 'Moving words married to tiresome tunes', *The Daily Telegraph*, 19 May 1998

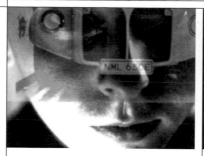

12–14 November 1998

SCANNER
SURFACE NOISE

From St Paul's Cathedral to Big Ben
and vice versa, London SW1–EC4

Taking the sights and sounds of London
and the nursery rhyme *London Bridge
is Falling Down* as the starting point
for a walk through the city, sound
artist Scanner gathered sound samples
and visual material as ingredients for
three evenings of live sound. Travelling
on a London bus, which retraced his
original route between Big Ben and St
Paul's Cathedral and back, he created
a series of live mixes, generating a sur-
real experience. The first in a series of
projects entitled 'INNERCity' in which
artists, writers and thinkers were invit-
ed to react to the city of London.

Presented with the support of the National
Lottery through the A4E scheme adminis-
tered by the Arts Council of England.

—

Biography
Scanner lives and works in London. His
controversial early work used scanned
mobile phone conversations which he
wove into soundscapes, but over time his
focus has shifted to trawling the hidden
noise of the modern metropolis. As well
as producing compositions and audio
CDs, his body of work includes sound-
tracks for films, performances, radio, and
site-specific intermedia installations.
Scanner has performed and created works
in institutions such as San Francisco
Museum of Modern Art, Hayward Gallery,
London, Centre Georges Pompidou, Paris,
Tate Modern, London and Moderna
Museet, Stockholm.

Project bibliography
Fiona Sturgess, 'Voyeurs of the world
unite', *The Independent*, 15 October 1998
Hettie Judah, 'Fare idea of the city',
The Times, 17 November 1998
Rob Young, 'Remote viewer', *The Wire*,
August 1999, pp. 40–45

27 November 1998

AUGUSTO BOAL
THE ART OF LEGISLATION

Former GLC Debating Chamber,
County Hall, London SW1

A series of workshops with activists
from different groups in and around
London culminated in a one-off perfor-
mance at the former Debating Chamber
at County Hall. Writer, performer and
social engineer Augusto Boal, well
known for his Legislative Theatre prac-
tice, 'passed' proposals for changes in
London housing, education and trans-
port. An 'INNERCity' commission

Supported by the National Lottery
through the A4E scheme administered
by the Arts Council of England.

—

Biography
Augusto Boal was raised in Rio de Janeiro.
Trained in chemical engineering, he
attended Columbia University in the early
1950s. After his doctorate he was invited
to work in São Paulo where he began
experimenting with new forms of theatre.
Boal introduced the idea of the spect-
actor, a spectator who is also an actor,
and began seeing theatre as a vehicle for
political activism. Shortly after the publi-
cation of *The Theatre of the Oppressed*, in
1971, he was arrested, tortured, and
eventually exiled to Argentina, then self-
exiled to Europe where he set up several
Centres for the Theatre of the Oppressed.
Boal returned to Rio de Janeiro in 1986.
In 1992 he ran as an at-large candidate
for the position of *Vereador* (Councillor)
of Rio and was elected. He developed
a Forum type of theatre – Legislative
Theatre – to work at neighbourhood level
to identify the key problems in the city.
The resulting discussions and demon-
strations became the basis for actual
legislation put forward by Boal.

Project bibliography
John Vidal, 'This man could give Archer
a few tips', *The Guardian*, 26 November
1998

13 December 1998

RICHARD BILLINGHAM
FISHTANK

BBC2 Television

Fishtank was produced for BBC
television and received its initial
broadcast in December 1998. The 43-
minute film is based entirely within
the small council flat where Richard
Billingham's parents Ray and Liz live
with his brother Jason and a small
menagerie of pets.
Billingham worked with editor Dai
Vaughan and television film-maker
Adam Curtis. Following its initial
broadcast on BBC2, the film has been
screened at film and video festivals
and in museums around the world,
and has been transferred onto 35mm.

—

Biography
Richard Billingham was born in the West
Midlands in 1970, and studied Fine Art
at the University of Sunderland. His first
book, *Ray's a Laugh* was published by
Scalo in 1996 and he was winner of
the Citibank Photography Prize in 1997.
He was short-listed for the Turner Prize
at Tate Britain in 2001. A touring exhi-
bition of his work opened at the Ikon
Gallery in Birmingham in 2000.

Project bibliography
Ryszad Gagola, 'Fishtank', *Artists
Newsletter*, January 1999
Matthew Sweet, 'Television review',
The Independent on Sunday,
13 December 1998
Duncan McLaren, 'Strategies for
survival', *The Independent on Sunday*,
13 December 1998
Richard Cork, 'Still lives and relative
values', *The Times*, 12 December 1998
James Lingwood, 'Inside the Fishtank',
tate, winter 1998, pp. 54–58
Oliver Bennett, 'My family and other
animals', *The Independent Magazine*,
December 1998, pp. 13–17
Adrian Searle, 'Family Fortunes', *frieze*,
January–February 1999, pp. 35–37

4–6 February 1999
JOHN BERGER /
SIMON McBURNEY
THE VERTICAL LINE

Former Aldwych Underground Station,
London WC2

In February 1999, writer John Berger and theatre director/actor Simon McBurney, accompanied by actress Sandra Voe, took the audience on a journey through time in a disused tube tunnel between Holborn and Aldwych, deep beneath The Strand, to a pitch-dark cave in France some 32,000 years ago.
An 'INNERCity' project.

Produced in association with Theatre de Complicite, supported by the National Lottery through the A4E scheme administered by the Arts Council of England.

Biographies
John Berger was born in 1926 in London. He lives and works as a novelist, painte, and art historian in France. Berger attended the Central School of Art and the Chelsea School of Art in London and has also taught drawing. In 1952 Berger began writing for London's *New Statesman* and quickly became an influential Marxist art critic. Since then he has published a number of art books including the famous *Ways of Seeing*, which was turned into a television series by the BBC. Berger has also produced a significant body of fiction, including *G.*, 1972, winner of the Booker Prize and the James Tait Black Memorial Prize. He is also the author of several screenplays and four plays.

Simon McBurney was born in 1957 in Cambridge. He studied at Cambridge and trained in Paris. McBurney is co-founder and Artistic Director of Theatre de Complicite with which he has devised, directed and acted in over 24 productions, toured internationally and won numerous major international awards. As an actor he has performed extensively for radio, television and feature films, including *Sleepy Hollow*, *Kafka*, *Tom and Viv*, *Being Human*, *Mesmer*, *The Ogre*, *Cousin Bette*, *Onegin*, *Eisenstein* and *Morality Play*.

Project bibliography
Lyn Gardner, 'The rhino now standing on platform two', *The Guardian*, 3 February 1999
Nick Curtis, 'Minding the gap in the time tunnel', *Evening Standard*, 5 February 1999
Paul Taylor, 'Growing underground to search for artists lost in time', *The Independent*, 6 February 1999
Susannah Clapp, 'Don't speak in the subway', *The Observer*, 7 February 1999

Publication
John Berger / Simon McBurney, with Sandra Voe, *The Vertical Line*, CD, Artangel, in association with Theatre de Complicite, 1999

1 April – 3 May 1999
DOUGLAS GORDON
FEATURE FILM

The Atlantis Building, Brick Lane,
London E1

Douglas Gordon continued his fatal attraction for the work of Alfred Hitchcock with his directorial debut of a feature-length film. A conductor, James Conlon, leads an orchestra in a performance of Bernard Herrmann's score for Hitchcock's film *Vertigo*. Only the features of the conductor, his hands, arms and face, are visible in the film.
The work exists in several versions: as an installation combining a large-scale projection of the film of the conductor with a small monitor playing a video of *Vertigo* (as it was first shown in London), as an installation combining two projections of *Feature Film*, and as a 35mm film. The first version lasts exactly as long as *Vertigo* itself, 122 minutes, and the second version, and 35mm film, last for the length of the musical performance, some 80 minutes.

Commissioned with Beck's and co-produced with the Centre Georges Pompidou, Musee National d'Art Moderne, Paris in association with the Kolnischer Kunstverein / Central Krankenversicherung A.G. and the participation of agnès b, Paris, the Caisse des Dépôts et Consignations, Paris, with the support of Galerie Yvon Lambert, Paris, Lisson Gallery, London, the London Arts Board and the Henry Moore Foundation.

Biography
Douglas Gordon was born in 1966 in Glasgow, and lives and works in Glasgow and New York. He was awarded the Turner Prize in 1996, the Premio 2000 at the 'Venice Biennale' in 1997 and the Hugo Boss Prize at the Guggenheim Museum, New York in 1998.
Recent one person exhibitions include Musée d'Art Moderne de la Ville de Paris 1999, Tate Gallery, Liverpool, 2000, Museum of Contemporary Art, Los Angeles, 2001, Kunsthaus Bregenz and Hayward Gallery, London in 2002.

Project bibliography
Marina Benjamin, 'And now … Vertigo without James Stewart', *Evening Standard*, 1 April 1999
Hettie Judah, 'The man who knew the score', *The Independent*, 1 April 1999
Adrian Searle, 'Hitchcock's finest hour', *The Guardian*, 3 April 1999
Tom Lubbock, 'Manoeuvres in the dark', *The Independent*, 6 April 1999
Richard Cork, 'Hitching a dizzy ride', *The Times*, 7 April 1999
Richard Dorment, 'Hitchcock from a whole new angle', *The Daily Telegraph*, 7 April 1999
Ralph Rugoff, 'An eye for intimate connections', *Financial Times*, 10–11 April 1999
Mark Sladen, 'The man who fell to earth', *The Independent on Sunday*, 11 April 1999
Alan Riding, 'In art, too, the sound is spooky', *The New York Times*, 11 April 1999
Tom Shone, 'A Hitch in time', *The Sunday Times*, 11 April 1999
Jonathan Jones, 'The director's cult …', *The Observer*, 21 March 1999
Louisa Buck, 'Douglas Gordon's directorial debut', *The Art Newspaper*, April 1999
Mark Francis, 'Lives of the artists', *Art Monthly*, May 1999, pp. 1–5

Publication
Feature Film a book by Douglas Gordon, Artangel / Book Works / agnès b, 1999, with CD
With essays by Raymond Bellour and Royal S. Brown

2–30 June 1999

RACHEL LICHTENSTEIN / IAIN SINCLAIR
RODINSKY'S WHITECHAPEL

Whitechapel, London E1

Rachel Lichtenstein's *Rodinksy's Whitechapel* connects the story of her quest for Jewish recluse David Rodinsky, who vanished from his room above a synagogue just off Brick Lane in 1969, with her own history (her grandparents immigrated to the Whitechapel area in the 1930s) in a small guidebook, highlighting the vanishing remainders of a once vibrant Jewish community.
Iain Sinclair traced Rodinsky's steps elsewhere in London, on the basis of the *A-Z* found in his room on Princelet Street.
An 'INNERCity' commission.

Produced with assistance from the National Lottery through the A4E scheme administered by the Arts Council of England, and the support of Harry Handelsman.

Biographies

Rachel Lichtenstein was born in 1969 in Rochford, Essex. She Studied at Sheffield University. Lichtenstein works as an artist, researcher and author and lives in London. Solo exhibitions include 'Forever Green', 19 Princelet Street, London, 1992, and 'Kirsch Family', Joseph's bookstore, London, 1999. Her book, *Rodinsky's Room*, was first published by Granta Books in 1999. It has since sold 25,000 copies world-wide and has been published in five countries.

Iain Sinclair was born in 1943 in Cardiff. He is a writer, poet, film-maker, editor and playwright and lives in London. Sinclair attended Cheltenham College, London School of Film Technique, Brixton, London, Trinity College, Dublin and the Courtauld Institute of Art, London. In the 1970s he founded Albion Village Press and used it to publish his own small volumes, mostly of poetry. His first novel, *White Chappell, Scarlet Tracings*, 1987, won him critical acclaim and a wide audience. Other novels include *Downriver*, 1991 and *Radon's Daughters*, 1994. His latest project, *London Orbital (A Walk around the M25)*, appeared as a book and a television film in 2002.

Project bibliography

Lyn Gardner, 'The lost spirit of Spitalfields', *The Guardian*, 22 May 1999
Sarah Kent, 'Art – Hotshots', *Time Out*, 1 June 1999
Niki Austen, 'Putting together the pieces of a man's fragmented life', *London Jewish News*, 4 June 1999
Marina Benjamin, 'The beguiling case of Rodinsky's Room', *Evening Standard*, 4 June 1999
Laura Cumming, 'The jury's still out', *The Observer*, 6 June 1999
Clare Melhuish, 'Escape from mythologised space', *The Architect's Journal*, 17 June 1999
Lilian Pizzichini, 'If the bricks could talk…', *The Independent on Sunday*, 20 June 1999
Jonathan Jones, 'East side story', *frieze*, issue 48, pp. 55–56

Publication

Rachel Lichtenstein, *Rodinsky's Whitechapel*, Artangel, 1998

17 June 1999–present

JANET CARDIFF
THE MISSING VOICE
(CASE STUDY B)

Whitechapel, London E1

Janet Cardiff devised a 40-minute audio walk through Spitalfields and Whitechapel. The walk starts in the Whitechapel Library and leads through a series of alleys and back streets towards Liverpool Street Station. The story intertwines a detective story, with references to film noir, and an architectural trail. Recorded on-site in London with binaural sound, it makes real and recorded, reality and fiction, almost indistinguishable.
An 'INNERCity' project.

Presented with the support of the International Initiatives Fund and Live Art Fund of the Arts Council of England, Visiting Arts, The Canadian High Commission, London, Alberta Foundation for the Arts and Ministry of External Affairs, Ottawa and the special help of William Palmer. Supported by Bloomberg News.

Biography

Janet Cardiff was born in 1957 in Brussels, Canada and lives and works in Lethbridge, Alberta and Berlin. She studied at Queens University, Kingston, Ontario and the University of Alberta. Group Shows include 'Nowhere', Louisiana Museum of Modern Art, Denmark in 1996, Skulptur Projekte Münster, 1997, and the Carnegie International, Pittsburgh, 1999. Recent exhibitions include 'Kunstraum', Munich in 2002, 'The Paradise Institute' at the 'Venice Biennale' in 2001 (with George Bures Miller), 'Forty Part Motet', presented at the National Gallery of Canada, Ottawa and in Salisbury Cathedral in 2001, and the Musée d'Art Moderne, Montreal in 2002. A major survey of Cardiff's work, including collaborations with her partner George Bures Miller, was presented at PS1 in New York in 2002.

Project bibliography

Jonathan Romney, 'Reclaiming the streets', *The Guardian*, 18 June 1999
Ralph Rugoff, 'A walk on the wild side', *Financial Times*, 19–20 June 1999
Susannah Clapp, 'Down these main streets a playwright must go', *The Observer*, 20 June 1999
Carol Peaker, 'The voice of a friend', *National Post*, 3 July 1999, p. 7
Tony Godfrey, 'Walk with mnemosyne', *Contemporary Visual Arts*, issue 25, 1999, pp.44–45
Claire Bishop, 'Janet Cardiff / Whitechapel', *Flash Art*, November–December 1999, p. 119
Rachel Withers, 'Janet Cardiff', *Artforum*, December 1999, p. 15
Monica Biagioli, 'Janet Cardiff. *The Missing Voice (case study b)*: an audio walk', *Artfocus*, winter–spring 2000, pp.12–13
Sarah Boxer, 'An artist who travels with you (on tape, that is)', *The New York Times*, 8 August 2000, pp. E1–E3

Publication

Janet Cardiff, *The Missing Voice (case study b)*, Artangel, 1999
With an essay by Kitty Scott and a CD of the actual work

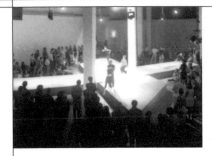

15–19 July 1999
DEBORAH BULL / GILL CLARKE / SIOBHAN DAVIES 13 DIFFERENT KEYS
The Atlantis Building, Brick Lane, London E1

A collaboration between Royal Ballet's principal Deborah Bull and contemporary choreographer Siobhan Davies. Involving dancers from the Royal Ballet and Davies's own company, the piece was presented in the Atlantis Building in East London. Contrary to normal practice, the audience was allowed to walk around the stage, while the two live musicians were placed on a smaller stage. For *13 Different Keys* Deborah Bull and Gill Clarke performed alongside Siobhan Davies Dance Company members Matthew Morris, and two Royal Ballet dancers, Jenny Tattersall and Peter Abegglen, as well as musicians Reiko Ichise (viola da gamba) and Carole Cerasi (harpsichord).

Produced in association with the Royal Ballet, supported by the London Dance Network and the Quercus Trust.

Biographies
Deborah Bull was born in Derby and trained at the Royal Ballet Schools. She joined The Royal Ballet in 1981. One of her leading roles was William Forsythe's *Steptext*, for which she won an Olivier Award nomination. In 2001 she began developing a programme for the Royal Opera House's alternative performance spaces while continuing her work as Director of the Royal Opera House's Artists Development Initiative. Bull has published two books, *The Vitality Plan* and *Dancing Away*, and has written and presented programmes for television and radio. She continues to perform on both stage and screen.

Gill Clarke was born in London. She was a founding member of Siobhan Davies Dance Company with which she performed and collaborated from 1988 to 1998. She was also a long-term collaborator with choreographers Janet Smith and Rosemary Butcher as well as performing free-lance with other choreographers including Rosemary Lee and Laurie Booth. Other collaborations have included choreography for Ricochet Dance Company, Tate St Ives and Royal Ballet dancers. Clarke became Head of Performance Studies at the Laban Centre, London, in 2000.

Siobhan Davies was born in 1950. She studied contemporary dance under Robert Cohan and Noemi Lapsezon. In 1980 she formed Siobhan Davies and Dancers, which later joined forces with the Ian Spink Group and Richard Alston and Dancers to form Second Stride. Davies founded the Siobhan Davies Dance Company in 1988 and was also Associate Choreographer for Rambert Dance Company from 1988 to 1993.

Project bibliography
Judith Mackrell, 'A right Royal makeover', *The Guardian*, 13 July 1999
Judith Mackrell, 'Take your platforms', *The Guardian*, 17 July 1999
Jann Parry, 'Who says the Royal Opera House couldn't run a bath?', *The Observer*, 4 July 1999
Jann Parry, 'Will you Marais me?', *The Observer*, 18 July 1999
Deborah Bull, 'Learning a new body language', *The Sunday Times*, 11 July 1999
Sophie Constanti, 'A few bridges too far', *Evening Standard*, 16 July 1999
Nadine Meisner, 'Contemporary meets classic', *The Independent*, 19 July 1999

1 January 2000–31 December 2999
JEM FINER LONGPLAYER
Trinity Buoy Wharf Lighthouse, 64 Orchard Place, London E14

Musician and composer Jem Finer conceived *Longplayer*, a thousand-year musical composition that runs continuously and without repetition from 1 January 2000 until 31 December 2999. The music can be heard at the listening post in London, in a former lighthouse overlooking the Thames. The music was also the soundtrack to the Millennium Dome's 'Rest Zone'. A mechanical device that will allow the music to run for its envisaged 1,000 years is under development.

Longplayer received financial support from the Millennium Festival, the New Millennium Experience Company and the Calouste Gulbenkian Foundation, with significant support in kind from Urban Space Managements, London Guildhall University, Apple Computer UK and Clifford Chance. *Longplayer* now falls under the care of The Longplayer Trust, which will ensure its future. www.longplayer.org

Biography
Jem Finer was born in 1955 in Stoke-on-Trent and lives and works in London. An artist and musician, he became a founding member of The Pogues in 1981 and spent the next 15 years writing, recording and touring. Additionally, he has written and recorded music for film, television, installations and public spaces. Finer also performs solo and in various groups and collaborations, among them L.E.G.O. (London Electric Guitar Orchestra), Anjali Sagar and Kodwo Eshun and Monk. Recent and ongoing projects include acting in and writing the score for the film *North Sea Circle* and *ghostones*, for the Museum of Contemporary Art Kiasma, Helsinki. Current projects include *pinball* (in collaboration with Franko B and Dominic Robson), *Hackney Wick* with Paul Shepheard, films and installations using footage shot in zero gravity with Ansuman Biswas and *Score for a Hole*, a piece of music of indeterminate length.

Project bibliography
Bruce Dessau, 'Looooooooooooongplayer', *Time Out*, 22 December 1999
Ruby Shepheard, 'The beat goes on', *Blueprint*, January 2000, pp. 16–17
Mark Espiner, 'This one will run and run', *The Guardian*, 24 May 2000
Jennifer Rodger, 'From here to (almost) eternity', *The Independent*, 3 July 2000
Charlotte Higgins, 'Music for an eternity', *The Guardian*, 9 September 2002

Publication
Jem Finer, *Longplayer*, with CD, Artangel, 2002
With essays by Jem Finer, Kodwo Eshun, Janna Levin and Christine & Margaret Wertheim

16 May–25 June 2000
SUSAN HILLER
WITNESS
The Chapel, 92 Golborne Road,
London W10

Witness is a work about vision and the visionary. The installation has hundreds of tiny speakers from which you can hear witness statements from people from all over the world (in their native languages and in English) who have seen UFOs, unusual phenomena or extra terrestrial visitations. The work was first presented in a former chapel in West London and subsequently in 'Intelligence' at Tate Britain. It then travelled to the 'Havana Bienal' and was subsequently shown in the 'Sydney Biennale' and in Roskilde, Denmark, in 2002.

Presented with the support of Tate Britain, The British Council and The Henry Moore Foundation, with thanks to Wentworth Anderson.

Biography
Susan Hiller was born in 1942 in Tallahassee, Florida. She lives and works in London. Hiller studied at Smith College, Northampton, USA and Tulane University, New Orleans and is Baltic Chair of Contemporary Art, University of Newcastle. Recent one-person exhibitions include Tate Gallery, Liverpool, 1996, Institute of Contemporary Art, Philadelphia, 1998 and Tensta Konsthalle, Stockholm, 1999. Selected group shows include 'Inside the Visible', Institute of Contemporary Art, Boston and Whitechapel Art Gallery, London, 1996, 'Out of Actions', Museum of Contemporary Art, Los Angeles, 1998 and 'Havana Bienal', Havana, 2000.

Project bibliography
Jonathan Jones, 'Warning: this woman is inside your head', *The Guardian*, 10 February 2000
Laura Cumming, 'Art', *The Observer*, 21 May 2000
Tom Lubbock, 'Close encounters of the transcendental kind', *The Independent*, 23 May 2000
Simon Grant, 'Testing our faith with tales of aliens', *Evening Standard*, 24 May 2000
Jonathan Jones, 'Susan Hiller, *Witness*', *The Guardian*, 25 May 2000
Richard Dorment, 'Close encounters of the aural kind', *The Daily Telegraph*, 31 May 2000
Waldemar Januszczak, 'Lend them your ears', *The Sunday Times*, 4 June 2000
Sarah Kent, 'Susan Hiller', *Time Out*, 7–14 June 2000
Laura Cumming, 'You can fill in the blanks', *The Observer*, 9 July 2000
Claire Bishop, 'Susan Hiller, Witness', *Make*, issue 89, September–November 2000, p. 32

Publication
Susan Hiller, *Witness*, with CD, Artangel, 2000

1–12 November 2000
TONY OURSLER
THE INFLUENCE MACHINE
Soho Square, London W1

Tony Oursler conceived *The Influence Machine* for Soho Square as a kind of 'psycho-landscape'. Delving deep into the history of the media, he has looked into historic shows which invoked the 'spirit' of the site such as late eighteenth-century phantasmagoria. The ghosts of key figures in media history such as television pioneer John Logie Baird and the Fox Sisters, who made contact with the spirit world in the mid-nineteenth century, roamed the square at night during the two-week presentation in November 2000.

Commissioned with Beck's in association with the Public Art Fund, New York, with the support of London Arts, the City of Westminster, The Stanley Thomas Johnson Foundation, The Henry Moore Foundation, the Calouste Gulbenkian Foundation, Tom Bendhem and Anita and Poju Zabludowicz.

Biography
Tony Oursler was born in New York City in 1957, where he now lives and works. He studied at the California Institute for the Arts. Recent one person exhibitions include 'Videotapes, Dummies, Drawings, Photographs, Viruses, Heads, Eyes, and CD-Rom' at the Kjunstverein Hannover, Konsthalle Malmö and Tel Aviv Museum of Modern Art in 1998 and a mid-career survey 'Introjection' at the Williams College Museum of Art, Williamstown, Contemporary Arts Museum, Houston, Museum of Contemporary Art, Los Angeles and Des Moines Art Center, Iowa in 1999 and 2000. He presented 'The Poetics Project' with Mike Kelley at the Museu d'Art Contemporani, Barcelona and 'Documenta X' in Kassel in 1997.

The Influence Machine was presented by the Public Art Fund in Madison Square Park in October 2000 prior to its presentation in Soho Square in London from 31 October 2000.

Project bibliography
Fiona Rattray, 'Heads, he wins', *The Independent on Sunday*, 22 October 2000
Martin Herbert, 'Under their influence', *Time Out*, 25 October 2000
Simon Grant, 'A face coming to a place near you', *Evening Standard*, 25 October 2000
Roberta Smith, 'Tony Oursler, *The Influence Machine*', *The New York Times*, 27 October 2000
Martin Herbert, 'Ghosts in the Machine', *Art Review*, November 2000, pp. 38–39
Gabriel Coxhead, 'Tony Oursler', *Dazed & Confused*, November 2000, p. 42
Waldemar Januszczak, 'Strangers in the night', *The Sunday Times*, 5 November 2000
Neal Brown, 'Tony Oursler', *The Independent on Sunday*, 5 November 2000
Adrian Searle, 'Tony Oursler / The Influence Machine', *The Guardian*, 7 November 2000
Richard Cork, 'A haunting in Soho', *The Times*, 10 November 2000
Ossian Ward, 'Who makes happenings happen?', *The Art Newspaper*, December 2000
Michael Cohen, 'Oursler's *Influence Machine*', *Flash Art*, January–February 2001, p. 52

Publication
Tony Oursler, *The Influence Machine*, Artangel / Public Art Fund, 2002
With a conversation between Louise Neri and Tony Oursler, and essays by Carlo McCormick and Marina Warner

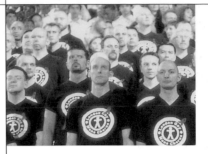

10–24 February 2001
MICHAEL LANDY
BREAK DOWN
former C&A shop at Marble Arch,
499–523 Oxford Street, London W1

Over the course of fourteen days,
Michael Landy systematically took
apart every single one of his 7227
possessions in a recently vacated
department store on Oxford Street.
The materials were circulated on a
roller and conveyor system, then sort-
ed, granulated and shredded on site.
During the course of the previous
year, Landy had made an inventory
of all of his possessions, sorted into
ten categories: Artworks, Clothing,
Electrical, Furniture, Kitchen, Leisure,
Perishables, Reading, Studio, and
Vehicle (his cherry red Saab 900
Turbo 16s with 105,455 miles on the
clock). The inventory was exhibited
on the walls of the C&A store behind
the dismantling and shredding areas.
At the end of the fourteen-day period,
every possession had been dismantled
and shredded. The remains, weighing
5.75 tons, were buried in a landfill site.

Break Down was the first of two projects
selected from The Times / Artangel Open.
The Times / Artangel Open series was
presented with the support of the
National Lottery through the A4E scheme
administered by the Arts Council of
England, The Henry Moore Foundation,
Thomas Dane, Karsten Schubert and
Anita and Poju Zabludowicz.

—

Biography
Michael Landy was born in 1963 in
London where he lives and works.
He studied at Loughborough College of
Art and at Goldsmiths' College, London.
Landy participated in the group show
'Freeze', in 1988. Solo exhibitions include
'Closing Down Sale', Karsten Schubert,
London, 1992, 'Scrapheap Services',

Chisenhale Gallery, London, 1996 and
'Michael Landy at Home, 7 Fashion
Street', London, 1999. Group shows
include '"Brilliant!" New Art from
London', Walker Art Center, Minneapolis,
1995, 'Sensation', Royal Academy of
Arts, London, 1997 and 'Diary',
Cornerhouse, Manchester (and touring),
2000, and the 'São Paulo Biennale'
2002.

Project bibliography
Richard Cork, 'If property is theft,
is he Crimewatch?', *The Times*,
16 October 2000
Stuart Wright, 'Breakdown & recovery',
Flux Magazine, February–March 2001
Louisa Buck, 'The broken artist',
The Art Newspaper, February 2001
Ann Treneman, 'The eve of destruction',
The Times, 6 February 2001
Tim Cumming, 'Stuff and nonsense',
The Guardian, 13 February 2001
Niru S. Ratnam, 'The dust brother',
The Face, February 2001, p. 242
Dave Beech, 'Michael Landy',
Art Monthly, March 2001
Richard Dorment, 'A deconstructed life',
The Daily Telegraph, 14 February 2001
Tim Cumming, 'The happiest day of my
life', *The Guardian*, 17 February 2001
Waldemar Januszczak, 'Everything
must go? ...', *The Sunday Times*,
18 February 2001
Gaby Wood, 'Going for broke',
The Observer, 18 February 2001
Lynn MacRitchie, 'The creative process
of destruction', *Financial Times*,
21 February 2001
Sarah Kent, 'Break Down', *Time Out*,
21 February 2001
Bryan Appleyard, 'Things ain't what
they used to be', *The Sunday Times*,
11 March 2001
Jonathan Jones, 'Imagine no posses-
sions', *Art Review*, April 2001
Dan Fox, 'Michael Landy', *frieze*,
May 2001
Claire Bishop, 'Rubbish', *Untitled*,
spring 2001, pp. 12–13

Publication
Michael Landy, *Break Down*, Artangel,
2001. With an interview by Julian
Stallabrass

31 March & 1 April 2001
ALAIN PLATEL AND
THE SHOUT
BECAUSE I SING
The Roundhouse, Chalk Farm,
London NW1
(Channel 4 / Artangel Media film
directed by Sophie Fiennes)

A one-off choral portrait of London
on a massive scale, *Because I Sing*
brought together voices raised from
across the capital: an A–Z of urban
choirs, sacred and secular, side-by-side
in a theatrical tribute to the democra-
cy and classlessness of singing. The
first in a series of collaborations with
Channel 4, broadcast in May 2001.

Because I Sing was sponsored by
Bloomberg and realised with additional
financial support from the National
Lottery through the A4E scheme admin-
istered by the Arts Council of England,
the Performing Rights Society
Foundation, the John Lyon's Charity, the
RVW Trust and with the special support
of Danny Melita and Dasha Shenkman.

—

Biographies
Alain Platel lives and works in Ghent,
and is best known for his pioneering
work with the internationally acclaimed
Belgian companies Les Ballets C de la B
and Victoria. Artangel presented his
piece *Bernadetje* in 1997 on a dodgem
track with a mixed-race company ranging
in age from 8 to 85. The piece *lets op
Bach* was brought back twice to
London's South Bank Centre in 1998.

The Shout is a sixteen-piece choir that
includes singers from a diverse range of
backgrounds including jazz, gospel, blues,
opera, contemporary, early music and
Indian classical. The choir was founded
by Orlando Gough and composer and
singer Richard Chew. Together they have
written four large choral pieces: *The Shout-
ing Fence*, South Bank Centre, London,
1998, *Corona*, first performed in Carnkie,
Cornwall, on the occasion of the solar
eclipse, 1999, *Journey to the North*,

2000 and *Sea Tongue*, premiered at
the Huddersfield Contemporary Music
Festival, 2001. Gough directs the choir,
which is currently touring its music-
theatre piece *Tall Stories* to venues in
England, Europe and America.

Orlando Gough was born in 1953 in
Brighton where he now lives. He was a
founding member of the bands The Lost
Jockey and Man Jumping. Gough writes
music for operas, plays, dance pieces
and music-theatre. Recent work includes
This House Will Burn, a dance piece
choreographed by Ashley Page for the
Royal Ballet, *Of Oil and Water*, a dance
piece choreographed by Siobhan Davies
and *Birds On Fire* for the viol consort
Fretwork.

Sophie Fiennes was born in 1967 in
Ipswich. Following a foundation course
in painting at Chelsea School of Art and
Design, London, she worked with director
Peter Greenaway. She met Michael Clark
in 1990 and went on to produce *Michael
Clark's Modern Masterpiece (Mmm...)*.
Her first short film for The Independent
Film Channel, USA, about Danish Dogme
film-maker Lars von Trier, was selected fo
various international festivals. Fiennes
film about Michael Clark, *The Late
Michael Clark*, was screened in February
2000. In 2002 Fiennes made *Hoover
Street Revival*, a documentary feature
produced by Fiennes's own production
company, Amoeba Film.

Project bibliography
Richard Morrison, 'Raise your voices',
The Times, 20 March 2001
Brian Logan, 'All together now',
The Guardian, 21 March 2001
Louise Gray, 'Fancy an international 600-
strong sing-song on moving staircases?',
The Independent, 25 March 2001
Mark Espiner, 'A choral line', *Time Out*,
28 March 2001
Michael Church, 'Where Londoners
sing together', *The Independent*,
30 March 2001
John L. Walters, '500 sing their hearts
out', *The Guardian*, 2 April 2001
Rick Jones, 'Here's to singing London',
Evening Standard, 2 April 2001
Rupert Christiansen, 'Never mind
the pantomime, listen to the voices',
The Daily Telegraph, 3 April 2001

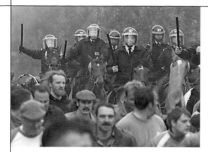

17 June 2001

JEREMY DELLER
THE BATTLE OF ORGREAVE
Orgreave, South Yorkshire
(Channel 4 / Artangel Media film
directed by Mike Figgis)

On 18 June 1984, one of the biggest
stand-offs of the miners' strike of
1984/85 took place in a field near
Orgreave, South Yorkshire, culminating
in a mounted police charge through
the village. Initiated by Jeremy Deller,
The Battle of Orgreave was a partial
re-enactment of what happened.
The event was filmed by Mike Figgis
for Artangel Media and Channel 4.

Produced in collaboration with Channel 4
with additional support from the National
Lottery through the A4E scheme admin-
istered by the Arts Council of England.

———

Biography
Jeremy Deller was born in 1966 in
London. He attended the Courtauld
Institute of Art, London and Sussex
University. Solo exhibitions include 'At
Home', Cabinet Gallery, London, 1996
and 'The Uses of Literacy', Norwich Art
Gallery, 1997. Group shows include 'Life
/ Live', Musée d'Art Moderne de la Ville
de Paris, 1996, 'Lovecraft', CCA,
Glasgow, 1997, 'Crossing', Kunsthalle,
Vienna, 1998 and 'Intelligence', Tate
Britain, London, 2000. Other projects
include 'Acid Brass', Botanic Gardens,
Glasgow (and other locations), 1997,
designing a T-Shirt for agnès b., 1998
and 'Now It Is Allowable', Swedenborg
Society, London, 1999.

Mike Figgis is an internationally celebrat-
ed writer, director and composer who
was born in Carlisle and lives in London.
Selected feature films include *Leaving
Las Vegas*, 1994, *Timecode 2000*, 1999
and *Hotel*, 2001. Documentary films
include *Just Dancing Around*, 1995,
Flamenco Women, 1997 and *The Blues*,
2002.

Project bibliography
Raymond Whitaker, 'When police batons
broke union power: artist re-creates the
Battle of Orgreave', *The Independent
on Sunday*, 10 June 2001
Martin Wainwright,
'Strikers relive battle of Orgreave',
The Guardian, 18 June 2001
Mary Braid, 'Miners side with the enemy
as Battle of Orgreave becomes art',
The Independent, 18 June 2001
Jonathan Jones, 'Missiles fly, truncheons
swing, police chase miners ...',
The Guardian, 19 June 2001
Tom Lubbock, 'When history repeats
itself too soon', *The Independent*,
19 June 2001
Tim Etchells, 'The Battle of Orgreave',
tate, autumn 2001
Lee Taylor, 'The Battle',
Flux magazine, July 2001
Dave Beech, 'The uses of authority',
Untitled, summer 2001, pp. 7–10
Alex Farquharson, 'Jeremy Deller –
The Battle of Orgreave', *frieze*,
August 2001, p. 108

Publication
Jeremy Deller, *The English Civil War Part II*,
with CD, Artangel, 2002
With essays by David Douglass, Howard
Giles, Stephanie Gregory, Mac McLoughlin,
Johnny Wood, Ken Wyatt and Jonathan
Foster

27 January 2002

FRANCIS ALŸS
TRIAL FOR A CONCERTO
The City of London

On 27 January 2002, Francis Alÿs
orchestrated *Trial for a Concerto*
for the City of London which involved
a number of musicians finding each
other within the boundaries of the
Square Mile of the City of London
through the sounds of their brass
instruments.
Trial for a Concerto marked the begin-
ning of an ongoing project in London,
which will continue through 2003 In a
variety of forms – actions, announce-
ments and rumours

Commissioned with Bloomberg.

———

Biography
Francis Alÿs was born in Antwerp in 1959.
He studied at the Institut d'Architecture
de Tournai in Belgium and the Istituto de
Architectura de Venezia, Italy. He lives and
works in Mexico City, where much of his
works is made on the streets of the city.
These performances and actions are then
transposed onto postcards with a succinct
descriptive text which are then distributed
throughout the world. Recent larger-scale
projects include 'Where Faith can Move
Mountains' in Lima, Peru and 'The
Modern Procession' in New York in 2002.
Recent one-person exhibitions include
'The Liar, The Copy of the Liar', Museo
de Arte Moderna, Mexico D.F. in 1997, 'Le
Temps du Sommeil' at the Contemporary
Art Gallery, Vancouver in 1998, 'The Last
Clown' at Fundació la Caixa, Barcelona
and Centre d'Art Contemporain, Geneva
in 2000 and the Musée Picasso, Antibes
in 2001.

15 February–17 March 2002

ATOM EGOYAN
STEENBECKETT

Former Museum of Mankind,
Burlington Gardens, London W1

Atom Eygoyan's *Steenbeckett* was a
labyrinth in miniature; a route around
an archive of personal history, down
empty corridors and up flights of
stairs to the abandoned projection
booth of a hidden cinema. The centre
of the installation was 2000 feet of
film running through pullies and
driven round by a Steenbeck editing
table. The footage was a one-take shot
of John Hurt's performance in Samuel
Beckett's *Krapp's Last Tape*. In an adja-
cent room the film was projected onto
a wall-filling screen. The location was
the former Museum of Mankind.

The project was realised courtesy of the
Royal Academy and the British Museum,
London.

Biography

Atom Egoyan was born in Cairo and
raised on Canada's West Coast. He lives
and works in Toronto. A writer and direc-
tor, he is the creator of a celebrated body
of work. Egoyan's many feature films
include *The Adjuster*, 1991, *Next of Kin*,
1984, *Exoctica*, 1994 and *The Sweet
Hereafter*, 1997. Many of his films have
received national and international
awards. Egoyan has written and directed
a variety of television films and pro-
grammes including *Gross Misconduct*,
1993 and has written episodes of *Friday
the 13th*, *Alfred Hitchcock Presents* and
The Twilight Zone.

Project bibliography

Alex O'Connell, 'Arts – Interview',
The Times, 4 February 2002
Atom Egoyan, 'Memories are
made of this', 7 February 2002
Jonathan Jones, 'Steenbeckett',
The Guardian, 16 February 2001
Mark Monahan, 'Tender farewell to reel life',
The Daily Telegraph, 16 February 2002
Jonathan Romney, 'Cutting edge
stories from reel life', *The Independent
on Sunday*, 17 February 2002
Sarah Kent, 'The splice of life',
Time Out, 27 February 2001
Fisun Güner, 'Rewinding Beckett',
What's On, 27 February 2002
Waldemar Januszczak, 'The best
Canadian art stays with you for ever.
The worst ...', *The Sunday Times*,
12 March 2002
Gareth Evans, 'The heart in the machine',
Sight and Sound, March–April 2002

4 September–17 November 2002

RICHARD WENTWORTH
AN AREA OF OUTSTANDING
UNNATURAL BEAUTY

General Plumbing, 66 York Way,
London N1

Richard Wentworth has lived in King's
Cross for some twenty five years.
At a moment of huge upheaval in this
particularly transient part of London,
Wentworth temporarily inhabited a
vacated General Plumbing Store on
York Way, overlooking the railway
tracks and the building sites at the
back of King's Cross and St Pancras
Stations. Inside the store he installed
maps and plans and films, ping-pong
tables and periscopes in an evolving
excavation of the fugitive nature of the
inner city. A wide-ranging interaction
programme fed into and out of
Wentworth's King's Cross HQ, includ-
ing walks and talks.

Commissioned with Bloomberg with the
support of the Foundation for Sport and
the Arts and William Palmer.

———

Biography

Richard Wentworth was born in 1947 in
Samoa, and lives and works in London.
He studied at Hornsey College of Art and
the Royal College of Art in London and is
currently Master of the Ruskin College of
Art, Oxford University. Recent exhibitions
include 'Point de Vue' at the Musée des
Beaux Arts et de la Dentelle de Calais and
'Faux Amis', a double-bill with Eugene
Atget at The Photographers' Gallery in
London in 2001. In 1999, he conceived
'Thinking Aloud' as a touring exhibition
organised by the Hayward Gallery in
which patents and paintings, doodles
and designs were presented alongside
each other as a means of probing the
creative process.

October / November 2002

STEVE MCQUEEN
CARIBS' LEAP /
WESTERN DEEP

London

A cinematic installation comprising
two related films which are presented
simultaneously in two adjacent rooms.
Western Deep was filmed in 2001 in
the Tautona gold mines South Africa.
Shot on Super-8, the film follows the
miners down the shafts and tunnels
to the working faces which are up
to two miles beneath the surface.
Caribs' Leap revolves around a key
moment in the history of Grenada in
1651 when a group of native Caribs
threw themselves off a cliff rather
than surrender to the colonising
French forces. All the material from
Grenada was filmed on Super-8 by
cinematographer Robby Muller and
reworked in post-production.

Commissioned with 'Documenta XI'
and the support of Heinz and Simone
Ackermans. Produced by Artangel,
'Documenta X' and Illuminations Films
in association with the Fundació Antoni
Tàpies, Barcelona and Museu Serralves,
Porto, the Arts Council of England,
The Henry Moore Foundation and
The Elephant Trust, Anita and Poju
Zabludowicz and Effects Associates
and The Mill, London.

———

Biography

Steve McQueen was born in London in
1969. After studying at Chelsea School
of Art and Goldsmiths' College in London,
he attended Tisch School of the Arts in
New York. In 1999 he was awarded the
Turner Prize at the Tate Gallery, London.
Recent one-person exhibitions include
the ICA, London, ICA, Boston and Kunst-
halle Zürich in 1999, Kunsthalle Wien in
2001 and Museum of Contemporary Art,
Chicago in 2002. He lives and works in
Amsterdam.

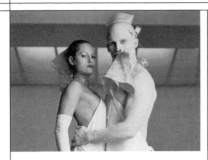

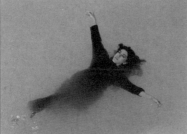

November 2002
MATTHEW BARNEY
THE CREMASTER CYCLE
London

In a specially customized cinema in London, Matthew Barney presented the full cycle of five *Cremaster* films, made between 1994 and 2002. Visitors passed through an installation with cast vaseline, astroturf and videos before entering the cinema. The presentation culminated in the final film of the cycle, *Cremaster 3*, completed by Barney in 2002. The three-hour epic is based on the construction of the Chrysler building in New York City.

Presented in London with the support of the Quercus Trust and the private patronage of The Cremaster Circle, including Kaveh and Cora Shelbani, Benjamin and Louise Brown, Peter Wheeler and Pascale Revert, Charles Asprey, Michael Hue-Williams, Lance Entwistle and Marianne Holterman and Luca and Nina Marenzi.

—

Biography
For a brief biography on Matthew Barney, see *Cremaster 4*, 1995.

6–10 November 2002
SHOJA AZARI /
SUSSAN DEYHIM /
GHASEM EBRAHIMIAN /
SHIRIN NESHAT
THE LOGIC OF THE BIRDS
Union Chapel, Islington N1

The Logic of the Birds takes as its source a twelfth-century Persian Fable, *The Conference of the Birds*, by the poet Attar and combines film and music theatre in a contemporary exploration of meaning, spirituality and feminism. An amalgam of film, music and live performance, *The Logic of the Birds* brings to life a haunting journey of feminine identity and individuality in a culture entrenched in patriarchal values.

Commissioned with The Kitchen, New York, Lincoln Center Festival, New York, RLG Productions, New York, Walker Art Center, Minneapolis and Change Inc., Milan.
The London Performances were presented by Artangel in association with the Iran Heritage Foundation and Bloomberg with the additional support of London Arts and the Arts Council of England.

Biographies
Writer, director, actor and designer Shoja Youssefi Azari was born in 1957 in Shiraz, Iran, and lives and works in New York. His films include *The Merchant and The Indian Parrot*, 1998 and *The Penal Colony*, 2000. Azari's other collaborations with Shirin Neshat include the lead role in *Turbulent*, 1998 and co-writing and co-editing *Rapture* and *Soliloquy*, both 1999, *Fervor*, 2000 and *Passage*, 2001.

Vocalist and performance artist Sussan Deyhim was born in Teheran, Iran and lives and works in New York. Her albums include *A Gift of Love*, with Depak Chopra, and *Madman of God: The Divine Love Songs of the Persian Sufi Masters*. Deyhim's appearances include John Claude van Italie's *Tibetan Book of the Dead*, Bobby McFerrin's vocal ensemble and Shirin Neshat's film *Turbulent*.

Writer, director and cinematographer Ghasem Ebrahimian was born in Iran and lives and works in New York. He wrote and directed the feature film *The Suitors* in 1988. Other films include a collaborative documentary about the Jews of Morocco and a feature entitled *The Blind Owl*. Ebrahimian's ongoing collaboration with Shirin Neshat began in 1997.

Shirin Neshat was born in 1957 in Qazvin, Iran, and lives and works in New York. Her solo exhibitions include shows at the Whitney Museum of American Art, New York, 1998 and the Serpentine Gallery, London, 2000. She has also participated in the 'Venice Biennale', 2001 and the 'Sydney Biennale', 2000. Neshat's films have been screened at international festivals such as the Rotterdam Film Festival, 1999 and the San Francisco Film Festival, 2001.

Summer 2003
GIYA KANCHELI
IMBER
Imber, Salisbury Plain
(Artangel Media / BBC film directed by Mark Kidel)

Used for Army training since World War II, the village of Imber on Salisbury Plain provided the inspiration and the site for Giya Kancheli's musical composition. Written for a chamber ensemble of string, wind and brass instruments, the Georgian polyphonic choir Rustavi and a solo duduk player, the piece echoes the evocative themes of memory, loss and displacement associated with the poignant story of Imber. The second part of the project is a film by Mark Kidel based on the history of the village and its remaining members, Kancheli's piece and the event itself.

—

Biography
Composer Giya Kancheli was born in 1935 in Tbilisi, Georgia. He lives and works in Antwerp. Between 1967 and 1986 Kancheli composed seven symphonies, including *In Memoria di Michelangelo*, 1974, and wrote an opera entitled *Music for the Living* with director Robert Sturua, 1982–84 / 1999. World premières of specially commissioned works include Piano Quartet in *L'istesso Tempo*, Bridge Ensemble, Seattle, 1998, *And Farewell Goes Out Sighing ...*, New York Philharmonic, 1999, *Don't Grieve*, San Francisco Symphony, 2001 and *Fingerprints*, Melbourne Symphony Orchestra, 2002.

CREDITS

We would like to thank Artangel's Board members
and Staff – past and present – for their support and
commitment over the past decade.

Staff

Kathy Battista
Griselda Bear
Candida Blaker
Ben Borthwick
Tabitha Clayson
John Farquhar-Smith
Tracey Ferguson
Lisa Harty
Louise Hayward
Cressida Hubbard
Samira Kafala
Natalie Kancheli
Deklan Kilfeather
Michael Krüger
Francesca Laws
Gary Leyland
Anna Malyckyj
Corinne Micallef
Milly K. Momin
Louise Neri
Antoinette O'Loughlin
Lucy Reynolds
David Scholefield
Lorraine Selby
Lucy Sharp
Melanie Smith
Melanie Steel
Miria Swain
Anne Vanhaeverbeke
Gerrie van Noord
Gerry Wall
Laura Woods

Board

Will Alsop
Jon Bird
Anne Carlisle
Siobhan Davies
Ben Evans
Nigel Finch
Piers Gough
John Kieffer
Jeremy King
Amanda Levete
Fred Manson
Suzanne Moore
Sandy Nairne
William Palmer
Jane Root
Phyllida Shaw
Gilane Tawadros
Marina Warner

ACKNOWLEDGEMENTS

How can we begin to thank all the people who have helped to make these 40 projects happen over the past decade?

Each and every one of these projects has been a collaboration. Every one of them has needed our colleagues at Artangel and every one of them has needed a community of people – sometimes a very large community – to help make them happen. We thank them for their passion and their commitment.

Each and every project needs partners. We would like to thank all the individuals and institutions who have shared our vision: our professional colleagues in museums and galleries, dance houses and television channels, festivals and biennials; our group of individual patrons, The Company of Angels, whose support has grown through the decade; those trusts and foundations and companies who have supported us regularly throughout the decade; Beck's, Bloomberg, *The Times* and *Time Out*; the Henry Moore Foundation, The Quercus Trust, The Elephant Trust, the Calouste Gulbenkian Foundation, the Stanley Thomas Johnson Foundation and, specifically for this book, the Fine Family Foundation.

Every project is like building a house of cards. Without a firm foundation, we couldn't have begun to build many of these works. That foundation has been put in place by public funding, and we would like to thank the principal agencies for their support of Artangel throughout the decade – the Arts Council of England, London Arts and the National Lottery.

We also extend our gratitude to everyone at Merrell Publishers for their partnership in the creation of this book. As with so many of our publications over the past decade, this has been the fruitful result of the close collaboration between editor Gerrie van Noord and designer Mark Diaper, to whom we are particularly indebted.

Most of all, each and every project has needed a great deal of belief.

We would like to thank everyone – and most especially the artists with whom we have had the pleasure to work – for sharing that belief.

JAMES LINGWOOD AND MICHAEL MORRIS
Co-Directors

PHOTOGRAPHIC CREDITS

N.B. In all cases where original letters, sketches and artworks have been reproduced, no credits are listed

MERRELL

First published 2002 by
Merrell Publishers Limited
42 Southwark Street
London SE1 1UN
Telephone + 44 (0)20 7403 2047
E-mail mail@merrellpublishers.com
Web www.merrellpublishers.com

Artangel
31 Eyre Street Hill
London EC1R 5EW
Telephone + 44 (0)20 7713 1400
E-mail info@artangel.org.uk
Web www.artangel.org.uk

Artangel is a registered charity no. 272796
Artangel is supported by London Arts and the private patronage
of the Company of Angels

LONDON ARTS

This publication is kindly supported by
the Fine Family Charitable Foundation

FINE FAMILY FOUNDATION

Distributed in the USA by Rizzoli International Publications, Inc.,
through St Martin's Press, 175 Fifth Avenue, New York, NY 10010

British Library Cataloguing-in-Publication Data:
Lingwood, James
Off Limits : 40 Artangel projects
1.Artangel (London, England) 2.Art, British – 20th century
3.Art – Commissioning – England
I.Title II.Morris, Michael
700.9'421

Artangel Limited Edition: ISBN 1 902201 14 0
Merrell Trade Edition: ISBN 1 85894 187 3

Edited by Gerrie van Noord, assisted by Ariella Yedgar

Designed by Mark Diaper, Berlin

Produced by Merrell Publishers Limited

Printed and bound in Italy